W9-BNT-072

Stephen Johnson
on Digital
Photography

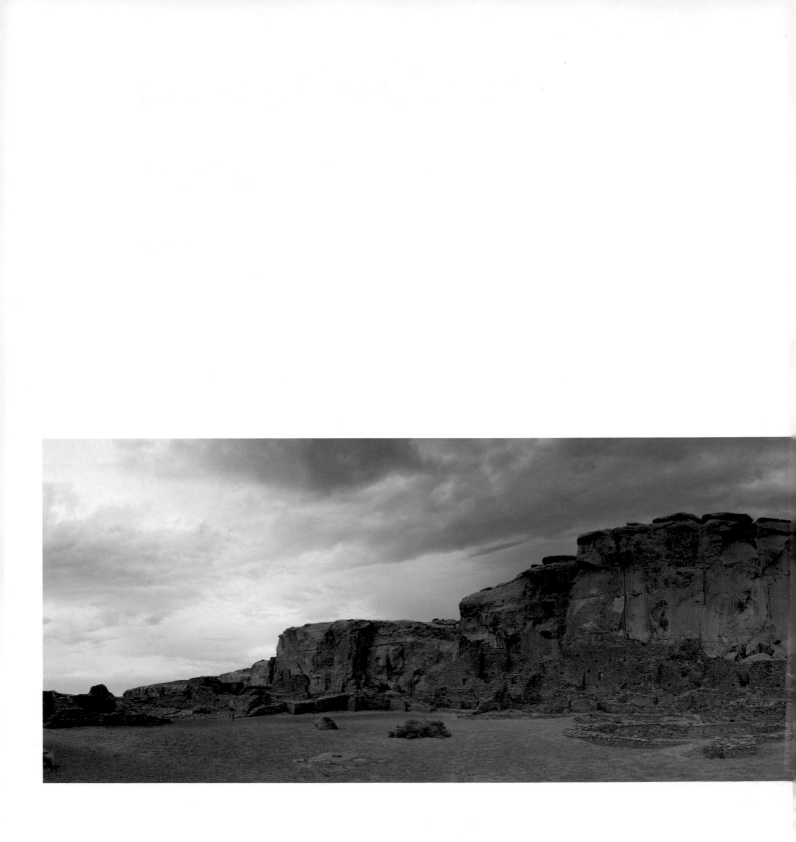

Stephen Johnson
on Digital
Photography

TEXT, PHOTOGRAPHY, AND DESIGN BY STEPHEN JOHNSON

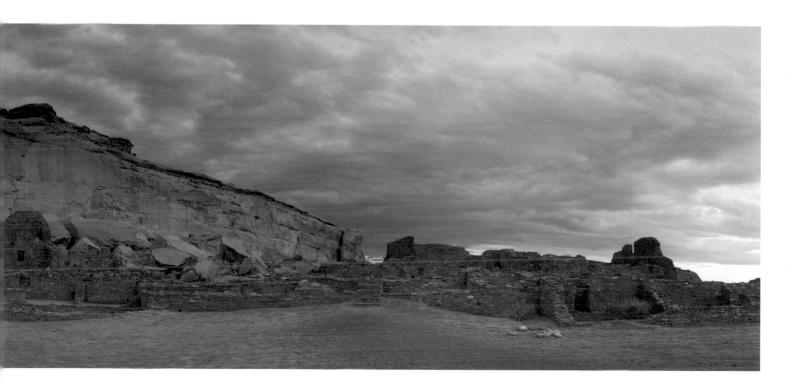

O'REILLY®

BEIJING · CAMBRIDGE · FARNHAM · KÖLN · PARIS · SEBASTOPOL · TAIPEI · TOKYO

Stephen Johnson on Digital Photography

Copyright © 2006 Stephen Johnson. All rights reserved worldwide.
Printed in Italy.

Unless otherwise noted, all photographs by Stephen Johnson.

Published by O'Reilly Media, Inc., 1005 Gravenstein Highway North, Sebastopol, CA 95472

All rights reserved worldwide. No part of this book may be reproduced in any form by any electronic or mechanical means (including photocopying, recording, or information storage and retrieval) without permission in writing from the publisher. Previously published and copyrighted works include articles in Stephen Johnson Photography Newsletters and website, View Camera magazine, California History, Digital Video, etc.

Executive Editor: Steve Weiss
Editor: Colleen Wheeler
Design: Stephen Johnson

The opinions expressed in this book are those of the author and do not represent the view of the publisher. While every precaution has been taken in the preparation of this book, the publisher and author assume no responsibility for errors or omissions or for damages resulting from the use of the information contained herein.

Many of the designations used by manufacturers and sellers to distinguish their products are claimed as trademarks. Where those designations appear in this book and O'Reilly Media, Inc. was aware of a trademark claim, the designations have been noted.

• Better Light™ is a registered trademark of Better Light.

• ColorThink™ is a registered trademark of Chromix Software.

• Eye-One™ is a registered trademark of Gretag Macbeth.

• Flextight™ is a registered trademark of Imacon.

• Illustrator™, InDesign™, and Photoshop™ are registered trademarks of Adobe Systems, Inc.

• Leafscan 45™ and Leaf DCB™ (Digital Camera Back) are registered trademarks of Leaf Systems.

• Macintosh G5™ and Powerbook™ are registered trademarks of Apple Computer Inc.

• PhotoDesk™ is a registered trademark of Eastman Kodak.

• PMS and PANTONE MATCHING SYSTEM® are registered trademarks of Pantone, Inc.

This is a production of Stephen Johnson Photography
PO Box 1626, Pacifica, CA 94044

To order Original Prints or take a Photography Workshop with Stephen Johnson
email: info@sjphoto.com
www.sjphoto.com

0-596-52370-X

Cover Photograph: Ice Wall, Kenai Fjords National Park, Alaska, 1995.
BetterLight Scanning Camera. 6000x7520 pixels, 12 bit, Tri-linear Array.

Title Page Photograph: Pueblo Bonito, Chaco Canyon, 2002.
BetterLight Scanning Camera. 6000x26176 pixels, 12 bit, Tri-linear Array.

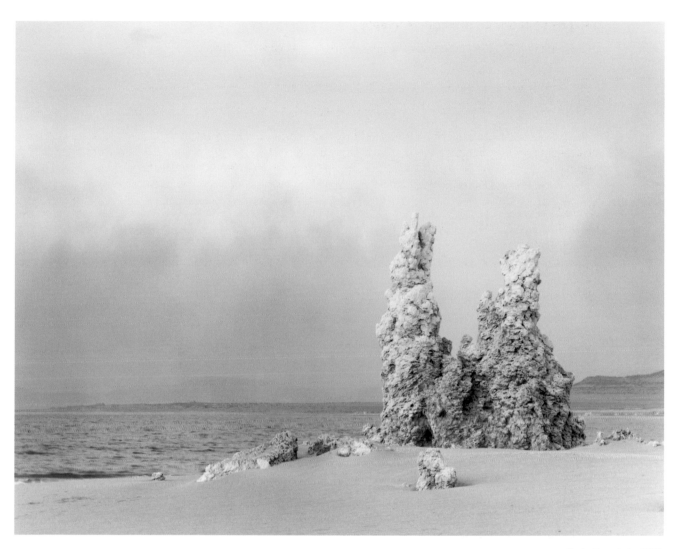

Dusk, Mono Lake, 1979.
Mamiya RB-67 camera. 6x7cm Kodak Vericolor film.

To Sara and Matthew,
You are my gifts back to this world

Previous books by Stephen Johnson:

At Mono Lake

The Great Central Valley California's Heartland

Making a Digital Book

Books to come by Stephen Johnson:

With a New Eye: A Journey through America's National Parks

Colophon

Type:
Adobe Goudy Oldstyle, Centaur, and Myriad Pro

Page Layout Software:
Adobe InDesign

Image Editing Software:
Adobe Photoshop

Press Profile, Color Separations, and Duotones:
Stephen Johnson, with thanks to Brian Ashe, Gretag Macbeth

Reproductions:
200 line screen on digital plates

Paper:
GardaMatt Art

Platesetting and Printing:
LEGO, Italy

Stephen Johnson "applies science to nature and creates art." His images create "an intimacy that brings subject and viewer close in ways conventional photographs cannot."

—*LIFE* magazine

"Steve is arguably the first digital photographer—I vividly remember the day in January 1994 when he told me that he'd shot his last piece of film. In this sorely needed book, Steve argues eloquently and passionately that digital photography is photography first, digital second, and places it in the wider context of photography's history and evolution."

—Bruce Fraser, author,
Real World Camera Raw, Real World Color Management, Real World Adobe Photoshop CS

"Steve reveals a depth of knowledge and breadth of experience that's unique among photographers, digital or otherwise, and converts his insights to an appealing and accessible form for the rest of us. His book will be a treasure forever."

—Richard F. Lyon, Chief Scientist, Foveon, Inc.

"Steve Johnson, one of the true visionaries of the digital photography era, offers us a technical tour de force and passionate artistic overview of the possibilities inherent in this new medium. *On Digital Photography* should be required reading for every aspiring photographic artist."

—Ted Orland, photographer and writer

"The hardest challenge to the digital author is to create a book that is not out of date by the time the ink is dry. Steve Johnson has broken through this barrier, creating the first book that address digital photography as a complete process, from digital's earliest beginnings, through today's technology knothole and ethical impact on our world. 12 on a scale of 10."

—Richard Newman, Education Coordinator, Calumet Photographic

"Stephen elegantly guides the reader through the complexities involved in color management while reminding us all that photography is art and no collection of techniques and tools should distract us from the joy and fun of that creative endeavor."

—Michael Stokes, Color Architect, Microsoft Corporation

"In this long-overdue book, Steve shares more than a decade of experience at the forefront of photography's evolution from silver to silicon, explaining the new technology, tools and techniques in straightforward language that every photo enthusiast will find both fascinating and enlightening."

—Mike Collette, President, Better Light, Inc.

Contents

Part 5: Color Spaces, Printing, and Archiving

Part 6: A Photographer's Digital Journey

Part 7: Photography, Art, and the Future

Appendix

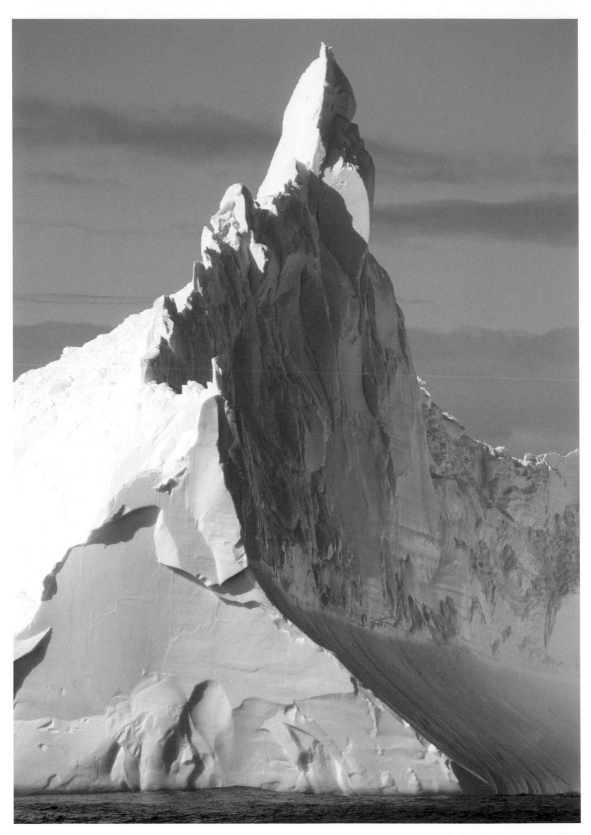

Iceberg Tower, Antarctica, 2005.
Canon EOS IDs Mark II. 3328x4992 pixels. 12 bit. Bayer-pattern 35mm format camera.

Acknowledgments

Personal Acknowledgments

For their inspiration, technical review, encouragement, and indulgence, I would like to thanks my friends Bruce Fraser, Michael Collette, Ted Orland, Dick Lyon, Mary Virginia Swanson, Michael Stokes, Henry Wilhelm, and George Dalke. Thanks for illustrations and belief to Bert Monroy, and to the years of good students who demanded visual clarification. Brian Ashe of Gretag was always willing to pitch in. My friend Ben Willmore graciously gave me his home on wheels for the last few days of preparation. My first editor on the project Wendy Renaldi must be given the real credit for getting this book underway and believing that I was uniquely able to create this work.

Special thanks go to my assistants Michelle Perazzo, Nick Kiest, Elizabeth Bredall, and John Csongradi for their help during this book production process. Thanks to Melissa Flamson for tenaciously gathering so many of the image rights we needed to make this book as broad-based as we wanted.

Warm personal thanks to my executive editor Steve Weiss for believing in my work through many companies and possibilities while persevering through very tight deadlines and budgets. My editor Colleen Wheeler became a confidant and believer in the project while still holding it to an independent standard of what this book could be. Deep thanks to both.

Mike Kohnke at O'Reilly reviewed the design and made some very helpful suggestions. Tim O'Reilly and Mark Brokering believed in this project and kept it going at the executive level.

An added thanks to my trusted and long-time friend Michelle Perazzo for faith, extraordinary hard work, and knowing that when it has to get done, it simply has to get done.

Although we didn't manage to stay together, Mary Ford, my wife of nearly twenty years, helped make this book possible by helping to make me who I am, long tolerating my shortcomings and giving me advice and counsel on many things design and common humanity related. Thanks for our kids and helping to make them so good.

Corporate Acknowledgments

Grants from the following companies helped make this book possible:

GretagMacbeth and most specially to Liz Quinlisk.
Adobe Systems, Inc. and a partner in crime from way back, Bryan Lamkin.

I am very grateful to Chromix Software, Hewlett-Packard, and X-Rite, whose donation or loan of equipment and software helped make this book possible.

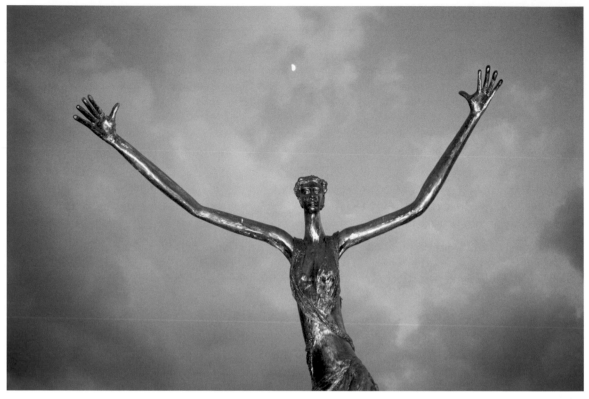

Sculpture and Moon, Paris, 2003.
Kodak DCS 14n. 35–105mm Nikon zoom. f8, 1/30. 3000x4500 pixels, 12 bit. Bayer-pattern camera.

This photograph was taken after a long day walking around Paris. It was my first visit there, and I wandered the streets for two days. As the light fell, I dropped into a garden and noticed these arms reaching up to the sky. The moon seemed held in suspension.

A Note from the Author

We are in the Stone Age of digital photography. We've figured out how to make some tools, but it is just now beginning to dawn on us what we might do with them. The journey has just begun, photography is still a very young art, and exciting changes are underway.

I have been teaching photography since 1977. Since 1988, I have been lecturing on the subject of the influence and empowerment of computer technology on photography. An important part of my life's work has been about sharing what I've learned in the hope of helping others find artistic expression and further their social concerns.

This book is essentially a distillation of what I've been teaching over the last 25 years. The advances in digital imaging have made me concentrate on the progress and effects of this transition, and to consider some issues that arise from these changes. I've also often been frustrated at the concentration on the technical aspect of digital photography with so little discussion of the aesthetics and heart behind the image making.

The reader should know a bit about my own taste in photography. I've admired the work of many photographers, and no doubt have been influenced by their work. Timothy O'Sullivan and Carleton Watkins, Eugene Atget, Lewis Hine and Dorothea Lange, Eugene Smith, Edward Weston and Ansel Adams, Eliot Porter, and Philip Hyde have all helped show me what photography can be and inspired me to try. Friends like Robert Dawson, Ted Orland, Peter Goin, Al Weber, Dave Bohn, Lyle Gomes, Don Worth, and many others have helped make my work what it is. Contemporary admirations run from Robert Adams to Jerry Uelsmann. There is so much fine work out there, it's hard not to take up the whole page.

My subject here is photography. This work is being written in 2005, so I can't help but focus on photography's transition into digitized electronic images. But the subject remains photography, and the "why we take pictures" is just as important as the "how." The interaction between the photographic technology and why we photograph occupies a fair amount of my attention.

Photography has always been about the highest technology of its time. It is no surprise we are now in the age of digital photography. It is also true that, at its best, photography does ride that crest where technology and art intersect. That intersection is part of what makes photography so fascinating for so many. But the deepest engagement that photography can bring remains its ability to capture and hold a moment before the lens. In this age of digital manipulation, that fundamental fact must be remembered.

This book assumes intervention in the image, not for the purpose of distortive manipulation, but to assert control over your work. It is an Adobe Photoshop–centric work, since Photoshop is currently the most common professional digital photographic tool. But the focus is not creating special effects. For those readers seeking guidance in image compositing and the myriad effects possible with digital imaging, other books should be sought.

I want this to be a holistic work that embraces the state of photographic tools and techniques, blended with some suggestions and experiences on why I make photographs, together with a consideration of the empowerment that even this Stone-Age digital technology enables. I don't imagine it's comprehensive; it is a collection of the subjects I thought worth including. No doubt I'll think of more as time passes. This is a sincere effort to make this the best book I knew how to make, but please forgive any errors or omissions that made it through our editing and review process, or became outdated as a result of ever evolving technology.

I hope you find the subjects as fascinating as I have and hope that this book helps you along your paths forward, perhaps backward, and certainly on occasion, sideways.

Stephen Johnson
Pacifica, California
April 2006

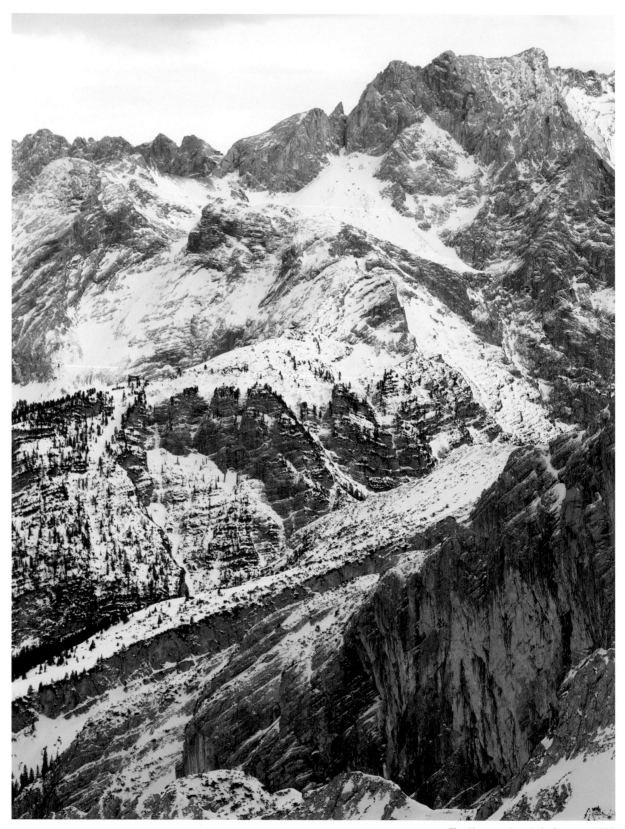

The Alps near Garmisch, Germany, 1995.
BetterLight Scanning Camera. 6000x7520 pixels. 12 bit. Tri-linear Array.

Part I: Evolutions

A Few Hints And Suggestions To Daguerreotypists.
There are very few who may not be capable of practicing the Photographic art,
either on paper, or metallic plates—but, like all other professions, some are
more clever in its various processes than others.
Impatience is a great drawback to perfect success, and combined with laziness
is a decided enemy. Besides this, no one can excel in Photography who does
not possess a natural taste for the fine arts, who is not quick in discerning
grace and beauty—is regardless of the principles of perspective, foreshorten-
ing and other rules of drawing, and who sets about it merely for the sake of
gain—without the least ambition to rise to the first rank, both in its practice
and theory. There is no profession or trade in which a slovenly manner will
not show itself, and none where its effects will be more apparent.

—Henry H. Snelling.
The History And Practice Of The Art Of Photography;
Or The Production Of Pictures Through The Agency Of Light. 1849.

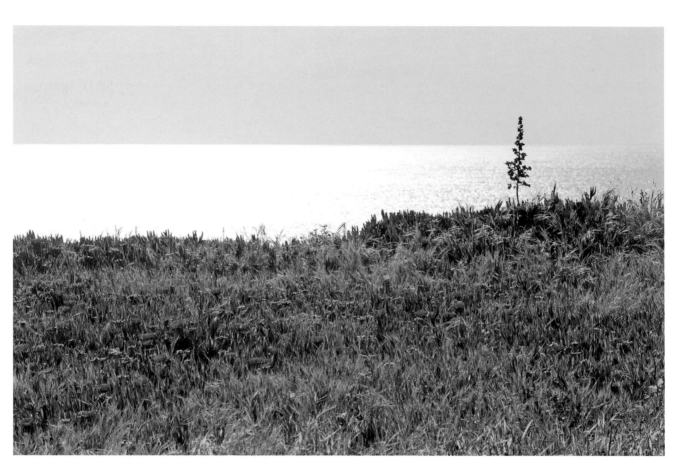

Mori Point and Pacific Ocean. Pacifica, 2001.
Kodak DCS 460. 2000x3000 pixels, Bayer-pattern camera.

This photograph was made after the installation of a temporary Park Service sign on the bluff, preparing for the dedication ceremonies celebrating the addition of Mori Point to the National Park Service's Golden Gate National Recreation Area.

Chapter 1: Introduction to Digital Photography

Even a year ago, I would never have believed that I would
have abandoned film completely so soon.

—Stephen Johnson,
Yosemite Press Conference, June 1994

The seduction of digital photography is broad and deep. The market penetration is now beyond doubt. This is where photography is rapidly moving.

For the amateur hobbyist, the allure might be the wonder of showing a shy child the portrait you made of them a moment ago or assuring relatives you do indeed have a reasonable shot of everyone. On a professional level, although film can still do much of what we need, more often than not a professional digital camera can perform the task better: The ability to preserve options, easily obtain client approval and satisfaction, and provide speedy delivery all make this transition to digital professionally compelling.

Why Digital Photography?

There are many substantive reasons for making the transition to digital imaging. For me, the decision has been made.

Immediacy: Seeing as you go is a core reason for the digital craze. Sharing the moment captured, being sure you have it, immediate gratification accounts for much of digital camera sales ascendancy.

Connection to the moment: With digital, photographs can be more connected to the moment than ever before. You can see and understand your results while you're still on site. It's the difference between comparing the image to the experience, instead of the memory of the experience seen weeks later on a screen back in your workplace.

Control over results: Rendering of the photograph can be more effectively controlled with digital. You can easily remake your photographs until you are satisfied.

Versatility: You can do almost anything you want with a digitized image, and very quickly. The photo can be used on a web page, burned on CD or DVD, printed and framed, or transmitted around the world, in only minutes.

Accuracy: The digital camera sensor can be matched to the scene to record the light similarly to the human experience of vision and color. This is a major improvement over film. (Although often not recognized as many of the automatic camera settings actually reduce the potential image quality.)

Fun: The "Gee Whiz" factor. "Wow, we can see the pictures right now!" That is a good reason: for the play of it. Photography should be about play, too.

Oaks and Lupines, Merced River, 1984.
4x5 Kodak Vericolor negative film. Burke and James 4x5 camera.

I came across these lupines after a hot day of wandering near the Merced River. We had been followed by a rattlesnake and were struggling with the harsh shadows. The flowers and oaks seemed so typical of my memories of the valley that the photograph became almost iconic for me. Years later I was scanning the negative for a job, and apparently misplaced it, as the negative has never been seen since. My 20MB scan is all I have.

A Few Beginning Questions

Many of the same questions keep coming up: some are basic conceptual issues, others are real-world problem solving. Here are a few common questions answered.

What makes a camera digital?

A digital camera uses a sensor and a digital convertor instead of film.

What is a pixel?

The pixel is the basic component of a digital image, a small "picture element" of specific brightness and color. It should be directly related to a combination of camera or scanner sensor sites.

How does a bunch of little squares make a picture?

Enough small pixels together, zoomed out, can form an image. It works like the dots of ink on newspaper when viewed from a normal viewing distance.

Is a pixel black and white or color?

Generally pixels are a mixture of blacks, grays, and whites representing differing brightness values in an image when recorded by a camera.

How is color made from pixels?

Three samples are taken, one each through primary colored filters of red, green and blue, much like our eyes see with three primary color-sensitive cells or our television displays with red, green and blue phosphors. The color is "encoded" through these filters, then reassembled as three black and white images, each colorized red, green, or blue, then layered together to form a "full color" image.

How many pixels do I need?

Thousands to millions. It depends on how big of a print you want and how much detail you want it to contain.

How come my prints don't look like my screen?

Your screen may be out of control, or perhaps you don't have the printer set correctly, or both. With screen calibration and correct settings, the print can be good approximation of the screen. Also, a print is not a backlit transparent image; it is colorant on a piece of paper.

I can't find my picture files? Where are they?

Did you index them? How were they named? Can you do a system-wide search for creation date?

My hard drive screwed up. Are my pictures gone?

They might be gone. Restart the computer. Try disk repair and file recovery utilities. If they are important enough, hard drive recovery services are available. Store your files offline on CDs or DVDs, and create multiple copies where the work is very important to you.

From Light to Pixels

In traditional photographic methods, light was recorded on a silver-salt–coated material. The silver tarnishes when exposed to light, making possible a photochemical system for taking photographs. By the late 1990s, digital cameras were starting to supplant these film-based cameras.

In a digital camera system, light (which is described as photons or as waves of energy) is directly captured by an electronic light-sensitive silicon device called a sensor. These sensors come in many varieties and elaborations; the common forms today are CCD (charge-coupled device) and CMOS (complementary metal oxide semiconductor). These sensors transform light energy into electrical energy (electrons) which can then be measured and translated into digital numbers and which are then stored and processed by computers. This translation into a digital form is performed by an A/D (analog to digital) converter. Programmed circuits assign a number to the signal indicating how bright the light was that stimulated the sensor. Here is a look at the stages by which light becomes pixels.

The Real Scene

The light-created scene we perceive with our eyes is extraordinarily complex and often contrasty, sometimes even beyond the range of our eyes. As our eyes dart around the scene, our iris muscle constantly dilates and constricts while the retina itself runs light intensity compensation, regulating the amount of light and its character in order for the signals to be sent to the brain. Photography attempts to capture this enormous amount of information with a single exposure.

The Camera Lens

The camera lens focuses light from the scene onto the camera imaging plane. The image will be reversed upside down as a result of the light waves criss-crossing at the focal point (the sun-spot of a magnifying glass setting paper afire) of the lens, then coming into focus at the focal plane.

The Silicon Sensor

The image sensor is the light-sensitive electronic "film" of the digital camera, somewhat like the common photoelectric cells, used in solar cells, light meters, and even simple door chimes. The sensor contains thousands to millions of these individual cells, each of which can be made into a pixel.

A Black and White Electrical Image

The sensor produces a set of electrical signals made by light projected on the silicon sensor.

If this were made directly into an image as in a video camera, where light strikes the sensors, an electrical current is pro-

THE DIGITAL PATH

THE SCENE LENS

duced and the image glows white, less light the glow goes to gray, no light, no signal and the image is dark. Such an image would be grayscale: black, white and intermediate shades of gray.

Conversion to Binary

The various intensities of electrical signals coming off the sensor are translated by the A/D convertor into absolute binary numbers according to their intensity. Low intensity signals create dark values, higher intensity signals are converted to brighter values. Computer-readable binary numbers are created by the A/D converter from those electrical signals and characterized by a series of absolute brightness values on a scale defined by the bit depth of the A/D. If eight "ones" and "zeros" are used to define the tones (8 bits of tonal depth), a total of 256 different conditions are possible, making for a grayscale tonal range from "0" black to "255" white. More ones and zeros make for greater bit depth and finer tonal gradations.

The camera system then converts this data into a standard image file format and stores it on disk. Computer image data is made up of a series of "on" and "off" conditions that can be stored and processed by a binary computer. Computers only understand these two conditions, expressed as 0 or 1. In order to hold complex data like photographs, strings of these digits are necessary. Various terms come into play denoting the amount of data held: bits, bytes, etc. *(See the section "Computer Image Data and File Types," later in this chapter.)*

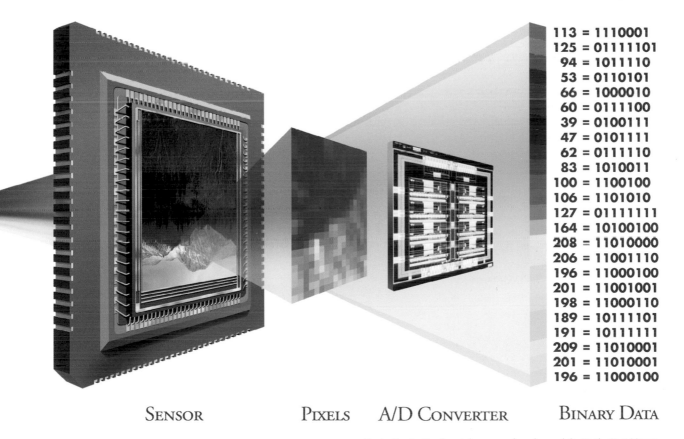

113	=	1110001	
125	=	01111101	
94	=	1011110	
53	=	0110101	
66	=	1000010	
60	=	0111100	
39	=	0100111	
47	=	0101111	
62	=	0111110	
83	=	1010011	
100	=	1100100	
106	=	1101010	
127	=	01111111	
164	=	10100100	
208	=	11010000	
206	=	11001110	
196	=	11000100	
201	=	11001001	
198	=	11000110	
189	=	10111101	
191	=	10111111	
209	=	11010001	
201	=	11010001	
196	=	11000100	

SENSOR PIXELS A/D CONVERTER BINARY DATA

Illustration by Stephen Johnson, and made much better by Bert Monroy.

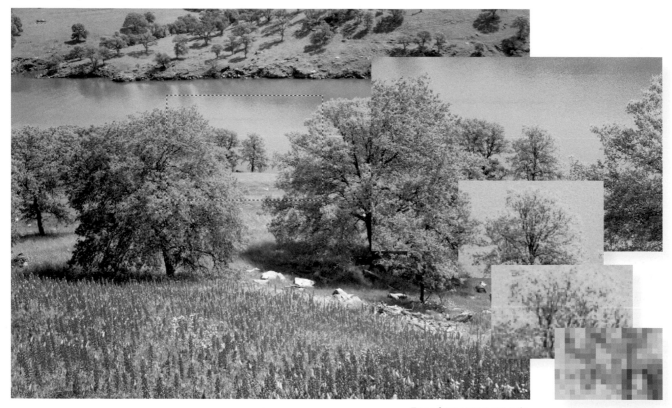

Zoom from picture to pixels.

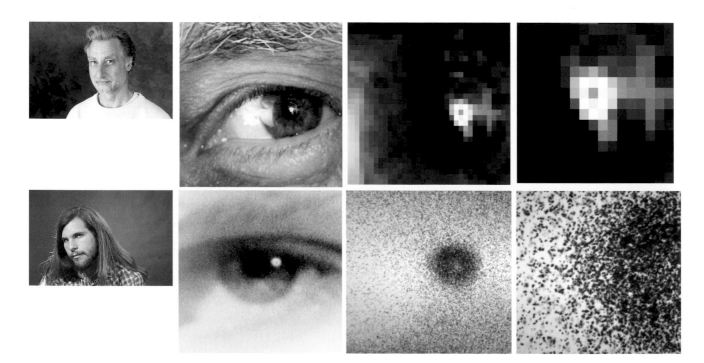

From Pixels to Image

In digital photography, little squares of gray make up a photograph, just as small clumps of granular silver make up an image on film. Enough pixels (picture elements, traced back to the sensors sensing sites), when seen from a normal viewing distance, start to form an image. Whether made from small squares of differing brightness or irregular clumps of silver grain, the continuous tone that you see in a photograph is an illusion.

Neither silver-based film nor digital camera data is continuous tone, but both can create the illusion of smooth tonal transitions by having a sufficiently small silver grains or pixels in sufficient number. It appears as though only image is present, not these constituent parts. Part of the magic of photography is in these created illusions that imitate reality.

Grain vs. Pixels

In traditional silver-based photography, we came to accept film grain as the medium in which the image was stored and rendered. The underlying sandpaper-like texture has simply been a fundamental part of what photography was. This underlying texture is so pervasive that it even engendered styles where the grain became a sought after affectation, sometimes to the point of almost overwhelming an image. On the other hand, many used large-format cameras and film to minimize grain and increase detail. Others found even huge prints from 35mm film acceptable in quality, often relying on sharply printed film grain to create an illusion of sharpness.

Pixel-based digital images in some ways are more limited in their enlargability because we are less accepting of large cubes on our images than we were of random sandpaper texture. Some photographers enlarge digital files in ways to soften the pixels; others re-introduce grain-like noise to mimic film's granularity

Pixels and Resolution

Quite simply, the more pixels (sensing sites on the sensor) in the camera, the greater the amount of detail the system can resolve. These sensors often contain hundreds of thousands, or even many millions, of sensing sites, and thus a shorthand terminology has developed using megapixels (or millions of pixels) as a way of describing a camera's resolution.

This is not unlimited, and as cameras get engineered with more and smaller sensing sites, the ability of the lens to interact with the sensor and deliver good data breaks down. As a single characterization of the camera, its number of "megapixels" only describes one quality, and is not the only issue to be considered. The quality of the pixels with regard to noise and other issues must also be considered, and will be discussed later.

opposite page

top: Pixels from Digital Camera.
left: 35mm at 1:1.
middle: 35mm bw film eye as positive.
right: 35mm bw film eye as negative.

bottom: Electron Micrographs of Film Grain.
left: 35mm at 1:1.
middle: 35mm bw film eye as negative.
right: 35mm bw film eye as negative.

Micrographs by Hirsh Scientific.

The Human Eye

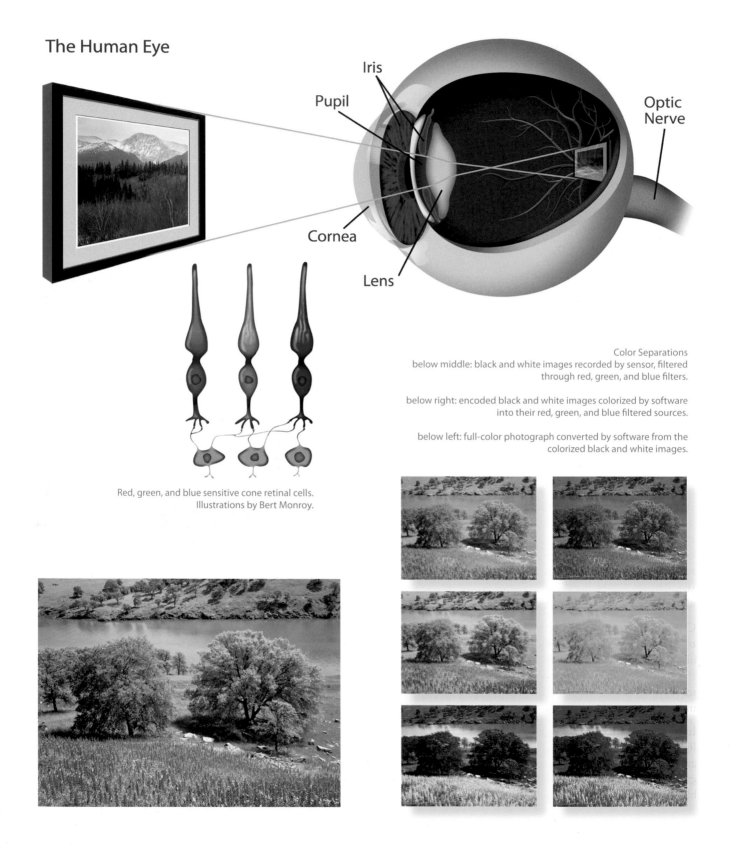

Iris

Pupil

Optic Nerve

Cornea

Lens

Red, green, and blue sensitive cone retinal cells.
Illustrations by Bert Monroy.

Color Separations
below middle: black and white images recorded by sensor, filtered through red, green, and blue filters.

below right: encoded black and white images colorized by software into their red, green, and blue filtered sources.

below left: full-color photograph converted by software from the colorized black and white images.

From Black and White to Color

When each was very young, both of my children, in only sightly different words, asked me when color was invented. Their association of old-time black white photos with the past and color photos with more recent events led them to suppose that color itself was a modern invention.

—Stephen Johnson

The introduction of photography in 1839 brought us our first black and white images. Although most of us see in color all of the time, in a sense we had seen black and white before: in very low light situations our vision is essentially black and white, making use of the rod retinal cells. The rods have good low light detection capabilities, but no color sensitivity.

Human and Photographic Color Interpretation

In many ways, the "creation" of color is the same in human perception as it is in a camera. The cone cells in the human retina are our color sensor cells, and they seem to be sensitive in three spectral peaks: red, green, and blue. In a sense, our eyes take in three separate images through red-, green-, and blue-sensitive cells, then combine them in our brain. Our eyes and brain work together to integrate the wavelength sensitivities of our eyes into what we call a full-color image.

The way we create color in photography is modeled on a similar principle. We imitate this process with multi-layered film or three-channel digital files. In digital photography, three color-separated (encoded) black and white images are sensed, then combined and colorized by image processing or viewing software.

But there is a significant difference between a human eye and a camera; a great deal of the color image processing is done right in the retina. As my friend Bruce Fraser notes, "One big difference between cones and CCD filter arrays is that cones have a center-surround structure where the center records the signal and the surround subtracts that signal from its neighbors. The data that passes through the optic nerve has already had signal cleanup and an approximately 10:1 compression applied!"

The spectral sensitivities of the human-visual system's cone (normalized to equal area). Roy S. Berns.

Our understanding of human vision is extensive and yet limited. We continue to learn and map more of the intricacies of how we see. Seeing turns out to be far more complex and conditional than many realized. I approach absolute statements of fact about human vision with some skepticism. Our knowledge is growing, but many times I've been told "facts" about vision that my own experience tells me are wrong. The basic primary color model (RGB) seems to be approximately right, although nowhere near that simple, and our color photographic model functions, but clearly a better understanding and imitation are warranted.

In the additive color theory model, what we see as white light is really equal amounts of red, green and blue light combined to appear white. In this model, all colors that we see can be defined as some combination of red, green and blue. Thus we can separate color into red, green and blue filtered black and white records (photographs) and recreate the color by colorizing the black and white images with their separated color and assembling them back together again (see "Light and Color" in Chapter 10).

Basic Guide to Digital Cameras

Digital cameras give us remarkable freedom, and they are packed with powerful tools. A wide variety of camera resolutions, features and file formats are currently implemented in digital cameras. This guide is designed to help get you started; most of these subjects are covered in more detail later in this book.

Resolution

In a digital camera system, resolution is defined by the number of sensing sites and the sensor, and is affected by the quality of the optics delivering light to the sensor. The fundamental limiting factor with small digital cameras is the resolution of the sensor versus the desired reproduction size of the final output. Digital cameras vary in their resolution from relatively low-res 640 x 480 pixels, to cameras capable of producing files in the 1500 to 3000 pixel range. Cameras lately have been designated by their total pixel count on the sensor, often expressed as megapixels, ranging from 1 to 14 megapixels, or 1 to 14 million pixels on the sensor.

Zoom

A zoom lens gives the user the ability to appear to get closer or more distant from a subject by varying the magnification on the lens. A zoom lens can be a very desirable feature, allowing the user to move in-and-out on a subject without moving at all. But beware of cameras claiming digital zoom features. They do not offer any additional resolution or capability; they merely crop the full resolution file from the camera into a smaller file, giving the effect of having zoomed into the scene.

Color Balance

Bright sun is warmer light than shade, which tends toward blue. Film was traditionally balanced for sunlight. Many digital cameras allow the user lighting condition customization, to set the color of the light that is present when the photograph is being made, such as sunlight, cloudy, tungsten, etc. This will make for more accurate color in the photograph. Many cameras have an auto balance feature that will attempt to adjust the camera's color balance to the current lighting conditions. For instance, most have icons or words describing settings designed for overcast days or tungsten light. Generally, you will get better results with your camera if you preset the white balance (kind of light you are in) to the appropriate ambient light present when the photograph is made.

A neutral gray balanced for sunlight would remain neutral, shade would tend to look blue, tungsten light reddish-yellow.

Camera Image Processing

Although built-in image processing in most cameras is designed to produce a good-looking result, a number of assumptions determine the quality of the resulting image. For instance, in order to please a mass market that likes high contrast in photographs, image-processing software built into cameras often drive shadows into featureless blacks and drive highlights to featureless whites. This will result in a reproduction in the final publication with no detail at either end of the tonal range. Many cameras now offer lower contrast image processing settings to reduce this over-processing of detail into featureless blacks and whites. Selection of lower contrast settings generally must be made before the photographs are taken.

In-camera sharpening is another image processing feature that should be turned off, so that sharpening decisions can be reached after the photograph is made and examined carefully on a large monitor. Turn off auto or in-camera sharpening and do it yourself by visual inspection in Photoshop. Over-sharpening is a very common problem. It can create strange halos, and cannot be undone.

General Camera Controls

Combining shutter and aperture controls allows the users to assert control over the exposure to the film or sensor. The quality of the photograph is affected in terms sharpness/motion and focus/depth of field.

Shutter

The *shutter* controls light by varying the amount of time the sensor or film is exposed to light, which also affects motion sharpness. The faster the shutter speed (for example, 1/250 of a second vs 1/30) the shorter the amount of time the shutter is open, helping to freeze motion caused by an unsteady camera or long lens motion. A move toward the next slower shutter speed is traditionally twice as much light, toward the next faster shutter speed is half the light. Intermediate speeds are available on modern cameras.

Typical Shutter Range: 1 second, 1/2, 1/4, 1/8, 1/15, 1/30, 1/60, 1/120, 1/250, 1/500, 1/1000, 1/2000

Aperture

The *aperture* controls the amount of light by varying the size of the lens opening, which also affects depth of field. It works much like the iris of your eye; in bright light the muscle contracts, making for a smaller opening, in dim light, the iris expands letting in more light. The smaller the aperture number (*f*3.5 vs *f*11) the greater the amount of light and the shallower the depth of field. *Depth of field* is a measure of the distances from the camera that appear sharply focused in the image. A move toward the next wider aperture (from *f*11 to *f*8) is traditionally twice as much light, toward the next smaller opening is half the light. Intermediate openings are available on modern cameras.

Typical Aperture Range: *f*3.5, f5.6, f8, f11, f16, f22

Choosing the Right File Formats and Compression

Digital image data is stored in a variety of file formats, and it's important to choose the right one for your image and the plans you have for it.

- ✦ TIFF is the most common editing format. TIFF can be nearly computer platform–independent and uncompressed. TIFF variants can also be compressed without quality loss in the LZW or ZIP mode, but these are not commonly available in-camera.

- ✦ JPEG is the most common compressed format. It is used in many cameras, and it is the default format on the Internet.

- ✦ RAW files preserve the original camera data and should be used whenever possible. It will force interaction with the file later and may not be convenient for some users (*for more on Camera Raw, see Chapter 9*). Many camera makers have adopted ways of holding RAW data that only their software can address. Adobe's Camera Raw plug-in and their DNG format attempts to make all RAW formats available to everyone and create an open documented standard.

- ✦ Cameras also have proprietary image file types based on make and model of the camera. Proprietary image software or camera formats should generally be discouraged, unless they provide an image archive capability that allows the user to store RAW data.

In order to achieve the highest storage capacity, small digital cameras have traditionally relied upon JPEG compression. At very high quality settings, JPEG compression causes 'relatively little visual harm to the original data, but does forever lose the real image data. In high-compression settings, the image quality of the digital photograph is severely degraded, with a kind of cubist imposition on the image. In low-compression modes, the image may be visually indistinguishable from an uncompressed version. Use the highest quality JPEG setting possible on the camera. This helps preserve the image quality that your digital camera is able to achieve, making for better prints and reproductions. Workflows like photojournalism that may demand the quicker saves of JPEG may be functionally dependent on this compressed format, but for the highest quality, JPEG should be avoided.

The Adobe RGB color space as wireframe with the sRGB color space within in full color *(see Chapter 13)*.

If disk space is your motivation for saving in JPEG instead of RAW, it is far better to carry extra memory storage cards rather than try to squeeze many images onto a single camera memory card. Remember that RAW saves the camera data, whereas JPEG saves a processed imitation of what the camera recorded given whatever settings were in place.

Setting Your Studio Monitor for Accurate File Viewing

In order to prepare files for maximal quality, it is ideal to view your digital images on a calibrated and profiled monitor. Calibration can be accomplished with a variety of screen calibration devices, which then also create a monitor profile *(see "Color Management" in Chapter 13)*. This gives some predictability to the way in which the monitor displays the images and, consequently, the kind of the image editing you assume needs to be done.

If your digital file appears to be too dark or too light it is important to note the gamma of the monitor and to make sure it is set appropriately for your system. For PC users, that is usually a gamma of 2.2; for Macintosh users, that is usually a gamma of 1.8, but evolving toward 2.2. This gamma setting will affect the overall brightness of the image throughout the process. A good monitor profile properly used makes this concern of little consequence.

Choosing Color Space and Balancing Color

Color space refers to a set of color definitions (often called a color profile) that establish the actual hue and brightness of the colors in the photograph. Carefully defining these colors allows files to be exchanged, devices to be calibrated, and translations to occur from one device's color capabilities to another. This process is basically what color management is all about.

If you are using a professional image editing application such as Photoshop to edit the digital photograph, it is possible to set the range of color definitions (working color space) of the image to a pre-defined setting. This can assure that your edits will be viewed consistently in the same color space when you first open the file and for subsequent edits later. Most cameras that tag an image with a color space profile will simply tag it with sRGB, a common monitor color space, which does not encompass nearly the range of color that the camera can see. These tags can be ignored when the photo is brought into Photoshop, or used if the camera manufacturer is really transforming what their camera sees into a defined color space.

When you make an image, it is very helpful to photograph something neutral gray in the same light and use it as a gray source for editing. At least set the camera's white point to an approximate light condition. Adobe Photoshop can be set to use this embedded camera tag (if one is present) or transform incoming files into a wider, more useful color space such as "Adobe RGB 1998." When saving files from Photoshop, make sure to embed the profile with the digital photograph so that it will be clear later on how the photograph was seen.

Resizing Images (Interpolation)

If the photograph is smaller than your desired print size, limited enlargement is possible through software image resizing (interpolation). This process makes up a new, larger file based on your original photograph. A good rule of thumb is that if you need a photograph one and one-half times larger than its native file size, a reasonable result can be obtained in programs like Photoshop with a bi-cubic interpolation *(see Chapter 9)*.

Editing Images

Good image editing software is critical to your digital photography world. The most common professional editor is Adobe Photoshop, although many find that its less expensive sibling Photoshop Elements meets their needs just fine. The basic tasks of managing your digital photos, viewing, naming, color and tonal correction, saving

Southwest Photo Workshop with Steve Johnson, Zion National Park, 2003.
Photograph by Ruth Knoll.

and printing, need to be accomplished. Digital manipulation that involves compositing and drastic changes to a photograph are a different set of desires that can also be accomplished in many image editors. There is a current move with Apple's Aperture and Adobe's Lightroom to make software that concentrate on image processing for photographs and leaves out image compositing, which lives more in the realm of creating new realties rather than carefully handling recorded light.

Be very careful when editing your digital file. Do not edit important detail into solid blacks nor over-edit your whites to the point that they no longer contain detail. If you're using Photoshop, the Adjustment Layers options provide a non-destructive image editing path that essentially builds editing layers on top of your image that can control the photographs appearance, but can be turned on and off at will and changed as you work on the image. Your original data is left intact "under" the layers. (*For more information, see Chapter 9.*)

Almost all image editing systems work in 8-bit image space, allowing for 256 distinct levels of tone from black to white in each of the RGB (red, green, blue) channels of the image. Some cameras capture 10 bits (1024 levels of gray) or 12 bits (4096 levels of gray). This additional precision in tonal rendering can be very helpful where important detail rests or major edits are needed.

By bringing 8-bit data into Photoshop, it is possible to give yourself some extra headroom to do major edits by first transforming your file from 8 bits to 16 bits, and then doing your editing. Some tools will no longer be available, but more dramatic edits can be made in the larger space with somewhat less serious side effects. When editing is complete, you can transform the image back to 8 bits for output if needed. But, as I said previously, photograph in RAW mode whenever possible—this will preserve the camera's native bit depth and color for later processing and editing.

Basic Photography Advice

Simplify your composition: include only the subject matter that is important to the idea. This often means simply getting closer. Sometimes it also means pointing the camera down so as not to dwarf your subject with vast amounts of unneeded sky.

Learn to use the camera before you make any critical photos. Don't risk the family reunion on an unfamiliar camera. Check your results and make sure you understand the settings and their effect on your desired image quality.

Using Digital Cameras: A Checklist

Use the following as a quick guide to help insure you take the best quality photographs possible by taking advantage of the features (and avoiding the foibles) available in today's digital cameras.

Basic Digital Camera Settings for Maximum Quality

+ Use TIFF or RAW file formats. RAW file formats should override contrast and sharpen settings, but can still influence the image you see on the camera LCD.
+ Avoid JPEG compression unless absolutely needed, then use the highest quality JPEG.
+ Set the Contrast to Low, so that you do not overexpose highlights or underexpose shadows.
+ Set Sharpen to Low or Off. Sharpening cannot be removed later, and it is better to do it by visual inspection in your image editor.
+ Set Digital Zoom to Off: it just fools the user into thinking they have zoomed in further than the camera is capable of by cropping the photograph.
+ Use the lowest ISO (assumed light sensitivity) setting possible. Boosting the ISO increases noise.
+ Set the LCD monitor to turn on only for quick review (unless the viewfinder is so bad you need to use the LCD). Leaving the LCD on all of the time will run down the batteries much quicker. For very close-up work, the LCD will give a more accurate view of what is in the photograph.

Additional Settings and Tools to Consider

+ Zoom in and simplify whenever your compositional desires allow.
+ Set appropriate Lighting Conditions: Daylight, Shade, Flash, Custom. Check the picture size, expressed in pixel dimensions—the larger the better.
+ Special effects such as sepia, black and white, etc., are unnecessary. (Apply these later in Photoshop).

Image Review & Histogram

+ Set the camera to display the image just made and to display the Histogram (image brightness values) to check your exposure. *(For more on interpreting histograms, see Chapter 9.)*
+ Check your image on the camera screen to see if you are satisfied.
+ Check your exposure by examining the histogram display to see if the highlight detail is within the right margin. The histogram is usually based on your camera settings for saving to JPEG, and may not accurately reflect the RAW file capture *(see Chapter 9)*.

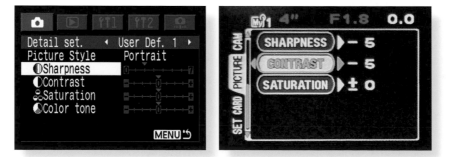

Canon's and Olympus' on-camera interface controlling sharpness, contrast, saturation. Even in RAW mode this can effect JPEG creation used to display images and histograms on camera.

Computer Image Data and File Types

Computer image data is made up of a series of "on/off" conditions that can be stored and processed by binary computer. Computers only understand these two conditions, expressed as 0 or 1. In order to hold complex data like photographs, strings of these digits are necessary. Various terms come into play denoting the amount of data held: bits, bytes, etc.

Data Content: The actual binary numbers and the kind of information they can define.

- Bits: one or zero (1 or 0) the basic on/off condition, in imaging, black or white
- Bytes: eight ones or zeros (1,0,0,0,0,0,0,1): 256 different conditions, in imaging enough data for 256 different brightness conditions to create basic grayscale pixels
- Kilobytes (KB): 1,024 bytes: enough data for grayscale images
- Megabytes (MB): 1,024 kilobytes: a lot of data, allowing more resolution
- Gigabytes (GB): 1,024 megabytes: a lot more data
- Terabytes: 1,024 gigabytes: a whole lot more data
- Petabytes: 1,024 terabytes: for the moment, more data than I can imagine

Image Type: The kind of image data contained in the file.

- Bitmap: for Line Art, OCR (optical character recognition), Maps, Drawings
 -1-bit: black or white
- Grayscale: Black and White Continuous Tone
 -8-bit grayscale: black and white photo
 -16 bit grayscale: black and white photo with more tonal information
- Color With Custom Palette
 -8-bit color (256 colors): Photoshop's Indexed Color
- Color Continuous Tone
 -24-bit color: color photo
 -48-bit color: color photo with more tonal information
- Vector based images: Type, Line Drawings as in Adobe Illustrator

Typical File Formats: The data format used to encode the image data. This can involve data sequencing, compression, various bit depths and metadata. There are many others, and many variants.

- JPEG (.jpg): a lossy compressed file format
- GIF (.gif): 8-bit color with limited palette of 256 colors
- TIFF (.tif): almost any pixel data can be defined in this format; can also contain vector and audio data
- Photoshop (.psd): proprietary Adobe Photoshop format can contain Layers; TIFF variant
- EPS (.eps): encapsulated postscript which can contain vector and pixel data
- PDF (.pdf): Adobe's portable document format which can contain page layout, pixel, and vector data
- RAW Camera Proprietary Formats (.dcr, .crw, .nef, .x3f, .orf): high bit depth unprocessed sensor data
- RAW File Documented Formats: Adobe DNG

Different Image Data, Different Image Capabilities

✓ Photoshop
BMP
CompuServe GIF
Photoshop EPS
JPEG
Large Document Format
PCX
Photoshop PDF
Photoshop 2.0
Photoshop Raw
PICT File
PICT Resource
Pixar
PNG
Portable Bit Map
Scitex CT
Targa
TIFF
Photoshop DCS 1.0
Photoshop DCS 2.0

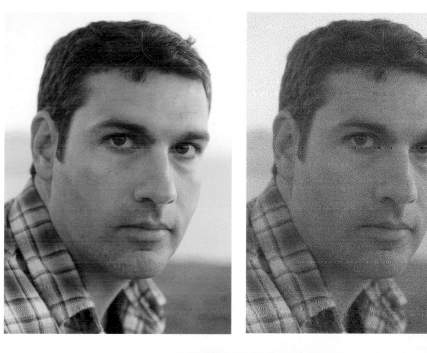

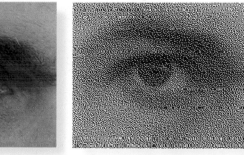

David Johnson at Mori Point, Pacifica, California, 2004.
Kodak DCS 14n. 3000x4500 pixels, 12 bit, Bayer-pattern camera.

facing page top left: RGB 24-bit color file (16.7 million colors), 644x909, 1.75MB
facing page top right: Photoshop's Indexed Color file (256 colors), 644x909, 660MB
top left: 8-bit grayscale file (256 grays), 644x909, 648MB
top right: Photoshop's Bitmap 1-bit (black or white with diffusion dither), 644x909, 196KB

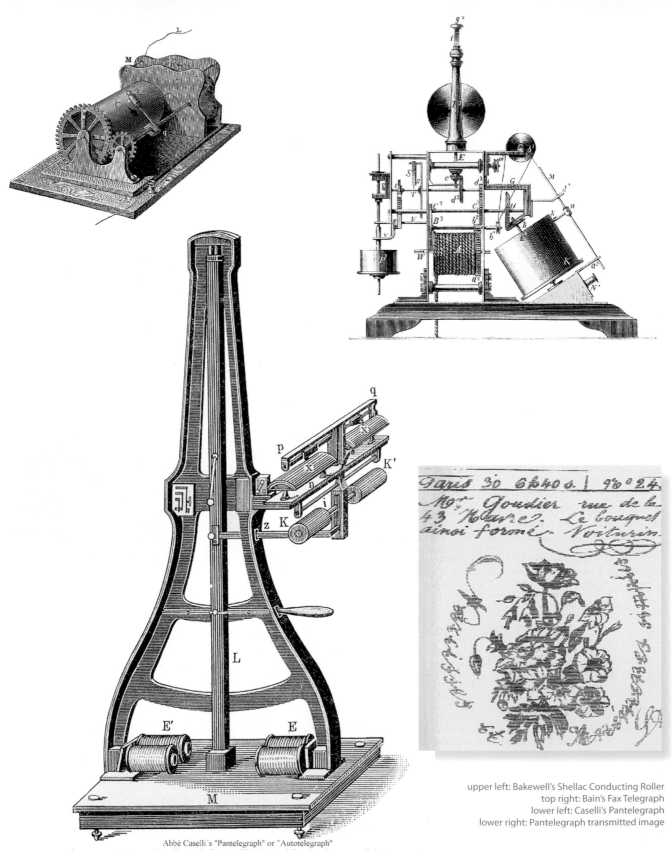

Abbé Caselli´s "Pantelegraph" or "Autotelegraph"
Improvements in transmitting Facsimile Copies of Writings and Drawings by means of electric currents.
E. P. 2532. 10. 11. 1855

upper left: Bakewell's Shellac Conducting Roller
top right: Bain's Fax Telegraph
lower left: Caselli's Pantelegraph
lower right: Pantelegraph transmitted image

Chapter 2: A History of Electronic Imaging

I have learned, as a rule of thumb, never to ask whether you can do something.
Say, instead, that you are doing it. Then fasten your seat belt.
The most remarkable things follow.

—Julia Cameron, *The Artist's Way* (1992)

Photography's evolution into an electronic medium has a long history, unknown to most of us. Some of the earliest devices for recording and transmitting electronically based images date well back into the mid–19th Century. Technologies for document reproduction, spy cameras and satellites, space imagery and publishing were all the precursors of today's dramatic transition into digital photography. This dynamic and compelling evolution began considerably earlier and was more advanced than is generally understood.

The Ancestors of Digital Photography

These unique and pioneering devices are direct ancestors of much of the digital imaging technology we use today. Some of the highlights of this digital evolution are detailed here.

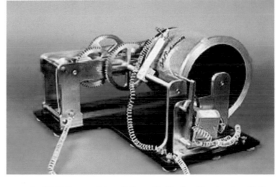

An 1848 fax machine: Bakewell's Shellac Conducting Roller.

Recording Telegraph (1843, Alexander Bain, Scotland)

An early pioneer of the telegraph and the inventor of the electric clock, Alexander Bain designed and patented the basics of the facsimile machine. His *recording telegraph* employed a stylus driven by a pendulum that moved over metal type in order to sense light and darks on a metal-plated source being sent. On the receiving end, the design called for a pendulum-driven stylus making a dark spot on chemically treated paper when an electric charge was received. Bain never actually performed a fax transmission. With his design he also came up with the scanning pattern used for progressive television type scanning.

Shellac Conducting Roller (1847, Frederick Bakewell, England)

Bakewell was the first to demonstrate Alexander Bain's idea, improving upon it by using clock mechanism-driven rotating cylinders as opposed to swinging pendulums. This *shellac conducting roller* system used foil-covered drums for sending and receiving images. Its first public demonstration was at the 1851 World's Fair in London. His system could only handle line drawings or handwriting and was never commercially implemented.

Pantelegraph (1861, Giovanni Caselli, Italian in France)

Caselli developed the first commercial fax machine, first used between Paris and Lyon, and later in many other places. His *pantelegraph* was made of cast iron and was a towering two meters in height, sending images from a sheet of tin written in non-conducting ink. These were scanned by a needle over a curved metal plate, transmitted, and written out on potassium ferrocyanide-soaked paper, causing blue images to appear. This made the printout essentially a cyanotype.

Caselli's device was the first to be able to transmit illustrations, and was used primarily for that special purpose. However, it was not a financial success due to the heavy tariffs levied in comparison to the cost of telegraph transmissions.

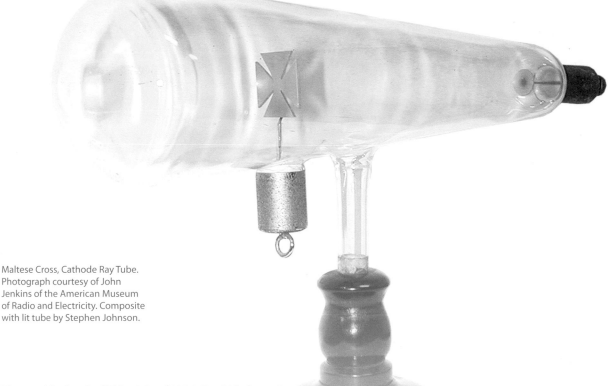

Maltese Cross, Cathode Ray Tube.
Photograph courtesy of John
Jenkins of the American Museum
of Radio and Electricity. Composite
with lit tube by Stephen Johnson.

Electro-Mechanical Television (1884, Paul Nipkow, Germany)

Nipkow proposed and patented the first electro-mechanical television, using a spinning disk to create and display images. He never built a prototype, and it was not until 1907 that a working device was built.

Cathode Ray Tube (1897 Karl Braun, Germany)

Corecipient of the 1909 Nobel Prize with Marconi for his work on radio, Braun refined the *cathode ray tube* into a controllable image-producing device, creating the oscilloscope and paving the way for more complex images.

Photoelectric Telephotography (1903, Arthur Korn, Germany)

Korn developed the first *photoelectric telephotography*, or light-sensitive fax, which differed significantly from earlier conductive methods. One of its major breakthroughs was allowing variable brightness values to be reproduced remotely. By 1908, it was in commercial use in Germany, and by 1910 it connected Paris, London, and Berlin. His method was the direct predecessor to the AP wirephoto, developed in 1934. His selenium-based techniques are what gave rise to the modern fax and the vidicon tube itself.

Mechanical Television (1920s-30s, John Logie Baird, England)

Baird brought Paul Nipkow's idea's to fruition, developing a working mechanical television. With the development of the electromagnetic television his technology fell out of fashion as the screens were small and indistinct in comparison. He later developed the first color television and the first three-dimensional television.

Modern Television (1927, Philo T. Farnsworth, United States)

Based on the cathode ray tube of Karl Braun, Farnsworth figured out how to refine earlier ideas and produce a clear, detailed image. A truly inspired inventor, Farnsworth is credited with over 165 inventions and is considered by many to be the father of television (and among its earliest critics). Extended litigation with RCA over his invention and their corporate creation eventually left Farnsworth the victor, but worn down by the struggle.

Electronic Imagers

Images made from electronic devices have enabled a host of technological innovations and the development of some key components at the heart of digital photography. Here's a look at some of the key elements from electronic imaging devices.

Vacuum Tube Imagers

The *vidicon tube* is a light-sensitive vacuum tube that was introduced in its most basic form with the invention of television, as the basis for TV cameras. Using a metal-like selenium to react with photons, it has a specially coated imaging surface that changes its electrical characteristics in response to incoming light (the image). This surface is then raster-scanned with an electron beam to measure the electrical characteristics of the coated surface.

Photo-multiplier tubes (PMTs) are very sophisticated light amplification vacuum tubes used as detectors in many scientific applications and in drum scanners.

Photo-multiplier (PMT) tube.

Radar

Radar was invented in World War II as a way of detecting enemy planes, ships, and rockets. Radar uses highly focused radio waves that are projected outward, then measures the amount of time the signals take to reflect back, thus producing a "blip" image of the target. As radar became more sophisticated, it was able to make three-dimensional images of the target, thus allowing for radar images rather than just silhouettes.

Photo-Diodes and the Charge-Coupled Device

Light-detecting silicon has been long used in light meters and other common technologies. *Photodiodes* were a refinement of those basic sensors and were eventually transformed into detectors that brought us images from the surface of Mars.

The invention of the CCD (charge-coupled device) was a turning point in the evolution of digital photography by creating a solid-state light sensor with photographic potential. It was invented by Dr. Willard Boyle and Dr. George Smith at Bell Labs in 1969 and presented in the Bell Technical Journal in April 1970.

The first working CCD image sensor was part of a video camera system. Sony and other companies quickly saw the potential of this technology and started experimenting with multiple applications. The CCD has served as the eye of the digital camera revolution.

Radar screen from USS Midway displaying approaching hurricane Alice, August 1962. U.S. Navy.

Complimentary Metal Oxide Semiconductor (CMOS) Sensors

CMOS sensors are a simpler-to-manufacture form of silicon light-sensitive sensor. Although initially used for commercial applications, such as pipeline weld inspection, these devices have dramatically improved in quality and have the potential to be much more controllable than the higher-priced CCD.

New Imagers

Imaging technology is in a state of rapid evolution. There are some fascinating new explorations going on with multi-spectral cameras and lensless optical systems. We will be in a state of rethinking our assumptions for quite some time.

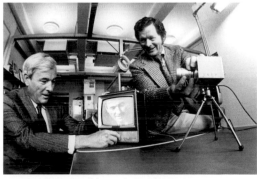

Dr. Willard Boyle and Dr. George Smith with their new CCD creating a video image on a television monitor. Reprinted with permission of Lucent Technologies/Bell Labs.

Analog and Digital

The sensors described in this chapter are not digital imagers at all; they create analog electrical signals that are then converted to digital (via A/D convertor) for the convenience of being able to be used by the limited binary number technology of our current computing methods.

In a sense, it is far more accurate to say that we are in the age of electronic photography; not digital photography as the digital aspect is a conversion after the fact of the light being captured.

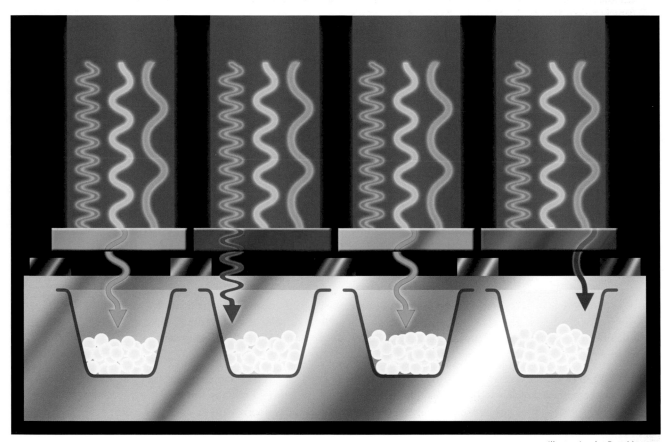

Illustration by Bert Monroy.

Solid-State Image Sensor

Most solid-state image sensors are made of crystalline silicon, an element with semiconducting properties. When photons of light with sufficient energy hit a piece of crystalline silicon, the photons are absorbed and their energy is transferred to electrons in the silicon, effectively knocking these electrons loose from the crystal lattice. In pure silicon, these loosened electrons quickly recombine with the crystal lattice, but the silicon in an image sensor has been processed to create thousands of individual "wells" (pixels) within the material, where electrons generated by incoming photons are collected and stored. After an exposure to incoming photons, the accumulated electrical charge in each pixel well can be measured to provide an indication of the amount of light striking each pixel well.

To produce a color image, filters are often placed over the silicon pixel wells that only allow a specific color of light—typically red, green, or blue—to pass through, so that each pixel well only responds to a specific color of light. Metal electrodes deposited on the surface of the silicon are used to control and transfer the accumulated electrical charge in each pixel well and to empty or "reset" each pixel well in preparation for another exposure.

The exact structure of the pixel wells, and the methods used for transferring and measuring the accumulated electrical charge in each pixel well, vary considerably among different kinds of image sensors such as CCD or CMOS, but the basic photovoltaic principle that converts incoming light into an electrical signal within a semiconductor is common to all these devices.

An Explanation of Silicon Imaging

A *photodiode* is a structure fabricated in silicon, designed specifically to convert incoming photons into an electrical current using the *photovoltaic* effect. These can be quite large, as in solar panels, or very tiny for imaging applications.

A charge-coupled device is a structure fabricated in silicon used primarily to transfer discrete packets of electrical charge from one location to another, much like a bucket-brigade where a charge is passed from one site to the next. Silicon has an intrinsic capability to convert incoming photons into electrons, and a CCD structure made with semitransparent electrodes can be used to capture the converted electrons from incoming photons, thus allowing a densely packed array of discrete photosites (pixels) to be made.

Many trilinear arrays use both photodiodes and CCD structures, each for the function it does best. An array of photodiodes optimized for converting incoming light into electrical signals is arranged in parallel with a CCD structure that is covered with metal electrodes (to remain "blind" to incoming light), and the accumulated packets of charge from the photodiodes are transferred periodically to the CCD structure, which then marches them off the image sensor to be measured.

A CCD area-array image sensor might use the CCD structures themselves as the light-conversion elements, as in the case of most pro-level CCD sensors (like those from Kodak and Dalsa). Such sensors must be shielded from light while being read out, as the charge transport mechanism (the CCD) is also light-sensitive. Smaller digital cameras, and most video cameras, use "interline" CCD sensors that have smaller photodiodes within a grid of CCD structures, so that one frame of signals can be transferred via the "blind" CCD structure while the next frame of signals is being collected by the photodiodes.

A CMOS (complementary metal oxide semicondutor) image sensor also uses photodiode technology for its light sensors, but instead of a CCD structure for moving the accumulated charge packets, a CMOS sensor has enough electronics at each pixel site to convert the tiny photodiode signal into a stronger signal that is then multiplexed onto a common electrical bus (one pixel signal at a time) to be measured.

Linear-array CCDs are used in satellite imaging, and probably also for other more classified mappings of Earth. An orbiting satellite can be a nearly perfect scanning mechanism.

—Michael Collette, BetterLight

STS-75 in flight Feb. 1997. The Space Shuttle has proved a unique imaging platform, and carried into orbit extraordinary remote imaging devices like the Hubble Space Telescope.

Remote Imaging Evolution

1840s and onward: Cameras on hot air balloons, early rockets, and pigeons

1907: Cameras on airplanes

1920s: Radar developed

1957: High flying spy plane, the U2 and SR71

1962: Returned film from orbit

1964: Video from space (Ranger 7, 1964)

1964: Digitally encoded vidicon images from space (1964: Mariner IV Mars fly-by)

1976: Photodiode from space (photodiode is not necessarily distinct from CCD)

1976: CCD from space (1976 KH-11 spy satellite)

1978: Radar imaging from space (Seasat 1978 was first "non military")

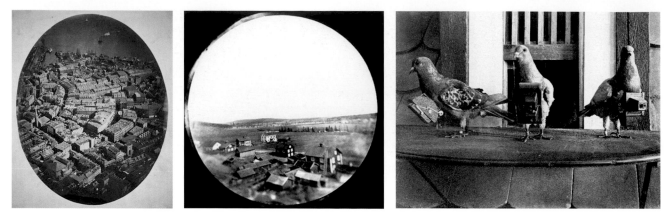

top left: Boston 1860 by William Black from Samuel Archer King's balloon. Courtesy: Boston Public Library
top middle: Swedish village attributed to Alfred Nobel's photo rocket in 1897. (Nobel was also experimenting with balloon-borne cameras at the time.)
Courtesy: Nobel Foundation
top right: In 1903, Dr. Julius Neubronner patented a miniature pigeon camera activated by a timing mechanism. © Deutsches Museum, Munich.

Sky, Spies, and Space

Many of the innovations we now have in the world of digital photography are direct descendents of the U.S. space program and the cold war spy programs run under the National Reconnaissance Program. The need to imagine and construct cameras that could fly high into the sky or into space and send back photographs became an imperative for national security and exploration. They were to become the eyes that could go where humans could not.

Many curious turns were made along the way, from cameras strapped to pigeons, to early rocket cameras, to complete processing labs sent into orbit to process film onboard. Balloons and early airplanes were the first practical remote-sensing platforms.

The imperative for espionage produced many technologies, among them the U2 spy plane and later the SR-71 Blackbird. These high-flying aircraft recorded very high-resolution large-format film images, but had the huge drawback of having to fly over the country being watched. One U2 was shot down over the Soviet Union, another over Cuba. Orbital devices eventually proved the answer. Today's digital photographer owes much to these projects.

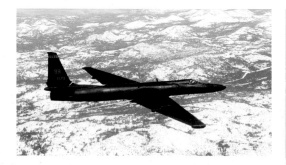

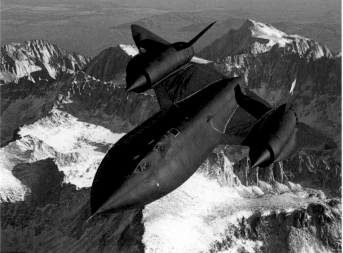

High-flying Spy Planes.
above: the U2 a high-altitude reconnaissance aircraft.
Speed: 475+ mph (Mach 0.58)
Range: 3,000+ miles above 70,000 feet. 1955 to present. USAF.

right: the SR-71 Blackbird a very high-speed, high-altitude
reconnaissance aircraft. Speed: Mach 3.2
Range: 3,200+ miles above 80,000 feet. 1962 to present. USAF.

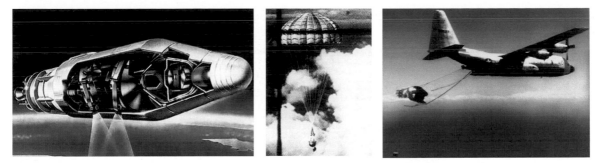

above: Corona Spy Satellite in orbit rendition, parachute return and airborne recovery. NASA.

The Corona Program (1958–1972)

Corona was the program name for a series of film-based spy satellites that returned 70mm film to earth from 1960 through 1972. The program consisted of six different and evolving designs that eventually were known as the KEYHOLE satellites. These devices consisted of panoramic cameras fed by very long rolls of film, that had re-entry vehicles to bring the film back to earth for mid-air capture, a very careful processing and interpretation exercise. Ultimately, the film load and need for immediate information dictated the life of these eyes in the sky. A huge desire was created for more immediate and reusable cameras in orbit.

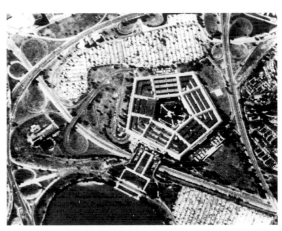

Pentagon. Washington DC. (Corona) Keyhole spy satellite.
Sept. 25, 1967. USGS.

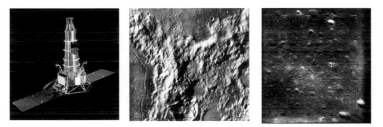

Ranger 1961–1965

The first American probe directed at the moon was designed to see if it could hit the target and learn as much as it could on the way and just before impact. Obviously, the pictures needed to be taken off the probe quickly as it neared its crash-landing. A television camera and radio transmitter were used to capture and reveal our first close-up photography of the lunar surface, transmitting until moments before the equipment's demise.

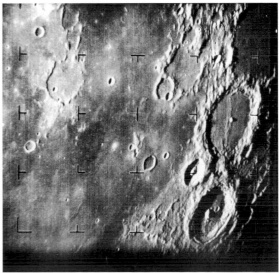

Ranger 7 took this image, the first picture of the Moon by a US spacecraft, on 31 July 1964 at 13:09 UT (9:09 AM EDT)
about 17 minutes before crashing into the lunar surface. (Ranger 7, B001)
Distance/Range (km): 2445.97, Instrument: Vidicon Camera B, Resolution: 1150 scan lines. NASA.

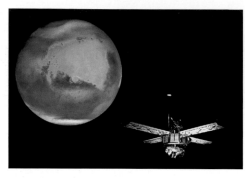

Mariner 4 image showing craters in the Memnonia
Fossae region of Mars. (Mariner 4, frame 10D)
Date/Time (UT): 1965-07-15 T 00:29
Distance/Range (km): 12,800.
Instrument: Television camera
Resolution (pixels): 200x200, 6-bit.
Filter: green

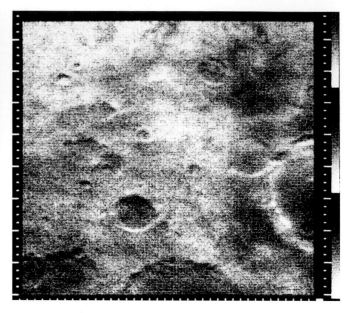

Mariner 1962–1973

Mariner was the first deep-space probe.
Versions of Mariner went to Venus, Mars,
and Mercury. In 1965, the Mariner IV
spacecraft flew past Mars for our first
glimpse of the planet from nearby, reveal-
ing their first look at Martian craters. The
camera system was a 6-bit 64-grayscale
video system. When the messages were received at the Jet Propulsion Laboratory (JPL) in Pasadena, California,
they were printed as numbered squares on ticker-tape, then colored in with 64 different shades of chalk to repre-
sent their brightness, then taped together into a large mosaic. When looked at from a distance, these chalked-in
pixels formed our first digital-like prints from space.

Mariner 4 was the first spacecraft to get a close look at Mars. Flying as close as
9,846 kilometers (6,118 miles), it revealed Mars to have a cratered, rust-colored
surface, with signs that liquid water had once etched its way into the soil. The
spacecraft had a television camera onboard which took 22 television pictures
covering about 1% of the planet. Initially stored on a 4-track tape recorder,
these pictures took four days to transmit to Earth. —*source NASA*

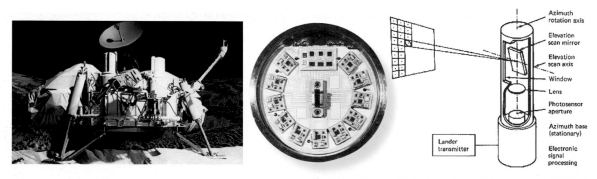

The Viking camera with its 12 pixel array. Schematic to right. NASA.

Viking 1970–1980

The Viking landers on Mars in 1976 were our first panoramic cameras on another world. Their photodiode cam-
eras worked with a mirror at the top of a rotating tube; the mirror swung up and down from zenith to the ground
nearby, playing image light across a 12-pixel array at the bottom of the tube. The image was built up one row at
a time, with the tube rotating (up to 342°) and mirror panning down for the next row. Each pixel of the 12-pixel
photodiode array was filtered for a different wavelength of light, for samples in RGB, IR, UV, and others.

above: Mercury, Mariner 10
Jumbled terrain antipodal to the Caloris Basin,
Mercury
(Mariner 10, Atlas of Mercury, Fig. 11-20)
Instrument: GEC 1-inch vidicon tube (TV) camera
Instrument Resolution (pixels): 700x832, 8-bit
Instrument Field of View (deg): 0.38x0.47
NASA Image ID number: Fig. 11-12, Atlas of Mercury
NSSDC Data Set ID (Photo): 73-085A-01S

right: This image of Venus is a mosaic of three images
acquired by the Mariner 10 spacecraft on February
5, 1974. It shows the thick cloud coverage that
prevents optical observation of the surface of Venus.
Only through radar mapping is the surface revealed.
This interpretation Copyright © Calvin J. Hamilton.

below: Viking 1 Lander image of Chryse Planitia
looking over the lander. The view, from 22 N, 50
W, is to the northwest. August 30, 1976. (Viking 1
Lander, 12B069) Viking 1 Lander Scanning Camera
(photodiode). Resolution (pixels): 512 vertical, 6-bit.

Camera illustration by Bert Monroy added to scene.

above: Saturn taken from Voyager 2. August 4,1998. This true color picture assembled from Voyager 2 Saturn images at a distance of 13 million miles from the planet. Three of Saturn's icy moons can be seen at bottom. They are, in order of distance from the planet: Tethys, Dione, and Rhea. Tethys shadow appears on Saturn's southern hemisphere. Image: PIA01364. NASA.
right: Artist's concept of Voyager spacecraft.

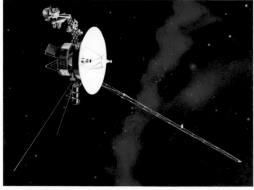

Voyager 1977–1989

The pictures the planetary grand tour sent back by Voyager 1 and 2 between 1978 and 1989 remain among the most impressive space images experienced in the first 30 years of spaceflight. Relying on gravity assist thrusts to move onto the next planet, the spacecraft took advantage of a unique plane-tary alignment and managed to visit Jupiter, Saturn, Uranus, and Neptune, making the gas giants of our solar system real (albeit strange) worlds to us for the first time.

Voyager's imaging system was built around selenium sulfur vidicon cameras digitized into 800x800 pixels at 8 bits with multi-spectral filter wheels in front of them. Color images were built up from multiple exposures of red, green, and blue. These photographs remain spectacular, even by the ever-changing expectations set by modern digital photography.

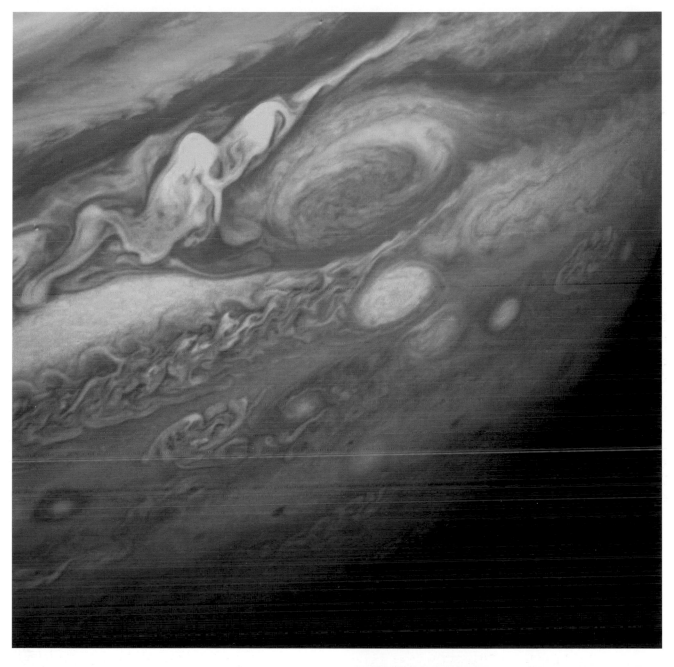

above: Jupiter's Great Red Spot and its surroundings by Voyager 1, Feb. 25, 1979, 5.7 million miles from Jupiter. Cloud details as small as 100 miles across can be seen. Image: P-21151. NASA/JPL.

right: Voyager 2 image of Neptune taken as it flew past on 2 August 1989. Image: PIA00046. NASA/JPL.

far right: Spacecraft Galileo's view of Jupiter's moon Io on August 27, 1999. Image: PIA02308. NASA/JPL.

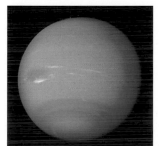

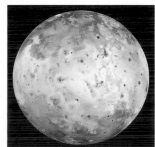

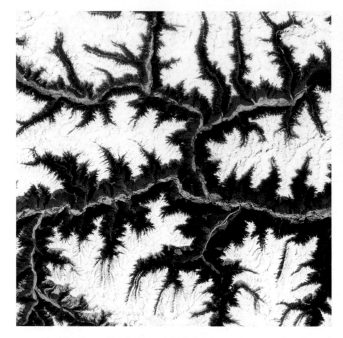

The Himalayas. 2/17/2002 by ASTER. Soaring, snow-capped peaks and ridges of the eastern Himalayas Mountains create an irregular white-on-red patchwork between major rivers in southwestern China. ASTER Path 136 Row 39, center: 29.93 N, 93.62 E. NASA.

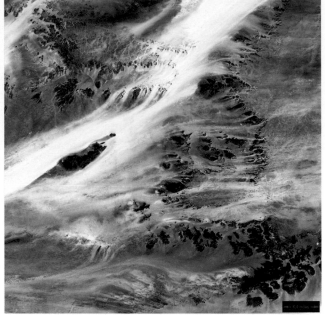

Terkezi Oasis. 10/22/2000. A series of rocky outcroppings are a prominent feature of this Sahara Desert landscape near the Terkezi Oasis in the country of Chad. Landsat 7 WRS Path 180 Row 47, center: 18.79, 22.92. NASA.

Landsat (1972–present)

Landsat geophysical satellites are the mainstay of the U.S. Geological Survey's global mapping projects. Launched from 1972–1999 in a series of increasing precision and special purposes, they account for many of the images we know of the planet Earth. The general field of study is simply called remote sensing.

Landsat satellites have evolved through video imagery into digital devices, and are multi-spectral, including bands for normal human vision color renditions as well as many bands for scientific study. Innovative additions have included thermal mappers and the thematic mapper for even more detailed looks at the earth. Scanning, panoramic techniques are used to build up images, and the actual imaging systems vary from video, to CCD, thermal, radar, and many others, depending on the imaging need.

And Beyond

Later satellite additions have included the Terra Satellite's Advanced Spaceborne Thermal Emission and Reflection Radiometer (ASTER) and many others. Some of the photographs being taken by satellites today are so dramatic and abstract as to rise to the level of earth forms recorded in intricate beauty, prompting NASA to even start a website called Earth As Art (http://landsat.gsfc. nasa.gov/earthasart/index.html). New deep space probes such as Jupiter's Galileo and Saturn's Cassini have brought remarkable new images back to us on Earth.

Spy Satellites Today?

We can indulge in much speculation regarding the kind of imaging equipment in orbit today. A standard reply in the sensor industry to my requests for higher resolution instant capture devices goes something like this: "If you have enough money, we can build almost anything." Given the budgets of governmental agencies, I can conjure up an image of very high resolution area arrays instantly capturing and transmitting views of earth. Linear arrays can also work very well when carefully synchronized to orbital speed. Of course, it may take hundreds of millions of dollars, or even billions, to make these few imagers, but like so many technologies we now count on, eventually these will become declassified and available for commercial purposes.

We would not have had the breakthrough Leaf DCB back in 1992 without chip development previously paid for by government contracts with Loral Fairchild. It made very high quality digital studio photography possible. Even so, when the camera was first built and sold for $30,000, the cost of the sensor itself was $7,500.

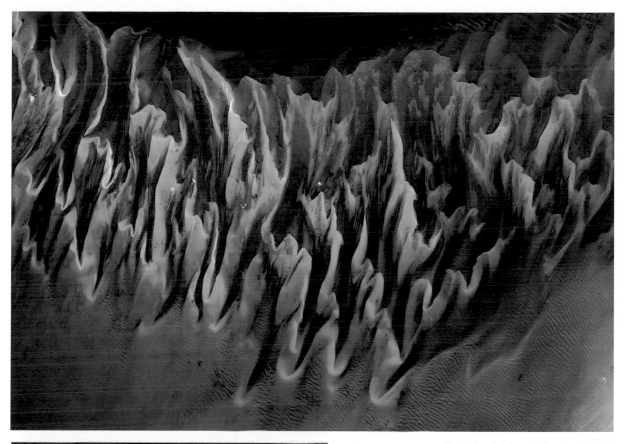

Ocean Sand, Bahamas, October 29, 2000.
The sands and seaweed in the Bahamas. Enhanced
Thematic Mapper plus (ETM+) Landsat 7. NASA.

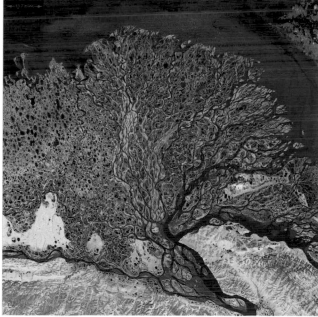

Lena Delta. 7/27/2000.
The Lena River, some 2,800 miles (4,400 km) long, is one of the largest rivers in
the world. The Lena Delta Reserve is the most extensive protected wilderness
area in Russia. Landsat 7 WRS Path 131 Row 8/9, center: 72.21, 126.15. NASA.

Wildfires in Southern California: Moderate Resolution Imaging
Spectroradiometer (MODIS) on the Terra satellite, October 26, 2003. NASA.

Detail from Thomas Moran engraving, 1873.
(*See Chapter 8 for full engraving.*)

The Evolution of Digital Publishing

No single commercial enterprise nudged digital imaging into its modern form like the publishing/printing industry. Their needs were very real, the technology of digital imaging offered new flexibility, substantial savings, and significant time reductions.

Printing has been around since inked Chinese wooden plates in the year 305 AD. In 1455, Gutenberg introduced moveable type. When photography came along in 1839, it took viewers to places wild and wondrous and left a desire to distribute these views to a wide audience. Although books and newspapers were becoming ever more available, for the first few decades of photography, printing could not take advantage of this new and popular media since there was no way to reproduce the continuous tone of a photograph with a printing press.

Steel and wood-plate engravings were created to redraw photographs into a reproducible form. Many picture books were published with these engravings, illustrating a world of detail suggestive of the original photography. While this created a lovely genre of photo-like engravings, it was a frustrating and expensive process.

Halftone and Photographic Reproduction

The development of the halftone screen in 1857 made photo reproduction possible by transforming photography's continuous tone quality into variable-sized absolute dots of ink that could be printed by a printing press. The basic process involved exposing high-contrast film through a beaded glass screen, breaking the light into small dots that varied in size depending on the amount of light striking the screen.

Capturing this process required the development of large and complicated cameras in order to aid the process of creating halftone film and photographic printing plates. These came to be known as Process or Graphic Arts cameras, now often known as Stat cameras. They were basically large-format view cameras designed for large copy work. Whatever size reproduction you needed, that size film/camera had to be used to create it. These cameras continued in use into the 1990s.

above: white to black blend, halftone imitation used for reproduction.
right: 19th/early 20th century Graphic Arts Camera. courtesy Hunter Penrose.

Color halftone printing brought even more complexity to the process, requiring multiple plates and rotated halftone screens to create the different printing plates on press for subtractive color printing. Color photographs were built up by making color separation films through red, green and blue filters, then making a higher contrast black plate. These were made as negative plates and printed with the primary color's opposites, cyan, magenta, and yellow, with the black added for contrast (CMYK). These screens were rotated so that the dots of ink formed color halftone rosettes rather then printing on top of each other.

The Development of Scanning

A method for bypassing this laborious halftone film-making process was clearly needed. With 19th century developments in transmitted images, there seemed to be technologies out there that might be evolved into replacing traditional graphics arts camera and process film.

Color Halftone reproduction. My cover of California History zoomed in on to show rosette pattern of rotated CMYK halftone dots.

In 1935, wirephotos were derived from Bell Lab's 1924 fax technology, storing and transmitting the electrical signal before it was printed out, and thus distributing photographs anywhere in the world through telephone signals.

Bearing a remarkable resemblance to some 19th century devices, the electrostatic mimeo stencil machine became a mainstay of educational reproduction in the 1950s and 1960s. An original was scanned on one drum, and then a charge was sent through to a parallel drum employing an electric arc to burn a hole in a stencil where black had been detected on the original.

The drum scanner employing a light-amplifying vacuum tube PMT sensor eventually revolutionized the printing industry. The basic mechanism is essentially a repeat of the mimeo stencil maker and the 1861 Pantellograph. The original photo is attached to a rotating drum, which has a detector lens assembly moving down the drum's length, sending light to the imaging photo-multiplying tube (PMT). It started with analog devices and soon became digital, linking to laser-based imagesetters to make printing film. It is still very much in use today.

Other Digital Graphics Developments

Other developments in modern graphic reproduction have significance in the evolution of digital photography.

In the 1980s, Scitex retouching workstations became available, allowing the digital editing of photo scans. The $500/hour charge to "scitex" a problem image became an expensive but conceivable expenditure to repair damaged film or spruce up an advertising photo, CCD-based scanners started showing up in the early 1990s and have now become the most popular form of technology for inexpensive (under $100) as well as very high quality ($50,000) desktop scanners.

Epson Perfection 4490 Desktop Scanner.

Making printing reproduction film from the digital scans was also an issue. Lasers were employed to write very precise half-tone dots onto high-contrast film imitating the use of traditional halftone dots that was used in the late 1800s. Initially this proved challenging for precise rotations angles and resulting moire patterns, but improved to become the industry standard.

Digital Prepress

Today, it works very differently. Almost all modern printing is done from digital scans, more and more from film-less digital plates (direct to plate, as this book is reproduced), with less manual intervention into the process. The printing industry is now widely digital in its creation of printing plates from photos. Ever more, the originals are digital camera files, not just scanned film. All of this integrates digital photography ever closer with printing presses and the whole graphic arts industry. The cross-pollination of need feeds development, feeding new ideas and new markets, which in turn feeds back again to original and expanded industries. This process continues to expand the capabilities of electronic imaging.

Today, a color printing job should cost no more if there is one small color photograph on the page than if there are 10, at least if you do the scan and prep yourself. The main reason for this is the huge reduction in hand work; manual separations, laying out litho film, stripping the separated film into register on the four separation master, all of these steps are now gone.

Education and Transition: Personal Evolution

This is the juncture where I entered the picture. As an individual photographer, I was subject to the vagaries of photographic reproduction without having any knowledge of how it worked. Curiosity and frustration led me to learn how the technology of photographs and printing presses worked.

My friend Jeff Denno ran Davis Office Machines in Merced, California where I grew up. Jeff was always helping me with political campaigns, work on behalf of causes important to me, and my own college applications. It was at Jeff's I used my first word processor and bought my first computer. I became very familiar with mimeograph machines, and on my college newspaper I started preparing halftone stats of my photographs and preparing text on a typesetter.

My work on behalf of Mono Lake in the late 1970s deepened the education. By then photography had become my chosen career, my exposure to beautifully reproduced photo books had taught me a bit about line screen and multi-ink black-and-white reproduction (duotones). I had a few chats with Ansel Adams about the Mono Lake project, and he steered me to Pacific Lithograph in San Francisco, who was just then printing his first edition of *Yosemite and the Range of Light*. Ansel also introduced me to David Gardner of Gardner-Fulmer in Los Angeles, who were doing some of the most beautiful prepress (work needed prior to printing the image on a press) and printing work.

At Mono Lake exhibition promotional brochure, 1979.
Mono Lake Coalition Calendar, 1990.

I wrote, designed, and press-supervised my first real printing job for a two-color (black and gray) photographic brochure announcing the *At Mono Lake* exhibition and setting the aesthetic stage of how the work would be handled. It went well and it plunged me into the world of drum scanning, laser imagesetting, and fine-line screen duotone offset reproduction. It helped that Ansel was still around working on the Yosemite book and the printer considered me a protégé.

From there I went on the supervise the printing of many Mono Lake Calendars, the *At Mono Lake* book, and eventually a book about the Great Central Valley of California. I learned about retouching stations,

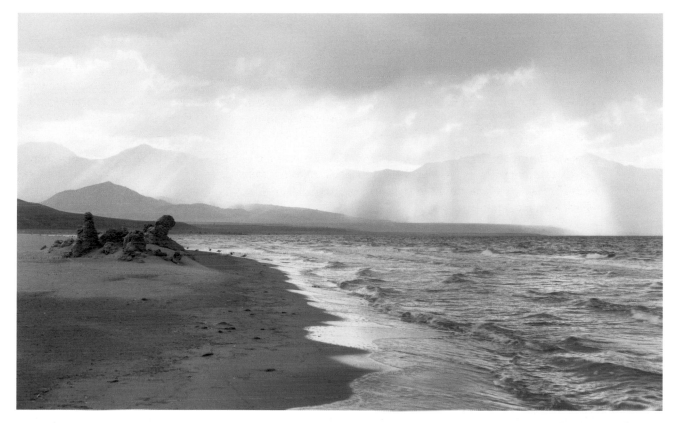

Storm, Mono Lake, 1979.
6x7cm Kodak Vericolor negative film. Mamiya RB-67 camera.

hand-bleaching film in potassium ferricyanide, and a few of the possibilities in scanning. This eventually prompted me to ask hard questions about sharpening and color balance, and various intricacies of offset press controls. I also had the opportunity to work with one of the first digital prepress houses, DPI, in San Francisco and their founder, Sanjay Sukuja, who would experiment with me for both our educations.

By the time the Central Valley book was coming into being, I was uniquely prepared to consult with emerging scanner companies and Adobe on their new Photoshop software. By the early 1990s, I had asked Adobe to add duotones to Photoshop, could often outscan a prepress house, and found I was educating people in the industry. My need for cross-knowledge about how all of the imaging technologies fit together turned out to be of value beyond my own needs. I was also lobbying heavily for the empowerment of people like me, to take control over the reproduction of their own work.

Trees and Cliffs. Pinnacles National Monument, California. 1999.
BetterLight Scanning Camera. 6000x8000 pixels, 14 bit Tri-linear array.

Chapter 3: On Photography's Bleeding Edge

This journey put him travelling through new territory daily, encountering and solving problems for years, literally on the bleeding edge of the new photographic technologies.

—a lost reference from a magazine article

I've been lucky enough to witness some of the evolutions in digital photography first hand, finding myself on a journey riding the bleeding edge of digital photography's evolution these last 15 years. It's an interesting place to be. Sometimes I want to do things that haven't quite been created yet. I have to sort of invent my way through that process, convince other people to help, or talk about the idea enough to get it planted in somebody else's head so that they imagine a solution. It has been an interesting ride, in some cases rewarding and in some cases frustrating.

On this bleeding edge there's been a sense of empowerment, of understanding the possible, finding out that I could do more than I could do any other way. There has been a great deal of improvisation in this process. Improvisation takes many forms—getting a friend to hack together a little piece of software or taking 4-ply matte board and linen tape and making a negative carrier for a scanner, whatever it takes to get the job done. Hopefully it keeps expanding my vision of what can be and what digital photography can mean.

I always believed that unless digital photography could rise to the quality that I had been able to achieve with silver materials, it was merely an entertaining curiosity, not a substantial technology. By about 1989, I began to see signs that digital photography was rapidly maturing. By 1994, I quit using film altogether because the image quality from a silicon-based system, which we now call digital photography, had so clearly surpassed anything I had ever seen out of silver halide in any form. I was stunned by this realization. I had to move forward assuming that silver was part of my past and electronic sensors were part of my future. Here are a few of my own experiences with the evolution of digital photographic technology.

Technology Illuminates California's Central Valley

I began this digital adventure without intending to. The plunge into electronic images began for me in the mid-1980s with the project that I did with Robert Dawson on our homeland of California's Great Central Valley. Many of the needs that arose while trying to create that project ended up being met by the advances in technology that were taking place at the time.

For instance, as we were building the exhibit for an opening at the California Academy of Sciences in Golden Gate Park in 1986, it became ever clearer that we had a complex story that we needed to tell about the Central Valley. The exhibit could easily be overwhelmed by text and graphics telling that story, rather than be the photographic exhibit that we knew it had to be.

To tell the story while keeping the photographs at the center, I came up with the idea of doing a computer video interpretation program. On spec for a Department of Defense training system, Sony had made a device called the Sony View System that integrated computer graphics with video that could be drawn from a laser video disk. What I designed for the exhibit that opened in June of 1986 was exactly that—we shot stills and video which we put on the video disk, and with computer graphics specialist Greg MacNicol we created a series of video graphics explaining some key elements of the Central Valley: the agriculture, the Native American history, and the water system. Greg also programmed the presentation structure. About six months after the exhibition opened, some representatives of Apple Computer called and asked if they could come up and learn from what we had done, as they were flirting with the idea of the Macintosh doing multimedia.

The Great Central Valley Project exhibition. California Academy of Sciences, San Francisco installation. 1986.

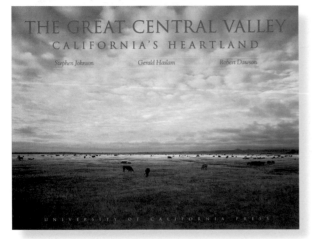

The Great Central Valley: California's Heartland by Stephen Johnson, Gerald Haslam and Robert Dawson. 1993. University of California Press.

The plunge into uncharted territory became much deeper with the production of a book associated with the project. When I was doing my previous book, *At Mono Lake*, I used waxed type cut out with X-Acto knives and ruby-lith on layout boards. I thought at the time, rather naively, that I would never, ever produce a book in that manner again. Little did I know that was truer than I would ever have imagined. At the time that I was asked by the University of California Press to do the layout of the book, Adobe PageMaker existed, the Macintosh SE existed, and I saw an opportunity to design this complex book that was taking shape in my mind electronically. I created a sample chapter from the book, printed it on nice paper, stripped original photographs by me and Bob into the layout, bound it, and presented it to the UC Press Editorial Board. They said they had never seen a proposal quite like that, and offered us a book contract. Without fully realizing it, my digital journey had just taken a significant step into the future.

The Development of Desktop Scanners

By late 1988 the first of the desktop scanners started to arrive, flatbeds at first and then Howard Barney provided one of the BarneyScan small 35mm slide scanners. His was one of the first desktop digital film scanners, and it was fine for comping copies of our larger format work. With that Barney Scanner came a piece of software called BarneyScan XP, which Adobe licensed a few months later and renamed Photoshop. So I always tease people that I was using Photoshop before Photoshop was Photoshop. This led to a reconception of how the Central Valley book could be put together. For the first time, it was conceivable that I might be able to do the photographic prepress myself, as I knew I could do the design on my own computer, in my own studio.

I mocked up the book with a lot of video captures as well, but about two-thirds of the way along the production process of the book I learned about Leaf Systems; they had basically built a 4x5 enlarger into a scanner. I could now scan anything from my 20 years of film-based photography. I contracted to do some promotional work with them and the Leaf Scan 45 arrived, finally allowing me to actually scan my 4x5 film directly. I was enthralled.

The Leafscan 45 had a curious feature: The scanner used Beseler enlarger 4x5 negative carriers to hold and load the film, which indicated to me that solid thinking was going on: a respect for the photographic process. You could open the door in front to adjust a nice Schneider lens. It had this curious format: 16-bit files. At the time, 8-bit files seemed huge and taxing on the machines. With the Leafscan I was making 200MB files at 16 bits from my 4x5 film, trying to process them on a Macintosh IIfx, in 1992. It was a rather slow process, but it gave digital eyes to 20 years of film and it was a fundamental step forward. In fact it scanned much of the Central Valley book, including the cover. Next thing you know, I was lecturing on how I made a book digitally and creating *Making a Digital Book* to answer the questions of the skeptics.

Leafscan 45.

The Leafscan Rotating Negative Carrier

When the Leaf scanner first arrived, I noticed there was a problem using the Beseler negative carrier. I had always cut my film into strips that hung out the sides of the enlarger negative carrier. That was no problem on the Beseler enlarger, but the way the Leaf scanner had been built there were confines to the scanning path which prevented film from hanging out the sides. Unwilling to cut my film in order to scan it, I improvised a solution. Taking 4-ply rag board, a protractor, and an X-Acto knife, I made myself a negative carrier that held the film lengthwise. It made perfect sense. You make what you need; that's what a photographer does, right? You need something, you make it rather than wait for someone else to make it for you. A few weeks later, my friend Jim Dunn from Leaf came by, saw my improvisation, and said "Steve, we just spent thousands of dollars designing a negative carrier that isn't nearly as good as this." I replied, "We ought to be able to work something out."

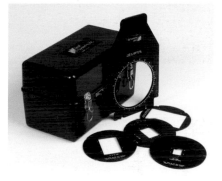

Leaf did end up licensing the design for production. These carrier sets may now be collector's items, and they didn't pay me nearly as much as they had spent for their prototype. Part of the contract called for the words "Carrier Design by Stephen Johnson" to be printed on the carrier. How's that for glory? (Fleeting though it may be; of course somebody removed my name on later sets.)

above: Leafscan 45 Prototype Rotating Negative Carrier and manufactured product. below: Film inserts with carrier and case.

That was one little tool created through simple improvisation to solve a problem. The film strips could now ride out the lip of the scanner. In addition, I needed multiple formats, so I made a circular inset for the different film formats which made it automatically able to rotate as well. It became the multi-format rotating negative carrier design.

Digital Duotones

In the process of doing the Central Valley book, I witnessed another advance in digital imaging take place with regard to the creation of duotone tools in Photoshop. Traditionally, when a black-and-white photograph is reproduced with halftone dots and ink, it is much better to do it with more than one color of ink. These kind of multi-plate reproductions are called duotones and were developed because the halftone process on its own can't reproduce the tonal range of a gelatin silver print using only a single ink. Traditional duotones were done by essentially creating color separations of black-and-white originals, using two different shots of differing contrast and exposure on two different sheets of graphic arts film. The process had evolved over the years, benefitting from many advances, including Ansel Adams' work on pushing the quality forward in his large-format black-and-white books.

The basic idea of a duotone in this context was to use a gray ink and a black ink. The black ink carried all the shadow detail and density, and the gray ink was used to reproduce the midtone and upper values. There was no digital equivalent. A workaround had been created where you would use a cyan, magenta, yellow file and you threw the gray ink into the cyan channel and you sort of simulated the duotone. It was a mess.

Making a Digital Book. Stephen Johnson Photography, 1993.

In the early 1990s, I was consulting with Adobe on this new product of theirs called Photoshop. I told them we needed a duotone feature in Photoshop and Russell Brown, the Art Director, agreed with me. We sat down with Photoshop author Thomas Knoll and the product manager at the time, Steve Guttman. Russell and I sketched out to Thomas what we wanted to see in Photoshop. Adobe came back six months later with what Thomas had written, the Duotone feature in Photoshop, and suddenly I could create duotone reproduction separations right on my desktop. Even though I had asked for it and knew it could be done, it was a stunning development. Adobe needed some examples of how you would use this feature to ship with the software and asked if I could

help. To this day, all of the sample curves that ship with Photoshop are the curves I wrote in May of 1992.

Digital Original Photographs

Digital originals didn't come along for me until I was teaching at Kodak's Center for Creative Imaging in Camden, Maine in 1992. The second generation of the Kodak digital camera backs had just become available. The first was a big video box that you carried in a sling over your shoulder that had a monitor and big cable running up to the Nikon body. It was called the DCS100, and it made these little 2MB files that were fascinating but impractical. The second generation was the DCS200, which made about 4MB black-and-white files. It also featured a color filter wheel in front of it that allowed you put a still life scene before the camera and snap the shutter. It would then take a photograph through the red filter, rotate, then take one through

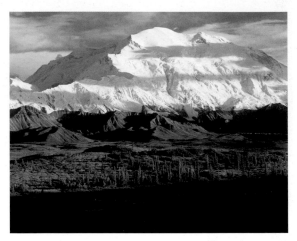

First image on Adobe Duotone poster Denali, Alaska, 1988.
4x5 black-and-white film.

the green and the blue, and you ended up with color files from this camera. Of course it had its downsides, and I carried around a little satchel of AA batteries because it seemed I could shoot about 10 shots per battery set.

Original Leaf DCB on Hasselblad 500EL.

Eventually, the same company that made the Leafscan came up with a digital camera back. In 1993, Leaf Systems built a digital camera back and mounted it on a Hasselblad. The Leaf DCB used the sensor that the Loral, the satellite spy defense contractor, had made for reconnaissance satellites, a 4MB chip with a 16-bit data path. The black-and-white portraits I was able to make with that camera stunned me. To this day I still use the Leaf DCB as a portrait camera. I ended up working with Leaf a bit on the development and promotion of the camera. This is still one of the most beautiful image-producing devices I have ever seen. It too could do color with a color filter wheel.

I started having many conversations with people in the high-tech industry of Silicon Valley over what this technology could do and needed to do in order to be a usable tool for photographers. With this history, people started coming to me and talking over ideas. Here was an experienced photographer who was also learning rapidly about digital imaging. The down side about that prominence was that I got an image of being persnickety about image quality, snobbish about gimmicks, demanding, over demanding—I actually wanted photographs without streaks through the middle of them. Keep in mind that when people were inventing this technology, it felt so miraculous just to get an image that it almost felt like it was enough. Other goals came to mind for some of us out there; we wanted to use these devices and software as high-end photographic tools.

The Scanning Camera

In the fall of 1993, just after the Central Valley book was published, a friend of mine, Jim Dunn, VP at Leaf Systems, called me up and said he would like to bring over a former employee of his by the name of Michael Collette. Mike had worked in his spare room at home for two years designing, building, and writing the software for a scanning insert for 4x5 cameras. I said, "A scanning camera? You mean he put a scanner in a view camera?" Jim said, "Yes, exactly. He wants to come show it to you." Mike came over in September of 1993 and showed me his camera. It was an overcast, kind of breezy day, and I set up the 4x5 on my deck. It took almost 4 minutes

Trees, Fitzgerald Reserve. 1994.
This photograph was made in March 1994 as part of the experimentation with the prototype BetterLight Digital Camera. These trees are at the Fitzgerald
Marine Reserve between Half Moon Bay and San Francisco. It is a color infrared shot, with only the red channel of the RGB file used. It was raining at the time
we made the photograph. We were protecting the camera and computer with the darkcloth. This image was the first photograph I made with the digital
camera that I felt was a strong image.
Location: 37 49 40Nx122 29 53W.

to make a 30MB photograph. Of course the trees were blowing in the wind which made the resulting photograph look kind of strange. I said, "Well, 32MB, that's kind of interesting, but couldn't you do a little bit higher resolution than that?" I was used to almost 200MB scans out of the Leafscan. Mike replied that he could do 140MB, and he just had to finish it. I encouraged him to come back when he was finished.

Mike called me in January 1994 saying his camera back was done, and he wondered if I would like to try it? We came up with a plan to go out around San Francisco and shoot with 4x5 color negative film, 4x5 black-and-white film, and 4x5 color transparencies and a digital sensor at the same time and compare. Mike said "I think you'll be surprised," and I said, "Yeah, I'd like to be."

Conservatory, Golden Gate Park, San Francisco. 1994.
Prototype BetterLight Scanning Camera. 6000x7520 pixels. 12-bit. Tri-linear Array.

The first place we worked was the Conservatory in Golden Gate Park. We didn't change the camera, we didn't change the lens, we didn't change the focus. We simply put a film holder in, shot an exposure, put the sensor in, shot an exposure, and controlled it with the old black-and-white PowerBook 160.

There are some strange aspects to that first photograph; namely, a few artifacts are present. I can tell you two stories and you choose which one you want to believe: while we were standing there, these three strange creatures materialized from a teleportation device of some sort from an orbiting spacecraft; the other is that three people were coming to check out the potential for a wedding reception inside the Conservatory and they happened to walk into my digital scanning photograph. In truth, the artifacts were three people checking out the place for a wedding reception who got transformed into tri-linear digital stick-people because the scan time from one side to the other took 3 minutes and 45 seconds. They came in, they looked, they talked, they thought about it, they moved away and they left their digital signatures. I learned something early on in the process. I cloned those out in Photoshop for the first two or three months after I made the photograph, but eventually I realized that was dumb—they were part of the image, and I should leave it alone. These lessons sometimes take time.

The Death of Film

We literally did a circle around town with our experiment. We went up to the Golden Gate Bridge, we went up to the Palace of Fine Arts, we went up to Coit Tower on Telegraph Hill for a view of the city looking toward the Golden Gate Bridge on kind of a misty day in January. At the end of the day, I made a photograph with Columbus and Bay Street in the middle of the frame. On the corner of Bay and Columbus is Tower Records. I took a loop to the film, then zoomed in on the digital file. The difference was hard to believe. That photograph completely floored me. January 15, 1994 was the last day I took film seriously as a recording medium. For me, this was the death of a film; it was not a material I could stomach using ever again. From that point on, when I had the choice between film or high-end digital, I was going to pick digital without any doubt whatsoever. (Of course, if a car had been driving through the scene at the time of exposure, it would have gotten all stretched out and weird. I was using a hand-built prototype of which only one existed in January 1994. There were still distractions to deal with in this new medium.)

Coincidentally that same week, the first Photoshop Conference was being held at the Sheraton Palace in downtown San Francisco. The Digital Pond (a pioneering Iris Printing House) had made me a beautiful, big 30x47 inch Iris print of the conservatory photograph on rag paper to show. I hauled the print over to the Photoshop Conference and started showing it around. People had no idea what to make of it. What is it? what could it be? a lot of people asked me. In fact, one photographer said to me a few months later, "I don't know what it is, Steve, but it can't be a photograph." I asked, "Well, what else could it be?" Then there was silence. Well, it couldn't be anything else other than a totally new way of making a photograph.

I was in the back of the room during the conference keynote, and Russell Brown was up front talking about tips and tricks in Photoshop. As I recall, Russell was putting a portrait of himself in between Ron and Nancy Reagan, cloning his head so he would be part of the conversation. He was having a great time and everybody was laughing. I was glossing over more of this double-headed play. Thinking over what I'd seen, it occurred to me that one way or another I had to take what I had experienced with the scanning camera and run with it. I had to see if this was real, if this shock of image quality that I had seen had potential to be a usable technology.

The Birth of a Project

It was on that day that at the first Photoshop Conference that I dreamed up *With a New Eye: The Digital National Parks Project*. This new technology was compelling, but I had to see if it was real and could actually be used to produce a body of landscape work. The national parks dawned on me as subject matter almost instantly. I knew they would be hard and test my use of the camera. I knew that it was important to portray the beauty of these places with as much integrity and power as my imagination and skills could muster. Even more fundamentally, the history of the national parks and landscape photography are intertwined. I also knew at first it might seem trite. "More color photos of the National parks. Well, that sounds original, doesn't it?" Those concerns were simply overridden by my sense of the appropriateness of the first major digital landscape photography project focusing on the parks.

The National Parks Project Commences

In June of 1994 with the Ansel Adams Gallery in Yosemite, we announced *With a New Eye: The Digital National Parks Project*. It was kind of gutsy, because I had never used the camera in a national park when we announced this project. I had come to Yosemite the weekend before the press conference, thinking, hoping that since I had done all this publicity about the press conference that I could make some decent photographs. I was lucky. I made some photographs I was happy with, and we were able to show them. The press conference was well attended with people from the gallery, the press, Silicon Valley, and a few old friends out in front of the Ansel Adams Gallery.

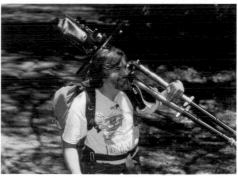

During the press conference, we made an infrared photograph in the middle of the meadow looking back at Yosemite Falls. I never would have guessed that I would have made a photograph of Yosemite Falls, much less during a press conference, that I would have cared anything about. This image proved to be an exception.

Steve Johnson at Yosemite Press conference announcing the National Parks Project. June 17, 1994. Photograph by Josh Weisberg.

By spring, I had been telling a few people about this project I was considering. One of them was Bryan Lamkin at Adobe, who stepped up as my first sponsor. Bryan made possible the beginnings of the National Parks Project by signing Adobe up as the first corporate contributor. Then in July, we hit the road with my assistant Darin Steinberg, heading for Yosemite's high country, Mono Lake, the Grand Canyon, and around the southwest.

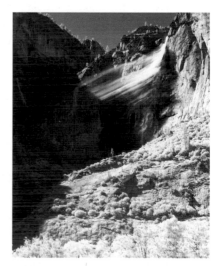

The technology I was using for the field work was the BetterLight Scanning camera, a brand new Sinar-X with the best APO-Chromatic lenses I could find, a GPS receiver, a color temperature meter, and solar panels to try and produce as much electricity in the field as I could. I carried a 6-megapixel Kodak DCS 460 built on a Nikon N90 body for documenting the project, with which I made thousands of images. At the time, neither CD nor DVD were possible for archiving, so I used a little DAT tape drive, 2GB per tape; it took me all evening to offload from the camera what I had shot during the day. Sometimes I was up until 2 or 3 a.m. offloading the data, so I could get up before dawn the next morning and photograph with an empty hard drive.

The project turned out to be quite a trip: 54 parks, 75,000 miles, at least 2500 full res photographs, and about 25,000 35mm format digital files. I wouldn't want to do this over again at this point.

Yosemite Falls, Infrared. 1994. BetterLight Scanning Camera. 6000x7520 pixels. 12 bit Tri-linear Array.

Press from the Project

The project has received quite a bit of press: there have been about 45 articles so far, and people keep calling. I guess they continue to be curious.

The one that floored me was a call from *Life magazine* in 1999 when they informed me my article in 1997 had been named by Folio magazine as one of the "Top 15 Critical Events" in 20th Century publishing. I said, "Right, what other stories have you got to tell me?" As it turns out, the personal computer, the Macintosh, the Internet and my article were the last milestones they mentioned in the 20th century important publishing events. I'm skeptical that I belong in this list, but if they want to put it there and publish it, I'll refer to it.

1981
IBM introduces the first personal computers.

1983
Apple introduces the Macintosh and the age of desktop publishing arrives.

1995
Salon Magazine, now Salon.com, the first professionally staffed Internet-based magazine, launches in San Francisco. *Salon* takes advantage of the Internet to engage in "continuous publishing."

1997
The December edition of *Life* runs a photo essay by landscape photographer Stephen Johnson—the first story to appear in a national magazine produced using the computer-to-plate process, completely bypassing traditional film.

A New Way of Seeing Brings New Challenges and Advantages

The scanning camera certainly altered my view of photographic time because the scanning camera inevitably forced a different view. Sometimes the long exposures caused significant problems. Sometimes the effects were actually advantageous. Sometimes it was just a matter of seeing and understanding differently. Some of those challenges and differences made my vision of what photography could become in its realism and its imitation of the human visual experience.

At the Mercy of the Wind

One time in Marin County there were puffy white clouds moving across the sky, sometimes blocking the sun, sometimes not. We got these big stripes across the landscape because the light kept coming up and down. It looked ridiculous. Trees blowing in the wind looked like a rendition by Van Gogh on acid. These are two major downsides: the wind motion on the subject and wind hitting the camera which I call *wind jitter*. These effects were bad news. The combination of trying to work this technology in the landscape and work these variables out proved challenging. Eventually I came to accept many of these effects just as a consequence of the medium, as I always did with other photographic technologies.

Depth Perception Effects

The translation from three dimensions to two is a new visualization exercise that can be worked to greater advantage with this process. I made a photograph in the Grand Canyon assuming that successive cliffs would tend to flatten out when made into a 2D photograph. I was interested in seeing if instead of the obvious depth and distance that I was seeing with my stereo vision, the special flattening would take on an ever so slightly abstract, stair-step quality. I saw some evidence of it through the camera, but there is nothing like seeing the photograph as a 2-dimensional rendering to know whether or not those effects work. When I opened the photograph on the computer, it was perfectly evident to me that what I had hoped to work would work. Depth did not always fall into place; sometimes it didn't work and I had to look at it again and figure out what it was that I had in mind and how I needed to change it to get it to be what I wanted it to be. I have failed as many times as I have succeeded, perhaps even more. But the whole point is, while this learning process is going on, I'm still there; I'm still looking at that landscape. I can still alter the way I make the photograph to try and understand what my motivation was to begin with and what I need to do to achieve it.

Field Control with the BetterLight Camera

With the second generation of Michael's camera, now sold under his brand name, BetterLight, came improved field control. You got a big prescan of the image, a histogram of the image, a tone curve editor, and a densitometer you could point anywhere in the scene to gray balance the image. I could adjust the tonal response of the sensor to whatever I wanted the photograph to look like, such as pulling tone points up to open up the shadows and at the same time pulling the highlights up to make sure the highlights had a little more brightness. The midtones could also be adjusted, perhaps down a little bit like I might have done after the fact in Photoshop, except that I was controlling the way the data was recorded and in high bit depth. It's an extraordinary level of control that I could now achieve up front, where it made the most difference. To say it is like having a digital zone system is still a huge understatement, because Ansel never imagined you could do something like this in the field. Once you get a taste of that kind of power, you never want to give it up.

There is power in the idea of taking the time to study the image, probe it, look at it. Staring through the 4-ply lens hood at the laptop computer screen, on the edge of a magnificent view. It is worth the effort. The ability to see what you are doing, while you are still out there doing it, is substantial, whether it's at the edge of the Grand Canyon, in Yosemite Valley, or at Kenai Fjords in Alaska.

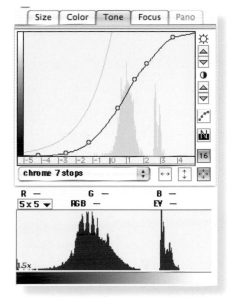

The BetterLight Viewfinder software Tone Editor and Histogram, which allow for a level of field adjustment previously unheard of.

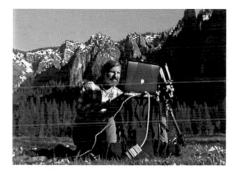

Steve in Yosemite from the Apple video
A Photographer's Journey.

Finishing on Site

The idea of taking a photograph as best as you can manage to take it is a process with which we are familiar. To then be able to take that a step further and look at the photograph you just made is quite an extraordinary step forward. You see the photograph in a way that you couldn't see before, with regard to composition, depth, and tone. To take this notion even further, in the summer of 2003 we built a digital lab in a 40-foot bus so that now on my field workshops we can not only make the photographs, we can open them, edit them, and print them while we are still out in the field.

The digital scanning aspect of my work has yielded an extraordinary quality and a fundamentally different way of making a photograph. The on-site review and image inspection became a whole different way of thinking about the completion of an image. The photograph is not finished in the darkroom later, it's done on site while you are still looking at the scene, the very scene that you are now seeing as a photograph. It is a much more fundamental connection to photographing the place when you see the resulting photograph while you are still at the place.

Very High Dynamic Range

The wide dynamic range of the BetterLight scanning camera was very satisfying, even shockingly good. But that doesn't mean it is always wide enough to capture an extremely contrasty scene. I began pondering this issue and realized there were a few options open to me.

In 1992, I had done some experimental work for the Ansel Adams Publishing Trust scanning some of Ansel's large format color work as prep for a book. A few of the transparencies had faded to the point that the highlight detail was barely there, but the shadows remained dense. Using the Leafscan 45, I made two scans—one for the shadows, one for the highlights and then crudely combined them in Photoshop 2. This method stayed in my mind and I have used it on occasion since.

Foveon X3

A new company, Foveon, assembled a three chip camera that made some remarkably artifact-free images. But ultimately what they had in mind to do was something very different. By the time I was consulting with them on the three chip camera image quality and working on writing a manual, they had already patented a better idea: A single piece of silicon that actually senses at three different depths within the pixel, banking on the fact that the red wavelength of light would penetrate deeper into the silicon than the green and the green deeper than the blue. They built a multi-spectral sensor array within every pixel of silicon on the sensor and dubbed it the X3.

I tested this prototype camera attached with duct tape to the back of a 4x5 Sinar camera. There were no heat generation problems in the camera, it was fairly well air-cooled. This was 2000x2000 pixels in this prototype, bigger than the one they ended up shipping in the Sigma SD-9 and SD-10 cameras. I was astounded at what they had done, because it is after all how all of this should work. We ought to have full resolution, from every pixel location, in every color, in every digital camera. So far, this is the only camera that has accomplished full resolution color in an instant capture, and they have a patent on the technology. Other people had flirted with the idea, but declared it couldn't be done. Only Sigma has licensed this idea.

I worked for two years on this camera, trying to get the best possible image quality and I have got to tell you, that I have never seen engineers so open to somebody who knows nothing about math, telling them that there may other options to consider. It was not because I know anything about imaging algorithms, but because I am looking at the results of the image processing and saying, "Hold it, this isn't working, the model may work, but the reality is that the image is getting worse." That feedback made a positive difference. It was a very rewarding process.

As of this writing the X3 sensor is still in its first generation, and I am hopeful that other adopters will drive it forward into larger arrays and evolved designs.

This is a photograph that was made with that. Now, ignore the subject matter for a moment and look at the detail on my eye… it is artifact free. It is just image.

Dynamic Range Experiment, in my Pacifica Studio, 1997. BetterLight monochrome scanning camera.

The principle remains essentially the same for expanding the dynamic range of original scene capture. Two or more photographs can be made and assembled together (*see Chapter 9*). But I wanted a more integrated way to accomplish this, so I experimented with a BetterLight Scanning back with a monochrome sensor head. It still used the tri-linear array sensor, and could still control each of the three sensors individually. My technique used one channel for shadows, one for midtones, and one to hold highlights, then blended them together in Photoshop with the Channel Calculations and later the Channel Mixer. With this method, I was able to hold 22 stops of scene dynamic range in the photograph.

The Magical Digital Bus

I got to know David Springett from the Community College Foundation when I spoke at the Sutter Club in Sacramento in 2002. We had dinner together and talked about the technology program that the CCF was doing, putting computers in buses and taking them to schools. I was interested in the possibilities, particularly the combination of technology and the arts. He invited me to do a keynote at his technical conference that he does every year called Tech Ed. At the conference I walked into one of the outfitted e-buses with computers on both sides of the aisle and thought "With the right machines, we could make an awesome digital photographic laboratory for workshops."

We approached Apple and they provided ten PowerBook G4 17 computers and ten HD 23 displays. Epson and Hewlett Packard donated some printers and thus was created what I affectionately call the Magical Digital Bus. It is a completely portable digital laboratory with satellite internet connection and DVD writers built in. It was remarkable to watch people go out, take photographs, come back in, look at them, print them and then go back out and make the photograph again. It's different than looking at the little LCD on the back of the camera. However miraculous those are and whatever progress they constitute, the idea of having this digital laboratory was a significant step forward in photographic education.

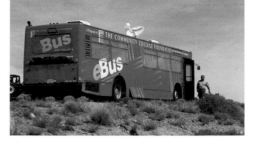

The Magical Digital Bus at Arches National Park, 2003. Photograph by Hannah Knoll.

I don't think I have ever seen people be so sure of themselves after a few days of working in the bus. That is not to say that they weren't still curious and wanting guidance, but people started to get the idea of what the possibilities were. Teaching with this kind of facility is astounding.

In the summer of 2003, we took the bus to the southwest on a 10-day journey. One morning we went way out to Grand View Point, which is deep into Canyonlands out among the cliffs in the parking area. People scattered on arrival, out to make their photographs. After a while it started getting warm out there. It was August, and the air conditioning on the bus was sounding better and better real quickly. I noticed that there was nobody around me any more, so I walked back in the bus and everybody was inside, under the air conditioner, editing the photographs that they had been shooting for the last hour and a half. I cajoled them into an impromptu critique right there, in the bus on the edge of the cliffs, and we went around the entire bus talking about the images they had just made. We then spent another hour there working the cliffs. It was an amazing process, the digital bus, the idea of a portable lab as a teaching facility. See your work, react to it, go out again. It was phenomenal.

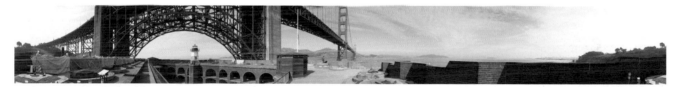

Ft. Point and the Golden Gate, 1995. As far as we were able to determine, the first 360° digital panoramic.

Digital Panoramics

In 1995, I sent out a New Year's card to a bunch of friends in which I told people about this scanning camera by Michael Collette I was working with. One of the people that answered was Howard Barney, who had built the original BarneyScan and originally licensed Photoshop from John and Thomas Knoll. Howard had sold BarneyScan and opened a machine shop in Portland and just played with projects he wanted to do. Howard called me up to say that he knew Michael Collette from his work with Leaf Systems and also that he had a design for a panoramic head for a scanning camera.

The hand-built Panoramic Adaptor by Howard Barney of BayHouse, Portland, Oregon.

Howard and Mike got back in touch. Howard designed and hand-built a panoramic head for the 4x5. Basically, it was a rotating stage that could be computer controlled. You mounted the rotating head on the tripod, mounted the camera on top of that, and the software talked to the motor, telling it how to turn. The sensor is put dead-on center of the lens instead of traveling across the back of the imaging area of the camera, a sweet place to work from. Then the whole camera turns. In fact you get better quality if you make every photograph with the panoramic head because the sensor is dead-on center of the optic, and so no distortion, no chromatic aberration, no nothing other than the best image that optic can produce.

In November of 1995 we made the first digital panoramic photograph with Michael's camera. There had been digital panoramic photos before; the Viking Lander that went to Mars in 1976 had a 12-sensor photodiode camera and panoramic capability. As far as we have been able to discover, there has never been a 360-degree digital camera until this. The BetterLight is actually capable of a 400-degree rotation. You will notice the same tree at both ends of the Ft. Point/Golden Gate Panorama. My approach for shooting panoramas with this technology has been generally to shoot about 370 degrees, creating a 10 degree overlap.

Steve in his Panoramic Room built by Robin Myers. 1998.

Big Prints and Panoramic Displays

Eventually, Hewlett Packard got involved and through the courtesy of Michael Stokes, made us some big prints on their DesignJet printers. We had these rather long prints, and the bridge looked really strange. It looms toward you and looms away, exactly the way it looked to the lens in this strange way of looking at the world. Back at The Digital Pond, my good friend Pete Hogg decided to host a little experiment where we took one of the prints, and glued its top edge to the outside of a huge round cardboard cutout, with the print facing inward. It was then hung by rope from their ceiling. When I stepped inside, it was like a photographic transport to another place, the most immersive photographic experience I had ever seen. The term was later picked up to refer to VR panoramic technology.

I wanted to replicate this experience. Hewlett Packard built a temporary display for their headquarters in Palo Alto. Apple commissioned a portable version in 1998, designed and built by my friend Robin Myers, who later constructed a 360-degree room for my gallery in Pacifica. These walk-in panoramic rooms allow viewers to be surrounded by the Grand Canyon or whatever print we manage to hang. The big prints do continue to amaze.

In many ways, I've been making photographs on the faith that I would someday be able to open the files. The very high resolution 1-gigabyte panoramics could not even be opened in Photoshop when we started to make them. On my second panoramic outing in late 1995, I stumbled onto a width limit in Photoshop; it wouldn't open an image beyond 30,000 pixels. The new panoramics were up to 65,000 pixels long. I kept making them anyway, knowing that eventually this problem would be solved. I couldn't resist these very detailed records of a scene. Of course, I also made lower-res, easier to deal with versions when I could. In 2003, this limit was overcome and I can now open these files and make good use of them.

Kilauea Iki, Volcanoes National Park. Hawaii. 1996.
BetterLight Scanning Camera. 9564x5010 pixels. 12 bit. Tri-linear Array.

Telephoto Wide-Angle Capabilities

Another application for the panoramic adaptor arose while working in Hawaii. I was out at Kilauea Iki in the morning mist, looking across the crater at a reddish dome. The dome looked strange in the mist and rock. I put on a long lens to isolate the dome, and the photograph lost its sense of place. I had to see the placement of the dome in its space for the photograph to work. I didn't like robbing the dome of its location, but if I didn't put the long lens on, I really couldn't isolate the dome from the areas around it.

That's when another solution occurred to me. I could put on the panoramic head, leave the long lens on, and pan across the crater walls. It suddenly occurred to me that I could pan across whatever I wanted. Make it into a telephoto wide angle. I had been carrying around the capability for seven months, it had never occurred to me before. Now, I not only make panoramics, I make telephoto wide angles as well, which is not the contradiction that it seems to be.

The New York Skyline Panoramic

Most of us make far more photographs than we ever print, and file away far more than we ever look at again. In 1998, we decided we were going to do some panoramics around New York City to display at the Photo District News conference, PhotoPlus. One of the places I always thought would be cool to do a panoramic would be looking back toward lower Manhattan from Liberty State Park in New Jersey. With the help of my friends George Moss and Pete Sucy, I toughed out a very windy day and made the photograph. I created a panoramic VR (virtual reality) file for the PDN website in a car on the way back to the Javitts Center, then filed the image away.

Then came September 2001. We were all consumed by the attacks at the World Trade Center, the Pentagon, and on the hijacked aircraft on September 11. After keeping the kids home from school, I did go ahead and go in to work for a couple of hours. I noticed my website was down and I couldn't figure out what was going on; I couldn't get it back online. I called the host and they said I was way over my data transfer quota, that I would have to up my quota because suddenly my site was being hit by the tens of thousands. As it turns out it was because I had this panoramic that included the World Trade Center right at the heart of the photograph. We upped the quota and I modified the page. I started looking for the full-resolution file. I found the preview that I had made the VR from rather quickly, a small 750x2000 pixel 20MB file. I made a panoramic print which was kind of fuzzy because, of course, I made it big. I cried. I couldn't stop looking at it.

The Seybold show was coming up, and we had a gallery in it. We talked about this quite a bit, whether we should do a print of this New York skyline with towers rising tall for that gallery. At first I couldn't even find the full res file and started to believe it may have been lost. Eventually, I found it on a DAT tape in a stack marked "Tapes to be indexed." It simply had not been indexed. I opened the file, and it turned

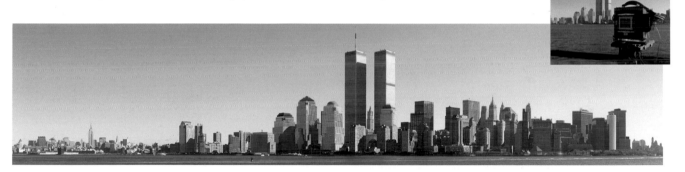

New York Skyline, October 1998. BetterLight Scanning Camera. 6000x28000 pixels. 12 bit. Tri-linear Array. Inset of BetterLight rig in custom Wisner 5x7 camera.

out it was around 600MB. As we all looked at the image, then made a big print, my staff and I all cried some more. I decided to show it at Seybold, even though it had nothing to do with the photographs I was making. Everybody that came in my gallery and saw that print said it was important to see it. One of the very reasons that I started using that digital scanning camera was for the extraordinary detail, and this became one of the reasons that this particular photograph was unimaginable not to show. The detail was such that you could easily see the people on the top of the towers on the tourist deck.

We made a 20-foot-long print on faith that it was sort of a step in the direction of never forgetting and put it up in the show. There were a lot of tears and a lot of good discussions about it at the show. It turned out to be a bit cathartic and something of a gathering point of grief. That print did something to my notion of what these panoramics and these high-resolution images can do. It once again redefined for me the nature of what photography can be. We all have known that it is a powerful tool for recording time, for holding memories, for holding some sense of who people were and what they were like. But to now do it with the fidelity that is unparalleled in the history of photography takes it into yet another realm in the history of humans recording the world. The panoramics have come to mean even more to me now.

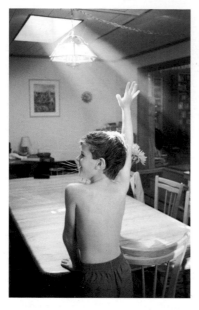

Matt Reaching for the Light. 1998. Kodak DCS460MIR. 2000x3000 12 bit infrared monochrome camera.

Digital Infrared

Silicon is extra sensitive to infrared, like silver is extra sensitive to ultraviolet. So with silver we know that if we shoot black-and-white film and a blue sky we get something that doesn't quite look right. The skies are too light. We have to put a yellow, orange, or red filter on to darken the skies. Silicon has a similar extra sensitivity to infrared. If you want to make a normal color photograph with a digital sensor, which is really a piece of silicon, we have to block out some of that infrared.

Mike Collette chose to design the BetterLight camera using a sensor with no infrared cutoff filter on it, so that you had to put the blue-green glass in the light path to make a normal color photograph. But of course, if you have to put the filter in the light path to make a conventional photograph, all you have to do to make a color infrared photograph is take the filter out of the light path.

Consequently, infrared photography became a possibility like it never had before in my work. So much so that I eventually bought an infrared black-and-white camera from Kodak. The photograph of Half Dome, made that first weekend I went up before the Yosemite Press Conference in 1994, is actually a black-and-white infrared. It held extreme dynamic range—from the highest, brightest light on Half Dome at last light, to all of the detail down in the shadowed Yosemite Valley. When you look closely at the file, there is no lack of texture and subtle shadow detail, just as there is no lack in the highlights. The dynamic range of this camera is between 9 and 11 stops. Fourteen stops in the infrared. Fourteen stops!

The implications were fascinating. One day while working at Crater Lake, I was startled when I noticed I could see something on my computer screen that I had not noticed with my eyes. On the screen I could see Mt. Shasta out on the horizon from Crater Lake looking south. Mt. Shasta is in northern California, and it may be 150 miles away but seemed to be showing up on-screen. I looked with my eyes, because I hadn't noticed it, and it was not there. Then I looked at the tiny PowerBook 540c screen, and it was there. I looked up again and it was not there.

Crater Lake, Infrared, 1994. BetterLight Scanning Camera. 6000x7520 pixels. 12 bit. Tri-linear Array.

At the time I didn't have a sophisticated setup. The backpack was laying open on the ground, the 540 was laying in it, and the hood wasn't working so I was using the dark cloth from my 4x5 to cover my head and block the light so I could see the screen. I was basically huddled over the PowerBook with this dark cloth, staring at the screen in disbelief, then popping up to stare at the horizon, trying to be sure that I was actually seeing more on my screen that I could see with my eyes. I was doing this back-and-forth kind of dance, looking at the horizon, stooping over the PowerBook, back and forth.

I had this distinct feeling that I wasn't alone and I turned around to see a semi-circle of Japanese tourists behind me. I was still puzzling over this, and by now I was a little embarrassed. Until one man said to me, "Ah, digital camera." That guy was right on, he knew what was going on.

We all know that infrared will penetrate the haze. What is on the horizon? Haze. What does the IR see right through? Haze. Shasta suddenly appears.

Digital Stereo

I've always been intrigued by stereo 3D photography. I used stereo aerial shots in my Mono Lake exhibition and experimented with an old Kodak 35mm Realist Stereo camera. Bringing depth perception into the photographic experience makes it that much more real. It was only a matter of time before I tried producing 3D photos digitally.

In 1996, I did my first digital, stereo photographs, basically using the shifting back of the 4x5. The testing was done with a simple tabletop setup, but quickly migrated to interior spaces and landscapes. I couldn't resist blending the process into panoramics as well, making for stereo panoramic photography.

We started making them out in the landscape, they turned out to be sufficient trouble that I haven't made a lot of them. It's a fairly simple principle with the 4x5: I shift the lens position to imitate the interocular distance, then color code the two channels on to the red and blue channels in order to create the red/blue anaglyph for use with standard stereo glasses.

These digital stereo photographs are done in full color, but it's hard to construct a means of seeing them in full color. You have to have polarized projection or multiple monitors or something of that nature, but then it's really cool because it is full color. I believe 3D is coming back, and with a depth of experience that will fundamentally deepen our experience of what a photograph can be.

above: Audience In Stereo Glasses,
San Francisco, 2003.
Photo by Nick Kiest.

top, right: Skeleton Still Life.
1996.
BetterLight Scanning camera.
Stereo anaglyph glasses.

above: Skeleton stereo pair,
BetterLight Scanning camera

left: Yosemite stereo pair,
Sentinel Meadow,
Yosemite National Park, 1998.
BetterLight Scanning camera.

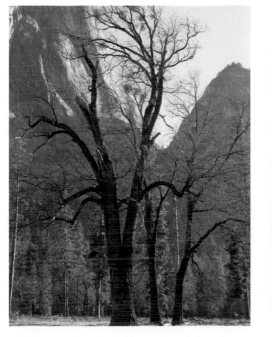

William Bouguereau, The Broken Pitcher, 1891.
Fine Arts Museums of San Francisco.

Detail from Broken Pitcher. 4x5 Kodak Ektachrome
film on left, BetterLight Scanning camera digital
file on right.

Using Digital Imaging for Copying Artwork

One particular use for this new technology was in making reproductions of art-work. High-resolution digital archives of artwork are important for preservation of deteriorating originals and for high-quality reproduction. In 1997, with the Fine Arts Museums of San Francisco, we did experimental copying with 4x5 film and with the BetterLight system. The results were not surprising to me by this point, but it was astonishing for some. The transparency lacked detail, was off color, and was in general a poor match to the painting. The scan was so beauti-ful that a poster was immediately printed from the scan.

One challenge did occur in the digital reproduction: the blue dress of the artist's subject glowed in the IR under the tungsten lights used for copying and had to be edited. It was a lesson learned about controlling the infrared with lighting and filtration when copying artwork.

The fragile nature of some artwork means that their exposure to light must be minimized. I developed a method of taking a number of low light photographs of the art work, and then digitally adding them together to build density and reduce any underexposure noise.

The Photographic Projects

Over the years, my own photographic work has largely been organized into photo-graphic projects. Whether coming to aid of Mono Lake in stress over Los Angeles water diversions, pursuing a search for my homeland of the Great Central Valley, noticing an ever greater attraction in my work for pastel color, my gut wonder at icons of the western landscape, pushing forward on huge panoramics, or playing with digital imaging—my intrinsic curiosity has driven me forward. Fundamen-tally, it is just plain engaging to follow your imagination and see where it leads. Sometimes huge bodies of work are created. At other times themes are just flirted with and gradually built into something over many years.

As Dorothea Lange said many years ago, and my friend Dave Bohn has since echoed, it is all in the wandering, and in seeing the world as an engaged inhabit-ant of this most curious world.

facing page from upper left:
Cowtracks near Mt. Diablo, 1982, from *The Great Central Valley Project*.
Summer Corn Tyler Island, 1984, from *The Great Central Valley Project*
Moonrise Mono Lake, 1980, from *At Mono Lake*.
Yosemite High Country from Lembert Dome, 1998, from *Digital Panoramics*.
Dune and Brush, Death Valley National Park, California, 1995, from *With a New Eye*.
Indians, Red Lake, Arizona, from the *Western Artifacts Series*.
Flesh Hills, Oregon, 1987, from the *Color Pastel Series*.
Ralph Putzker, 1977, from *Portraits*.
George and Mary Oppen at Pt. Reyes, 1975, from *Portraits*.
Challenger Dreams, 1990, from *Digital Composites*.

A Project Portfolio

Foresta Burn, Yosemite National Park, 1994.
Prototype BetterLight/Dicomed scanning camera, 6000x7520 pixels, 12-bit.

Part 2:
The Digital Breakthrough

Unlike any other visual image, a photograph is not a rendering, an imitation or an interpretation of its subject, but actually a trace of it. No painting or drawing, however naturalist, belongs to its subject in the way that a photograph does.

—John Berger

First Outing with the Prototype
Scanning Camera.

above: First photograph the
Conservatory in Golden Gate Park,
January 1994.

right middle: the set-up.

right bottom: Foresta Burn,
Yosemite with inset red square.

right: the deer I never saw, neither
when I was there, nor during years
of looking at the print.

Chapter 4: New Heights of Image Quality

*The finest works of art are precious, among other reasons, because they
make it possible for us to know, if only imperfectly and for a little while,
what it actually feels like to think subtly and feel nobly.*

—Aldous Huxley

We are in the midst of the first real revolution in photography. Evolving from silver to silicon has practical, financial, temporal, and aesthetic implications that are far reaching for the medium. Having now crossed the threshold of general availability, digital cameras are coming to be understood from the perspective of what is within fiscal reach of most users. While this carries with it much delight, it is only a hint of the power of this transformation and can prejudice views of digital camera's capabilities from entry-level perspectives.

The seduction of digital photography for me was the increase in image quality. Real color, open shadows, detailed highlights; these are qualities that elude film, qualities I had intuitively sought for decades. On the medium- and high-end cameras now available, comparisons with film now often leave the film in the dust of image quality failure. This is particularly true of the very high resolution scanning cameras I've been using since 1994, but is becoming ever more true of medium-format and 35mm SLR digital cameras that are more and more commonly available.

My own darkroom sits unused, now for almost ten years. I cannot take it apart. Twenty years of film, many times of joy and frustrations are in those confines, and the many that preceded this particular darkroom I built in 1985. The simple truth is, I've left the constraints of the darkroom behind. Despite the beauty that I know can be created there, at most I see the darkroom now as an occasional visit to a craft of my past. I can simply see more, print more honestly, and, I think, more beautifully in this digital age.

Film Reality vs. Digital Reality

The way we've seen the world through silver-based photography is not the way it looks to our eyes. Harsh black shadows, over-saturated, out-of-whack color, and the sandpaper texture (random granular interference filter, i.e., film grain) are some of the downsides we accepted (as there was little choice). We had even tried to take advantage of these characteristics by evolving those limitations into styles. We all did it because there seemed to be no other way of thinking, and occasionally much beauty actually came from this process.

For instance, the black shadows of film may be as telling a distortion as any. Are shadows really black? Almost any photo magazine suggests they are, and so have your photographs. But go outside, look at the shadows—they are not black; they have detail, substance, reality. The closest I've found to black shadows is wet rain-soaked ground lit only with fast falling light.

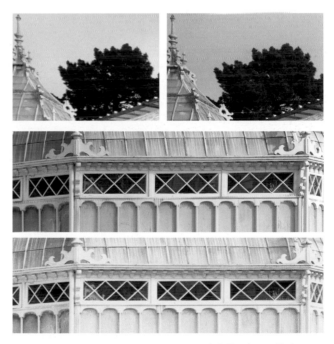

top left: Ektachrome film's green.
top right: the BetterLight Scanning Camera on same trees.
middle: stained glass on the BetterLight.
bottom: stained glass on film.

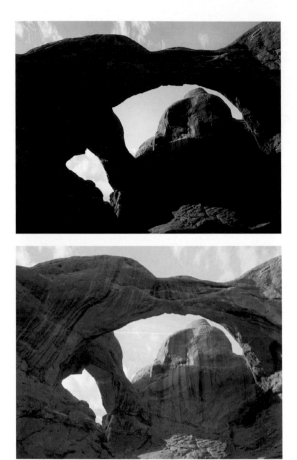

Double Arch, Arches National Park. Utah. 1995.
top: film contrast simulated.
bottom: as made with high dynamic range BetterLight camera.

Real Color

In some ways, silicon reacts to light in a similar manner to our eyes, unlike film, whose color biases have long frustrated photographers. First of all, the digital sensor can be balanced to the light of the scene, rather than only factory balanced for a particular color temperature or attempt to be modified with a Color Correction filter. Many colors that are traditionally hard for film to render can be captured much more accurately with digital than with a silver system.

For example, dark greens are one of the problem colors where film has turned foliage into a less-than-pleasing rendition when compared to our visual experience. These dark greens are often rendered muddy bluish-black instead of green. A good digital camera system can see and hold much more of our real appreciation of the natural scene.

Open Shadows, Detailed Highlights

The Zone System was developed largely out of both frustration with film's tonal range and a desire to customize its rendering of shadows and highlights. Film responds to light with what is generally called the characteristic curve, where shadows are somewhat depressed in the "toe" of the film curve and highlights are bumped up and flattened on the "shoulder" of the curve.

Silicon can be made to react to light in a much more linear, straight-lined fashion, where additional light builds highlight tonal response in a straight line up from the midtones, and shadows darken in a similarly predictable straight line fashion. This makes the sensor more able to see untruncated shadows and highlights without unduly blocking them up or dropping detail out. This extended predictability of response into the highlights and shadows is a major step forward to being able to record the contrast range of the real world. With no inherent shoulder flattening as in a film curve, highlight densities (data) build in a predictable linear fashion, allowing a delicate rendition of subtle differences in detail. A new delicacy is now possible, with restrained color, realistic tonality, and subtle nuances of detail in highlights and shadows.

A great example of this is an overcast sky, where cloud texture and form records on film as almost undifferentiated white, or the delicate highlights on white travertine as shown in the photos to the right. The straight-line tone response of silicon records those slight differences in texture and tone much better than film.

Extended Dynamic Range

A substantial advantage of silicon over film is increased dynamic range. Film typically can record brightness values from about 4 stops on transparency film to 6–7 stops for negative film. A good silicon sensor can record upwards of 10 stops in visible light and perhaps 14 in infrared. This increased ability to record highlight and shadow detail simultaneously is a real advantage of electronic digital imaging.

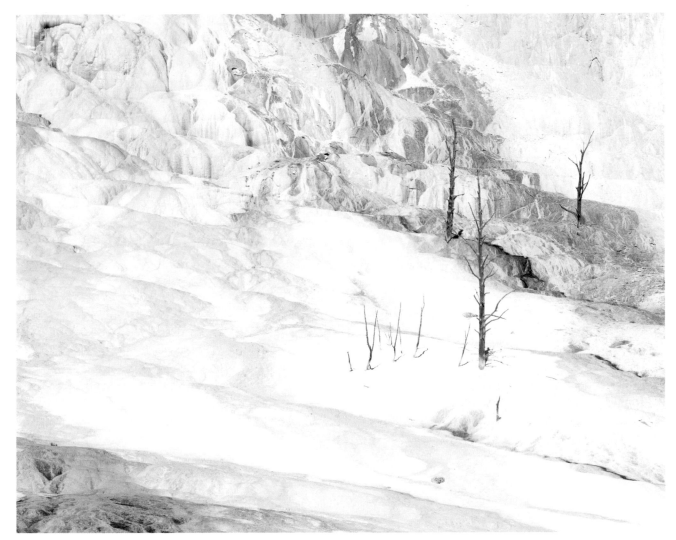

Travertine, Mammoth, Yellowstone, 1995.
BetterLight Scanning Camera, 6000x7520 pixel, 12-bit, Tri-linear array.

right: 1:1 detail of delicate highlights from the Yellowstone photograph above.

We perceive the real world with a variety of senses, perhaps most profoundly with our eyes. Our visual experience of the world is supplemented with stereo vision and the continuum of time. Single image photography does not carry this additional information. Within the eye, our iris muscles are in constant motion, regulating the amount of light reaching the retina. We also seem to have an adaptive threshold on light intensity, making us more sensitive in low light, less so in bright light even within a single scene. The task of photography is to capture a single scene per photograph, with only one aperture setting, and yet still sum up our human visual experience of the scene. The contrast of the real world is challenging, with well over a 100,000:1 lighting variance, making the camera's ability to see shadow and highlight extremes, a difficult task.

Bit Depth

Bit depth is essentially the tonal resolution of the image. It is a description of how many levels of gray the file contains to imitate continuous tone. Digital photographic convention was long ago set at 8 bits per color per pixel. This was thought to be enough information to provide steps of tone from black, through dark and light grays, to white. On screen, this may be sufficient for fooling the eye into seeing continuous tone, but is not adequate to encode tonal transitions in the real world, nor to hold subtle differentiations in tonal change. Insufficient bit depth can also cause image posterization where smooth tonal transitions get truncated into visible tonal jumps in brightness.

Eight bits of tonal depth is enough to describe 256 levels of gray. Higher bit depth devices are needed to hold the tonal distinctions produced by sensors that have a wide dynamic range, and are thus capable of seeing a wider range of highlights and shadow detail. Higher bit depth also aids poor data sampling of shadow tonality. The device should allow for holding the 10 bits (1,024 levels of gray), 12-bits (4,096 levels of gray), 14 bits (16,384 levels of gray) or even 16 bits of image data (65,563 levels of gray) as a RAW file or in 16-bit space. The greater the bit depth of the device the better, given a quality sensor that merits the fine sampling.

New Levels of Detail and Resolution

Silicon seems to gather more detail than film. It isn't always easy to see in line pairs/millimeter resolution tests and sensor detail comparisons, but it seems to be undeniably visually true. A full frame 35mm sensor of 11 or 14 megapixels seems clearly able to out-resolve 35mm film, even 6 megapixels challenge it. The BetterLight Scanning Camera with its less than 4x5 imaging area seems well beyond 8x10 film resolution. A 40x50 inch print on my gallery wall bears this out rather dramatically. There is no grain, the sky is clear blue/cyan with no hint of anything other than the light from that sky on that day, and the image seems deeper still in terms of detail. Yet, it is merely a 2x enlargement of the digital scan, but a 4x enlargement of what 16x20 film would produce.

Of course, the resolution of a digital image is directly linked to the acquiring device and to your eventual print size requirements. Although actual resolution is expressed in megapixels or pixel dimensions, dpi and ppi are often also used incorrectly. The term *dpi* (dots per inch) is a printing reference, and *ppi* (pixels per inch) describes only half of the information needed. It must also be accompanied by image dimensions for the resolution to be understood. (*See Chapter 14 for more on printing.*)

8-bit 256

10-bit 1,024

Grayscale steps:
below: grayscale transitions scaled for differing bit depths.
8 bit for traditional capture.
10 to 14 bit for today's digital cameras.
15.1 bit shown as it is Photoshop's internal bit depth when dealing with 16-bit files.
16 bit as current high-end editing space.

12-bit 4,096

14-bit 16,384

15-bit 32,768

16-bit 65,536

Grayscale steps:
top: 10 zone scale representing 10 stops of exposure.
middle and downward: 32 steps, 64 steps, 128, steps and 256 steps as showing tonal transition in 8 bits of grayscale tonal information.

Noise

Electronic noise is the film grain of the digital era. This noise can appear from editing (exaggerating small shadow differences), an underexposed image, poor circuit design, signal amplification (gain), and long exposure buildup of seemingly random (dark current leakage) electrons. Giving the photograph sufficient exposure is the first step to avoiding digital noise. Using a camera at its lowest rated ISO (light sensitivity rating) will keep the signal strong enough to prevent most gain noise. Keeping the exposures to fractions of a second will prevent most long exposure noise. Camera designs are being improved to help relieve many of these problems.

Color Artifacts and Moiré

The Bayer-pattern area-array sensors (*see Chapter* 6) found in most digital cameras do not sample the entire imaging area for each color; rather, they alternate between green, red, green and blue. Consequently, detailed subject matter can have color fringes and fabric can be rendered with moiré patterns. Full resolution color recording is always a better idea in principle. (*For more on Color Rendering see Chapter* 6; *for Artifact Repair, see Chapter* 7.)

below left: Bayer-pattern sensor with hair problems.
below middle: full resolution sensor without hair color issues.
below right: sensor noise.

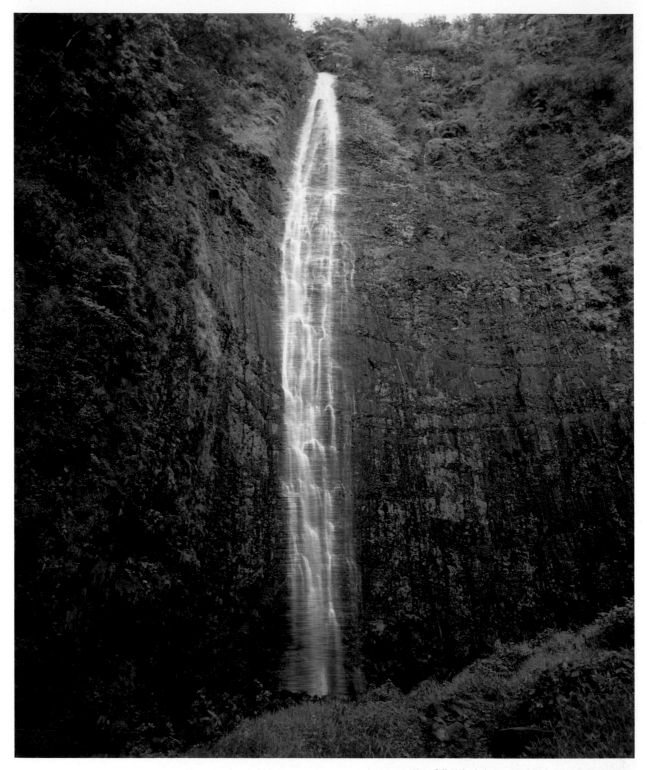

Waterfall, Haleakala National Park, Maui, Hawaii, 1996.
BetterLight Scanning camera. 6000x7520 pixels.
Color Balanced: In the photo above, the sensor has been custom balanced for the shaded lighting.
Color Unbalanced: (In the version of the photo on right) Daylight balance in shade makes a blue cast (like daylight film).

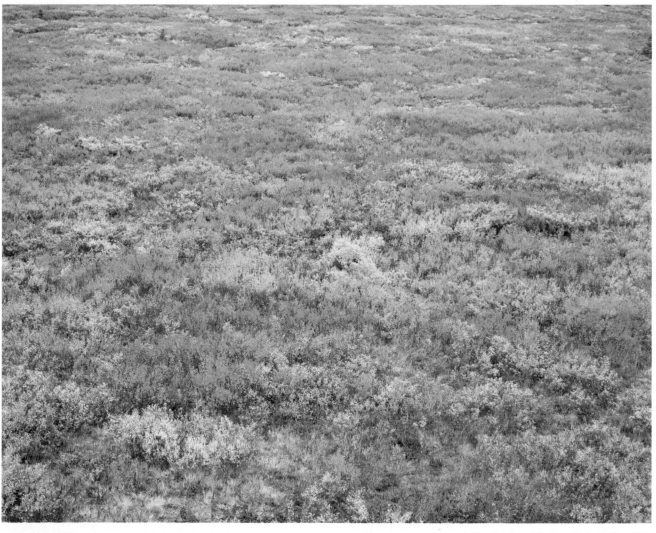

Tundra, Denali National Park, Alaska, 1995.
BetterLight Scanning camera, 6000x7520 pixels.

Saturation Examples:
left bottom: An unreal silver
rendered world often pumps up
the natural world.
above: The real world is a gentler,
more subtle place.

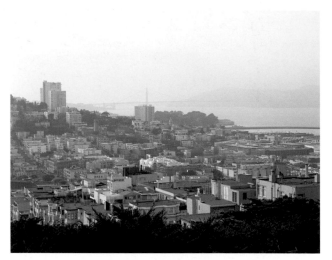

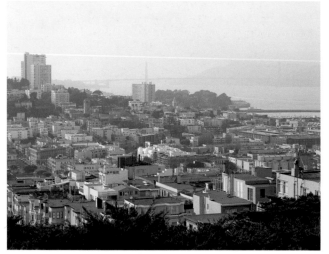

Film Digital Comparisons
This series was made to discover how 4x5 film rendered scenes compared to the high end of digital photography, the 4x5 scanning back.

above right: The San Francisco cityscape set was made in January 1994 on the first day out with Michael Collette and his prototype digital scanning back. These comparisons are between 4x5 E100 transparency film (top) scanned with the Linotype Tango drum scanner and the prototype 4x5 back, which became the BetterLight camera system. Each is enlarged to about 400% for this reproduction.

The enlargements are on the right. Film on top, digital below.

above left: Baker beach Trees, 4x5 film enlargement.
left: digital rendition.

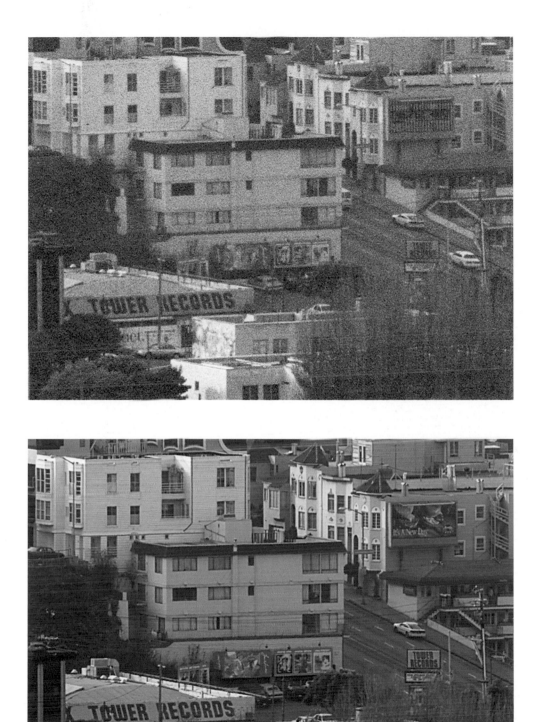

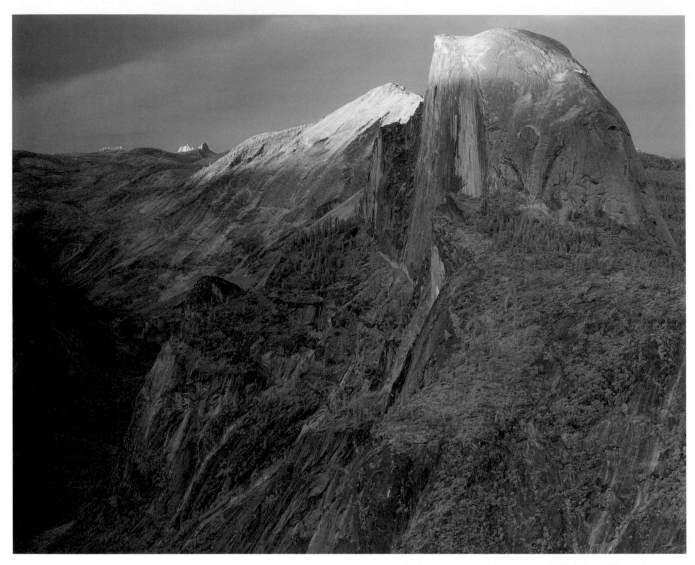

Half Dome, Infrared, Yosemite National Park, 1994.
BetterLight Scanning camera. 6000x7520 pixels. 12-bit.

I made the Half Dome photograph on the first weekend out in a national park with the scanning camera. As I mentioned earlier, I was on the spot as I had scheduled a press conference with the Ansel Adams Gallery the next weekend to announce the project, and felt I really needed some great images to show. The stereotypical view from up on Glacier Point was too good not to try, and although we encountered some technical glitches that almost lost the light, I managed an infrared that I was quite proud of. The color infrared was blended from the red and green channels so that it tonally resembled a conventional panchromatic black-and-white photograph. The detail and dynamic range astounded me.

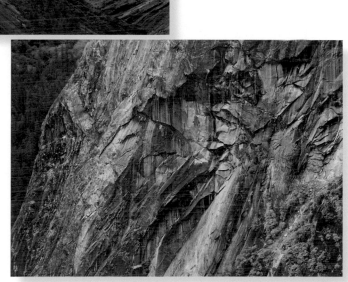

Unparalleled Detail

Various sections of the Half Dome shot on left seen at 1:1.
They are arranged in their approximate relative locations
within the full file.

Camera LCD display showing picture thumbnail and histogram. A histogram is a graphic display of the brightness values of the pixels in the image. The taller the peak, the more pixels of that value. The left side of the graphic are the black and dark values, with the represented pixels getting brighter toward the right.

Chapter 5: Process Differences in the Digital Age

You learn to see by practice.
It's just like playing tennis, you get better the more you play.
The more you look around at things, the more you see.
The more you photograph, the more you realize what can be photographed and
what can't be photographed.
You just have to keep doing it.

—Eliot Porter

In the last chapter, we went over some of the technical aspects that set digital photography apart from traditional film photography. In this chapter, I want to consider some of the ways that the actual process of making images has changed in the digital age.

Seeing As You Go

As I mentioned before, the innovation of seeing the real image as it is made is a fundamental advance brought about by digital photo-imaging. Translating the momentary glimpse through the viewfinder, or the seduction of the large ground glass, into an actual recorded scene does much to inform, eliminate error, and build confidence in image-making. The instant feedback of digital actually teaches you about the process and reinforces the knowledge just gained.

This process can affect exposure, composition, and facial expressions in portraiture. Of course, like any other option, it is only as useful as it is used. If you don't take the time to see what you've done, you are really not in a very different position than you were with film-based photography, where delayed gratification is the name of the game.

Confirming Exposure

Determining the ideal exposure for a scene has long challenged photographers. No small part of the reason for this difficulty is the distance in time from making the photograph to seeing the result. Digital imaging has the potential to eliminate this disconnect by allowing us to see the photograph on site and examine the exposure via a graphic plot of the brightness values of the image known as the histogram display.

I haven't even carried a light meter for years. Although the built-in meter is along on the digital SLRs, my view-camera work had always required a separate meter, like my Gossen Luna-Pro. In fact, the only way I really came to understand exposure and the Zone system was to carefully meter and place different aspects of the scene on the 10-zone scale that characterized film's dynamic range latitude. Now my exposure is my meter reading, with the display before my eyes and a graphic brightness plot via the histogram there for the reading.

The manner in which digital values are counted and possible noise in the shadows is determined suggests treating the digital file much like transparency film, by keeping the exposure as high as possible (away from blocked up shadows) without letting the highlights overexpose to white. The basic thrust being, capture as many photons as possible and keep needed shadow detail as bright as possible. (*For more on Histograms, see Chapter 9.*)

Controlling Color Balance

Controlling color balance in the photograph is more possible now than ever before. Whether it is through actually balancing the sensor to the lighting conditions like the BetterLight scanning camera can do or simply tagging a file with a custom gray balance or closest preset, the improvements over film are real.

Examine Your Photograph

Exploring the recorded image for successful focus and depth is an important capability only partially recognized and used up to this point in the new digital camera world. Getting into the habit of examining your results will yield significant improvements in your photographs. Review the file, zoom in on the image on the camera's LCD screen, try to understand what you have done. Re-photograph the scene if needed. With digital you can raise your expectations, then fulfill them.

I've heard the process of checking your camera LCD called "chimping." The implied pejorative is shocking to me. If there's any one thing that is revolutionary in the advance in photography represented by this digital age, it is the ability to inspect your work. Ignore such ridicule, and use the tools to their fullest.

Considering Perspective and Depth

Examining the results after having made the photograph gives the image-maker a great opportunity to inspect their own point of view, position, camera adjustments, and subtle aspects of composition that a "through the viewfinder" process can only approach. Such inspection takes time and likely a computer on which to view the digital photograph so that the image is large enough to actually examine, but the capability is unique and powerful. Sometimes a minor perspective shift has big consequences in the effectiveness of the image. (*See also "Photographic Composition" in Chapter 18.*)

One of the ways this feedback loop is really effective is in understanding the transition from 3D reality to 2D photograph. Without consciously realizing it, illusions of depth are often depended upon for the photograph's success. When that depth does not come through, compositional strength may be reduced and impact lost in the photographic translation. Inspecting the rendered photo, even in the field, can help you understand the impact of any depth illusion loss.

A photograph from my Grand Canyon trip in 1995 brought this point quite dramatically home. Yaki Point is a highly visited site that, at dawn, I found completely empty. The quiet and isolation were great, but I was challenged by depth and scale. The scene I was seeing was bouncing back and forth in my mind as one of enormous depth, and also a flat scene of some abstraction with zig-zagging lines of lit orange and green. Every time I closed

Nikki at Zion, 2003.

While doing an introductory field lecture on composition and seeing, I noticed my assistant Nikki and the parking lot and fence behind her. It seemed a perfect moment to talk about perspective. I made the first photograph from my standing lecturing height, then simply kneeled down to change the scene completely to one of Nikki surrounded by trees.

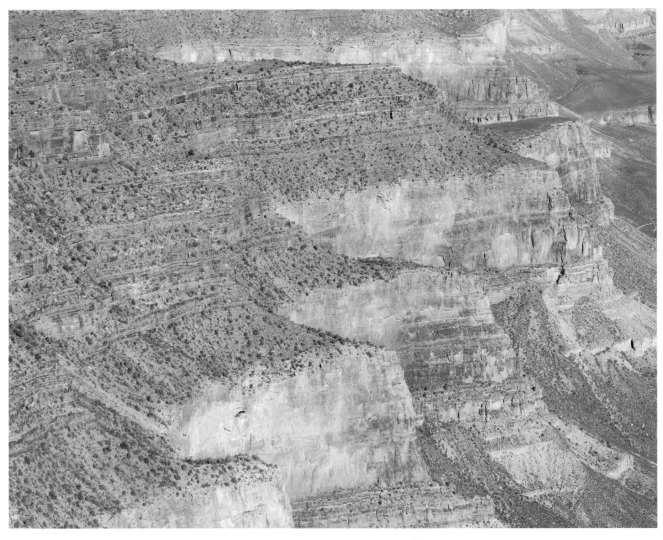

Cliffs at Dawn. Yaki Point, Grand Canyon National Park, 1995.
BetterLight Scanning camera. 6000x7520 pixels. 12-bit. Tri-Linear Array.

an eye, the scene flattened and became slightly abstract, strengthening the design I was putting together. When I opened both eyes, the depth perception of my stereo vision made the distance the big message instead of the design. I knew the depth would not carry in the photograph, and I suspected the design would work as flat 2D. Seeing the finished photo on the my laptop monitor confirmed my suspicion, the design came forward, the implied space receded, and for me at least, the composition worked.

Interaction with Subjects in Portraiture

Photographs of the human face may be the most touching and challenging of all photographic endeavors. We are fascinated by our fellow humans above most other subjects. Rarely do photographs fail as miserably with momentary changes as they do with portraits.

Seeing a person's actual facial expression captured in real time allows the subject to participate in the creation of their recorded image. This level of involvement by the person you are photographing is an important and remarkable breakthrough in photographic portraiture. Elusive smiles can be certain of capture, and sensitivity to weight, hair, and that ephemeral "doesn't look like me" phenomenon can be honed-in on much more effectively than with film's inherent long delay and distance from making the photograph. Finishing the portrait with certainty, and client approval, makes an often difficult challenge much easier.

left: Bruce Fraser, 1994.
above: Darin Steinberg, 1993.
Leaf DCB in studio with strobes.
2000x2000, 16-bit digital back on a Hasselblad camera.

The soft, umbrella-diffused light on Bruce and the split-lighting on Darin in these portraits make for very different looks to the images. However, both are making eye contact with the camera, which I have always found compelling in portraits. These were both made with the Leaf DCB, which created 16-bit archive format files, able to be retoned into a dramatically different tonal look and feel, even now, more than 10 years after exposure. This preserves the idea from traditional photographic processes of reinterpreting the negative, but takes the options many steps forward with the versatility of high-bit-depth files and the extreme tonal edits that are possible.

Michelle Perazzo, 2000.
Early prototype Foveon X3 chip on Sinar 4x5. 2000x2000 pixels.
This photograph was processed as black and white from the full resolution RGB sensor data made possible by the X3 chip technology. Having the option to process the images as color or black and white creates a new flexibility that can now be exercised with very high-quality results, and does not undo the synthesizing of color by then desaturating or deconstructing the image into grayscale.

Matt and Mary, 1999.
Foveon 3 chip camera, 2000x2000 pixels.

Photographing kids is always a challenge, particularly an active one like Matthew. Over the years he has been encouraged to cooperate by seeing the results of the photograph quickly, playing into his desire for instant gratification (like we all have) and giving him the satisfaction of knowing he is being recorded somewhat like he sees himself. Of course, it didn't hurt that his mom was happy with the photograph as well.

Tree at Dawn. Blue Ridge Parkway, Virginia. 1994.
BetterLight Scanning Camera. 6000x7520 pixels. 12 bit. Tri-linear Array.

Part 3: Input, Light to Silicon

When I have a terrible need of—
shall I say the word—religion.
Then I go out and paint the stars.

—Vincent Van Gogh

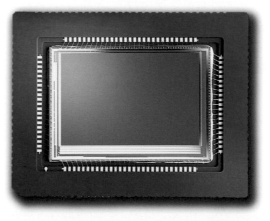

Silicon Sensors.

above: 4000 x 4000 Loral area array CCD used
in the Dicomed BigShot.
middle: Foveon X3 area array CMOS sensor
used in the Sigma SD9 and SD10.
bottom: Kodak 6000 element Tri-Linear Array
CCD used in the BetterLight scanning camera.

Chapter 6: Sensors, Gray, Color, and Wide

We must remember that a photograph can hold just as much as we put into it,
and no one has ever approached the full possibilities of the medium.

—Ansel Adams

The "film" of a digital camera is the electronic light sensor chip that records the image. In various forms, these area arrays and linear arrays are used in cameras, scanners, industrial applications, spy satellites and spacecraft, with their design determined by their application and budget. The number of sensing sites on the sensor (in effect, pixels) leads to the real resolution of the resulting photograph. Color derivation from these different approaches have various advantages/disadvantages, as does resolution and bit depth.

Basic Features of Digital Sensors

Characteristics that distinguish silicon sensors are their methods of gathering light, their handling of color, their resolution, and their dynamic range.

Monochrome Sensitivity

Silicon sensors are analog black-and-white devices. They are neither digital nor do they produce a color photograph natively. Color photographs made with these devices have to be encoded through the color separation process.

Area and Linear Arrays

All hand-held digital cameras are built with *area array sensors* that can capture an image in a fraction of a second, like a traditional camera. Consequently cameras made with an area array sensor can be used hand-held.

Of necessity, area array sensors have many hundreds or thousands of pixels in height and width and can be expensive to produce. For example, a television camera delivers adequate information with a 640 x 480 sensor as normal NTSC TV is 525 lines of information. Whereas an 8 x 10 print at 300 ppi needs about 2400 x 3000 pixels.

Scanners use *linear arrays* which are made up of a line of sensors that are moved over the imaging area to build up an image. Linear arrays consequently take time to make a photograph, but can be made much cheaper because of dramatically fewer sensing sites having to be manufactured onto a sensor. Scanners typically use linear arrays.

Sensor Resolution: Megapixels

Sensor resolution, measured in *megapixels* (millions of sensors), determines detail the sensor is capable of recording. It doesn't inform you of the quality of the optic delivering the light, nor does it tell you anything about the digitization process or electronic design of the data path. Marketing wars over who has the best camera have often come down to a numbers game of who has the most megapixels on the chip. While it is certainly true that image resolution is directly influenced by the number of sensing sites on a sensor, the quality of the optics may be an equally important contributor. Furthermore, resolution must only be one of the factors weighed, as noise, color technology, light sensitivity, and optics all come into play when trying to ascertain image quality.

Hands and Skull, 1993.
Leaf DCB. 2000 x 2000 pixels. 16-bit.

Sensors, Black and White

While most digital cameras are made into dedicated color systems, electronic sensors are black-and-white (gray-scale) devices. However, there have been many black-and-white digital cameras and camera backs on the market. Their image quality has been stunningly good, with a tonal range and detail that awoke many of us to the very real possibilities of original digital capture. We should remember, that deep space probes and spy satellites remain black-and-white devices for the sheer image quality possible, encoding visible color only when needed, with a more likely bias toward infrared and ultraviolet wavelengths.

Small Black-and-White Cameras

Initial digital camera designs were small dedicated black-and-white devices of relatively low resolution. Many started appearing in the 1990-91 period, including cameras from Chinon and Dycam (Logitech FotoMan) most producing images in the 320 x 240 pixel range at less than 8 bits. Casio also had popular entries into this new gadget market.

Dedicated 35mm Styles

The first 35mm style digital SLR cameras were black-and-white devices. The Kodak DCS 100 was a Nikon F3 SLR with a 1.3 megapixel CCD (1024 x 1280 pixel) black-and-white digital back attached onto its back, and a tether running out to what was then a VCR-type control/storage/viewing unit. A year later they introduced the DCS 200 on a Nikon N8008s with 1.54 megapixel (1524 x 1012 pixels) sensor. The DCS200 was a completely portable black-and-white camera, with an auto-rotating filter wheel for color (much like what Leaf would later employ). Later black-and-white models from Kodak were optional versions of color camera models like the 2000x3000 pixel DCS460m and 760m.

Medium Format Digital Camera Backs

The Leaf DCB (digital camera back) was the first digital add-on back for medium format cameras that I used. It was made for the Hasselblad, Mamiya and could also be attached to view cameras. Its remarkable tonal range and well-designed software made it an ideal studio portrait camera. Many have followed, including cameras from Megavision and Dicomed.

Kodak DCS 100 with shoulder unit and DCS 460 as standalone SLR.

Scanning Cameras

The scanning backs for view cameras are by their very nature native black-and-white devices, ready for the images to be kept as color separated black-and-white images, blended into panchromatic views, or processed into color from the encoded spectrum. The color separation and processing also allows selective filtering such as using the red channel for skies, the green for dark foliage.

Infrared

Silicon's light sensitivity is good in the visible spectrum, but extends well into the infrared. To prevent the image being overwhelmed by this IR sensitivity, an IR cutoff filter is placed before the sensor. This makes for normal looking panchromatic photographs. Without the filter, such a camera becomes an infrared black-and-white photographic device. With a red filter attached, the resulting images look very much like black-and-white infrared film, except without the grain, and far less exposure guessing. Kodak made such a camera, the 6 megapixel DCS 460ir introduced in 1995.

BetterLight viewfinder software in monochrome mode, capturing only the red channel of filtered light.

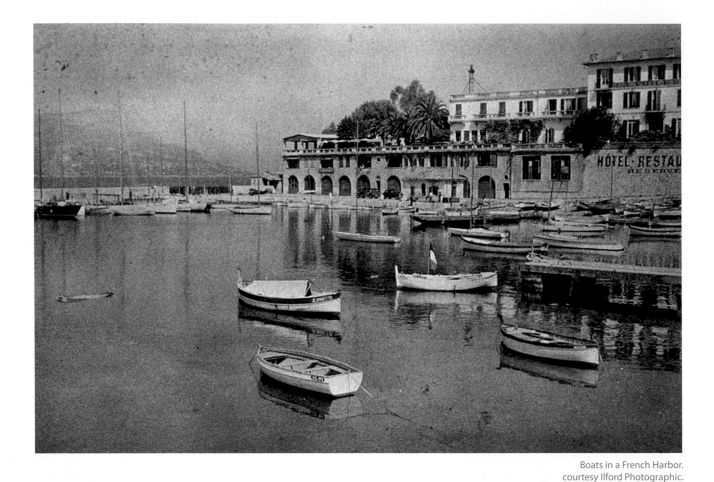

Boats in a French Harbor.
courtesy Ilford Photographic.

The Autochrome
Invented by Auguste and Louis Lumiére in 1904, the Autochrome was the first practical color film. Introduced in 1907, it consisted of a glass-plate coated with colored potato starch grains acting as colored filters for the light. These plates were sold until 1930.

Fruits and Flowers Still Life.
courtesy Ilford Photographic.

Autochrome box label, circa 1910.
courtesy Ilford Photographic.

Autochrome color pattern scanned on Leafscan 45
by Stephen Johnson.

Rendering Color in Photography

As I've mentioned, electronic sensors are basically black-and-white luminance devices, much like a simple light meter or photoelectric door chime. Rendering color from these devices is a challenging and interesting exploration of how we see, and how we imitate that process electronically.

As discussed earlier, we seem to see color with three kinds of light sensitive cone cells in our retina, each kind of cone cell is sensitive to different wavelengths of light which we "see" as one of the primary colors of light, red, green and blue. Thus what we call visible color is essentially encoded in the eye by separating the wavelengths of light and integrating them in the brain into a full color mental image.

We build imaging systems that attempt to replicate this human vision model by filtering light through red, green and blue filters, then recording the resulting images with our photographic technologies, which even after almost 200 years of photographic innovation, remain at their core black-and-white devices.

Three Exposures to Encode Color with Black and White

The first color photographs were made simply by making three exposures onto black-and-white plates (usually positive plates), one each through a red, a green, and a blue filter. These images could then be projected back through these filters, superimposed and seen as full color. Eventually cameras were made that incorporated a prism and three sheets of film under filters to accomplish this color encoding process all at the same time.

Devin Tricolor 3-plate camera. 1938.
Courtesy Foveon.

Color Film

The first practical color film, the Autochrome, simply hitchhiked off this principle and covered the glass plate with a mixture of colored potato starch grains creating a tricolor filter array through which the light had to pass before striking the black-and-white film. Of course, the same filter array was in place after the film was developed and consequently became the viewing filters through which light passed to see the photograph.

Modern color films used multiple layers of black-and-white silver emulsions, each filtered with dye filter layers to separate the color, then is selectively dyed or dye synthesized in color developer to create the colorant eventually left in the film.

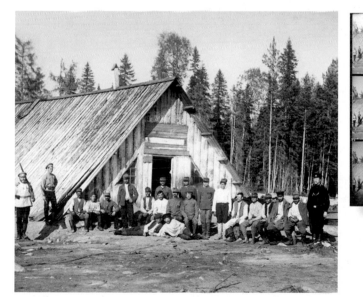

Sergei Mikhailovich Prokudin-Gorskii (1863–1944), a pioneer in the field of color photography, embarked on a photographic survey of Russia in 1907. His unique images of Russia on the eve of revolution were recorded as three separate images on one glass plate and exposed in rapid succession through three different color filters.
from: Library of Congress.

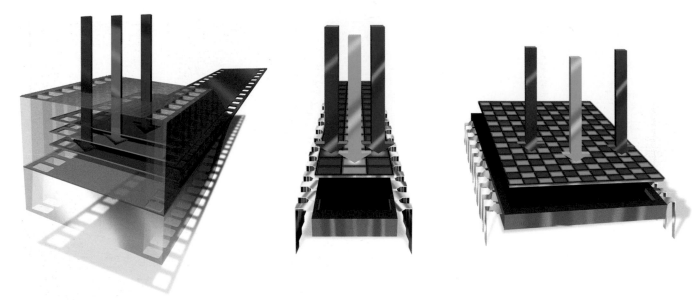

Color Film.
Three layers of black-and-white silver-based emulsions, stacked together and filtered to react to red, green, and blue, the primary colors of light.

Linear Array: Full Resolution Color Silicon Sensor.
Each line of sensing sites detects red, green, or blue and is passed across the imaging area, as in a scanner or scanning camera.

Area Array: Bayer-Pattern Silicon Sensor.
Intermittent samples from red, green, and blue filtered pixel wells, dominated by green sensitive areas.

The Creation of Electronic Color

As has been mentioned earlier, the goal is to record light and color the way we see, the problem is that we use grayscale materials and devices to imitate our color vision. How that light is filtered into red, green and blue is much of what differentiates color sensors.

Electronic Color: 3-Pass and Tri-Color

Initially, color scanners used a filter wheel in front of the lens to make three separate scans that were then combined to make the full color image. This was a widely used technique, and is still much in use today, from some digital camera designs to spacecraft cameras.

The variant was to build a sensor with color filters already laminated to the sensor, thus providing the color separation on board. This was very practical for scanners using linear arrays which could simply be made with three stripes of sensors instead of one.

Electronic Color: Bayer-Pattern

The problem was more complex for instant capture devices that need all three colors captured simultaneously. Improvisation once again came into play and the Bayer-Pattern filter distribution method was constructed to kluge instant color from a single monochrome sensor by alternating primary color filters across the sensor's light sensitive areas.

Many significant problems were created along the way because of the fact that each pixel is sensing a different color, consequently there is no whole image of continuous color information, only geographically dispersed data. Various color fringing and information drop-out issues arise, along with further improvisation to blur, repair, and hide the problems. (*See "Sensor Artifact Repair" in Chapter 9.*)

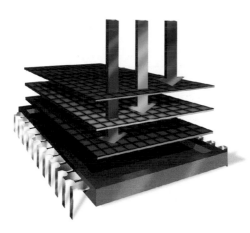

Area Array: Full Resolution Color Silicon Sensor. Each sensing site detects red, green, and blue, all three primary colors of light. Currently only Foveon X3.

Illustrations by Bert Monroy.

Micrograph of Bayer-pattern sensor, courtesy Dennis Walker.

right: Prism-based three sensor optical path, using Foveon prism. courtesy Foveon.

far right: Micrograph of linear array sensor. Shortened from 3 images to fit here. courtesy Kodak.

Electronic Color: Tri-Color Sensors

Recording all three primary colors of light with the full sensor resolution was accomplished through splitting the light through a prism, and sending it to three discreet sensors, thus capturing more information than the Bayer pattern method. Potential loss of light from the prism, the expense of the prism, and the consequent registration and optical distortion remained significant issues.

A breakthrough was accomplished by Foveon with their X3 sensor by devising a way to capture different wavelengths of light on a single location of the array using stacked pixels, recording all three primary colors of light with the full sensor in an instant.

A scanning back also employs a tri-color sensor in a much simpler implementation, simply three linear array sensors side by side. The sensor is then moved across the imaging plane to record the image. This allows for full RGB scanning with a slight offset in time (hundredths of a second) between the samples.

A Look at 48-bit Color with Bruce Fraser

My friend Bruce Fraser and I have been on the same side of many arguments for technological innovation over the years. As controversy continues over the value of high bit depth photographic data, I thought it would be appropriate to include an slightly updated version of something we wrote together many years ago. Sensors are at the core of image quality. A high-quality sensor can produce current worth measuring far beyond 8 bit's 256 voltage measurements.

High bit depth color (16 bits or more per channel in grayscale, 48 bit or more in color, sometimes called *Deep Color*) is an important step forward in the evolution of digital photography. Original assumptions that an 8-bit grayscale would be sufficient to render scanned film and prints have not proved to be accurate, and as digital imaging moves forward with both sensors and A/D converters becoming more capable, their ability to deliver good high-bit-depth data makes them ever more able to scan existing images better and record the real world more accurately than film.

For Scanning from Film
Film scans present many challenges. The hardest films to scan for detail are transparencies with critical low-end shadow detail. These photographs are often scanned right at the edge of a scanner's dynamic range, with a desire to edit shadow detail in order to make it more visible. Providing more distinct levels of gray so that nuances of detail (brightness differences) can be assigned during the scanning process, allows image editing software to keep those differences intact during editing without truncating values into little or no tonal differences.

For Editing
Major editing of a digital 8-bit image file creates the distinct possibility that large gaps in the histogram can be created as a result of moving data around to achieve a desired edited appearance. These gaps are good graphic indicators of likely posterization in the final image. Such posterization may not show on the monitor, but may well show on final, often expensive, output. Higher bit depth editing simply gives more values for the edited file to assign and hold the transformed data. This is a benefit even if the file is eventually going to be assigned only 8-bit values. Using 48-bit color significantly increases the ability to do a series of edits with far less damaging consequences.

For Digital Cameras and the Real World
The real world has a much more continuous gradation of tonality than 8-bit data can record and render. As digital cameras become ever more capable, their ability to deliver good digital data at 10-, 12-, 14- and even 16-bit precision is increasing. Currently there are cameras on the market that deliver a good 12- and 14-bit data, and scanners delivering up to 16-bit data.

Additionally, as more digital original images are created, the challenges of only 8-bit color become particularly visible in photographs of smooth tonal gradations like a sky transitioning from horizon to zenith, or colored product backdrops where tones have to transition smoothly in the final photograph. A smooth tonal transition requires having enough data values to render an illusion of continuous tone. Higher bit depth files with capable camera systems are simply more capable of achieving this goal.

For CMYK Separations
The conversion from RGB to offset CMYK constitutes something of an assault on the image quality of the RGB file. We know that most CMYK offset press conversions involve transforming the data into a much smaller color gamut. This loss can be minimized by converting 16-bit RGB data to 16-bit CMYK, with some of the resulting data loss prevented. Additionally, the 16-bit CMYK space further minimizes color loss by simply having more precise values that can be assigned to the converted data, reducing errors that can cause banding (posterization). Some companies are already offering imagesetters than can image 16-bit files.

For Leveraging Dynamic Range
As many digital devices increase in their ability to see deep into shadows and highlights simultaneously, there naturally results a need for greater precision in the recording and transformation of that data. 48-bit color is also crucial in this context.

High Dynamic Range Photography

The best of silicon sensors can see a broader range of brightness values than most films. This is usually expressed in terms of stops of dynamic range or exposure latitude. This capability can be further increased by specially built cameras with modified sensors or by simply making a series of exposures for later combination.

Dynamic Range Expansion Through Multiple Exposures

A photograph's ability to hold shadow and highlight detail is determined when the photograph is made by the chosen aperture/shutter speed and the tools used to record the image. A given exposure can only contain what the materials used to record the image are capable of seeing and holding. But by combining different exposures, across a range of shadow, midtone and highlight capture goals, it is possible to hold extreme ranges of illumination.

These different photographs with different exposures can then be combined in software to yield tonal captures way beyond anything we've seen with conventional methods.

Special Multiple Exposure Cameras

Cameras can also be built with modified means of capturing the light, in order to implement this same idea of multiple exposure combination.

Spheron has built a panoramic scanning camera with huge dynamic range based on ideas along these lines.

This has even forced the idea of a higher dynamic range space than 48-bit color, namely 96-bit color, and an encoding of digital data with a floating point numbering system rather than traditional bit counting.

The idea of multiple exposure sampling is very well-suited for scanning camera technology, but can also be adapted now for tripod-based still-lifes and photography with minimum motion over a short period of time.

Sensors could be constructed to sample for low levels of light, ideal exposure, and very high light levels by simply varying the exposure time between two or three multi-samples. This could also be done with auto-bracketing features in current 35mm-style digital cameras.

Integrating the differing exposures into a file that looks "correct" and yet contains such a wide range is certainly a tonal challenge. Whole new tonal mapping functions have to be created as well as a taste for seeing detail in highlights and shadows where film has rendered us accustomed to huge tonal truncations and heavy contrast.

low light medium highlights

Sun and Shade Napa with Spheron 96 bit panoramic camera.

Spheron Camera.

facing page: Doolough, Connemara, Ireland. 1996.
BetterLight Scanning Camera in Panoramic mode. 4500x22959 pixels. 12-bit. Tri-linear Array.
This sky in this photograph posterized in an 8 bit CMYK conversion, and was smooth in 16 bit.

Sea Lions, Galápagos, 2005.
Canon EOS 1Ds Mark II. 3328x4992 pixels. 12-bit. Bayer-pattern 35mm format camera.

Chapter 7: Digital Camera Techniques

Photography to the amateur is recreation,
to the professional it is work,
and hard work too,
no matter how pleasurable it may be.

—Edward Weston

Things are changing in photography. Some changes are delightful; some are disorienting. Digital photography is fundamentally a different way of capturing light. The focal length of lenses lengthen because the sensors are smaller than 35mm film. Many photographers accustomed to larger format 4x5 aspect ratios are now working in 35mm rectangles, and the proportions seem out of whack. Much of this will settle in over time, and some technology will adjust. For instance, full-frame 35mm sensors are now on the market, as well as specially designed lenses for the smaller chips, both of which will ease some of these transition pains.

The digital cameras available today are often packed with an array of features and pushed by marketing-driven distinctions. Over the last few years some of the cameras from different manufacturers even had the same sensor, but differed in electronic design, color handling and physical layout. Some of the market distinctions are real, and others are exaggerated. Different sensor types, resolution, noise, viewing systems, and supported accessories all add up to real differences.

This overview and comparison of techniques, technologies, design and functionality differences will hopefully help sort out some of these differences and create a useful basis for comparison and buying decisions.

Features

Viewing System

+ SLR: a single lens reflex (through-the-lens viewing system) camera in 35mm & 120mm format and styles with interchangeable lenses.
+ Viewfinder: a fixed lens camera usually in a sub-35mm size, usually still provides through-the-lens viewing of live signal from camera.

Resolution

+ Expressed as megapixels, or millions of pixels. This number directly relates to how much data is gathered and therefore how large of a print that can be made from the capture.

File Formats

+ JPEG: a compressed file where 8x8 squares of pixels (64 pixels) are stored as an equation (discrete cosine transform) rather than the actual information from the camera. This results in image quality loss which on low compression settings may be hard to detect.
+ TIFF: the most standard form of holding digital picture information without data loss. Often results in a fully processed file 3x the size of what the sensor recorded, therefore consuming processing time in the field time and disk space. Lossless compressed TIFF variants include LZW and ZIP compression.
+ RAW: unprocessed image data from sensor, holding the information the camera captured. Results preserve options but require processing in software to transform into a photograph.

JPEG compression preview in Photoshop's Save for Web option.
upper left: original.
upper right: quality setting 100.
lower left: quality 50.
lower right: 0 quality (maximum compression).

JPEG Compression
The Real Data: 8x8 pixel squares of 64 pixels rendered from their binary numbers of eight ones and zeros.

10101010,10101010,10101010,10101010,10101010,10101010,10101010,10101010,10101010,10101010,10101010,10101010,
10101010,10101010,10101010,10101010,10101010,10101010,10101010,10101010,10101010,10101010,10101010,10101010,1
0101010,10101010,10101010,10101010,10101010,10101010,10101010,10101010,10101010,10101010,10101010,10101010,10
101010,10101010,10101010,10101010,10101010,10101010,10101010,10101010,10101010,10101010,10101010,10101010,101
01010,10101010,10101010,10101010,10101010,10101010,10101010,10101010,10101010,10101010,10101010,10101010,10101010,
x3 for a 3-channel color file

$$t(i, j) = c(i, j) \sum_{n=0}^{N-1} \sum_{m=0}^{N-1} s(m,n) \cos \frac{\pi(2m+1)i}{2N} \cos \frac{\pi(2n+1)j}{2N}$$

A JPEG Discrete Cosine Transform
This is why JPEG can look so bad. It is replacing real image data in the image with an algorithm imitating an 8x8 block of pixels, 64 in total. The formula describes tone and color transitions within these cubes of data.

Color Rendering (silicon, like silver, is only black and white sensitive)

✦ Bayer-pattern area array: a sensor covered with red, green, and blue color filters. Most instant capture cameras are designed with this kind of sensor. Results in interpolation (making up information) and color edge artifacts that can be only partially repaired in software. The most sophisticated of these cameras using this sensor design minimize the artifacts with a blurring technique (low pass filter) before the image strikes the sensor.

✦ Foveon X3 multi-layered: a sensor design by Foveon that samples red, green and blue light from every pixel site on the sensor. Results in no Bayer-pattern interpolation artifacts forming and should be compared in megapixels to Bayer-pattern cameras 3x its resolution.

✦ Scanner/linear array: three linear arrays sensing full color, building up the image with a scan.

✦ Three shot: a camera system that takes three black and white photographs through red, green, and blue filters to build up a color image. Results in only tripod, still life images being practical.

Bit Depth

✦ The number of gray levels or brightness values created by the camera to render tonal transitions in the photograph. 8 bits is the minimum in most imaging systems, but cameras with 10, 12, 14, and 16 bits are on the market. Most hand-held camera systems are now 10 or 12-bits. This results in greater nuance of tonal change with higher bit depth, and possible tonal banding with too little. Bit depth is related to dynamic range, in that a high dynamic range sensor can benefit from higher bit-depth processing.

Noise

✦ Digital cameras are real electrical devices. Real electrical devices carry both the electrical signals we intend and random signals we don't want. Those signals are called noise, and they are essentially the film grain of digital photography. There is chip noise and electronic circuit noise. Relative noise is expressed as signal to noise ratios and applies to digital audio as well. The higher the signal to noise ratio, the better, and the lower the noise, the better.

ISO Ratings

✦ Much like film, silicon sensors have an inherent light sensitivity. The lowest ISO in a camera's settings is probably its real sensitivity. Higher ISO settings are essentially signal boosting (gain amplification), much like pushing film (overdeveloping). This results in exaggerating native noise and making the photograph more granular.

Marketing

✦ Some features are questionable as features at all. Some seem meant to confuse the buyer, such as digital zoom. Digital zoom is a function that crops the image so that you appear closer, but gives you no additional information.

Ease of Use

✦ One of the biggest complaints about digital cameras are functions buried in multiple layers of complex menu selections viewed on tiny camera LCD screens. The potential buyer should try the camera and explore whether the functions they need are accessible or inconveniently buried. Basic controls like focus, aperture, and shutter speed are rarely available with manual dials except in the more expensive SLR format cameras.

Weight and Size

✦ You won't use your camera unless you are willing to carry it with you. With our love of photography and the seduction of gadgets, the awkward shapes and weight can get to be an issue. Examine a camera for its ease of handling before purchase.

Memory Cards

✦ Compact flash, Microdrives, Smart Media, Dx cards, and Memory Sticks are just some of the in-camera removable storage cards found in cameras today. Standardization and durability are considerations to keep in mind as well as speed of writing and cost. Fast, medium-capacity Compact Flash is probably the best middle ground at the moment.

Connectivity

✦ USB, USB2, Firewire (IEEE 1394), and SCSI are all connection protocols for allowing your camera to communicate directly with your computer. The likelihood of easy connection to your computer now and for the next few years is a good way of thinking over compatibility, which currently seems to argue for Firewire and USB2.

Basic Digital Camera Techniques

My own photographic prejudices run toward deep image fidelity to the original scene and preserving as much information as the camera can record. The techniques I employ are consequently geared toward those desires. Most of the special effects others may desire can be accomplished after the fact in image editing software and special effect plug-ins.

Start in RAW

As I suggest elsewhere, I strongly recommend making your photographs in your digital camera's RAW mode. Although this forces processing after the fact, it is your best bet for preserving all of the visual information your camera is capable of holding. This can be balanced and transformed in high bit depth and saved as such.

Establish White/Gray Balance

Establishing the right color balance can be a difficult challenge. Most color casts can be detected by looking at the balance of what should be neutral grays in the image and checking their RGB balance. Neutral should be equal in RGB. The process can be aided by taking a photograph with a patch of spectrally neutral light gray card under the same light as the photograph you want to balance. This can then be used as a source point for the white/gray balance tool in Photoshop's Camera Raw and other editing tools. This is not the same as a traditional 18% photographic gray card. It really does need to be spectrally neutral, so that using it to balance RGB values results in neutralizing the image, not the off-color gray card. Additionally, cameras and Photoshop work better with a brighter gray than the traditional gray card.

Lens cap with a *GrayCaps* spectrally neutral gray card attached.

Gretag's MacBeth ColorChecker.

Determine Digital Exposure

Use the built-in light meter to establish your basic exposure. Check the results with your histogram display. Think of the digital photograph much as you would with slide film, and expose for the highlights so as not to blow them away. The shadow detail will fall where the sensor is capable of holding it. Use the camera's built-in histogram check the data. Many cameras will warn of overexposure by flagging areas of the image that are at or near overexposure. A quick minus exposure compensation exposure can be made to take care of the potential problem. The exposure should be rechecked.

The problem gets a little tricky because of the way digital data is measured and bits are counted. The highlights produce more voltage and are counted with more numbers, and thus the upper values are dramatically better sampled than the shadows. If important dark detail is present, it is better to record it lighter (as long as you don't blow out the highlights), then darken to your desired appearance in Photoshop later. This gives you more recorded shadow and mid-tone information, even if they don't look quite right at first.

Pre-scan with the BetterLight camera showing over-exposed areas in red.

It is better to weight the exposure as high up the tonal values as possible, while being very careful not to blow out the highlight detail you need. Digital brightness values are counted in bits upward from 0 for the shadows. Every step in brightness upward is basically twice the previous number of electrons, building to the full tonal value available, or white. Thus, counting from top down in 8-bit space, the brightest bit, values 128–255, occupy fully half of the tonal values available in that space, therefore affording the smoothest gradation of tones. As the data goes into the shadows, the number of bits available to characterize the brightness plummets dramatically. Again, give the digital file as much exposure as possible to keep the brightest tonal data high up on the histogram. This will maximize the data points underlying the tonal differentiations.

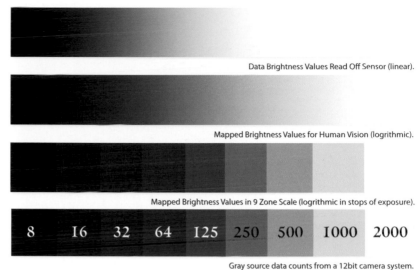

Data Brightness Values Read Off Sensor (linear).

Mapped Brightness Values for Human Vision (logrithmic).

Mapped Brightness Values in 9 Zone Scale (logrithmic in stops of exposure).

| 8 | 16 | 32 | 64 | 125 | 250 | 500 | 1000 | 2000 |

Gray source data counts from a 12bit camera system.

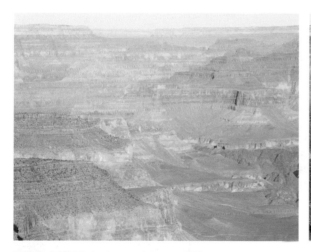

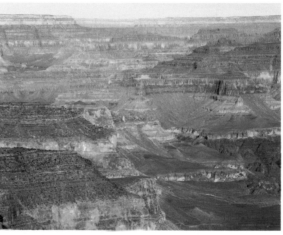

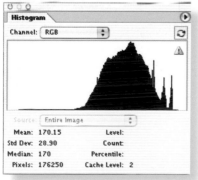

Exposure kept high to keep shadows open, but more importantly to keep the bulk of the image data in tonal range with high bit counts.

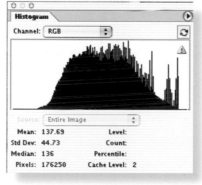

Image edited for normal appearance, taking advantage of detailed tonal differences held by bright exposure.

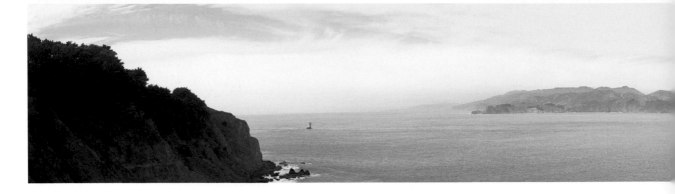

Multi-Exposure Panoramics Techniques

VR Rotating tripod mount.

Panoramic photography has been greatly enabled by the capability to build panoramic views from a sequence of exposures. This is done with a series of photographs made while rotating the camera between frames. These individual frames are then joined together in a (hopefully) seamless collage through a process called *stitching*. There are several software packages that are designed to composite these images together, including Apple's original QuickTime VR Authoring Tools and Photoshop's built-in panoramic stitcher, Photomerge.

Most applications and manual stitching processes will work best when the camera setup is level and the overlap of images is consistent. A panoramic stepping head for your tripod can be helpful to aid consistent rotation and overlap. About a 25% overlap is helpful for blending these images together, but this will vary with the focal length of the lens used. It can also be very helpful for blending if you choose a single aperture/shutter speed combination and use it for the entire rotated set. This will minimize potential sky blending issues, which can be almost impossible to eliminate.

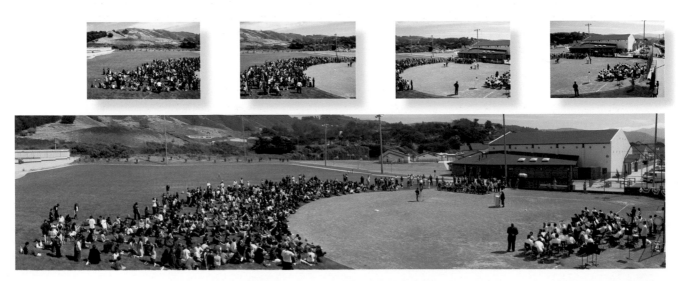

Ingrid Lacy School Dedication, Pacifica, California, 2003. Kodak DCS 14n. 3000x4500 pixels. 12-bit. Bayer-pattern camera.
above: 4 individual frames were geometrically corrected and then stitched with Apple QuickTime VR Authoring Tools.

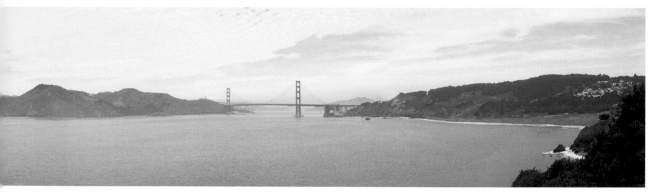

Golden Gate from Lands End, San Francisco, California, 2001.
Kodak DCS 460. Handstitched in Photoshop.

Hand-held work sequences require more care and work after the fact. Do your best to find a marking within the viewfinder to line up the horizon and keep it there as you rotate the camera. If major geometric distortion is present in the final set, correcting individual frames with Photoshop's perspective correction controls might improve subsequent stitching success.

Multi-Exposure Dynamic Range Expansion

A particular scene may contain a brightness range beyond the capability of the film or digital camera to record. Using the raw mode in cameras will help this issue by preserving all of what the camera could see. If the scene is still beyond the contrast range of the camera, taking more than one photograph of the same scene at different exposures and then combining them into a single frame, allows the user to expand the range of shadow and highlight detail you can record.

Whether two or three exposures (or more) are needed can be determined by metering the scene to see how far apart the extremes of desired detail fall. In a digital camera system with histogram display, make sure that the shadow detail exposure is well up from the left of the display, and that the highlight exposure is well down from the right. If the range is extreme, a series of mid-range exposures may also be needed but will further complicate blending them into a single image. Camera auto-bracketing can also be used to auto-accomplish this same exposure task with somewhat less consideration on the individual scene's needs.

These exposures can then be combined in Photoshop using the technique found in Chapter 9 and as HDR files. A number of third-party software solutions are also available to combine differing exposures. If the tonal range of the final combination is extremely wide, some overall tone compression might be necessary to make the image look right to you. Using Curves, I usually start with a slight S curve, brightening the 3/4 tones and darkening the 1/4 tones. The resulting appearance is directly related to how silver-based film records light, and we often find ourselves seeking a similar look and feel. It is not clear to me whether this is based on our own human visual inclinations (which some will argue), or based on our long history of looking at photographs and expecting them to look a particular way.

HDR Dynamic Range Expansion

Combining more than one exposure to record a range of contrast beyond your camera's capability was one of the reasons for creating Photoshop's HDR (high dynamic range) format. Although difficult to transform elegantly into a usable file, the HDR encoding is a very useful archive format and can help you preserve and integrate a wide range of data.

The procedure for creating the files is rather straightforward, the challenge is to map the tonality back out so that the visual appearance is pleasing. The following seems to be a workable procedure.

1. Meter your scene for the best overall exposure.
2. Note the highlights and/or shadows that are flowing off the histogram to the left (shadows) and to the right (highlights).
3. Take additional photographs using the Shutter control (not the Aperture) at 1 or half-stop increments to bring the highlights into proper exposure, and shadows up a good exposure.
4. Select the photographs to be assembled in Adobe Bridge, then, under Tools, Photoshop, Merge to HDR (or in Photoshop, under Automate, use the Merge HDR mode) combine the photographs.
5. Select 32 bit mode for HDR encoding.
6. Adjust the Set White Point slider so that highlights are held.
7. Save your file.
8. To transform to normal 16 bit mode for general image use, re-open the HDR file and convert the file through the mode command which will bring up the HDR Conversion dialog box.
9. My best success has been using the Local Adaptation drop down selection, then adjusting the curve as best I can for final appearance.
10. Using traditional curves and Levels Adjustment Layers, further fine tune your edits to your taste.

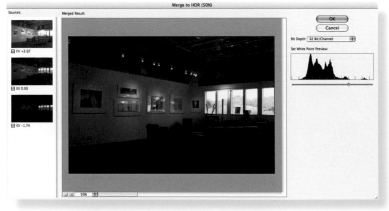

Merge to HDR, with 32 bit mode selection and white point preview slider.

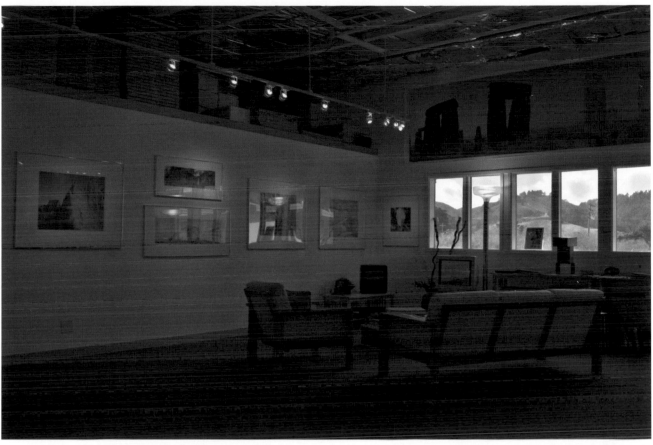

Main Gallery, Stephen Johnson Photography, Pacifica, California.
Integrated file from three exposures, holding detail from deep shadows inside the space to sunlit mountains of Pedro Point and the Golden Gate National Recreation Area beyond.

Kodak DCS 14n. 3000x4500 pixels, 12 bit, Bayer-pattern camera.

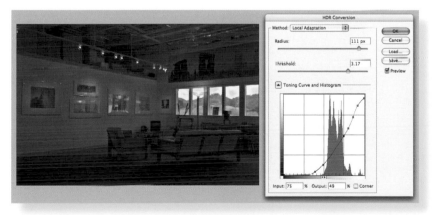

HDR conversion back to 16 bit file. Note, the Local Adaptation drop down has been selected and a curve drawn to attempt a normalized appearance that integrates the very wide dynamic range.

Depth of Field Increase/Decrease

Our photographic desires are limited by many constraints. The photographic constraints to record what is in front of the lens is a fundamental aspect of what makes photography a wondrous medium. But the technical issues, like optical behavior and recording medium limitations, are areas where we are always working to make photography better.

Innovative combinations of using different versions of photographs are now more possible in this digital age because of digital editing software and potentially precise registration between images. Depth of field expansion is one of those areas of possibility. In situations with stationary subject matter where a small aperture is not practical or possible, you can combine more than one version of a scene into a finished image that bypasses traditional optical limitations.

Depth decrease is commonly achieved by selecting the areas on which you want to achieve a soft-focus, then carefully blurring that area to your satisfaction. The selection process is usually the most difficult part of this procedure:

1. Select the area you want softer.
2. Duplicate it into a new layer so that it can be worked on separately.
3. Work the Gaussian Blur filter to the look you want.
4. Erase from the blurred layer (to see through it) the area that you want to stay sharp.
5. Clean up any blending problems (like fine hair) by erasing through the blurred layer, generally with a reduced opacity eraser for more subtle blends, for blurred layer into the underlying original file.
6. Vary the opacity of the blurred layer for additional control over look and feel.

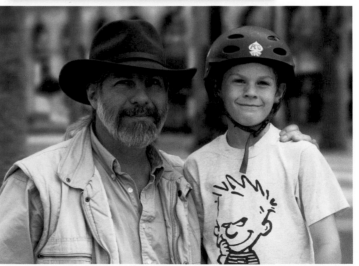

Although I can rarely imagine a time when I want to blur an image, and therefore struggled to find an example. Here is one that was already soft behind the people. The older guy may be a little blurry anyway. Photograph by Mary Ford. Olympus 5050. 2457x1788 pixels Bayer-pattern camera.

above: Matt and Steve, San Francisco, original slightly blurry scene behind the boys.

above right: Layers palette with erased boys on blurred layer.

right: boys with Gaussian Blurred buildings.

Vidicon Tube Depth of Field set:
left to right: top focus, middle focus, bottom focus.
below: finished composite.

The basic procedure for depth of field increase would be:

1. Using a tripod, make a series of photographs encompassing the depth of field you want to record. Allow for some focus overlap between shots to build smooth transitions between them. This can be accomplished through changing the focus or the aperture and focus. Keep in mind that different focusing points within an image will also scale an image, which can make reintegrating a challenge.

2. Assembling these images together is not easy if the distances are great. Open your base file and paste all others into layers stacked above, background layer. For the purposes of this procedure, I'll use a three-image integration as the example.

3. Erase the out-of-focus areas of the image on top of your base file to see through to the in-focus areas below. This commonly might be done by erasing an out-of-focus foreground in the second shot because you refocused the lens to sharpen an out of focus background. This should be done with a soft-edge brush, with many history states set in Preferences and careful inspection as you go.

4. Save the layered file and both of your originals for later use depending on what flaws you may see in the image after looking at it for awhile.

5. Flatten the file when finished.

Sensor Artifact Repair

Photography has always been rewarded and challenged by its technology. Today is no different. We are liberated by the technology and constrained by it. Where funkiness occurs in image quality or from data storage errors, we can now at least bring the power of digital photo editors to bear on trying to repair the shortcomings of the recording medium.

Color Artifacts and Moiré

Typical Bayer-pattern sensors can form strange color edges and moiré patterns (concentric rings formed by interference patterns unequal in frequency or beyond the resolution of the camera) from their unequal sample of color taken from the original scene. These artifacts are sometimes called color aliasing. The Bayer-pattern sensor causes these artifacts, with twice as many green filtered sensors as red and blue, leaving a great deal of color information missing which has to be made-up through interpolation of at least the red and blue channels (*see Chapter 6*).

Sara and Matt, 4th of July Picnic, 1995. Kodak DCS 14n. 3000x4500 pixels. 12-bit. Bayer-pattern camera.

There are a variety of ways for minimizing this effect. One is to carefully blur the light before it strikes the sensor so as to prevent these artifacts from forming, softening the photograph. Another approach is to transform the RGB file into the Lab color space, thus separating brightness information from color information. The L channel contains a black and white version of the image; the A and B channels encode the color. As most of these Bayer-pattern artifacts show up as a color fringing problem, the color channels can be blurred to mask the problem.

A and B color channels can be blurred to mask artifact problems as shown here in Photoshop's LAB mode/channels.

Blur In-Camera

Some cameras are constructed with a carefully designed filter (anti-aliasing or low pass) that blurs the frequency of light most likely to form these color artifacts in the image. This filter is placed in front of the sensor and permanently affects the resulting photograph. The Kodak 560, 660, and 760 cameras featured a removable blurring filter, but recent models from other manufacturers have the blur filter permanently attached.

In-camera blur does work, and it can prevent most of the artifacts from forming. The consequence, however, is that your photograph is permanently softer than it would be otherwise. This softness can show up as an uncanny blurriness in fine detail like hair.

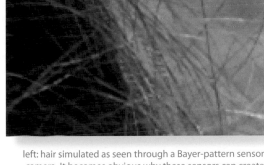

left: hair simulated as seen through a Bayer-pattern sensor camera. It becomes obvious why these sensors can create problems—they can't resolve everything they are trying to image.
above: the real artifacts that appeared in the file.

Auto-Repair

Auto color blurring available in Adobe's Camera Raw plug-in (under Detail) and other software packages sets up an automatic sequence of conversions and blurring to reduce sensor artifacts. The best of these can be adjusted to your needs or turned off altogether.

Lab Blur

The Lab blur repair technique involves changing the file to the Lab space, then using Gaussian Blur to soften each of the two color channels separately. Act on only one channel, but keep the channel Visibility eye icon turned on for RGB so that you are constantly seeing the full color-corrected result. Use the gentlest blur possible, as a heavy hand will show itself in the form of a strange blurriness to the color of the photograph.

Filter-Based Repair

Various software packages are available to do this color blur routine. Camera Raw has some built-in routines. Camera Bits Quantum Mechanic is an alternative add-on that appears in the Filter menu and is one of the best. There is also the Reduce Noise filter in Photoshop shown on the next page.

Moiré patterns of color rings can also be formed with Bayer-pattern sensor cameras. The Moiré Eraser from Camera Bits helps this problem.

Sensor Noise

Silicon sensors can produce very clean images, but they can also carry with them electronic noise (seemingly random electrons) that resembles film grain. This electronic noise in digital cameras is exaggerated by signal boosting (gain amplification from raising the light sensitivity rating or ISO), small sensors, poor circuit design, and long exposures. Noise is present in any electronic design, and signal-to-noise ratio is the typical term for expressing intended signal strength relative to unwanted electronic garbage. The higher the ratio, the lower the inherent circuit noise and the cleaner the resulting photograph. In digital photography, the least intense signals are in the shadows, where noise lurks. Here are some of the common causes of noise.

Sensor noise

+ Signal boosting: refers to overrating the sensitivity of the sensor, or pretending it is more sensitive than it is by raising the ISO. These techniques are all essentially under-exposing the chip, then amplifying the signal to boost brightness. It is very similar to traditional "pushing" film development (under-exposing then over-developing), producing grainy images with little shadow detail. Usually, the lowest ISO possible on a digital camera is its real ISO, and everything else is the result of signal amplification. Use the lowest ISO possible for the maximum signal, resulting in the least amount of noise.

+ Small sensors: the quality of the signal coming from the sensor has a direct relationship to the size of the area of silicon (pixel) collecting the light. The smaller the pixel, the less the light collection ability versus the resident electronic noise. This can result in higher megapixel cameras (with very small pixels) actually resulting in lower quality images than those made from a lower resolution camera, because of the very small sensors with their inherently weaker signal and greater noise.

+ Poor electronic design: conservatively designed electronic circuits take into account heat generation, likely signal spillover, and real light sensitivity. As digital cameras have entered the commodity market, cheaper designs and more casual manufacturing controls have also proliferated. Even as digital consumer cameras were being birthed, their video chip ancestry meant that their inherent noise might be less evident in the video signal which the chips were originally designed to capture. Although it is not always true, usually, the less you pay for the camera, the greater the noise it will produce.

+ Long exposures: the longer a silicon sensor is detecting light (collecting photons), the more noise builds up due to random "leakage" (signals where they don't belong) or "dark current" (signals without photon stimulation) electrons. Consequently, longer exposures tend to be much noisier than short exposures. Some applications (like astrophotography) actively cool their chips because there is less dark leakage at cooler temperatures, and therefore fewer random electrons jumping around. The hotter the sensor, the more random electrons are generated, and the noisier the file. Keeping your camera cool and exposures

Photoshop's Reduce Noise filter. Care should be exercised not to reduce noise to the extent that you blur the image beyond your tolerance.

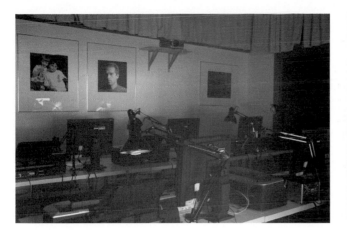

Image with sensor noise from long exposure. 6 seconds at f4.8, ISO 80. Kodak DCS 14n.

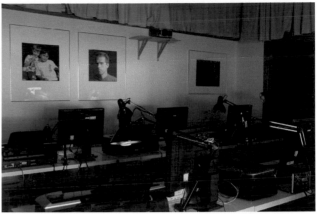

Image taken in Long Exposure mode and without sensor noise. 30 seconds at f4.8, ISO 6. Kodak DCS 14n.

short will minimize the problem. If a long exposure is necessary, a camera designed to take dark current measurements should produce significantly better images. This is also known as a dark frame, an image of the sensor with no light striking it. This is essentially a picture of the noise, which is then subtracted from the image to remove the generated noise.

Noise Prevention

Prevention is the best cure for sensor noise, so do what you can to stop this ugly stuff from forming and messing with your photographs.

+ Give the sensor lots of light (as many photons to count as possible).
+ Use the lowest ISO possible and don't underexpose.
+ Check noise characteristics of camera before purchase.
+ Look for dark current measurement/subtraction functions on long exposures when considering a new digital camera purchase. Investigate to see if this function is present.
+ Keep the camera cool. 65°F is better then 110°F, although this only helps a small amount.

Camera Firmware

Many cameras are adding special firmware routines to take dark current measurements and subtract them for the signal the camera is recording. This is a very useful feature in a camera.

The routine closes the shutter and records the signal for a similar length of time as the needed exposure, then makes the photographs, and in some designs measures the dark signal again and subtracts both from the noisy file. The results can be spectacular.

Obviously you want a low noise camera, but this routine is very useful. In a way, it is about noise suppression through measurement, whereas astrophotography which needs very long exposures, uses noise suppression through chilling the sensor to very cold temperatures. Both can work, and can let silicon sensors imitate and in many cases surpass what film could do with very long exposures.

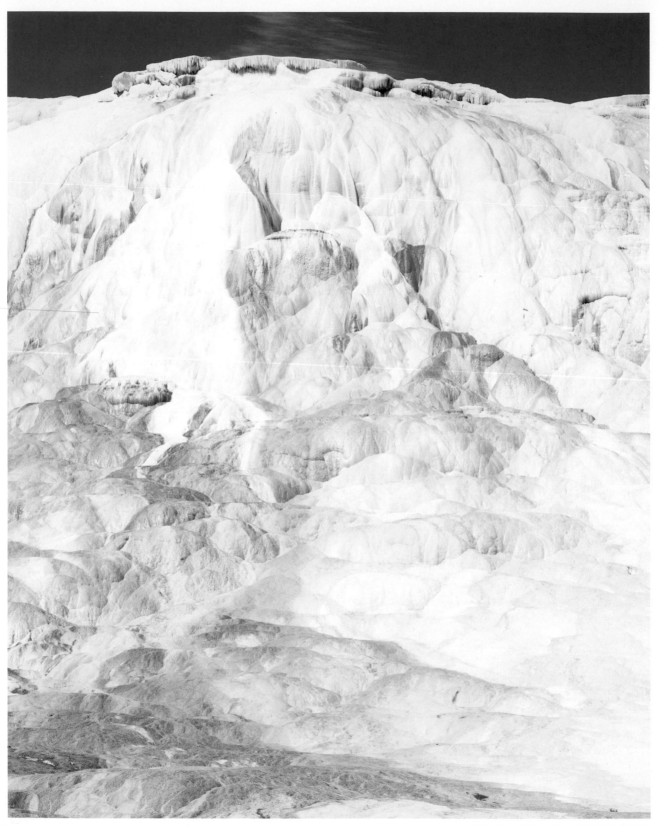

Travertine, Yellowstone National Park, 1995.
BetterLight Scanning camera. 6000x7520 pixels. 12-bit. Tri-linear Array.

Chapter 8: Scanning

While there is perhaps a province in which the photograph can tell us nothing more than what we see with our own eyes, there is another in which it proves to us how little our eyes permit us to see.

—Dorothea Lange

Film and print scanning is still the most common path into the world of digital photography for many photographers. Scanners were available before digital cameras, and they matured much more quickly.

Scanning was certainly my entry point. With decades of film in the archive, film scanning will be part of my professional life for many years to come. My scanning experiences started in the late 1980s with Ricoh desktop scanners and the BarneyScan desktop slide scanner. I soon started working with companies in the industry trying to elevate the devices to much higher quality, hoping to create something akin to the quality of the images being scanned, or better.

Types of Scanners

The original distinctions between scanner types was based on their transport mechanisms and sensors. By the late 1980s, the prepress industry had come a great distance into the digital age and had settled into some rather reliable working methods.

Drum Scanner

In a drum scanner, originals are taped onto a drum that rotates, while the scanning sensor moves over the image and detects the light through (in the case of a transparency) or from (in the case of a print) the image which is then color separated and digitized.

The PMT (photo multiplier tube) scanner is still the mainstay of many prepress workflows. The PMT imaging system is very high quality. Some desktop drum scanners now use CCD (charge coupled device) sensors rather than the expensive PMT technology of many floor models. Of course, there are also some hybrid desktop PMT scanners.

Film scanned in this manner is usually brushed with a mounting fluid (an oily substance) that prevents concentric interference lines, known as Newton rings, from forming between the surface of the drum and the surface of the film. Of course, that same oil needs to be cleaned off before the film is stored. Film being fragile, this cleaning process can permanently damage your original.

The trouble and risk of oil mounting makes drum scanners of decreasing interest to many photographers. The more traditional negative carrier projection design seems safer for the film (*see the upcoming section "Film Scanner"*).

Flatbed Scanner

Flatbed print scanners are very similar to copying machines. A glass scanning bed holds the original face down, and a mirror with light tube moves across the print and reflects the images across an internal lens that projects onto a linear array CCD. Very high resolution scans are possible, even with moderate resolution scanners, as the original is so large. But of course, the quality of these prints is limited by the sharpness of the print itself. A 600 or 1200 dpi print scanner works well for most print scan needs.

Flatbed scanners are also sometimes equipped with backlights and setups for scanning large film as well as prints. These can work well for very large format film, such as 8x10, but the design is not ideal for film and a compromise in image quality often results from the multi-purpose print/film flatbed designs.

The least expensive of these cost as little as $100 or less, with the more expensive multi-function high-quality film/print flatbed scanners ranging up near the $50,000 mark.

Film Scanner

Dedicated film scanners are essentially digital enlargers. Some, like the Leafscan 45, even used traditional 4x5 Beseler negative carriers. The film is projected through a high quality lens in a carefully aligned path onto a linear array CCD. The CCD is fairly high resolution (2000 to 8000 elements) and engineered for 12 to 16 bits of data. Generally, these are designed so that the film is moved very slowly across the optical path to cast its image through the lens onto the sensor. These were initially three-pass devices with a single monochrome sensor and a tri-color filter set. Film scanners are now commonly designed with tri-linear arrays sensors that scan all three primary colors of light in one pass across the sensor.

These devices work better than print scanners for film because of their higher resolution coupled with the small size of film and more precise optical path. Scan ppi can be very high, up to 8000 ppi.

The Scan As Archive

Scanning film and prints not only makes the images available for digital photography uses, it can also act as an archive. Scanning old film locks its deterioration in time, it can no longer fade once it is in digital form. The data might be lost, which is a separate issue, but the binary numbers will remain stable as long as they are readable. Given the desire to preserve as a motive, you want to scan at the highest resolution and highest bit depth possible. It is also true that the more you suspend decisions about editing tonal range, the more data you are likely to preserve.

above right: untoned (linear gamma) 16-bit scan.

This can be done by using scanners that are capable of scanning in a RAW mode, but this produces un-toned 16-bit files, which can be very hard to edit in Photoshop. The basic problem is that they will be gamma-encoded to a linear 1.0, which means, among other things, that they will look very dark to those of us with human vision. Photoshop's tone editors are not designed to pull such dark data apart and gracefully redistribute it to

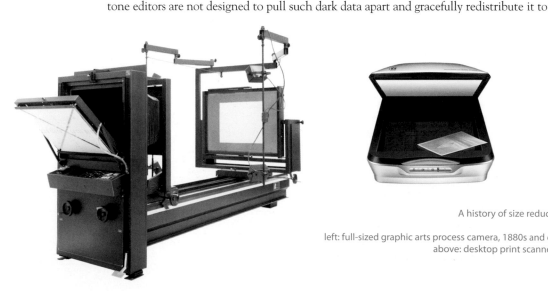

Preparing for Reproduction:
A history of size reduction and increased convenience.

left: full-sized graphic arts process camera, 1880s and on. photo courtesy Acti Cameras.
above: desktop print scanner, 1990s and on. courtesy Epson.

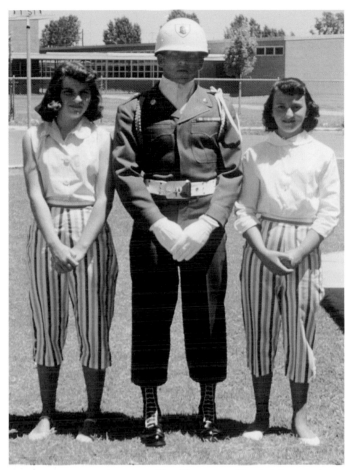

above: same file with sequenced Levels Adjustment Layers.

Johnnie on Leave with Friends, 1953. Kodachrome 35mm slide. Scanned in 16-bit RAW with the Leafscan 45 in the early 1990s. Edited by imposing two Levels Adjustment Layers, first to move the midtones into visibility, the second to normalize the appearance. These were then placed into a Layer Set to make it easy to turn them off and on, and separate the major tone changes from later tweaks. A final Hue and Saturation Adjustment Layer was added to correct some gross color casts.

a more human-normalized appearance. So a well-used workaround is to do more than one tonal edit in sequence, as Adjustment Layers, which allows you to gradually normalize the appearance, while still leaving the underlying data intact. When you have a sufficiently normal looking image, you can then add, on an Adjustment Layer as above, for color tweaks and other needed edits.

As my friend Bruce Fraser pointed out, it may be even easier to simply create a custom 1.0 gamma color space and assign it to your file, then convert to a more normalized gamma. This can be done by choosing Custom RGB from Photoshop>Edit>Color Settings>RGB Space, and creating a gamma 1.0 version of your preferred working space, such as the Adobe 1998 RGB as a 1.0 Gamma instead of 2.2. Name it carefully and reset to your normal workflow when done.

Scanning Considerations

A new world of responsibility and opportunity awaits when you take control of image acquisition. One clear advantage to scanning and image editing yourself is the amount of time you can devote to the process. You will likely be able to spend many more hours working on a scan than you could ever afford to pay someone else to do. Thus, doing your own scanning allows you to indulge of any of your perfectionist instincts. Your original photographs or negatives need never leave your hands. It is also possible to scan images merely for consideration, thus greatly expanding your choices in digital form.

The quality of your original image is critical. The adage "garbage in, garbage out" is particularly true for scanning. In addition, there are many scanners to choose from, many of which are of marginal quality. A good scanner cannot make a bad photograph beautiful. Conversely, a mediocre scanner is not likely to do justice to your image. It doesn't pay to buy a cheap scanner.

As I mentioned before, most desktop scanners sold today have CCD light sensors, although some of the newer (but more costly) drum models now employ high-quality traditional PMT tubes. While almost all desktop scanners are CCD-based, there is a world of difference between them. The quality of the transport mechanism alone (and consequently the registration of your image) can justify great differences in price. When you consider the quality of the scanner's optics, filters, and general electronic design, it's clear: any scanner worth buying is not likely to be the cheapest.

Scanner Bit Depth

I recommend scanners with greater dynamic range than the conventional 8-bit depth (256 levels of gray). 8-bit scanners rarely deliver 8 good bits of information to the computer (256 levels of gray accurately reflecting the original print's tonal range). Most of today's scanners are in the 10- to 12-bit range. Higher bit depth scanners should also have a greater dynamic range. Thus they can see a wider range of highlights and shadow, which is very important for scanning the deep shadows or color transparency film. The scanner should allow for custom conversion of 10 bits (1,024 levels of gray), 12-bits (4,096 levels of gray), 14 bits (16,384 levels of gray) or even 16 bits of image data (65,536 levels of gray) from their greater bit depth back to an 8-bit file.

More importantly, the software supplied with the scanner should allow you the option of saving the scan in a 16-bit tone adjusted linear file. A linear file lets you "treat Photoshop as the scanner" later, as all of the image data the scanner could see should be in the linear scan. A good rule to follow is this: the greater the bit depth of the scanner, the better.

Scanning Grayscale Images

A good looking black-and-white print presents special problems to desktop scanners. Black-and-white photographic paper can deliver very deep blacks, with subtle details in both shadows and highlights. Most of this subtle detail is lost by all but very high-quality print scanners offering 12–16 bit depth. Careful scanning (using scanner controls and available prescan adjustments) and comparison with the original is a must.

Scanning with Color Accuracy

Color accuracy is often an elusive goal for digital photography. Nevertheless, with some effort and a good eye, spectacular results are possible. Registration by the scanner of the three image planes is critical. Misregistration of color can occur if your scanner has been poorly constructed, has poor optical design, or is simply misaligned. Color purity and good separation of color are also important. Your scanner should use good quality filters (for accurate separation) and feature precision optics that bring all colors in focus at the same point, thus minimizing chromatic aberration. Dark, muddy color scans can be a problem on lower-priced scanners.

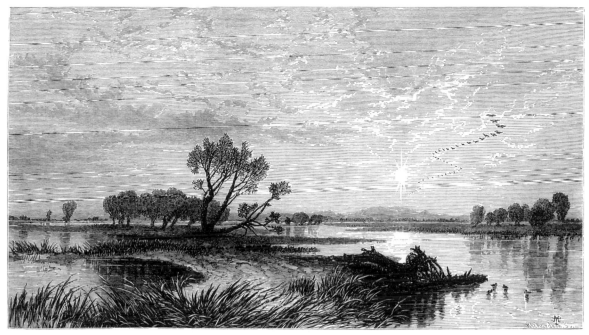

San Joaquin River, 1873. Thomas Moran.
Scanner: Agfa Horizon, CCD print and film scanner.
Source: 1873 printed engraving.

Scanning Line Art

Several special techniques are helpful when scanning line art. Subtle variations in line weight can easily be lost when using a scanner's line art (1-bit) mode, even when you carefully adjust the scanner's threshold settings. Consequently, it is often better to scan in grayscale and then carefully convert the image by raising the contrast based on the visual response you can see with every edit, to a virtual black or white illustration. Sharpen the image before conversion to line art (1-bit file bitmap is Photoshop's line art mode). The goal is to see very little difference between your carefully edited grayscale scan and the new 1-bit (line art) version.

Alternative Scanning Software

A few software packages are available for scanning that support a variety of film and flatbed scanners. These packages often offer more advanced controls than the simple software that comes with the scanner and sometimes are rather modest in price.

Keep in mind that if prescan adjusts are offered in a software package, you need to be sure that the software is tapping the higher bit depth of the scanner, making adjustments in the scanner's raw data, and then handing off the converted file to you with an option of 16 bit.

The engraving above, by Thomas Moran, was scanned from *Picturesque America* a wonderful two-volume set published in 1874. My set was in great shape, but it was over 100 years old and needed special care. With its large 11x17 inch scanning platen and high resolution (1200 dpi), the Agfa Horizon scanner did a fine job.

Basic Principles of Scanning

The following are some fundamental parameters to keep in mind as you are scanning your film. Remember, time and care invested up front not only protects your film, but results in a far more useful result. It is well worth the effort and time to make the best scan possible.

- ✦ Everything is in the scan.
- ✦ Straighten your original before scanning. Post-scan rotations other than 90° or 180° are time consuming and force image resampling (interpolation).
- ✦ Dust the print or film (and the scanning glass on flatbed) before scanning. With film, extremely careful handling is very important.
- ✦ Handle film with care. The original film is very precious, and it should be handled only by the edges and cleaned with film cleaner only if absolutely necessary. If canned air is used, be careful not to tilt or shake the can when spraying, as it can send out propellent and will fog your film. If there is something really nasty on the film that requires vigorous cleaning or rewashing, make the best scan you can first, then clean and rescan. This is a precaution just in case damage occurs from cleaning.
- ✦ Warm up the machine. Most scanners need some warm-up time before the lamp stabilizes and the calibration procedure is accurate.
- ✦ Make the best scan possible. Post-scan editing deteriorates the image (causing potential posterization) by stretching 8-bit 256 gray levels per channel to new values without necessarily filling in the gaps left behind (see, for example, the histogram below). If your scanner allows pre-scan color correction, use it to adjust your image to your needs. When necessary, it is better to make several scans to get the best scan possible than to heavily edit an 8-bit image after scanning.
- ✦ Make the judicious pre-scan adjustments. Make sure your pre-scan adjustments aren't post-scan edits. Some scanning software can give you the impression that it is altering the way a scan is acquired, while, in reality, it is simply post-scan editing the image before allowing you to see it. Such adjustments aren't usually effective, primarily because you could probably do a better job editing the image in Photoshop. Pre-scan adjustments are about controlling the conversion of the scanner's data capabilities into a deep and editable archive file. This adjustment is usually accomplished in the A/D converter behind the CCD array, where analog data from the array is converted to digital data for the computer. It is much like adjusting the development of film to specific lighting contrast conditions of the scene. In high-bit depth scanners, this can essentially pull out of the scanner's deep vision a result that may be almost finished.
- ✦ Treat the scan as an archive. I recommend thinking of scanning as the creation of an archive of the image, capturing and holding the most information possible. Scan at 16 bits, use the highest optical resolution of the scanner, and be careful to preserve highlight and shadow detail. This can then function as your digital negative, from which all other edits and customizations will flow. Some photographers prefer to scan linear data preserving everything the scanner could in a somewhat raw form, skipping pre-scans adjustments, and doing all edits in Photoshop. As these files come in very dark, they can be a challenge to edit in Photoshop.

Histogram before editing.

Histogram after substantial editing, revealing large gaps in grayscale data. Lesson: adjust your scanner for the scan you want, and scan in high bit depth.

✦ Scan to the needed size and resolution. Acquiring more data than you need creates storage problems and slows down your computer. Acquiring less data than you need risks revealing pixels in your final halftone-screened image. Generally, you should choose 300 ppi as an accepted and mostly acceptable input ppi at your desired size. For 35mm film with its 1-inch height, that would take a 3000 ppi film scanning resolution to make a 300 ppi output scan at 8x10.

✦ For halftone prepress needs, twice the ppi (1.5 works well) for whatever lpi halftone screen you intend to print. Watch out for scanning software that interpolates data. If your scanning software allows you to scan at a higher ppi than the scanner can see, it is creating—not imaging—those pixels. A scanner whose CCD is 400 ppi cannot acquire an image at 800 ppi without making up some information (such a scanner might scan 800 times an inch and only make up data in one axis). In general, scan at no higher resolution than the true optical resolution of the scanner.

✦ Everything is in the scan.

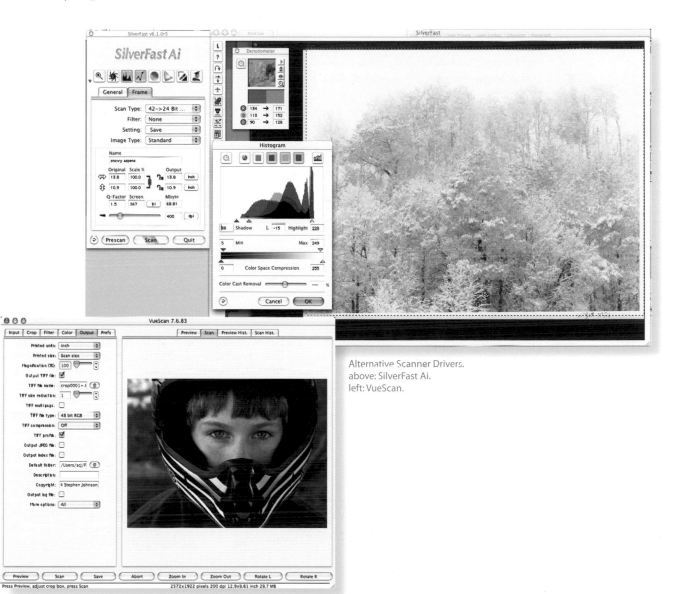

Alternative Scanner Drivers.
above: SilverFast Ai.
left: VueScan.

Common Scanning Controls

Here is a list of the kinds of controls generally found on professional scanners. They will vary according to the manufacturer of the software and the capabilities of the scanner itself. Some terminology may vary, and your workflow will ultimately be determined by your willingness to fuss with the controls, the successes you see, and the particular needs of the film or print you are scanning.

+ Pre-scan: generally, a quick, low-resolution scan to determine the area to be scanned.

+ Scanning area: setting that defines the area to be scanned.

+ Input size: the size of the original.

+ Output size: the desired size of the final scan, often expressed as a percentage with dimensions. Anything other than 100% might force interpolation depending on the software design.

+ Output ppi: the desired pixels-per-inch (sometimes referred to as dpi) of the final scan, given an output size. You must know the optical resolutions of the scanner to avoid software interpolation.

+ Pixel dimensions: the actual resolution of scanned image—pixel width and height. This is your real determinant of file size coming out of the scanner.

+ File size: the size counted in megabytes. In 8-bit, file size is a good predictor of the way we normally think of needed data, but in 16-bit the file size doubles without increasing spacial resolution.

+ Brightness: the overall lightness of the image, often set with curves or sliders.

+ Contrast: the relative intensity (lightness or darkness) of blacks and whites in final scan.

+ Tone curve: basic tone controls for creating tonal relationships between shadows, midtones, and highlights which can be used to shape the overall appearance of your scan.

+ Histogram sliders: black and white points adjustment with midtone controls generally added in the center. Be careful not to block up shadow detail or wipe out highlight detail.

+ Gamma: the overall brightness of the midtone values of the final scan.

+ Color balance: the balance of the red, green, and blue channels, used for customizing the color of the scan, correcting off-color prints, or compensating for a poor-quality scanner.

+ Focus (film scanners): the control for focusing the scanner on film, usually by adjusting the lens for maximum contrast.

+ Film type (film scanners): the place to indicate positive or negative, color or black and white, and possibly even emulsion type.

+ Output mode: the place to indicate line art, grayscale, and color, as well as 8-bit, 16-bit, etc.

+ Profile: the scanner source profile, either supplied by scanner maker or custom made by user

+ Output file format (if scanning software is not working as Photoshop plug-in): format for the final file; TIFF is most universal.

+ Sharpening (USM-unsharp mask): scanner sharpening that might work for automated workflows, but should generally be turned off so that you can sharpen your scan by inspection in Photoshop. (*See "Sharpening" in Chapter 9.*)

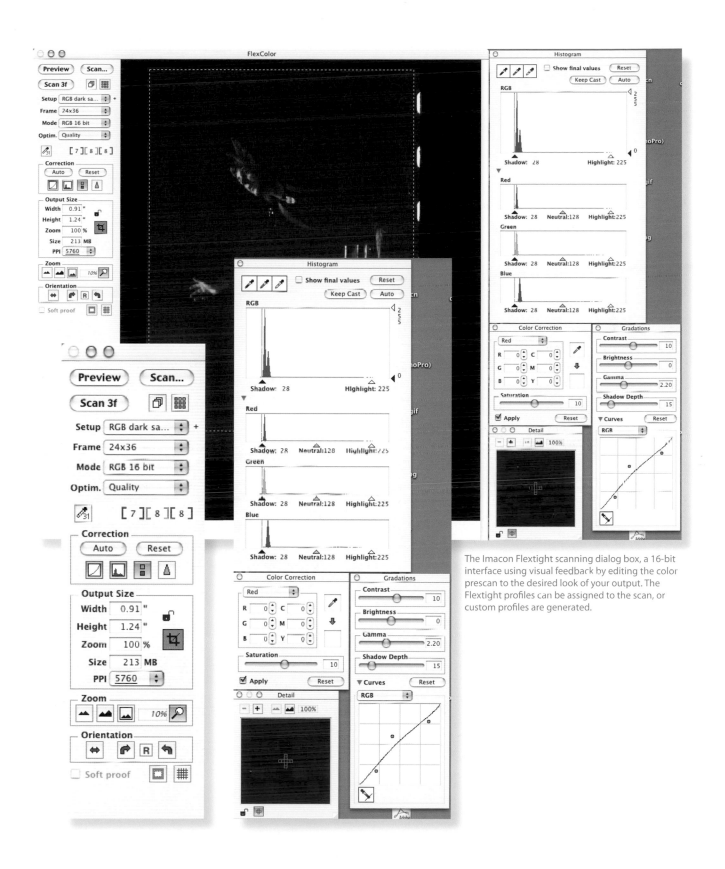

The Imacon Flextight scanning dialog box, a 16-bit interface using visual feedback by editing the color prescan to the desired look of your output. The Flextight profiles can be assigned to the scan, or custom profiles are generated.

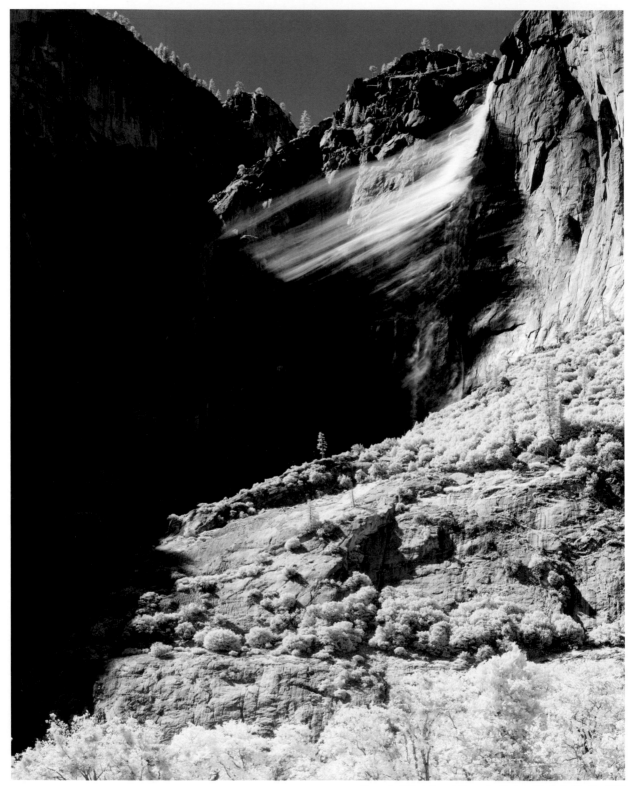

Yosemite Falls, Infrared, Yosemite National Park, California. 1994.
BetterLight Scanning Camera. 6000x7520 pixels. 12-bit. Tri-linear Array.

Part 4:
Techniques of the Digital Darkroom

*Both the grand and the intimate aspects of nature can be revealed in the
expressive photograph.
Both can stir enduring affirmations and discoveries, and can surely help the
spectator in his search for identification with the vast world of natural beauty
and the wonder surrounding him.*

—Ansel Adams

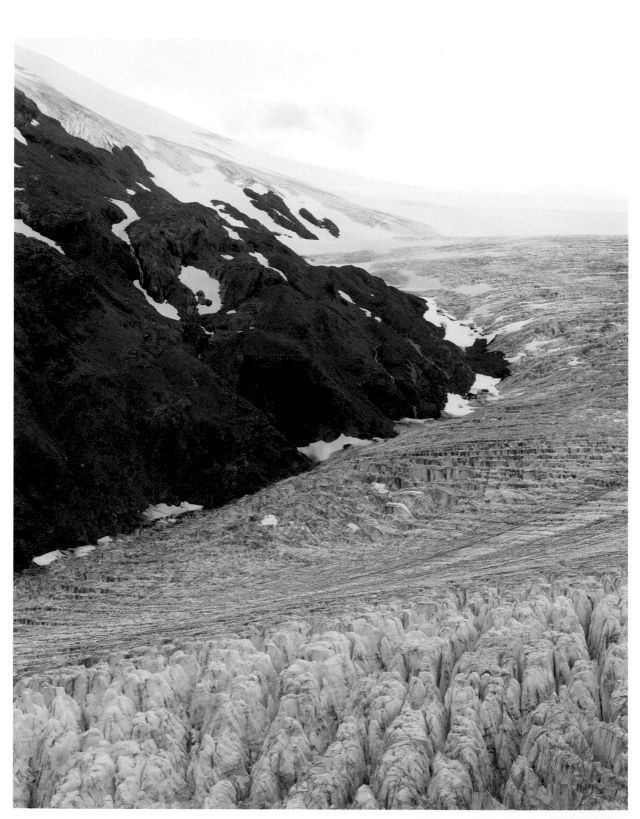

Exit Glacier, Kenai Fjords National Park, Alaska. 1995.
BetterLight Scanning camera. 6000x7520 pixels. 12-bit. Tri-linear Array.

Chapter 9: Controlling the Digital Image

Look and think before opening the shutter.
The heart and mind are the true lens of the camera.

—Yousuf Karsh

The controls that we can now assert over the digital photograph are rather impressive. Many are analogous to traditional darkroom techniques, and some have darkroom equivalents only in historical lust. Many of these possibilities that never existed before definitely constitute advances in artistic control over the photograph. This chapter uses Adobe Photoshop capabilities as a means of exploring the digital photographic possibilities to bring out the best of what an image can be.

Adjusting Images for Tone and Contrast

The look and feel of a print is obviously influenced by paper choice, but as always, the tonal structure and contrast of the image ultimately contributes much of the visual communication that flows from a composition. Traditionally we made darkroom tonal adjustments by choosing a particular paper grade and paper developer combination, and then further modified the appearance of the image by burning and dodging. Paper contrast grades, silver content of the paper, and paper finish, whether paper was matte sprayed or high gloss—all influenced the final result. Now, image editing tools like Curves and Levels can control digital file tonal appearance, with paper qualities and printer/ink choices still affecting depth of black and overall look and feel. Electronic burning and dodging brushes darken and lighten specific areas. (Some historical need for this intervention was caused by enlarger density fall-off and is now gone.) Specific areas of images can be worked with these brushes or by careful use of selection tools, and then editors like Curves and Levels can be used for more precise adjustments.

With electronic image editing, we now have highlight and shadow density controls that can greatly expand detail control with overall look and feel decisions. Additionally, Photoshop allows dynamic range expansion through the use of multiple exposures and other techniques, giving a digital photo system power reminiscent of the goals of the Zone System developed by Ansel Adams and Fred Archer in the 1940s.

far right: Classic Elwood 5x7 enlarger, circa 1930s.

right: Photography Workshop Student Curt Kiest working onboard the Magical Digital Bus, created by the Community College Foundation and Stephen Johnson. Somewhere in the southwest on the August 2003 "Journey through the Southwest" workshop.

The Histogram

A histogram is a common graphic measure of the data in a digital file, which is simply a plot of the brightness values of the pixels in your digital photograph. The more pixels at a particular brightness level, the taller the graph at that point. The plot starts with the darkest values on the left and then moves across the brightness range so that whites are on the far right. Midtone values are between the two.

This histogram graphic can be used as a measure of your original exposure, and it can be used as an editing guide after the fact. It is one of the fundamental measurement tools in the digital imaging world. The Histogram window should always be open in Photoshop and always checked on your camera.

There is no ideal histogram. Its shape and spread are completely image dependent. A low-contrast image would have a narrow spread, while a high contrast image with absolute blacks and whites might fill the graph from left to right. For instance, an image that contains subject matter such as fog could have a very narrow histogram, because few differences in tonal values would be present, whereas an image shot in bright sunlight might be very contrasty, even beyond the range of the camera to see, therefore forcing the user to make choices as to where to place the exposure on the histogram.

A good exposure is generally understood to mean that there is plenty of detail in both shadows and highlights, and that data is neither flowing off the histogram to the right (blown-out highlights) or going off the graphic to the left (blocked-up shadows). An overexposed image might have important detail bleeding off to the right or lost highlights. An underexposed image would have important detail buried on the left side of the graphic, likely to be lost in sensor's noise. (*See "Determine Digital Exposure" in Chapter 7.*)

The Histogram, Your Friend & Informant.

above: the Photoshop Histogram window with all colors showing.
top: an underexposed image, needing more light.
right: an overexposed image, needing less light.
bottom: a grayscale progression showing peaks for 10 tonal steps.

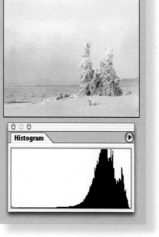

Three normal histograms.
left: a contrasty subject with a wide range of data.
center: a dark subject with a lot of dark values.
right: a pastel subject with few blacks.

Photoshop's Densitometer

In traditional photography, you knew someone was serious about their exposure and printmaking if they used a densitometer to measure film and print density. (Or at least you knew they cared about technique, which of course sometimes gets in the way of concentrating on the simple beauty of the potential image before you.)

In Photoshop, you now have a roving and instantaneous densitometer constantly at your disposal, in the form of your cursor moved anywhere over the file. You should learn to use it, and learn from it the state of your files, what they contain, and how to edit them.

Info Window

The Info Palette is the display for your roving digital densitometer. It should always be left visible. Anywhere you move your cursor, the digital brightness/color values of the image are displayed. When editing, the original brightness value is displayed, followed by a "/" with the new edited value. This can be very useful to know where your edit started and its current state.

Keep in mind that 0 is black with absolutely no detail, and 255 is absolute white. I generally try to keep some room on both ends of the tonal scale so as not to drive data to either extreme of black or white, holding information from about 15 to 240.

Selecting Color with the Eyedropper Tool

The Eyedropper tool is a color selector that can be used to click on any color or tone on the image and have it be selected as the foreground painting tool. Opt/Alt-clicking will select it as the background painting tool. Double-clicking on the painting color window will open the Color Editor, where you can edit the color for a different use, find a special Pantone® color to match a color in the image, or any of dozens of other reasons you may want to edit the color.

Color Samplers

Located as a sub-menu tool under the Eyedropper, Color Samplers are lockable measuring tools that allow you to monitor multiple critical areas for changes as you edit the file. They can be selected to measure multiple areas of concern, particularly those near black or white that you want to prevent from becoming absolutely devoid of detail. If you are in search of a neutral color balance, these samplers might also be used to track multiple near neutral areas as you edit them toward no color cast.

above: Photoshop's Info window displayed with 4-color samplers.
below: Photoshop's Info window in mid-edit state, with before and after edit numbers displayed with "/" in between.

A Tonal Primer

Understanding tonal editors and their effect on the image is critical to taking advantage of the image controls now available. Terms like highlights, midtones, and shadows need to be clearly understood in their photographic and digital meanings.

Although there are no precise cutoff points between these brightness ranges in an image, here are some general descriptions to help you get a sense of the range.

+ Highlights: the upper tonal ranges of an image, including white and light grays. Tonal range numbers would generally be the upper third of the values. In percentage 0%–33%, in 8-bit 170 to 255.

+ Midtones: the middle brightness areas of an image including lighter and darker midtones. Tonal range numbers would generally be the middle third of the values. In percentage 33%–65%, in 8-bit 85 to 170.

+ Shadows: the darker portions of the image including blacks and dark grays. Tonal range numbers would generally be the bottom third of the values. In percentage 66%–100%, in 8-bit 0 to 85.

In Photoshop, the Curves editor is the general tool for adjusting tonal range. Edits can be made anywhere on a curve. To understand the use of the Curves tool, it is helpful to start with a general tone point like midtones, and move it up and down to see the effect. Moving the tone point up and down with keyboard arrows can allow for much more careful edits than pulling the control point with the cursor (see "Photoshop Curves" later in this chapter).

To limit the edit's effect on other tone areas, it can be helpful to add control points (selected points on the curve) at the midpoint of each of these ranges. If you make a drastic edit, you may need to add and move adjacent tone control points to smooth out the curve and avoid odd appearances and apparent posterization.

If a particular area in an image is of concern, move the cursor to the area, Cmd/Ctrl-click on it, and a tonal control point will appear on the curve for your edit.

(Photoshop has Dodge and Burn brushes, but I rarely use them. Making a careful selection and then editing only the desired area for tone change can emulate traditional dodging and burning but with far greater precision and subtlety than the brushes provide.)

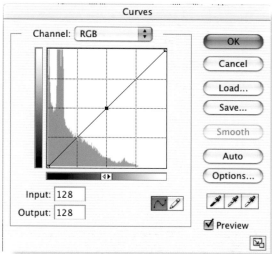

The Curves editor with histogram added to demonstrate the relationship between curve points and image density.

Highlights

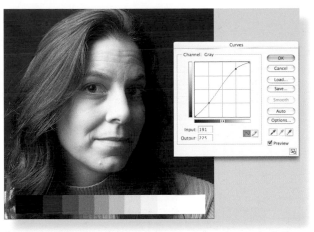

A highlight modification, lightening the upper values. A control point has been added at the quarter tones to prevent lightening the shadows.

Midtones

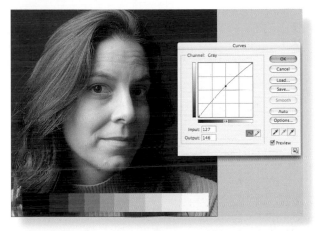

A lightening of the midtones without any additional control points, allowing a smoothed blend of the edit into shadows and highlights.

Shadows

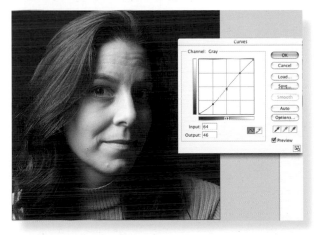

A shadow edit, slightly darkening the shadows. Control points have been added to the midtones and highlights so that they will not move with the edit. In this case, the midtones were also manually darkened a little to smooth the tonal transition from shadow edit.

A Layer Primer

Photoshop Layers were created to allow for the building of images on top of a base image for compositing, adding text, or editing adjustments. A Layer is a full-fledged image sitting on top of another image, or a full-fledged edit sitting above an image, all contained within the same file, and all changeable and editable as well as saveable and loadable. This feature is far more powerful than it may at first seem.

Assembling multiple images together in a controllable, rearrangable manner (compositing) is the primary reason Layers capability was created. It gives the user unique flexibility to execute any editing command on just the desired layer, leaving all other components of the image untouched.

You can create a new layer from the Layers menu or by simply pasting an image from the clipboard. You can select a layer by clicking on it in the Layers palette. It can be moved to another location in the layer hierarchy by simply clicking and dragging it to the desired location. Layers can be saved with the file in the Photoshop or TIFF file formats. Just remember, the more layers, the larger the file.

Layers Features

+ Transparency: refers to the ability to see through one layer to another. Some degree of transparency needs to be part of the layer. For instance, a small image may be brought into a larger file, all areas beyond the imported file's edge will automatically be transparent and will not block the Layer below. If it comes in with white edges, they will need to be selected and deleted to make the image blend into the image below. Transparency is set by default to display as a checkerboard pattern.

+ Lock: refers to the ability of Photoshop to keep the layer from being changed inadvertently.

+ Move Tool: allows the layer, (or, when selected, any component of a layer) to be moved.

+ Masks: a Mask is an image through which a Layer's effect is blocked, or passed through (much like masking tape blocks paint from going where you don't want it to). Any floating selection will automatically generate a mask (when a new layer is added) through which that Layer will be seen. The mask can be manually selected, edited, and viewed full screen under the Channels tab or by selecting Menu>Load.

+ Visibility: indicates whether effects of a layer are visible or not. Clicking the eye icon next to each layer in the Layers palette turns viewing of the layer on and off, thus allowing you to turn off the "effects" of a given layer.

+ Blending Mode: refers to the way the layers are composited. You can choose this from the pop-up menu in the layer palette. These are compositing modes for the Layer, from Darken to Lighten, Luminosity or Hue. (Coverage requires more possibilities than the space in this book allows.)

+ Opacity: provides simple control for varying the transparency or opacity of the layer.

+ Layer Sets: groups of layers you can create to organize complex layered files.

+ Layer effects: a variety of special effects which can be imposed on the image. For example, layer effects like Drop Shadow and Bevel can be particularly useful with text on images, to provide contrast difference and aid in readability.

Text Layers

Text is automatically entered into its own new layer in Photoshop and it stays suspended as an independent vector type layer unless it is flattened into the image. This means the type can be re-edited for content and style, as well as remain as a vector-based description of the type shape rather than a bit-mapped pixel-based rendition like the photo that sits below. This type layer can be kept this way for postscript printing or flattened into pixels to become a permanent rendered part of the image.

Adjustment Layers

Adjustment layers are like suspended edits on the image, readjustable in their editors (by double-clicking) and seen through editable masks and opacity. This is such a powerful aspect of the Layers implementation that the Layers capability would be worth having for this alone. (*See "Adjustment Layers" later in this chapter.*)

Layer Options and Modes

Blending Modes: calculation modes of how Layers are blended together

Opacity: degree of Layer or Layer Effect opacity as percentage or slider

Fill: degree of fill opacity of pixels in Layer as percentage or slider

Layer Lock Menus

Lock Transparent Pixels

Lock Image Pixels

Lock Position

Lock All

Visibility: turn Layer on and off

Mask: edit mask

Layer Group: groups of Layers

Layer Types

Composite Layer

Adjustment Layer

Type Layer: editable vector text

Layer Mask linked to Layer

Clipping Mask (with Option key on Layer border) to affect only Layer immediately below

Indicator of Adjustment Layer working only on Layer immediately below

Link Layers

Layer style: special effect, such as drop shadow

Mask: creates mask through which layer will operate

New Adjustment Layer

Copy Layer: duplicates Layer

Delete

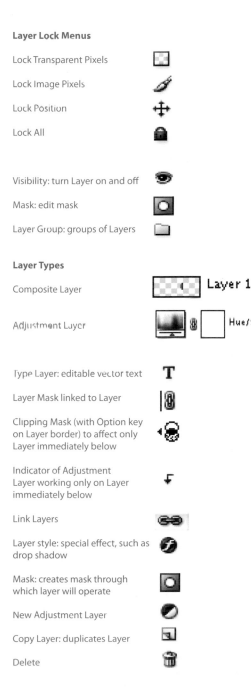

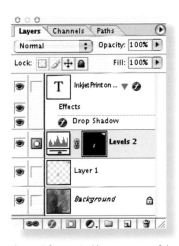

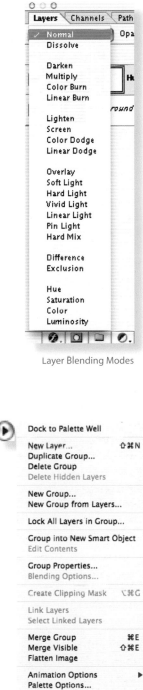

Layer Blending Modes

above: A few typical layers on top of the "Background" (base photo).
As you move up the palette you see:

—Layer 1 is a pasted-in image composited on to the image.

—Levels 2 is an Adjustment Layer that uses the Levels editor to adjust the file. It also has a mask automatically made from a floating selection when the layer was made. This limits the layer's effect to the white areas of the mask.

The "T" is a type layer, still editable, and here it has a Drop Shadow effect added.

below: a Layer Set shown and a list of possible Effects.

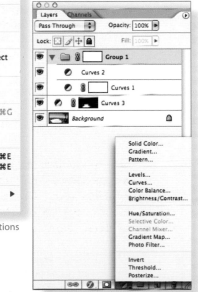

Layer Options

Type, Blending Mode and Effects

Martian Landscape with Type layer in Overlay Blending mode, and Type effects of
Drop Shadow and Bevel/Emboss.

A Few Simple Layer Examples

My normal use of Layers is Adjustment Layers using Curves, Levels, and Hue/Saturation to fine-tune the photograph. There is so much more that can be done that it seemed of value to include a few examples of how Layers can be used for color correction, blending, type, illustration building, and dodging/burning.

Many of my friends are quite good at compositing, for which Layers are extremely well-suited, and many of them use tens to hundreds of Layers for various corrections, tweaks, and sharpens. Simple though these examples may be, I hope these few are helpful.

Layer Groups and Visibility

left: Mars with RGB grayscale files assembled showing blue sky result. Group 1 set of color correction Curves turned off.
right: Layer group of corrections making the scene appear as NASA said it actually would if we were standing on the surface.
Group 1 set of color correction Curves turned on.

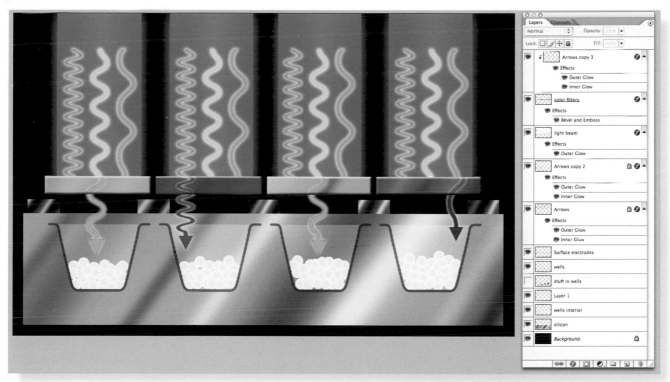

Bert Monroy's CCD Illustration from earlier in the book with all Layers revealed.

Dodge/Burn Mask

Soft Light 50% mask for dodging and burning with paintbrush tools.
bottom left: original scene.
right: painted 50% mask Layer.
bottom right: image seen through mask.

Levels

Photoshop's Levels tool is the ideal editor for a quick tonal adjustment of black and white points on the image. It is an endpoint and midpoint tonal editor, well-suited for controlling whites, blacks, and midtone brightness. (*See "Determine Digital Exposure" in Chapter 7.*)

In conjunction with its histogram display, the Levels editor has long been the place to start for quick inspection and adjustment of the darkest areas of the image (short of black), and at the opposite end of the tonal range, editing the brightest areas of the image to a brighter tonal rendition. In general usage, Levels allows you to quickly perform a slight brightening or darkening of the image with the midtone slider.

The Levels editor. The black and white triangles are endpoint tonal controls, while the gray triangle in the center is for midpoint control.

The Levels editor is a self-smoothing interface. If you move either a highlight or shadow slider, the midtone point will also move (even though the 1.00 number will not change), remaining the midpoint between your adjusted black and white points. This may not be what you have in mind, and you can restore this change by moving the midtone slider back until the image regains its original appearance in the middle values. The Preview box must be checked to see the edits.

The embedded histogram only graphs starting tonality, it does not update with your changes. The independent Histogram display window should always be left visible on the desktop to track edit effects on the tone distribution.

Levels Features

- **Endpoints**: these controls allow for adjustment of the black or white points in an image.
- **Input Levels**: the basic adjustment tools in Levels, operated either through sliders under the histogram or by entering values in the fields above the histogram.
- **Output Levels**: black or white Output Levels limit how dark or light of a value can be in a file. White Output Level can be brought down to "gray up" blown-out white areas and Black Output Level can "open up" blocked-up blacks from being totally black. A changed Output Level endpoint clips the blacks to grayer black, or whites to a grayer bright value.
- **Eyedroppers**: these color balance tools allow you to set any point on the image to black, mid-gray, or white. These values are defined by default as 0, 128, and 255. They can be custom set by double-clicking on the tool and entering new numbers into the RGB values, such as 15 for black and 240 for white to hold some tone.
- **Auto**: clicking this button causes automatic tonal correction mapping of the image to preset values.
- **Options**: controls the Auto Correction function. The tonal goal points can be changed from their defaults of 0, 128, and 255. More conservative ranges would be similar to my suggestion above (15 and 240 respectively).
- **Video Overdrive Preview**: holding down the Option key and dragging either the white or black endpoint will overdrive the video signal and allow you to drag the slider to quickly find the lightest or darkest point in an image.

 (*Color channels operations for color correction are discussed in Chapter 10.*)

Photoshop Curves

The Curves editor in Photoshop gives us many of the tonal adjustment controls we always dreamed of having in the darkroom. It allows you to shape the tone of your photograph, making independent and differing shadow, midtone, and highlight adjustments. Curve editors are extraordinary tools that have become very common in image editing packages.

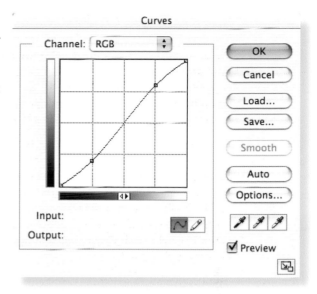

Curves Features

- ✦ Input: the original value before the edit.
- ✦ Output: the brightness value resulting from the edit.
- ✦ Curve Display/Inversion: the Curves editor can have either black at the bottom and read out in 0–255, or white at the bottom and read out in 0–100%. The arrow in the middle of the grayscale bar changes this display behavior. The graybar at the left indicates current orientation.
- ✦ Curve/Pencil: smoothed edits or free-form.
- ✦ Eyedroppers: these color balance tools allow you to set any point on the image to black, mid-gray, or white. These values are default defined as 0, 128, and 255, respectively. They can be custom set by double-clicking on the tool and entering new numbers into the RGB value fields, such as 15 for black and 240 for white.
- ✦ Auto: clicking this button causes automatic tonal correction mapping the image to preset values.
- ✦ Options: controls the Auto Correction function. The tonal goal points can be changed from their defaults of 0, 128, and 255. More conservative ranges would be similar to the suggestion above, with 15 and 240 respectively.
- ✦ Tone Point on curve: Cmd/Ctrl-click on the curve to create a point on the curve you wish edit.
- ✦ Control point limiters: adding additional control points to limit the movement of the tone smoothing functions of the Curves editor
- ✦ Cmd/Ctrl-clicking on an image problem area selects a location on the curve that can be used as a control point for correction.

(Color channels operations for color correction are discussed in Chapter 10.)

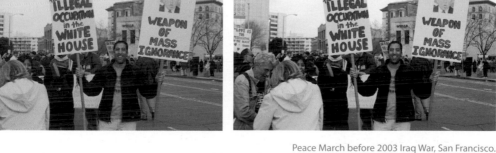

Peace March before 2003 Iraq War, San Francisco.
left: somewhat gray image holding detail in shadows and highlights.
right: image after editing with example "S" curve Curves edit shown at top of page.

Contrast and Curves

Traditionally, we changed paper grade when we wanted to change the contrast of a photographic print. A Grade 2 paper was considered normal, Grade 3 created images higher in contrast, and Grade 1 created lower-contrast images. These effects can be simulated easily in Photoshop with the Curves tool.

The Curves editor can vary the contrast of an image in many ways. A simple contrast change can be accomplished by moving the tonal end points (back and whites). To lower the contrast of an image (which is essentially a one-grade-lower paper effect), move the white input endpoint down from 255 to 241 (0 to 5%) the black from 0 to 10 (100% to 98%).

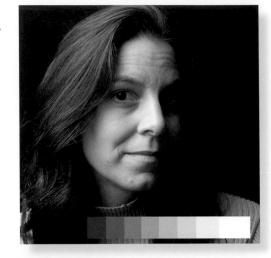

To raise the contrast of an image (as though moving to a higher grade paper), move the white endpoint (Input) over from 255 to 243 (0 to 5%), leaving the Output at 255 (0%), and move the black to Input to 13 (95%), leaving the Output at 0 (100%).

These numbers are just examples of slight contrast decreases and increases and will obviously change depending on your desired look.

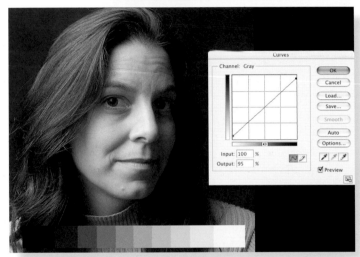

above: lower contrast by graying up black and white endpoints.
below: higher contrast by brightening white and darkening black endpoints.

You can make more drastic changes or changes that lower contrast in highlights while increasing it in highlights. Almost any combination is possible and bespeaks the level of tonal customization now possible with digital photography and image editors like Photoshop.

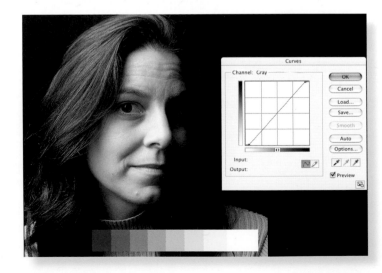

Adjustment Layers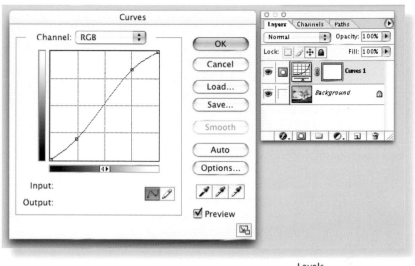

The arrival of Adjustment Layers made a dramatic step toward flexibility and iterative editing in Photoshop. This feature allows you to create edits that are held in suspension with an editing Layer, and can then be changed, masked, reworked for fine-tuning, and turned on and off, without actually editing the file.

A number of the image editing tools in Photoshop are available as Adjustment Layers, including the primary editors: Levels, Curves, and Hue/Saturation. An adjustment layer can be created from the Layers menu or by clicking on the New Adjustment Layer button.

The fundamental advantage of using Adjustment Layers is that they can be undone, redone, and fine-tuned in relation to one another. This makes iterative editing possible without the inherent data loss of multiple sequential edits, avoiding the possibility of trying to undo something that was done earlier.

Adjustment Layer Features

✦ To create an Adjustment Layer, go to the Layers palette and click on the white and black circle, which will cause the Adjustment Layer types to appear.

✦ Simply clicking the eye next to an adjustment layer turns visibility (and functionality) for the Layer on and off. Clicking on the editor icon reopens the editor dialog box for further work.

✦ Remember that standard Layer features like Opacity and compositing modes are also available for an Adjustment Layer. This further customization of the edit can make for extraordinary control.

✦ Layer on Layer Adjustments: any Adjustment Layer can be set to act only on the immediate layer beneath it. Move the cursor to the line separating the two layers, hold down the Alt/Opt key (the cursor will change to a double circle), and click. This can be undone by repeating the action.

✦ Masks: when an Adjustment Layer is invoked, any current selection will automatically generate a mask channel through which the new layer will work. This mask can be edited in place by selecting the layer and using any of Photoshop's image editing tools for custom mask modification. The mask can be loaded for careful editing by Opt/Alt-clicking on the mask. To return your view and edit to Normal Mode, Opt/Alt-click on the mask again.

Enlarging and Interpolation

In traditional photography, film size, enlarger height, and print tray/developing capabilities determined the size of the print. Digital file resolution and printer size are now the determining factors. A digital file can also be enlarged through software, but not unexpectedly, the image breaks down like an over-enlarged film original. The visual effect of the breakdown looks different, but, the image quality results can quickly become just as unacceptable.

If you simply make a big print from a digital photo, you risk revealing the underlying pixels that make up the image. Interpolation (accessible through the Image Size command in Photoshop) is the process by which a larger or smaller new pixel structure is made up from the existing data. No real information is added; the pixels do resize, although when the interpolation is dramatic, the newly formed smaller pixels can end up forming an image of the original pixel structure now fuzzy, rather than just a representation of the image.

Many people will find mild interpolation in the 1.5x range to be an acceptable loss of image quality. Interpolation beyond that gets ever more reductive of the original image content. Contrary to some software packagers' claims, you don't get great looking big prints from small files without consequence. The original resolution reveals itself one way or another. Ultimately, you will be the judge of what is acceptable or good, but I strongly encourage you not to lower your standards of photographic beauty in the desire for big digital wow.

Image Resizing

Resizing digital photographs up and down in size are common tasks in image editing programs. In Photoshop, Image Resize controls this process. This function can be used to make the file larger, or smaller, or simply recalculate the way pixels are measured. The Resample box must be checked for the data change. If you are merely telling Photoshop to assign a different ppi to the image, leave Resample unchecked.

Interpolation

Digital resizing is accomplished through interpolation, where existing pixels are the basis for making up new pixels. In Bicubic interpolation, a sample is taken from 16 points around an existing pixel, and the new pixels are created from that data. In Bilinear interpolation, the data is extrapolated from 4 points, and Nearest Neighbor interpolation uses the pixel immediately preceding or following the new pixel. Bicubic is considered to be the best of these basic approaches.

On occasion, you may need to make the image smaller. For instance, you may need to reduce size for 72 ppi web display or easy transmission. It's a simple task whose only real downside is the loss of detail resulting from having less information in the smaller file. Many feel that a dramatic downsize is better accomplished through a series of steps downward (perhaps in 50% steps) rather than a single calculation.

Enlarging your digital photograph is another matter. Slight upsizing (perhaps 10% larger) has only a mild impact on the quality of the photograph, but dramatic enlargement can quickly take a fine look-

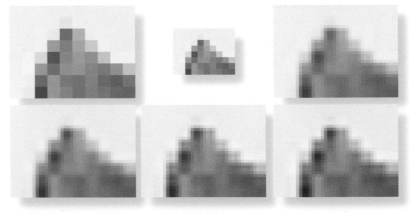

top left: nearest neighbor interpolation to 40x32.
top middle: original pixels 20x16.
top right: bilinear interpolation to 40x32.
bottom left: bicubic smooth interpolation to 40x32.

bottom middle: bicubic interpolation to 40x32.
bottom right: bicubic sharp interpolation to 40x32.

above: resized down for web display.
below: straight file at full size at 940x750
pixels@300ppi, 3.13x2.5 inches.
right: resized upward by 150%.

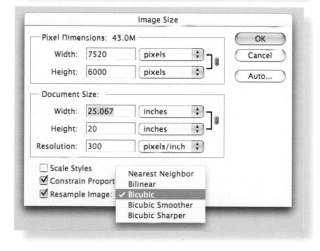

Creekbed and Cliffs. Katmai National Park Alaska, 1995. BetterLight 2mb prescan.
Forever Trapped as a Small File: My assistant Darin walked into the full res scan
as it was running. I threw it away and started over, only to find my battery power
was gone, leaving only this small prescan. I may have lost the photo, but Darin
remains a good friend.

ing small image and transform it into a blurry mess of undefined
detail and soft stair-stepping pixels. Finding that in-between point
is the key to making Image Size a useful feature rather than a tool
of self-delusion.

Resolution Calculator

The Image Size screen is essentially a resolution calculator built
into Photoshop. It is available under the Edit menu in Photoshop,
or any time you create a file.

1. Create a new file.
2. Enter the desired size and resolution (based on your print
 needs and tolerance for image breakdown; *see Chapter
 14*).
3. The file size results are shown beside Pixel Dimensions at
 the top of the Image Size dialog.

Sharpening Formulas

There are many ways of making up information, and
as one might imagine many ways to imagine data
that isn't available. From variations on bicubic, to
Sinc calculations, to fractal geometry, all are used
in existing products and have their converts. None
of these methods substitute for capturing the image
with enough resolution for your needs.

Image Size

Pixel Dimensions: 43.0M

| Width: | 7520 | pixels |
| Height: | 6000 | pixels |

Document Size:

Width:	25.067	inches
Height:	20	inches
Resolution:	300	pixels/inch

OK
Cancel
Auto...

☐ Scale Styles
☑ Constrain Proport
☑ Resample Image:

Nearest Neighbor
Bilinear
✓ Bicubic
Bicubic Smoother
Bicubic Sharper

Sharpening

The final appearance of an image is influenced by many things, with the apparent sharpness being one of the critical factors. There is no feature in any software that can bring into focus a photograph whose lens was not focused properly when the photography was made.

The Unsharp Mask (USM) function in Photoshop is an edge contrast enhancement tool. The filter looks for tonal changes in the image, then exaggerates the difference between them, controlled by the filter's sliders. This can give the appearance of a sharper, tighter image.

Unsharp Mask Features

✦ Amount: how much of an increase in edge contrast should be applied

✦ Radius: how far in pixels on either side of a contrast change the sharpen will be applied

✦ Threshold: how much of a contrast change must be encountered before the filter is applied (this can control sharpening of the image without undo sharpening of film grain)

Keep in mind that you don't have to sharpen all three channels of a color file in the same way. Many digital cameras suffer from noise in the blue channel of the color file, which can be exaggerated in sharpening. You can simply select one channel, sharpen it to your taste, and inspect the results.

Additionally, after a sharpen you can Fade the filter (under the Edit menu) through the Luminosity mode and reduce possible emphasis of color artifacts caused by the original sharpen.

There is no magic set of numbers for "ideal" sharpening. Factors that influence the results are obviously the sharpness of the capture or scan: the resolution of the file, film grain, or digital noise; the paper you are printing on, and naturally, your taste. I generally start with a sub-pixel radius, then increase the amount until it looks correct to me. On my high resolution scanning back photographs, I leave the threshold to zero, on film it usually goes up to 4 or 5. There is no gospel here; you need to experiment and discover the results that please you. Remember, over-sharpening can create image halos around hard tonal edges, outlining these areas in black or white lines.

Photoshop's new Smart Sharpen has a steep learning curve and we hoped it would simply address some of our concerns about control of light and dark contours. I've found it to be too unintuitive for general use, and that it does not directly address the challenges I face.

Alternatives to Sharpening in Photoshop

There are various alternative to Photoshop's sharpen functions. Some are "hand done," other solutions can be purchased as add-in filters or Photoshop Actions.

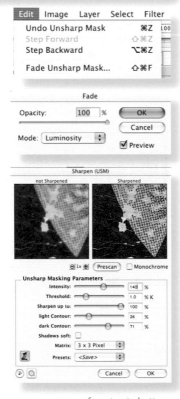

from top to bottom:
Photoshop's Unsharp Mask filter.
Previous Edit Fade option.
Fade using Luminosity.
SilverFast's Sharpen with light and dark contour control.

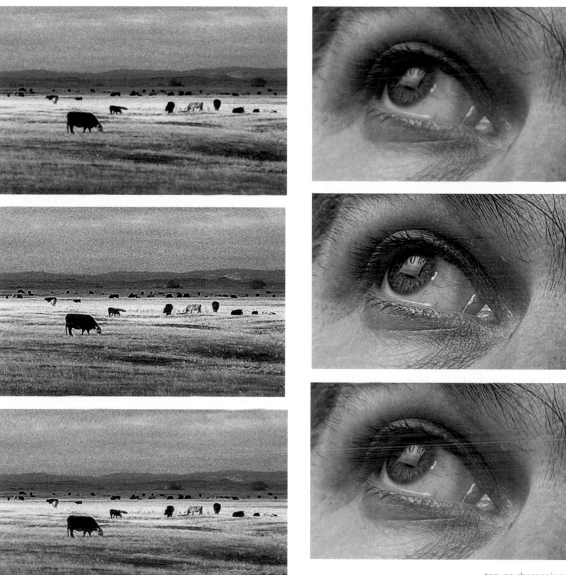

top: film scan, no sharpening.
middle: film scan oversharpened.
bottom: film scan with what seems to me like about the right amount
of sharpening.

top: no sharpening.
middle: too much sharpening creating halo.
bottom: seems to me like about the right amount.

One manual technique involves using edge selections as sharpen masks by using the Find Edges filter under Filter/Stylize on a duplicate Layer, creating a Luminance mask, inversing the selection, and sharpening your underlying file through the selection.

A variety of sharpening software packages and Actions that are tuned for different conditions are offered from different companies. References to SilverFast HDR, PixelGenius PhotoKit Sharpener, and NIK Sharpener are listed in back of this book.

Creating Black and White from Color

Deriving black and white photographs from color images has a long history, ranging from the straightforward to the strange. For instance, internegatives (film copies of negatives or slides) have been made from color film and copy negatives from color prints. At one point Kodak Panchromatic Black and White paper was developed in order to print color negatives, sensitive to all colors to accurately reproduce the encoded color tonal qualities. Of course it could not be used under normal black and white darkroom orange safelights, because of the paper's broad color sensitivity.

In a sense, the proliferation of dedicated color cameras made the task of creating black and white images more difficult, or less direct at least. We could no longer simply put black and white film in the camera.

With a few exceptions, digital cameras come built to separate color into its primaries and make color photographs. Consequently, those lovers of black and white have to create color files and then transform them into black and white. Many cameras automate this process by allowing the user to select black and white as a final product, often delivering an interpolated and processed RGB file with the saturation simply brought down to zero.

Today the digital darkroom makes these tasks simple, but you are still able to employ nuances of tonal translation beyond most of our darkroom imaginations. A number of tools can create this transformation, from a simple RGB to Grayscale conversion, a Hue and Saturation change (–100 saturation), to Channel Mixer, to Duotones. Additionally, some software packages like Kodak's Photo Desk allow for deriving black and white photographs from the color images by modeling the processing after traditional black and white film/filter combinations. The BW Wratten #25 processing "look" gives the effect of black and white film taken through a dark red filter.

Cassie Rashleger, 2005. Photograph by Michelle Perazzo.
above right: full-color photograph.
middle: 100% red channel color
information used to create black and white image, as in Channel Mixer control on its right.
bottom: a blend of red (30%), green (35%), and blue (30%) channels for a more custom look as shown in control to the right of the photograph.

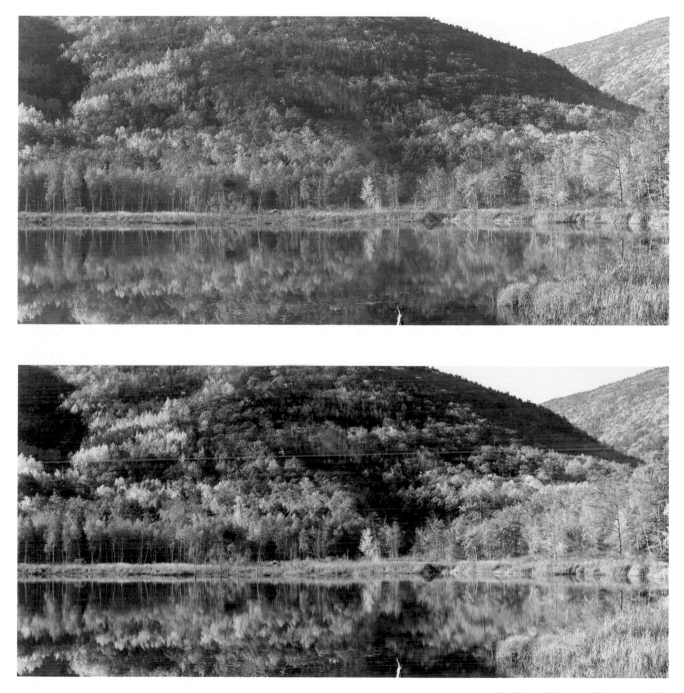

Pond, Acadia National Park, Maine, 1995.
Color file, black and white photo derived from only the red channel.

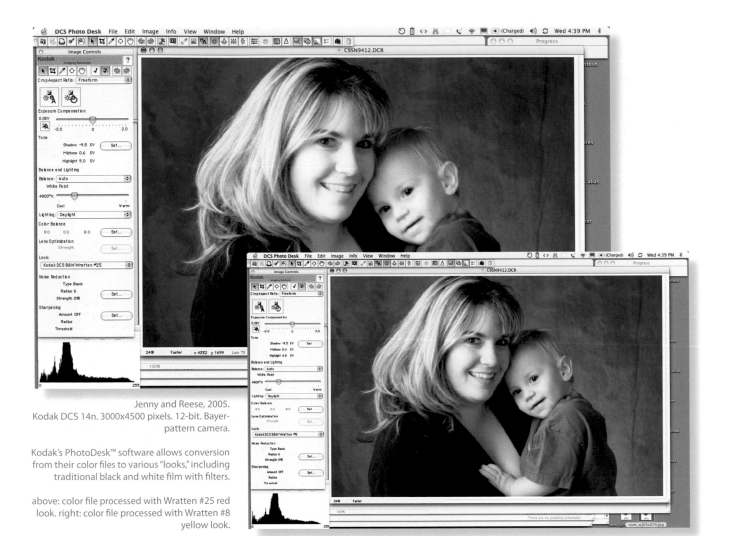

Jenny and Reese, 2005.
Kodak DCS 14n. 3000x4500 pixels. 12-bit. Bayer-
pattern camera.

Kodak's PhotoDesk™ software allows conversion
from their color files to various "looks," including
traditional black and white film with filters.

above: color file processed with Wratten #25 red
look. right: color file processed with Wratten #8
yellow look.

left: Simple black and white conversions, using Channel Mixer
with Monochrome box checked.
above: The most common method is to use Hue and
Saturation with the Saturation slider down to -100.

Matt at Joshua Tree, 1997.
Kodak DCS460M. 2000x3000. 12-bit monochrome camera.

Black and White Digital Originals.
Digital black and white cameras have actually been made. The original Kodak DCS 100 and 200, the 460m, and 760m as well as infrared versions, were sold mostly for government survey work and law enforcement. A design like the Foveon X3 chip gives a good starting point by not sub-sampling the pixel resolution of the sensor, allowing for a full-resolution black and white image to be derived without color processing.

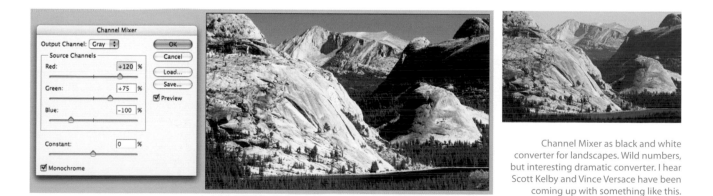

Channel Mixer as black and white converter for landscapes. Wild numbers, but interesting dramatic converter. I hear Scott Kelby and Vince Versace have been coming up with something like this.

RAW Files and Adobe Camera Raw

For the first few years of digital cameras, JPEG was the only picture-saving option in many cameras. As a compressed format with permanent data loss, this was not an acceptable format. Eventually, many of us working in the industry were able to convince camera makers to support uncompressed files, but they were implemented as fully processed TIFFs and therefore were big and slow to save.

In the early 1990s, Kodak, Leaf, and BetterLight pioneered in what has generally become known as a "RAW" format—holding onto their camera data and building software to process these "sensor dumps." In response to many of our requests, additional camera makers have started incorporating a raw archive format into the file saving options in many cameras. Adobe has even created a documented standard for Raw files known as DNG (Digital Negative), and many companies ares starting to support it.

Preserving the data that the camera sensor can record is a very high priority for pulling every nuance of photographic information from the camera and for long-term options to reprocess and later improve the image as software improves.

The Camera Raw plug-in for Photoshop is Adobe's contribution toward a universal interface for accessing and interacting with a variety of camera manufacturer's RAW/archive formats. The following settings from Camera Raw's Advanced menu give you access to some very powerful tools.

Camera Raw automatically launches when you double-click on a supported RAW file format from Adobe Bridge.

General Tools

+ Histogram Display: graphically displays each color's brightness values in the image.

+ Settings: provides camera processing default settings, previous conversion or custom conversions you've set up, or new settings you want to save.

Workflow Options: Image Size Space and Depth

+ Space: set your working color space, such as Adobe RGB 1998, to transform the photo into.

+ Size: choose pixel dimensions, either native to the camera (no + or –), size reduction (–) or size increase (+).

+ Depth: choose 8 or 16 bits; if camera is more than 8 bits of data, select 16 bits to save more of the tonal distinctions of your original file as processed.

+ Resolution: set the ppi ruler unit you want attached to your pixel dimensions.

Tools Palette

+ Color Sampler/Neutralize: sample RGB values displayed or force gray balance of color under curser when clicked. Can also be used with the Cmd/Alt key to create Tone control points on Curve editor.

+ Magnifying (Zoom) Tool: zoom in or out on the image; can be clicked/dragged.

+ Hand Scroll: scroll around the image.

+ RGB Densitometer: displays RGB brightness values under cursor.

+ Color Sampler Tool: a lockable densitometer to track edits.

+ Crop tool: allows freehand and proportional cropping at the RAW level, undo with Clear Crop on dropdown menu from arrow.

+ Straighten Tool: draw line along lines in image to be leveled, i.e., horizons.

+ Rotate: rotate the image clockwise or counterclockwise.

Additional Tools and Controls

+ View Percentage: view percent of image magnification or reduction.

+ Preview: see adjustments as you make them.

+ Shadows/Highlights: click to colorize areas of the image driven to pure black or white.

+ Calibrate Tab: fine-tune color adjustments for your camera. Can be saved for later use.

Adjust Menu

+ White Balance: set the basic starting point color adjustment settings (Auto, As Shot, Daylight, Tungsten, Fluorescent).

+ Temperature: make basic manual color adjustment from red to blue.

+ Tint: fine-tune color adjustment from green to magenta.

+ Exposure: control basic image appearance, drag left to save highlights.

+ Shadows: control shadow blackness or grayness.

+ Brightness: set overall brightness of the upper tonal range.

+ Contrast: set relative intensity of blacks and whites.

+ Saturation: set color saturation (intensity).

R: 174 G: 141 B: 115

The RGB Densitometer.

The Calibrate tab.

The Adjust tab.

Raw Dynamic Range Expansion

Adobe's Camera Raw plug-in has opened up many cameras' RAW file formats to a wide audience of digital camera users. This software is a great step forward, providing a standard interface and encouraging photographers to save and take advantage of all the information the camera's sensor can provide.

However, working with very contrasty photographs still presents a problem. Barely held highlights and important detail in the shadows can be difficult to preserve with Camera Raw and therefore be difficult to edit effectively in Photoshop. Dynamic range expansion is possible with a single contrasty image and Camera Raw.

The following procedure solves this problem, processing two versions of the photograph in Photoshop (one preserving highlight detail and the other shadow detail) and then combining them simply in Photoshop Layers by means of a Luminance Mask selection. (Of course, this same technique can be used for combining two different exposures from the camera.)

1. Process the image in Camera Raw so that it has good open shadow detail (blown highlights are OK). Keep the file in 16-bit mode.
2. Copy the image to the clipboard and close the file.
3. Reprocess the image so that it has good highlight detail (blocked shadows are OK).
4. Paste the shadow detail image from the clipboard into the highlight detail image, creating a new layer.
5. Turn off viewing of the top layer (shadow detail layer).
6. Select the bottom layer (highlight detail layer).
7. Create a Luminance Mask from the bottom layer (Load Channel as Selection from Channels palette).
8. Select the top layer and delete the now-selected blown-out highlights. Next Select None so that there is no selection.
9. Double-click the Background layer in the Layers palette (to rename and unlock), which will enable Opacity adjustment for both layers and allow custom tonal balance adjustments.
10. Edit for the desired appearance.

Load Channel as Selection from Channels palette.

right top: compromise processed from Camera Raw.

right middle: processed for shadow detail.

right bottom: processed for highlight detail.

Composite of highlight and shadow processing.

Photoshop History

The History option in Photoshop lets you go back in time on your photographic journey through image editing. You can either return globally for entire image restores, or you can use the History Brush to paint in local corrections back to an earlier state. Photoshop Histories disappear when the file is closed, so even if you have accidentally saved a flattened file, don't close it, as all of the history states are still available as long as the file is still open.

History States

Under General Preferences, you can set the number of History States that Photoshop will hold onto. The default is 20; I usually reset it to 200. The larger the file, the more edits and the more memory it consumes, but there can be a kind of digital salvation in having the option of going back in time.

History Brush

You can paint History states back in for precise restoration using the History Brush. First, select the state you wish to paint, then select the History Brush and paint away. This tool can be controlled like any other brush for size, shape, hardness, etc.

Kids and Feet, 1995.
Kodak DCS 14n.
3000x4500 pixels. 12-bit.
Bayer-pattern camera.

The intended effect on the image was to make the photograph black and white, except for the kid's feet and socks. I used the History Brush here to selectively paint the color back into a desaturated photograph. The history source was the state just before the desaturate action, then the brush was used to paint the color back in on the desired areas. This could also be done by painting on a Hue and Saturation Layer Mask.

Spires and George, Mt. Rushmore National Monument, 1997.
BetterLight Scanning camera. 6000x7520 pixels. 12-bit. Tri-linear Array.

Chapter 10: Color Correction and Editing

*It is the eye of ignorance
that assigns a fixed and unchangeable color to every object;
beware of this stumbling block.*

—Paul Gauguin

We see in color, and we mostly photograph in color (despite the fact that many of us love black and white). Color relationships and basic principles of image editing are critical to interacting with digital color photographs. In this chapter, we'll explore advantages of high-bit depth color, color fidelity, and color relationships as they relate to image acquisition and editing.

From an archival standpoint, special consideration should always be given to preserving color information and color differences for later use, as tastes and needs change. This argues for a high-bit depth workflow and the use of Adjustment Layers for edits that may need to be altered for other uses. The following pages explore light and color, color editing, and Photoshop's color editing controls.

Digital Color Basics

There are some key issues and opportunities to keep in mind when working with color in digital images.

Quick Correction

The Variations tool in Photoshop allows for a quick preview and correction of various color and tone corrections that guide the less experienced user in the direction of the correction they might be seeking. It is essentially a digital reconstruct of the traditional color ring-around test procedure that helped photographers achieve the correct color filtration for color darkroom printing, except with far more power.

Detecting Color Casts

Sometimes it is easy to see that the photograph isn't right but difficult to tell exactly what is wrong. Looking for casts in neutral gray areas can sometimes give you the needed clue. A traditional color filter viewing kit from the darkroom days can also be of help; just by looking through the filters you can see what makes the photograph better. This is particularly true of prints, where the image is fixed onto paper and you can no longer adjust the file with software. Photographing a spectrally neutral gray card with your scenes can help provide the needed starting point in the digital image. (*See "Basic Digital Camera Techniques" in Chapter 7.*)

Editing Neutrals

If you can see that there is a color cast in an area that should be gray, you can use the Info palette in Photoshop to provide a readout of the out of balance of RGB numbers. A gray should be equal values of RGB numbers, all the same, regardless of

My old darkroom Color Ring-Around cardboard and tape printing easel. The windows allowed a combination of color balances to be exposed onto paper a single sheet of paper. 5 seems to be missing.

Photoshop's Hue and Saturation control.

top: The Variations editing control modeled after the traditional color ring-around.
bottom left: Sara doing MacBeth chart-holding duty.
bottom right: Monitor being calibrated by X-rite's Monaco Optix.

whatever brightness they may be. You can then edit the file to lower or raise the number that is out of balance to whatever balance you need. Achieving that neutrality is a good starting point for most color correction.

Sometimes the middle balance tool in Levels or Curves will snap the balance into place. Other times, careful hand-editing, sometimes even in the Lab space, is needed, where the A and B channels can be edited to make an area dead-on zero for neutrality. *(See "Photoshop's Densitometer" in Chapter 9.)*

Calumet's Lee Color Print Viewing Filter Kit.

Adjustment Layers for Color Editing

Most of your edits in Photoshop should be done as Adjustment Layers. These layers allow a correction edit to float above your file, acting as a portal through which to view the edited image. They are essentially edits held in suspension, ready to use, held as edits in progress, or flattened onto the underlying image to execute a permanent implementation of the change. *(See "Adjustment Layers" in Chapter 9.)*

Problem Photographs

Both of these photographs from my national parks project have proved to be very difficult to edit and print. The color corrections in both cases always seem to come down to the green/magenta balance.

The Yellowstone Travertine really does have some neutral grays in the flow near the right tree, and it has to print neutral or the whole print is off.

The Mount St. Helens photograph always needs the special attention wherever dirt is present, the green/magenta axis is always in play; if either is off, the dirt just looks wrong. Many hours have been spent riding that very delicate edge.

The primary colors,
red, green, and blue,
combining to make white.

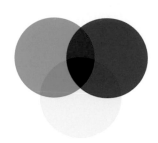

The secondary colors, (or subtractives)
cyan, magenta, and yellow,
combining to make black.

Light and Color

Most of us learned in Finger Painting 1A that the primary colors are red, blue, and yellow; but these colors refer to pigment and paint rather than light. In fact, the primary colors of light are red, green, and blue. Thus, objects appear as a certain color because they absorb some of these primary colors and reflect others. A red object appears red because it is absorbing green and blue light, while reflecting red toward your eyes. White paper reflects all three primaries equally, making it appear white, while black absorbs all three. A yellow object reflects equal amounts of red and green while absorbing blue. Intermediate colors are made up of varying combinations of the three.

Secondary colors are the opposites of the primaries and consist of equal amounts of their adjacent primaries on the color wheel. Thus, cyan contains equal amounts of blue and green, magenta contains equal amounts of red and blue, and yellow contains equal amounts of red and green. Most color editing interfaces adjust the balance between the primary color and its opposite, or secondary color.

The secondary colors are also known as subtractive colors, because they are the opposite of the primaries, they absorb red, green, and blue. Subtractive colors (cyan, magenta, and yellow) are used to subtract primary colors from the white of paper or the light of a projector. Consequently, subtractives are used in printing processes, color transparency film, and color photographic paper.

Color Filters
A color filter will transmit (lighten) its own color and absorb (darken) others, completely blocking its opposite on the color wheel. That is why a red filter appears red—it lets red light through while completely blocking cyan. This selective absorption and transmission allows the colors we see to be separated into three black-and-white images, encoding light into a full-color image.

Computerized color images are created by three separate black-and-white images, one each through a red, green, and blue filter, encoding human vision color into three filtered black-and-white images. These three images are colorized and combined by the computer to give the effect of a full-color image on the computer's screen. When you edit color, you are essentially editing individual black and white channels, emphasizing or de-emphasizing red, green, or blue.

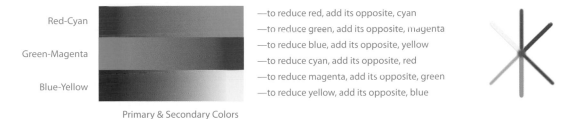

Red-Cyan

Green-Magenta

Blue-Yellow

—to reduce red, add its opposite, cyan
—to reduce green, add its opposite, magenta
—to reduce blue, add its opposite, yellow
—to reduce cyan, add its opposite, red
—to reduce magenta, add its opposite, green
—to reduce yellow, add its opposite, blue

Primary & Secondary Colors

Basic Principles of Color Editing

Here's a list of the basic principles for color editing:

- Everything is in the scan/photograph. Make it the best it can be from the beginning. Don't assume you will fix the image in editing.

- Use neutral, predictable room light in your work environment.

- Use, a neutral gray screen background so that the screen background color does not influence your color editing decisions (adjust the background in the monitor/display controls).

- Include a neutral gray patch (from a spectrally neutral gray card) in the scan when possible to ease your detection of color casts.

- Know your colors: familiarize yourself with the primary colors of light (red, green, and blue) and their opposites (cyan, magenta, and yellow). Most of your color editing decisions will be based on these relationships.

- View proofs in known light, 5000–6500°K light (daylight color films are balanced to 5500° digital cameras daylight color temperature tag is usually 5000°), and/or in a variety of real-world situations.

- For film scans, correct film's idiosyncrasies: color film has inherent color biases that can and should be corrected—excessive blue in shadows, color shifts from long exposures, mixed color temperature light sources within an image. Be aware of these common problems and correct them whenever possible.

- Calibrate your monitor with instrumentation. The goal is to have a predictable relationship between your output print and the screen in real working conditions (color temperature and ambient light). You can execute a visual monitor calibration, Adobe Gamma software supplied with Photoshop, or the ColorSync Display Calibrate control on the Macintosh.

- Sharpen after color editing. Color and tonal transitions may otherwise be overemphasized and require you to do additional editing on your image.

- Spot dust and fix other flaws after sharpening or you may miss flaws revealed by the sharpening, forcing a re-examination of the image and thus more spotting.

- Convert RGB to CMYK: If the file is needed for prepress or dedicated CMYK printer, convert RGB (red, green, blue) image to CMYK (process printing inks color separation of cyan, magenta, yellow, black) as a last step. Know what kind of CMYK is needed. Avoid editing CMYK files through your RGB monitor if possible.

- Everything is in the scan/photograph. Don't assume you will fix the image in editing.

Gretag MacBeth's Sol Source daylight viewing lamp.

Color Balance

Color Balance

Color Levels: 0 0 0

Cyan ——————————⊙—————— Red
Magenta ———————⊙————————— Green
Yellow ————————⊙———————— Blue

OK
Cancel
☑ Preview

Tone Balance
○ Shadows ⊙ Midtones ○ Highlights
☑ Preserve Luminosity

Photoshop's Color Balance dialog box.

Hue and Saturation

Although I do most color cast and color corrections in Curves or Levels, the basic color control in Photoshop remains the Hue and Saturation editor.

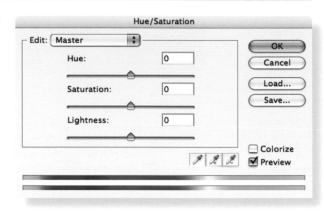

Primarily, this control is used to globally raise or lower saturation (intensity or vividness of color) according to the photograph's needs. However, its selective color saturate/desaturate capabilities allow for a very handsome fine-tuning of color that may not be off color, but simply out of balance in terms of its relative "colorfulness."

In my judgement, it may also be one of the most misused of Photoshop's capabilities, as saturation is often cranked up in an attempt to replace content of substance with vivid color. Here is a run-through of the Hue and Saturation controls in Photoshop:

+ Edit: this is where you choose the channel you want to work with. Master acts on all channels of color, the remaining selections in the pop-up list are the primaries and secondaries. Any color you choose within the image can be added to this menu, but it only allows six choices so that making new choices forces reassigning the presets.

+ Hue: at 0 this slider leaves the basic hue cast of the image unchanged. Sliding either right or left moves the hue balance of the image toward the color depicted in the spectrum display at the bottom of the editor window. These changes can be done for all colors, for any selected color range, or for a floating selection or layer within the image.

+ Saturation: changes the intensity of the color on an axis, from a grayscale rendition at –100 to an overdriven, acid-trip-looking mess of completely saturated color at +100. (Not that I have an opinion of its overuse.)

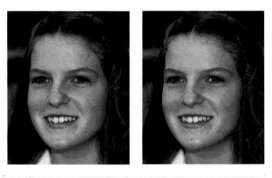

+ Lightness: allows pastels or shades of a color to be controlled.

+ Colorize: is mostly used as an overdrive of black-and-white images to full saturation of whatever color you choose, including a black-and-white tint look when saturation is brought down.

Selecting Colors to Edit

A range of color can be edited in the image by using the eyedropper to select colors within the image. Select an individual color from the drop-down menu rather than from the Master, then click on the image to select a color. You can also slide the range indicators to control range of edit and blend. Additional colors can be added or subtracted from the edit with the + and – eyedroppers.

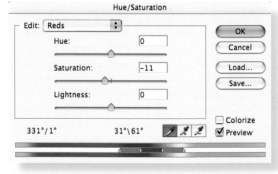

Color range selected by choosing Red, then clicking on a flesh tone in a portrait resulted in the creation of the above range.

Using Curves Tool As a Color Editor

Although the Hue and Saturation control is used for many color edits, my main color correction tool is Curves. The Curves editor is primarily a tone editor, but when individual color channels are operated on, it becomes a powerful color correction tool.

You can make global color corrections simply by going to the channel that most closely matches the problem color (or go to the one that is the opposite on the color wheel). Start with a midtone shift in the opposite direction from the color cast. Look for neutrals in the image and monitor their change. It can be very helpful to set Color Samplers at various locations of concern so that you can easily monitor their change. (See "Photoshop's Densitometer" in Chapter 9.) Including neutral grays in the image can be very helpful in using the automated color balance midtone eyedropper. With the midtone eyedropper, click in the area that should be neutral gray to attempt a Photoshop auto neutralization. Better yet, photograph a small neutral gray card in a separate photograph made at the same time and use it as your balance source. (See "Determine Digital Exposure" in Chapter 7.)

above: slight color correction in the red midtones
below: slight yellow increase in the shadows

Here are some common problems to be on the lookout for and ways to address them:

+ Mismatched Lighting: the most common color cast problem is mismatched lighting and image processing. Acquiring RAW images and processing them according to your tastes in Camera Raw should take care of most issues. But for almost any other source, you may need to correct the color from the way the photograph was made into a more natural rendition.

+ Not Daylight: shade subjects made with daylight settings often require editing back a strong blue cast. Simply adding yellow may take care of the issue, but the cast may be more complex with additional blue being present in the deep shadows and something more of a cyan cast in brighter affected areas. A Blue channel Curve Adjustment Layer that adds some yellow in the midtones, and perhaps a bit more yellow in the shadows might help this problem. A Red channel edit may also be needed to add some red (counteracting the cyan cast) in those brighter areas. Of course, if some daylight was present and recorded normally, it will need to be left unchanged by excluding that area from your edits with a pre-created or post-painted mask.

+ Blue Shadows: another common problem with film scans is blue color casts in the shadows. This might be addressed by going to the Blue channel, setting control points on the midtones and highlights so as not to affect those areas, then Cmd/Ctrl-clicking on the image's problem area. This selects a location on the curve that can be used for correction. Most color casts are slight, and small movements of the curve control point with the up and down arrow keys are often sufficient to accomplish the task.

Changeable Edits
Remember, if you execute your edits as Adjustment Layers, they can be continuously re-edited with no data loss and viewed in context with the effects of other Adjustment Layer edits.

Additional Color Controls

Color corrections can be made from a variety of places within Photoshop. You can make everything from a gross to a subtle change, and no particular path is the absolute "right" way of doing things. Many of these edits work best when at least a rough selection is made of the areas of concern. Some editors are specifically designed so that you do not have to make a selection. The image's needs and your intentions determine whether changes to narrowly defined geographic areas within an image or broader image-wide changes are in order.

Color Balance

The Color Balance editor is an underrated and very useful tool for quick color correction. Its individual controls for each primary and secondary color, combined with its quick shadow, midtones, and highlight tone range buttons, make it very powerful.

It is true that more careful and controlled edits can be made using Curves as a color correction tool, but it is impressive how often some very simple moves in Color Balance take care of problems.

Replace Color

A specific color replacement may be called for, and Replace Color might provide just the power you need. This is often used for the purpose of changing product colors (clothes and cars in a catalog, for instance) or other such digital tricks. But it can also be very useful for correcting a color where the film or digital camera simply failed to reproduce a color correctly.

The Fuzziness slider enables a range of color to be affected and can be added to or subtracted from with the plus and minus eyedroppers. Although this editor is designed to allow you to work without having to select the color with selection tools, selecting a general area of concern helps the process along by reducing the likelihood that an unnoticed similar color elsewhere in the image might be affected unintentionally.

Selective Color

If the red is red, but not quite the right red (or any color for that matter), this tool might do the trick. It allows you to fine-tune a particular color with great precision. Very subtle skin tone corrections can be made (usually by editing reds), and whites and neutrals can be edited for subtle corrections of slight color casts.

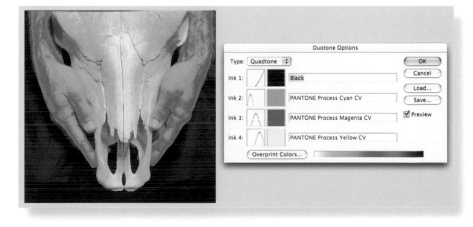

Match Color

This is a powerful editor for matching color between files. It is often most useful on flesh tones, where differing sources and processing make a set of portraits disconcerting in the skin color differences, even with the same people in the frames.

Duotone for Special Effects

Although not what this tool was intended to do, Duotone has proven very useful as a creative colorization tool. Whether you're using duotones to create special separations for screen printing or simply as a tinting tool for black-and-white files, this editor is very flexible. Keep in mind that the Duotone mode was designed as a prepress feature to create multiple printing plates. If you use it as a colorization tool, the file will need to be converted to RGB so that desktop printers can understand the file being sent.

Photoshop's Duotone feature used to colorize an image for special effects. An approach like this could be used to create photo silk-screen separations, previewing the inks in place.

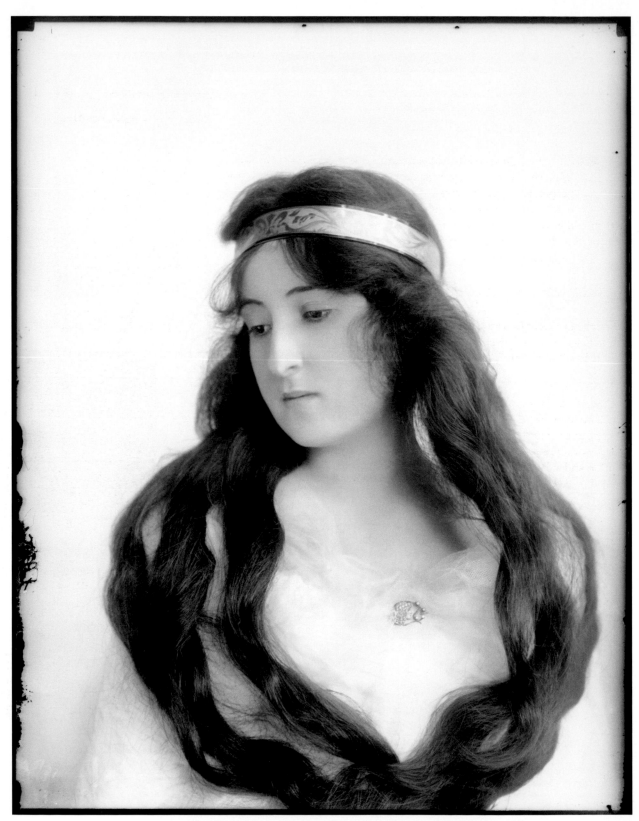

Portrait with Braided Hair, Merced County, California, circa 1920, Frank Day Robinson. From the collection of Stephen Johnson.
8x10 glass plate scanned with Linotype Circon Scanner and SilverFast scanning software. Scan and restoration ©2006 by Stephen Johnson.

Chapter 11: Restoration

Most history is guessing, and the rest is prejudice.

—Will and Ariel Durant

Messing with history causes really bad karma. It devalues the very work we are trying to "enhance." Antiquity is not merely about charming quaintness, it is about real people who lived real lives with very real loves and sorrows. The impulse now to process them into contemporary notions of "restoration" in Photoshop should be exercised with restraint, great care, and respect for actual image content. Anything less misses the point and turns our visual history into mere decoration and historical fiction.

Avoiding Historical Fiction

Wm. Newton & Martha Texas Owens, circa 1880s.
An example of airbrushing replacing family history.

I've worked very hard over the years to restore family and historical works with very careful judgements and much restraint. A restored photograph with veracity is rarely perfect. It will likely still show signs of wear and age, and perhaps it should.

Damage

Print tears, stains, and scratches are the most common problems with old photographs. In patches of empty sky, heavily textured cloth, or some studio backgrounds, much of the problem areas can be minimized without much fictionalizing. The limits to which any spotting or restoration goes is always going to be a matter of individual judgement calls. Caution and a deep respect for whatever "truth" might be contained in the original are not bad guides.

Color Scanning As Tool

Often, the very damage needing repair may be different in RGB channels, thus giving us a chance to repair an image by tapping information still intact from the original.

Using the photo to the right as an example, you can see that many of the problem stains are magenta in color, therefore, the Green (magenta's opposite) channel of a color scan encodes most of the problems. By using the Red and Blue channels, most of the stains can be "removed" simply by channel copying, with the real information from the photo replacing the problem areas in the Green channel.

Carnival Photo, 1937. Elvira.
top: original photo with magenta stains.
far left: green channel showing stains.
left: red + blue channels combined with most stains gone.
above: restored file from red and blue, then re-colorozed.

Dust Removal

Dust is the photographer's enemy. Age, dusty negatives, and corrosive droplets of time and general material existence on the planet seem to add more problems. The digital tradition up to this point has been to use the Rubber Stamp tool to clone nearby pixels onto the area of dust. This works fairly well and is still often the only way to deal with many problems. But there are other ways.

Auto dust removal as in the Photoshop feature Dust & Scratches can be helpful but often does too much where it is not needed in order to get it to do work where it is needed. You can finesse this through use of multi-layered Photoshop files, duplicate the image into two identical layers, apply a careful but assertive use of the Dust & Scratches filter on the bottom layer, then use the Eraser tool to punch a hole through the top, unfiltered layer to the "auto-retouched" layer below. Thus, you end up using the image itself to self-spot.

1. Duplicate dusty file by dragging the image layer to the page icon on the Layers palette.
2. Turn viewing off for the top layer, then select bottom layer.
3. Run a fairly aggressive Dust & Scratches filter on the bottom layer, being careful to make the Radius large enough to get most of the spots you need to lose, then dial the Threshold up to as high as you can to bring texture back without preventing your dust removal.
4. Turn viewing back on for the top, unretouched layer, and then select it as the active layer.
5. Use the Eraser tool to erase your dust spots on the unfiltered top layer. This will let the dust-removed layer show through from underneath. Your brush will likely need to be hard-edged so as not to blur grain.
6. Flatten layers when done.

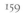

John and Martha, 1914. 4x5 copy negative from postcard photo, scanned with Leafscan 45. Scan and restoration ©2006 by Stephen Johnson.

Dust & Scratches on bottom layer having erased through original as explained on the previous page.

Unspotted detail.

Finished scan detail.

Dust & Scratches filter 4.

Dust & Scratches filter 7.

Restoration Case Study: The Central Valley Book

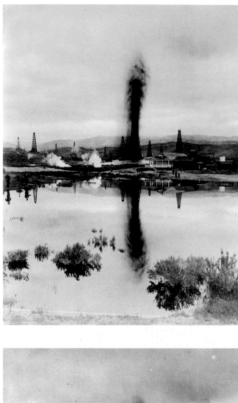

Lakeview Gusher, Kern County, c. 1910.
Photographer Unknown.
Scanner: UMAX 1200 flatbed scanner. Source Image:
5x7 black-and-white copy print.
top: restored. bottom: original.

One of the real pleasures of doing the Central Valley book was the publication of photographs from the 19th and the early 20th centuries—many of which had never been published before. The desktop technology that enabled restoration of these wonderful old images came into being in 1989–1990, just at the time I needed it.

Using Photoshop on the scans, I was able to restore cracks in glass plate negatives and remove stains, mold, and scratches. Photographs with considerable fading were also brought back to life.

The obvious ethical question that arose was, what is appropriate to do during restoration and what should be left alone? My fundamental guideline was this: no real objects could be added or removed from a photograph. Thus, painting in missing feet or mountains was unacceptable, but repairing damage was not. (I follow the same basic guidelines with my own photographs. I will certainly spot a print with brush and dye to remove dust that may have been on the film or paper. I will do my best to make detail visible. I will work very hard to make the image color accurate and as beautiful as possible.)

I know that beauty is highly subjective, but I do believe that a black-and-white photograph can glow when it contains a rich black in the deepest undetailed shadows and a pure white in the highlights. I worked in those directions with most of my historical restoration work. In some cases, old photographic processes simply did not produce such contrast. Where that was the case, I tried to be faithful to the original, as was the case in many of the glass plates in my Central Valley collection by Frank Day Robinson.

Restoration is an area where Photoshop makes a substantive difference, allowing to see deeply into the image, restore fading (even through infrared copying) and remove film artifacts such as dust and peeling emulsions. The program's Clone tool (or Rubber Stamp) is a powerful spotting tool. Ninety percent of my 1988–1992 image restoration for the Central Valley book involved use of the rubber stamp to copy or clone an adjacent area of the image over dust or scratches. Of course, some additional and powerful tools have been introduced since then, such as the Dust & Scratches filter.

I also used Photoshop's tonal controls during my restoration of historic images. With these critical tools, I restored contrast and detail to faded photographs. Areas of detail that had been obscured by the yellowing of the photographic paper were made more visible. Dark shadows were lightened slightly to make subtle detail more apparent.

Many of the problems I encountered were caused by the copy negative and second-generation print process. Additional dust, soft-focus grain, and loss of detail in shadows and highlights were common problems I came across. I tackled such difficulties with additional spotting, careful sharpening, and the creative use of duotone inks to emphasize tonal transitions.

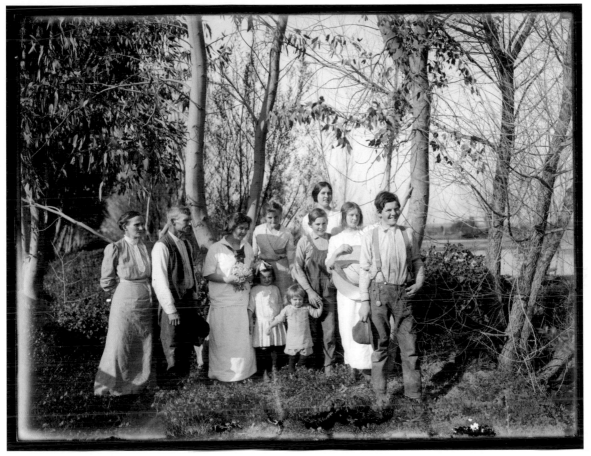

Family in Trees, Merced County, California, circa 1915. Frank Day Robinson.From the collection of Stephen Johnson.
8x10 glass plate scanned with Linotype Circon Scanner. Scan and restoration ©2006 by Stephen Johnson.

Gray Originals

Historical work is often faded and gray. There is a strong temptation to drive blacks into the images. You need to be very careful doing this, as a gentle, natural tonal transition can rapidly become harsh and clipped. Although the Levels control is an excellent place to control black point, it is not a good place to start to correct this problem, because it is likely to create a steep tonal plunge into black. It is better to use Curves, create a gradual darkening of the shadows, and still watch the near-dark tones for evidence of information being lost or posterized. It may require the addition of some specific tone-control points to drive some shadow details down, while keeping slightly brighter points from going with them.

Get Great Scans
As you might imagine by now, it is very important to work with high-bit depth scans made with plenty of exposure to give you the editing room and tonal separation from noise to make these edits.

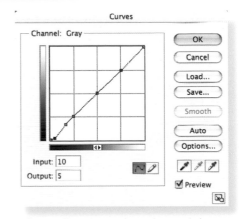

Curves adjustment used to make very dark grays into near blacks, with control points added to limit edits to a specific area tone.

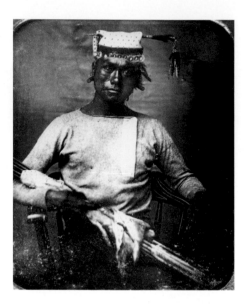

Southern Maidu Man, 1854. Photographer unknown.
Autry National Center, Southwest Museum, Los Angeles. Photo #1346.G.1
Scanner: UMAX 1200 CCD print scanner.
Duotone Separation: Stephen Johnson/Adobe Photoshop.
Source Image: 8x10 black-and-white copy print Original Daguerreotype.

A Global Spotting Technique

While working on the Central Valley project, I developed a technique that has proven quite useful for repairing dust-splattered images. To repair such images, I pasted a copy of the area over the original, (now into a new Layer) and set the Paste controls to darken or lighten (depending on whether I was trying to lose light spots or dark spots). Then I offset the pasted area slightly offset from its original location. This technique required a fair amount of edge blending, opacity control, careful inspection of the result, and a double hit with opposite settings if I had both light and dark spots in the same area that needed work.

The method saved hours of spotting and hundreds of mouse clicks. It also replaced the damaged area with the true adjacent image, preserving subtle tonal changes that would otherwise have been easily be lost during long painting sessions with a cloning tool. You must be very careful of double image or blurring effects, as these can show up and must be removed via Eraser and/or Blending Options custom.

As Photoshop has evolved since that time, I would modify the process and paste the copied section into a new Layer, adjust the Blending mode to lighter or darker as needed, then move location of the pasted section to hide the splatter.

The Clone Tool

As mentioned earlier, the pixel cloning technique using the Clone (Rubber Stamp) tool remains the traditional method of digital spot removal and the method I used more than any other on the Valley book.

Choose a brush just larger than the spot, Opt/Alt-click on the area to be cloned, then stamp out the dust. Remember to vary your source points and select the stamp brush's hardness/softness to match the image's blending needs. On a difficult open area needing a careful tonal transition match, set the brush for 50% opacity and clone from both sides of the tonal change.

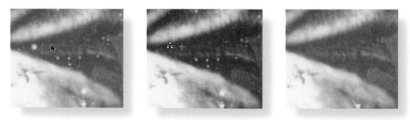

Photoshop's Clone Tool (and Brush controls) used to remove white dust spot.

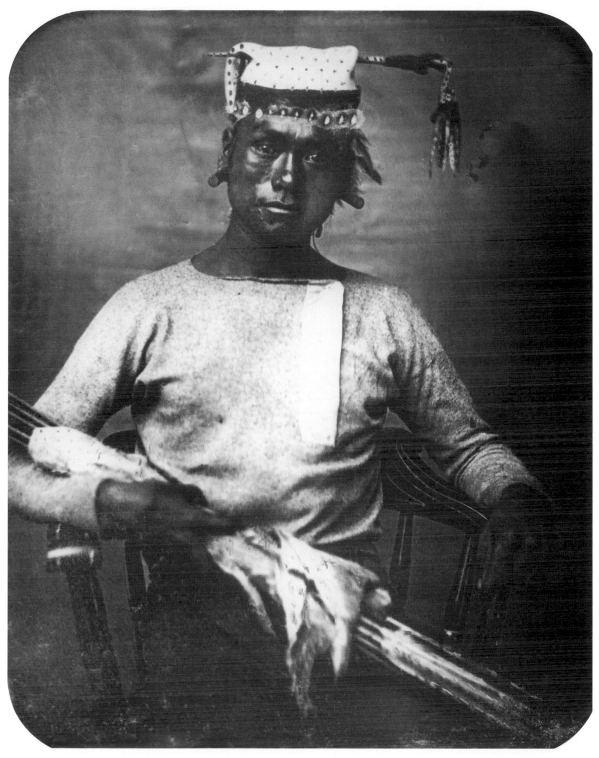

above: restored photograph.
upper left: original photograph.

Mudflower, Death Valley, 1978.
6x7cm Ilford FP4 negative. Scanner: Imacon Precision II scanner.

Chapter 12: Duotones and Photographic Reproduction

Printing technology has evolved dramatically since Guttenberg and his movable type. After the invention of photography in the 1830s, the desire to reproduce photographs on a printing press was frustrated until the development of the halftone screen in the 1860s. (The effort to develop color printing was its own hill to climb.) But basic photographic reproduction lacked the beauty of the photographs themselves. This challenge was experimented with for most of the 20th century, and by the 1950s and 60s, high-craft multiple-ink printing was being skillfully explored as a means of reproducing fine-art photographs. By the late 1970s, high-end drum scanners and laser-based imagesetters were addressing the issue with even greater potential.

Halftone Reproduction in Black and White Photography

Single-color halftone reproductions of photographs don't fully imitate the tonal range of a black-and-white photographic print. Blacks and whites are sacrificed and turned gray in order to hold detail in both the shadows and highlights. Duotone, tritone, and quadtone reproduction allows for up to four printing plates and ink colors to be used to print a black-and-white photograph. The Photoshop Duotone feature is designed so that up to four inks (with differing tonal curves and inks) can be applied to a single grayscale image. Thus the feature allows a high level of customization of ink color and printing density, which will reproduce rich tonal ranges and imitate color casts that might be found in historical or toned work.

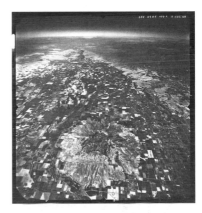

For example, the use of black ink might be restricted to printing only the shadow detail and some midtone values, while light gray ink might be used to print highlights. By distributing different tonal ranges in the print to specific ink colors, many of the shortcomings of photomechanical reproduction are overcome. Additionally, the process allows for a great deal of freedom to reinterpret the photograph on the printing press, because different areas of the tonal range can be lightened or darkened without effecting other critical areas in the image.

Duotone Techniques from The Great Central Valley Book

Reproduction of the black-and-white photographs in our book posed a number of challenges. First, the quality of the historic photographs we chose varied widely. Some images had great contrast, while others were quite flat. Nevertheless, I wanted all the images in the book to visually belong together and reproduce as beautifully as possible. I adjusted the scans considerably (and frequently re-scanned), but often the real opportunity to achieve my goal came when creating Duotone curves for reproduction. I was able to create curves that allowed for no black ink in the highlights. The upper ranges of tones were carried entirely by a light gray ink (PMS 423) well suited for the tonal areas it represented.

Sacramento Valley from 60,000 feet. 1968. USAF.
Scanner: Agfa Horizon. Source Images: USGS 9x9 inch print.
left: Progressives (black plate and gray plate) and Duotone curves.
top: Conventional single color halftone. lower above: Duotone.

Merced River Canyon, infrared, Yosemite National Park, 1994.
BetterLight Scanning Camera. 6000x7520 pixels. 12-bit. Tri-Linear Array.

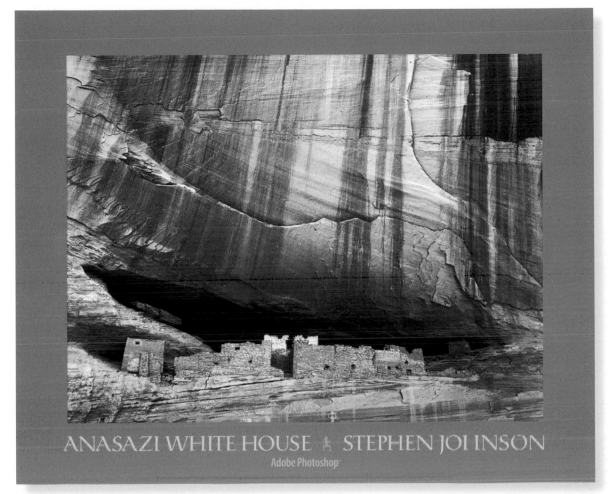

ANASAZI WHITE HOUSE ⚘ STEPHEN JOHNSON
Adobe Photoshop™

About 20,000 posters were distributed at the Adobe booth during Seybold San Francisco in the fall of 1993. As posters were brought in, the stacks stood five feet tall, but shrank rapidly, requiring constant replenishment. The poster is still in print from me.

Original Poster Credits.
This poster was created with Adobe Photoshop 2.5, Adobe Illustrator™ 5.0. Photograph, Design and Production: Stephen Johnson. Direction: Russell Brown, Jeff Parker. Original Film: 4 x 5 Kodak Plus-X™ negative. Scanner: Leafscan 45. Image Setting: Digital Prepress International, San Francisco. Printing: Hemlock Printers, Burnaby, British Columbia, Canada.

The Adobe Anasazi Poster Project

In 1993, our second Duotone promotional poster for Adobe used my photograph of the White House ruin from Canyon de Chelly National Monument in Arizona. It was printed as quadtone with dull and gloss varnish. We wanted the poster to be beautiful and informative, so the back contained a fairly complete tutorial on how the poster was assembled.

As a quadtone project, a series of four inks were chosen to build density and image color:

◆ Black for the shadows

◆ Pantone Cool Gray 11 for midtones

◆ Warm Gray 4 for the upper midtone values

◆ Cool Gray 1 for the highlight casts

(posters available at www.sjphoto.com)

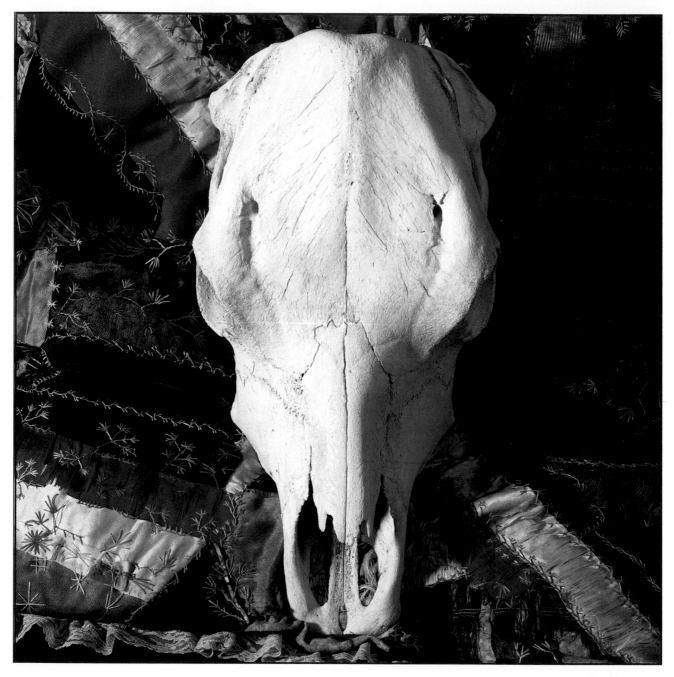

Skull and Quilt, 1993.
Leaf Digital Camera Back on Hasselblad.
2000x2000 3-exposure 16-bit camera.

Part 5:
Color Spaces, Printing, and Archiving

A man's work is nothing but this slow trek to rediscover,
through the detours of art,
those two or three great and simple images in whose
presence his heart first opened.

—Albert Camus

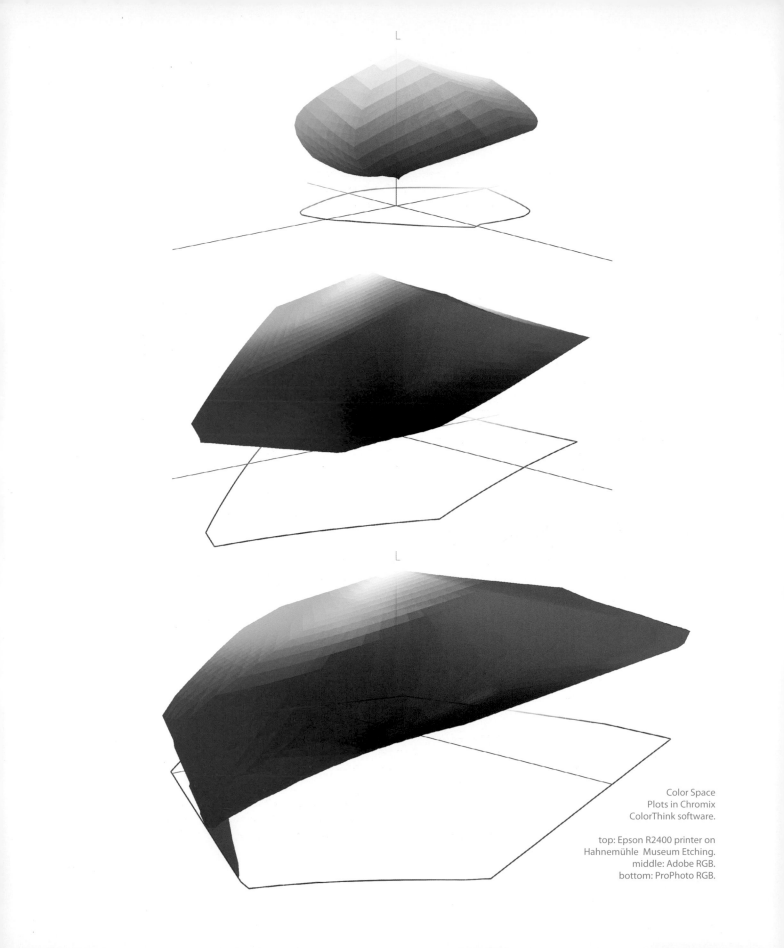

Color Space
Plots in Chromix
ColorThink software.

top: Epson R2400 printer on
Hahnemühle Museum Etching.
middle: Adobe RGB.
bottom: ProPhoto RGB.

Chapter 13: Color Management

Color is my day-long obsession, joy and torment.

—Claude Monet

Color management could also be known as color confusion, marketing hyperbole, or the black hole. There has been much oversimplification and much over-complication of this subject. In fact, done carefully and with reasonable expectations, managing your digital color workflow can make a tremendous positive difference in the overall usability of a digital photography system.

An Overview of Color Management

Color management is mostly about describing the color capabilities of different devices and linking them together with a language of color that translates from one to another. This is a critical translation; otherwise, the color capabilities of one device will simply send undefined colors to other devices, which will in turn print or display however it happens to print or display, without any control other than the manufacturer's assumptions and current device conditions. That is often the case when you have no color management in play, and the color is understandably out of control.

Color Spaces

A color space is a range of color definitions modeling human color perception, and color space can be interchanged, displayed, and printed with some predictability. These ranges of color can be modeled, plotted in various ways, and compared. Color spaces are defined in the Lab colorspace, a model of color definitions that maps human color perception into measurable form.

Color Profiles

Profiles are descriptions of the color capabilities of a real-world device such as a camera, display, scanner, or printer. The Lab values in these descriptions are used by imaging software and provide the key for translating color information from one device to another. These are often referred to as ICC Profiles (a commonly accepted profile format), meaning they conform to the standards of the International Color Consortium, a group of imaging company representatives who work on color standards, such as defining the information in a profile.

Color Management Module (CMM)

The Color Management Module is the software engine that does the math translation from one profile to another. This translates image color from one set of color capabilities (color gamut) to another device's color capabilities.

Displays

Your portal into your digital photo world is the computer display on which you view your image. It needs to be at least in a known state (characterized), and preferably a calibrated state so that the colors it displays provide a good representation of the digital file.

Many displays are simply in whatever state they happen to be, or have been adjusted to look "good" without any external reference as to how that relates to the signal being sent by the computer. Looking good may not be a correct representation of the file, and therefore using that skewed screen as a source of visual information for photo editing and printing can be very problematic.

Many printer companies complain that their single most common customer support call is the fact that prints don't look like the screen. The printer will print the data, in whatever state it's in, and without color management. No other part of the system knows what the viewer is seeing on the computer screen. A calibrated display and a good display profile addresses this issue.

Color Managment Workflow

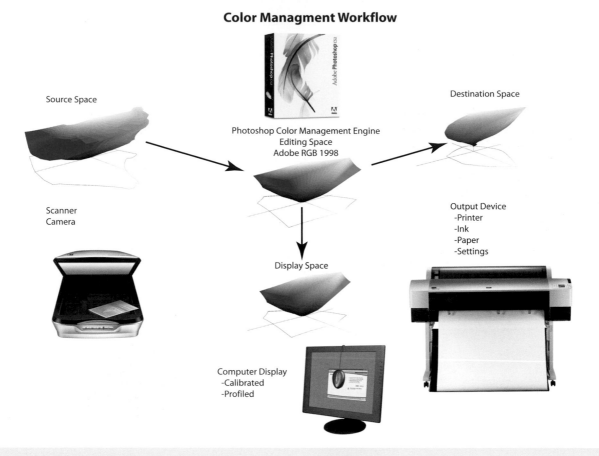

Editing Spaces

Editing spaces refers to the set of color definitions used by Photoshop to define precise spectral meaning of the colors within the image. They are not definitions of a device, but rather a set of color definition parameters within which to operate. Editing profiles need to be well-behaved and well-suited for editing images, with uniform tone response for each channel, and also gray balanced, so that equal amounts of RGB make a neutral gray. Some of these spaces also have wider gamuts, so you aren't limited to the gamut of your display or a particular output device when editing your images. A common editing space that meets many needs is Adobe RGB (1998), and other such spaces include sRGB, ColorMatch RGB, ECI RGB, and ProPhoto RGB.

Device Profiles

Profiles that describe the behavior and capabilities of real devices are called device profiles. Although they have different roles, they can be cross-assigned, leading to flexibility and confusion.

Source Profile: a description of the color capabilities of the device that the image is coming from, such as a scanner or digital camera. Scanners can profile well, but digital cameras are difficult to profile because of the many variables involved in customizing the making of photographs.

Display Profile: a description of the color capabilities of the computer display in its current condition. This profile describes what color will look like to the users as they look at the screen. Our judgement of the display colors can be influenced by ambient lighting conditions, the color of the viewer's clothing, and colorful desktops that skew color perception.

Destination Profile: a description of the color capabilities of the device that the image is being printed to, such as an inkjet printer. This description is very specific, and it requires knowing the printer, paper, ink type, and settings.

Soft-Proof: an image processed by Photoshop or other application and displayed on the computer display that attempts to imitate how the print will look when finished. CMYK soft-proofing for prepress has been used effectively for many years. RGB soft-proofing to simulate desktop printer requiring RGB data has proven more challenging.

Picture to Print with Color Management

Granite & Brush, Acadia National Park, Maine, 1995.

This image's colors don't fit within the printer's capabilities—therefore, they must be transformed into colors the printer can produce. That is largely the task of printer color management.

These three graphics show:
1. The photograph's color plotted in the Adobe RGB color space.

2. Those same points shown with the Epson 2200 printer space.

3. The movement needed to transform the image color outside the gamut of colors into color that can be printed by this printer, with this paper.

This gamut mapping is the challenge, purpose, and opportunity of color management.

The Lab color space graphics:
The L axis is luminance, or brightness, which goes from black at bottom to white at top;
the B axis ranges from yellow to blue; and the A axis from magenta to cyan.

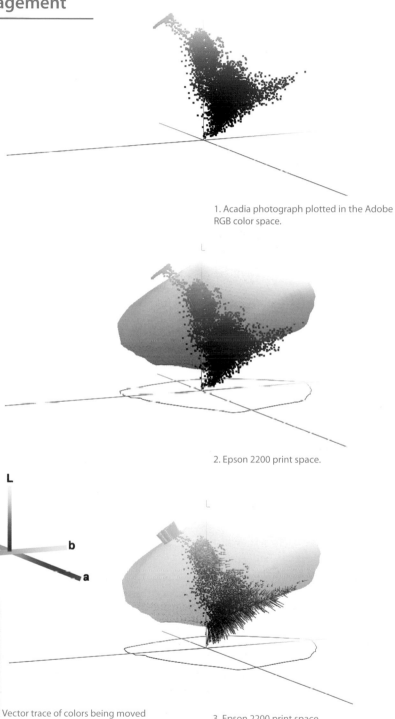

1. Acadia photograph plotted in the Adobe RGB color space.

2. Epson 2200 print space.

3. Epson 2200 print space.

Vector trace of colors being moved into the printer space from Adobe RGB. Perceptual Rendering Intent. Color Space Plots in Chromix ColorThink™ software.

Color Management in Practice

Color management can get pretty dense and theoretical quickly. All of this effort is simply trying to describe what these devices can do, and how to transform color between them. A profile of any real-world machine is a device profile, but I find it useful to break them down to distinguish how they are used.

Source Profiles

The *Source Profile* refers to a profile describing the color capabilities of the device which produced the file.

✦ Scanners: good scanner makers provide a basic profile of their scanner. These profiles take into account the lens, lamp, and software producing the scan. Custom profiles of scanners can be made with color calibration targets like the IT8 printed on color paper, transparency, and negative film. These targets are scanned in a raw mode on the scanner. Color profile–making software is then used to read the file, determine how it is different from what it knows is on the target, and create a new source profile. This has the potential to be a more accurate profile than a more generic profile supplied by the manufacturer.

✦ Cameras: cameras are hard to profile. There are many variables in play, such as light conditions, optics, and huge contrast range differences between photographs and the user's taste. Many cameras are now tagging their pictures with a display profile like sRGB or a color working space like Adobe RGB. Neither of these are camera profiles and should not be used as such. Some cameras use internal source profiles, and then translate them into standard color spaces.

Display Profiles

Display profile refers to a description of the capabilities and current condition of your display.

✦ Visual characterization with software: Apple Display Calibrator and Adobe Gamma are visual calibration software tools that use your eyes and judgment to adjust the display and create a profile. They should be used if there is no hardware solution available.

✦ Display calibration with hardware and software: packages with sensor and software are available from a variety of makers.

✦ Integrated display/calibration: the ultimate hardware/software solution is a package with software and sensor integrated into the display by the maker.

✦ The Internet: the sRGB color space was created in an attempt to find a colorspace that would describe generic uncalibrated displays on a PC. It is a reasonable assumption for web page viewing conditions; therefore, files transformed into that space with an sRGB profile embedded should look reasonable on most web browsers and screens that match the assumption.

Kodak IT8 Test Target on color photographic paper. This is designed to profile how scanners render color.

Apple's Display Calibrator Assistant. This is designed as a careful visual feedback loop to create an approximate display profile.

far left: X-Rite's Monaco OPTIX[XR] display calibrator. above: GretagMacbeth's Eye-One Display calibrator on an Apple LCD display.

Printer Profiles

A printer profile is a description of how your printer prints color with the current ink, settings, and paper. These can come from various sources, or you can make your own with the proper hardware and software.

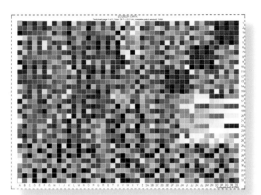

ECI2002r CMYK 1485 patch Profiling Testchart.

+ Supplied profiles: supplied by the manufacturer for their printer, paper, ink, or software. These are generic to model, and they vary in quality. Free.

+ Custom generic profiles: supplied by third-party profile producers for specific printer types. These are generic to model and they vary in quality.

+ Custom profiles: a profile of your specific printer made by a service. These are specific to your printer. If you follow procedures carefully, they can be quite good.

+ Your own custom profiles: your own custom-made profiles with your hardware and software. If done correctly, these are likely to be the highest quality profiles. (See "To Profile a Printer" in Chapter 14.)

Rendering Intents

When color has to be translated between two different devices with different color capabilities, the CMM (color management module) has to make decisions as to how to map color into the different space. Some color from the source may fit easily within the color gamut of the output device, but others may not. The control of how this mapping is done is called rendering intent. There are many strategies for rendering out-of-gamut color, but the two most commonly used variations are these:

+ *Perceptual rendering*: attempts to preserve color relationships so that visual relationships remain. For example, suppose there are two close reds that are noticeably different, but one is in the gamut of the printer and one is not. With perceptual rendering both would likely be changed, moving the out-of-gamut color into the space, while moving the red that was in-gamut so as to maintain a visual difference between the two.

+ *Relative Colormetric* rendering: attempts move only the colors that are out-of-gamut into the color capabilities of the device. Color that is in-gamut should, in theory, be left alone.

In Practice

Implementing a color-managed workflow requires integrated use of these capabilities. Education is required for the people (usually us) responsible for managing the color, together with a vigorous calibration enforcement.

1. Your display must be calibrated regularly, preferably with hardware.

2. You should know where the file came from and transform the file from its source space to your Photoshop working space.

3. Print to your printer's profile, either by having Photoshop manage the color (preferred), or by using the manufacturer's color workflow. Be very careful not to do both. (See "Printing Software" in Chapter 14.)

GretagMacbeth's Automated I/O Stage for the Eye-One Spectrophotometer.

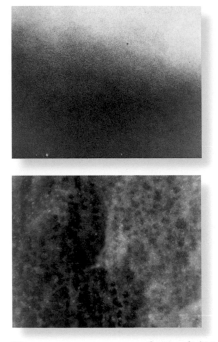

Microscope views at same magnification of inkjet (bottom) and Chromogenic (top) color prints.

Steve Johnson in his studio inspecting an Iris print, 1998. Steve Simmons.

Longevity Factors for Photographic Prints

—Fading due to light and UV exposure
—Color shift from air pollution
—Color shift from optical brightener fade
—Dye migration
—Mold
—Paper coating breakdown
—Paper breakdown

Paper samples from Epson and Hahnemühle.

WIR Display Permanence Ratings

1. Kodak Edge chromogenic color paper: 19 yrs.
2. Fuji Crystal Archive chromogenic color paper: 40 yrs.
3. Epson Ultrachrome & UC K3 on gloss paper: 65–85 yrs.
4. Epson Ultachrome & UC K3 on rag paper: 60–108 yrs.
5. Hewlett-Packard Vivera Dye/Gloss-Satin paper: 80–108 yrs.
6. Epson Ultrachrome K3 Black & White on rag paper: 90–150 yrs.
7. Canon Lucia pigment inks: >100 yrs.
8. Hewlett-Packard Vivera pigment inks: >200 yrs.
9. Epson Archival pigment inks: >200 yrs.
10. Gelatin-Silver black and white print (archivally processed): 300–500 yrs.

source: Wilhelm Imaging Research (WIR): www.wilhelm-research.com.

0	19	40	60	70	80	100	200	300-500

1	2	3	4	5	6 /7	8/9	10

Chapter 14: Printing—A New World

Beauty is the point of departure
and the endpoint
Perfection is the Goal
Longevity a Necessity
Printing is Joyous and Painful

—Stephen Johnson

Leaving the darkroom behind has opened the doors to photography and printmaking like never before in photographic history. The pent-up passion to make our own prints is finally being released for many people with the introduction of inkjet printers of extraordinary quality. There are others who had found the chemicals of the darkroom too harsh for their health and are now freed again to pursue their passion for art. This all amounts to empowerment and a great flow of creative juices.

Printing in the Digital Age

It is also true that a new level of control over the look and feel of prints is now well in place. A constant mantra that I hear is that photographs that were difficult or impossible to print are now hanging on walls and being enjoyed.

Photographic Quality on the Desktop

The advent of very fine dot inkjet printers has revolutionized photographic printmaking. High-quality dye-sublimation printers presaged the inkjet, but had greater per unit expense and some of their own development issues. Costs continue to plummet and quality keeps rising. It is a very interesting time to make prints.

Direct Control

Direct interaction with repeatable printing processes is a dramatic step forward for most photographers, giving us control, freedom, and frustration simultaneously. Good working methods can reduce wasted prints and gain consistent control over the printing process. This is not to suggest that things are yet easy for the perfectionist in each of us. Extraordinary prints can still be painful to produce.

Permanence

Initially, inkjet prints were known for fading. The general impression was that they looked good, but were not going to hang around. Their sheer beauty compelled the development of longer-lasting inks mated with stable papers. The advent of inkjet pigment has led to a huge increase in the longevity of color photographs. Long-lasting processes such as pigment and rag papers are factors that can dramatically increase the life of the finished photograph. Conversely, fugitive dye sets, mismatched papers, and cheap inks can lead to prints fading in months, weeks, or even days.

Accelerated aging tests, such as those conducted by Wilhelm Imaging, have predicted that some of the newer pigment inkjet prints are likely to last many hundreds of years. Some carefully engineered dye/paper combinations are even reaching near the 100-year mark. This is quite a remarkable breakthrough and finally relegates our traditional notions of color print life to a mere memory from the past.

Papers and Paper Qualities

Paper has always exerted a fundamental influence on print appearance. It cannot be otherwise. This is certainly still true in the digital age. It is just that now there are so many more choices than ever before. There is glossy, semi-gloss, matte, 100% cotton rag, smooth rag, and rough rag. None quite match the unique beauty of air-dried gelatin silver; some look very much like platinum, and some treatments look so new as to have no real historical antecedent.

Digital inkjet printing has opened up a whole new world of possibilities. Differing paper material, textures, color gamut, and maximum apparent blackness are all considerations in paper choice. Traditionally, 100% cotton rag has been thought of as the most stable paper, and by many of us, the most beautiful. But there are many considerations: mould-made paper can have a rougher texture but may not be rag. Optical brightness can be added to make the paper whiter (blue-white, which glows in UV), but can fade, thus shortening the life of the color balance that was printed toward yellow. The surface texture and its durability are very important considerations in the perceived beauty of the print and in its practical handling.

Direct Digital Printing Technologies

It seems reasonable to call any fixing of an image into concrete form, even if ephemeral, a form of printing. From the flickering image of a web page on a CRT monitor, to a labored fine-art print, to the ten-thousandth copy from an offset press, these are all printing. Inkjet, laser, LED and other technologies, including hybrid silver/digital combinations are all coming into wide availability, and are producing very different looks and feels in the resulting prints. The following overview should help keep them distinct:

+ Screen Display: the most basic way of interacting with the image and is, of course, the "fixed" image of the Internet.

+ Inkjet: droplets of ink sprayed onto the paper, initially for type and crude images; it is now among the highest image quality.

+ Laser and Color Laser: laser charged drum that attracts toner which is then fused onto paper with heat. Primarily used for business purposes; as the quality has risen and the price has come down, it has become a personal publishing device. These now range from desktop devices all the way up to full-fledged printing presses that fill a room. These digital presses have created a new niche in printing, "short-run color," which addresses job needs in the hundreds, rather many thousands, without the pre-press costs of making printing plates.

+ Electrostatic: largely used for graphing and technical renderings where size and line work are the driving force. There have been some photographic uses as quality has gotten better.

+ Dye-sublimation: a matrix of heating heads that diffuse dye from a colored patch of ribbon onto paper. Dye-sub printers provide a continuous tone appearance, give a photographic look and feel, and are rather fast. With the added protective layer developed in recent years, these produce quite handsome results. They are very popular in the wedding and commercial portrait market.

+ Imagesetters and Platesetters: for producing halftones onto film or plates for printing presses. The direct-to-printing plate technology has now cut film out of the reproduction process, reducing steps and increasing sharpness, but creating proofing problems as there is no film to proof.

+ Film Recorders: to image a digital file back onto various sizes of film, from business quality graphics to large-format sheet film that seems like original. The client can still have transparencies if they want via a film recorder.

+ Laser/LED Photo Printer: to image a digital file onto photographic paper, giving the resulting prints a traditional look and feel. Currently in wide use are the Océ Lightjet and Durst Lambda.

Inkjet Printing Technologies

Inkjet printers have been differentiated by their method of ink delivery. The drive forward has been largely about getting the ink droplet size ever smaller, creating the appearance of a dot-less, continuous-tone print. This illusion of continuous tone was further enhanced by introducing light versions of the cyan and magenta inks to carry upper midtone and highlight values, as lighter inks are harder to see as dots.

These various approaches to ink delivery have advantages and disadvantages in dot size, reliability, and tonal renditions. Permanence can also be affected by formulations required for the ink delivery and solvents that tend to migrate colorant over time.

✦ Thermal inkjet: a micro-heating element is used to steam-eject ink onto the paper. New printheads often come with new ink. This technology is used in Hewlett-Packard, Canon, and Lexmark inkjet printers.

✦ Continuous flow: ink is given an electrostatic charge as it passes through a very small aperture, then passes over an electrostatic deflection blade that pulls droplets out of the ink path before they hit the paper. The non-deflected droplets make it to the print. This complex technology was developed by Iris Graphics and helped to birth fine art digital printing.

✦ Piezo crystal pumps: tiny piezo crystals expand when electrical current is applied, acting as ink pumps in print heads. Epson has spearheaded this technology and driven it into some of the finest digital image printmaking I have seen.

Offset and Prepress

Digital imagery became usable largely because of the needs of the publishing industry. Prepress and digital publication assembly is still a driving factor for many involved in digital photography. (*See "Prepress Considerations" later in this chapter.*)

A File Prepared for Printing

Making a beautiful print involves many considerations—most importantly, selecting among the available technologies for the look and feel that makes your work look the best you can imagine. The practical aspects of what you can afford come into play rather quickly, and your desires may have to be tempered by your budget. It is true, though, that so many compelling options now exist that most budget and aesthetic goals can be pursued.

It's critical to have a working methodology with pre-print problems solved if you're going to find satisfaction with your printing processes. Here are the issues you must take care of in order to construct and repeat a sound printing workflow:

✦ Calibrated monitor: you must have a calibrated monitor in order to know what you are seeing. Remember, a huge number of printer tech-support calls arise from the printer not matching an out-of-control screen.

✦ Tone and color editing: the photograph should be finished (image-edited) to your satisfaction before you print. Make your edits in Adjustment Layers to maintain flexibility. Edit using Photoshop's Info and Histogram palettes for constant feedback on your editing choices.

✦ Size and resolution choices: make sure you make decisions that are appropriate to the data available. Restrain your greed for size at any cost and examine the image's perceptual needs for scale.

✦ Printer, paper, and settings: save pre-sets of inks, paper, and output dpi. Reload and check that the print settings actually did reload the presets.

✦ Take it slow and understand your choices: don't flail about pushing buttons, turning on features you don't yet understand, and printing as though there were no costs involved. The cost of the frustration will likely exceed even the potential high cost of wasting ink and paper.

✦ Be consistent and methodical: practice good record keeping; it can be the most critical learning tool of all.

Two Modern Pigment Inkjet 13x19 Printers.
left: HP Photosmart Pro B9180.
right: Epson Stylus Photo R2400.

Printing and Resolution

I've always believed that digital photography needed to be as good or better than traditional silver-based imaging. That is true of digital printing as well. Recently, there seems to be a trend toward claims of very large print capabilities from relatively low-resolution files. Part of this can be attributed to good interpolation software in printer drivers, but most of it is hype designed to make the user think that more can be had for less. I find it very sad that many people and manufacturers are accepting or promulgating more over-enlargement and lower print quality than we ever would have thought acceptable in the traditional silver-based photographic world. Buying a big printer doesn't make your files contain enough data to print big. Be wary of manufacturers' claims about the size of print that's possible from their cameras. Look hard and expect very high quality. When you don't see such quality, you may simply have printed larger than your data merits.

Scale and Perception

Possessing a big printer and making high-resolution files does not necessitate that you make large prints or prints of any particular size. The image's content in subject and treatment should always be the primary considerations of print size, bowing to the scale or intimacy that the photograph demands. This might even trump all of my concerns about quality; the print may just have to be 8x10 feet. More likely, certain images will function well at a "native size" to the file (*as described below in "Print Resolution Pixel Dimensions"*), some will need to be pushed upward and skirt the edges of acceptable quality, and still others will simply need to be small, quiet prints that take on a preciousness that can be quite lovely.

What Do You Need?

The number of pixels you need for a print is not much of a mystery even though a dozen conditionals come into play. Basically, you need enough digital information being sent to the printer to ensure that it does not resolve pixels nor start to breakdown due to digital enlargement (interpolation).

First of all, let's get some basic terms straight: dpi refers to dots of ink on paper which have a real size, whereas ppi refers to pixels in an image which have only the size you assign. If we accept as a general rule of thumb that the input file needs to be around 300 ppi (which, of course, can be debated) at whatever size you intend to print, the following numbers give a simple but reasonable calculation of the data needed.

Print Resolution Pixel Dimensions

✦ 300 ppi print at 8x10 inches requires:

300x8 = 2400 pixels by 300x10 = 3000 pixels, or 2400x3000 pixels

2400x3000 pixels = 7.2MB x3 (RGB for color) = 21.5MB

So, by simple calculation, you can assume a 20MB file has about enough data for an 8x10 print. This could be considered the file's "native size" on this printer. There may be substantial disagreement with this calculation, based both on a desire for big print and a legitimate difference of opinion as to what is acceptable print quality. Although I occasionally drop the input ppi below 300 for printing, this is my input resolution rule of thumb, which has generally been born out by my own experimentation and desire for pristine prints.

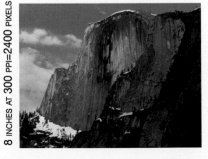

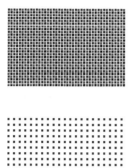

Conditional Factors

Many variables influence print appearance, including printing technology, paper, and ink choices. The basic variables are:

- ✦ Quality of original file (usually sharpness)
- ✦ Quality of printer
- ✦ Output pseudo dpi (i.e., 360, 720, 1400, 2880)
- ✦ Paper surface (rag shows less detail and breakdown)
- ✦ Your own lust for print size vs. breakdown in print quality

Digital Camera Input and Resolution

Keep in mind that many printed files will come from Bayer-pattern sensors (see left), where the apparent resolution has already been synthesized upward from what the camera could actually see. Then, in turn, the photographer often decides he wants a big print. This is not a formula for great image quality and can easily represent a step backward from film-based enlargements.

Many will argue that prints made with Epson printers should have 360 ppi going in as their print heads are 720 ppi and an equal division downward makes sense. You should experiment yourself.

The Bottom Line

If you can see pixels on the print, you've blown it up too big for sure. But more fundamentally, the image breaks down when a limited amount of data gets resampled upward. Some find as low as 200 to be an acceptable range of input ppi. The bottom line is, don't take opinions and value judgements as gospel. Make test prints at different input resolutions, examine carefully, and make your own judgments.

Bayer-pattern sensor with alternate RGB-sensitive pixels. Half of the pixels are green-sensitive areas, one-quarter each for red and blue. On a 6-megapixel camera, this would be 3 megapixels of green, 1.5 each of red and blue, all interpolated upward to 6 megapixels each for the standard 18MB final interpolated RGB file. Consequently, 2/3 of the data is made-up. Under the parameters above, this should yield a good looking, even if interpolated, 8x10 inch print.

a 100-pixel file at 300 ppi = 1/3 inch

the same 100-pixel file at 100 ppi = 1 inch

the same 100-pixel file at 10 ppi = 10 inches

Pixels Are Only As Big as You Make Them

These 100 pixels to the right can be measured in a variety of ways, depending on the ruler you impose on them.

- ◆ They stretch up 10 inches in this book, therefore are 10 ppi. 10 ppi measures 10 pixels making up an inch.

- ◆ 100 ppi would require all of these to make an inch wide image.

- ◆ At 300 ppi, this "pixel" block would measure one-third of an inch.

Pixel Dimensions: 1000 bytes
Width: 10 pixels
Height: 100 pixels
Document Size:
Width: 1 inches
Height: 10 inches
Resolution: 10 pixels/inch

Pixel Dimensions: 1000 bytes
Width: 10 pixels
Height: 100 pixels
Document Size:
Width: 0.1 inches
Height: 1 inches
Resolution: 100 pixels/inch

Pixel Dimensions: 1000 bytes
Width: 10 pixels
Height: 100 pixels
Document Size:
Width: 0.033 inches
Height: 0.333 inches
Resolution: 300 pixels/inch

Printing Software

There are a variety of software categories involved in the printing process. The following sections cover some considerations for each.

Printer Driver from Manufacturer

You should always try the printing method supplied by the printer maker first. Explore the built-in capabilities you have already paid for before you spend additional money on alternative software and profiles. These built-in drivers were once quite poor, but they have improved dramatically and are generally worth trying for many printing needs. For those who want to assert deeper control over print appearance, other methods may be needed.

Photoshop and Printer Color Management

Photoshop can control the color management of the printer, or it can get out of the way. It's up to the user to decide its behavior. Employing the printer's driver means that you have to tell Photoshop to leave the color management to the printer.

To Set Driver Control in Photoshop:

1. Set Photoshop's print dialog box to Show More Options.

2. Select Let Printer Determine Colors if you want the built-in driver to control the printing. This tells Photoshop not to manage the color.

3. Then set the driver's behavior according to the paper, resolution, and color look you desire. Keep track of these settings. The settings should be named carefully and saved under presets for re-use.

Let Printer Determine for Color Handling, select behavior in printer driver for paper, photo rendering.

With Epson printers, like the 2200, good, straightforward results can often be obtained by using the driver and setting color management options to "Photo-Realistic" and "Epson Natural Color" for a known Epson paper.

Profiled Path with Photoshop in Control

1. Set Photoshop's Print dialog box to Show More Options.
2. Select Let Photoshop Determine colors in Color Handling.
3. Select the desired printer profile in the Printer Profile.
4. Select No Color Adjustment in the subsequent driver screens. (In Hewlett-Packard printers, the selection would be Application Managed Color.)

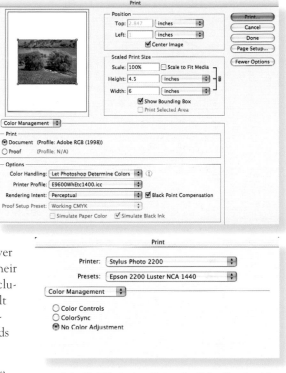

You must choose either Let Printer Manage Color or Let Photoshop Manage Color. Then you must follow through with either selecting No Color Adjustment or choosing the driver printing choices you need in order to avoid double color management. The specific drivers vary, and will evolve, but these principles must be watched.

Third-Party RIPs

The procedures outlined above use the manufacturer's print engine to make the print; they merely shift color management to either the driver or to Photoshop. Because the printer makers make tuning decisions to their drivers for what they believe is its best overall use, assumptions and conclusions about black levels, ink limits, and other print quality issues get built into their software. Asserting fine control can require changing those assumptions and customizing the printer's behavior to your individual needs by using additional software.

These are often called printer RIPs (raster image processors) and they are print driver replacements, often functioning as a completely independent piece of software designed only for printing. Traditionally, RIPs were thought of as being PostScript drivers; this is no longer always the case. PostScript is now often an added feature to a RIP.

Select Let Photoshop Determine Color, then load the Printer Profile. Proper paper must still be selected (as was selected when profile was made), then turn off printer adjustments (on Epson printers, choose No Color Adjustment) in printer driver.

These printing alternatives specialize in this very fine control of the print and should only be considered when other processes don't allow the control sought (*see Appendix*). Features include customization of paper and ink characterization, profile creation and control, print job spooling (to store and reprint print jobs), nesting (to organize multiple print jobs on a single sheet, sometimes even with different printing parameters), and bypassing underlying assumptions of color balance that lead to strange color biases (often seen as green shadows to magenta highlight casts) when printing black-and-white images with common color inkjet printers. These can be powerful tools, but they add to the cost of your digital printing solutions and can cause their own time and use issues. They may be well worth the cost, but they should be examined carefully before purchase with these criteria in mind:

✦ Color fidelity and gray balance: does the color look right and how well does it print black and white with color inks.

✦ Screening: what is print quality as compared with print quality from maker.

✦ Supplied profiles: are there profiles for a wide range of printer/paper combinations, including those you use.

✦ Watch out for prepress prejudice (CMYK only workflow), which may complicate, add many features you don't need, and increase the learning curve for most photographers. Printers are CMYK devices, and this level of control can improve quality but can also complicate matters.

✦ Good design, ease of use, and installation.

✦ Support, both technical and for a broad range of printer models.

To Profile a Printer

The following summary provides a short guide to the basic steps for creating your own custom printer profiles.

1. Using the Print with Preview option, print appropriate target and size for printer type, measuring device and profiling software. Most printer drivers treat inkjet printers as though they are RGB printers (despite the fact that they are CMYK + additional colors), so RGB targets should be used. Do not interpolate or re-size the target file other than nearest-neighbor interpolation. With the exception of initial Color Handling, prints made from your new profile must be printed exactly as you printed the profile test target.

 a. Photoshop print settings (with More Options, Color Management tab visible)

 i. Color Handling: No Color Management

 ii. click Print for printer driver dialogs

 b. Printer Driver Settings

 i. Color Management tab: No Color Adjustment

 ii. Print Settings tab:

 —Exact or Nearest paper type

 —Desired print resolution (720, 1440, etc.)

 —Save and name the PreSets for reuse

2. Allow print to dry (cure). 24 hours should be plenty.

3. Measure printed target with spectrophotometer.

4. Create profile using profile creation software.

5. Make print.

 a. Use Let Photoshop Determine Colors in Color Handling with new profile as the Printing Profile.

 b. All other settings exactly the same as target was printed, such as No Color Adjustment.

> **Advanced Option**
> You can profile over a setting other than No Color Adjustment. The trade-offs are:
>
> ♦ No Color Adjustment = wider gamut, but often plugged shadow detail with most media type settings.
>
> ♦ Epson's Photo-Realistic = slightly smaller gamut, cleaner shadows, better gray balance.
>
> *—from my friend Chris Murphy*

Making the Print Look Right

To help your print look as you intended, you have to know the condition of the device through which you are viewing your digital photograph: your computer monitor.

Matching the Monitor

The primary working goal is to have the confidence to use your monitor as a reliable representation of your photograph. Naturally, when it comes to printing, we want the image to look like what we saw on the computer display, only better.

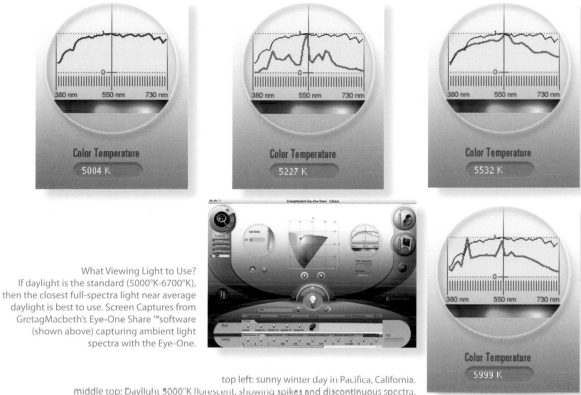

What Viewing Light to Use?
If daylight is the standard (5000°K-6700°K), then the closest full-spectra light near average daylight is best to use. Screen Captures from GretagMacbeth's Eye-One Share ™software (shown above) capturing ambient light spectra with the Eye-One.

top left: sunny winter day in Pacifica, California.
middle top: Daylight 5000°K florescent, showing spikes and discontinuous spectra.
top right: Gretag's quartz-halogen Sol-Source Lamp, showing close match to daylight.
bottom right: 6500°K florescent viewing booth, showing some spikes and discontinuous spectra.

If the file is in a known state, the monitor calibrated, and a good printing profile employed with consistent settings throughout, your print should look very close to how it looks on your screen. However, you must still allow for differences between the transmitted light of your monitor and the reflected light of your print, together with density differences inherent in both. Remember that the print must also be allowed to evolve as its own entity, regardless of preconceptions and simulations.

♦ Viewing Light: you must view the print in known, consistent lighting ideally the same light in which you want others to view the print, and, hopefully, the same white point as your monitor. Generally this is D50, or about 5000°K, near daylight. This does not match interior or gallery lighting, but it does come close to real-world daylight. You can mimic daylight with artificial lighting such as 4700°K quartz halogen Solux bulbs and daylight 5000°K florescent. (*See Appendix.*)

Metamerism

An additional concern, made dramatic by the introduction of pigments, is *metamerism*, a shift in hue under differing lighting conditions. Our eyes adapt to normal metamerism fairly well, but recent pigment inkjets have had a particular problem with color shifts beyond what we are accustomed to, what our eyes can easily adapt to. A print balanced for daylight tends to go very warm/magenta under tungsten. A print balanced for indoor 3200°K looks green in daylight. Decide on your viewing condition and print to it. Or, alternatively, do as I do (which can be reckless) and believe that prints need to be made for daylight and that over time most viewing conditions will evolve to be near daylight. Also, I often supply a 4700° K Solux bulb to go with the print. (*See Appendix.*)

Close, But Not Quite There

If the print is close, but still not quite what it needs to be, you can edit the profile with profile editing software like GretagMacbeth's Profile Editor or Kodak's Custom Color ICC. However, unless it is a consistent problem, it is probably better to improvise a little and tweak any small differences into the file by editing it to print exactly the way you wish. These should be very small, perfectionist-level changes, not major changes that might indicate that the profiling workflow is not working for you.

✦ Color Casts/Neutralization: look for colors that still seem off in the print, either in saturation or hue. You will need to edit the file, and may make it look somewhat incorrect to compensate for the final printer differences. For example, if the print is slightly too green, you may need to add a little magenta (green's opposite) to compensate. This will make the screen image look off, but the image may then print correctly. A viewing filter kit may help you detect where the problem lies.

✦ Adjustment Layers: use Adjustment Layers to make these "screen to printer" corrections. These layers are completely undo-able and editable for careful tweaking toward the print that you desire. Remember to view the print without the correction layer turned on so that you are seeing the original file you were trying to match.

Kodak Color Print Viewing Kit.

right: a Curve adjustment adding 6 points (on the 0-255 scale, 2 points on the 0-100 scale) of magenta to the file for correction of a slight green cast in the print.

right facing page: correct print.

below left: print as slightly too green.

below right: print with added magenta from curve on right to correct greenish cast, making the screen image appear too magenta, but printing correctly.

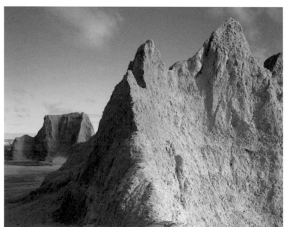 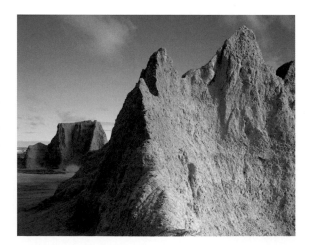

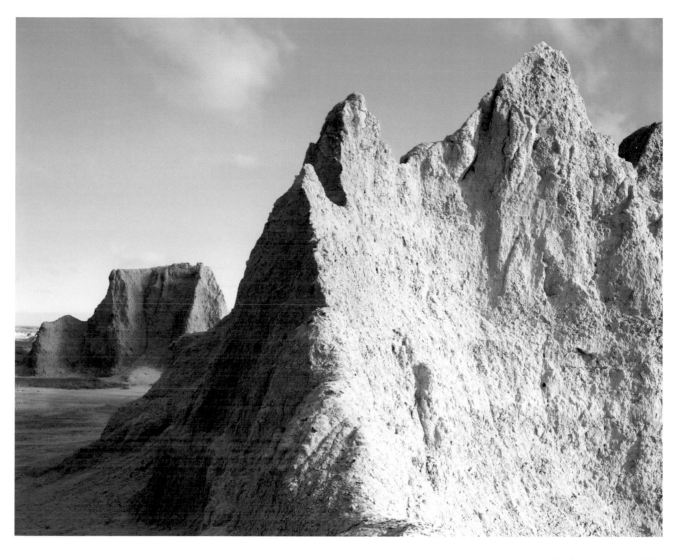

Towers, Badlands National Park, South Dakota, 1997.
BetterLight Scanning Camera. 6000x7520 pixels. 12 bit. Tri-linear Array.

Digital Black and White Printing

I fell in love with photography largely because of the beauty of a black-and-white gelatin-silver print. I have now mostly abandoned that darkroom approach in favor of digital printing. However, my darkroom remains intact, with lots of paper in the freezer. I am in something of a black and white limbo-land, but I'm enjoying the exploration.

Inevitably, we compare our black and white results to traditional printing methods, whether gelatin-silver or platinum. A digital inkjet-based print is a different animal—one that can chase the look and feel of other mediums and that has its own unique aesthetic potential. The path you go down is of your own choosing; I'm finding it difficult not to pursue many as I try to understand what I want out of a black-and-white print in this digital age.

Black-and-white printing is both necessary and difficult. It is critical to many of us for its sheer beauty and because the language of photography does not always require color. In fact, scenes are often strengthened without color, relying instead on black and white's inherent increased abstraction.

Digital printers are designed to print color. Many twists and turns in gray balance and tricks to human perception are employed to make the highly capable color printers we now have. But many of those very improvisations make printing neutral black-and-white prints very challenging. It is also true that most of us would prefer to have only one printer, one that will print our color and black and white equally well. This can be very hard to do.

Various ways have been developed to creatively adapt to black and white challenges: substituting the printer's color inks with black and grays (even 6 or 7 grays with black), elaborating workarounds to avoid a printer's default color processing, or adding gray inks to the color set. All work to some degree. A list of some of the options follows.

Lyson QuadBlack toneable inkset.

Cone's Piezography ink colors.

Black Gray Custom Inksets (a Few of the Many Manufacturers)

✦ Lyson: Lysonic Quad Black Cool Tone, Lysonic Quad Black Neutral Tone, Lysonic Quad Black Warm Tone and Quad Black Toneable Inks; combining three channels of archival Lyson Quad Black Neutral with two channels of Quad Black Warm and two further channels of Quad Black Cool

✦ MIS: Carbon, Medium Warm, Neutral, Cool

✦ Cone Piezography: Warm Neutral, Selenium Tone, Carbon Sepia, and Cool Neutral

Gray Ink Plus Color

+ Epson Ultrachrome K3 (on selected Epson printers)
+ Hewlett-Packard: color, plus extra black and grays (on selected HP printers)

Issues with Black-and-White Printing

Software

+ How do you preview and control the printing?

Neutrality

+ Paper/ink combinations produce image color variations.
+ Viewing conditions and color temperature of light influence neutrality of most black/gray ink combinations.

Density

+ Comparison to silver usually results in inkjet not quite coming up to a similarly rich black.

Longevity

+ How long will these inks last on which papers?
+ How are they tested, by whom, according to what standards?

Paper

+ Rag papers harken back to platinum printing and births an altogether new look.
+ Glossy looks more like traditional silver prints.

Black inks for matte and glossy paper

+ New Inks from Epson and others.
+ Photo Black for glossy papers. Matte Black formulated for matte papers, extra need for black density.

Print Drivers/Control

Black/Gray Ink Printing Software

+ RIPs (raster image processors): software to translate your data into the printer's format.
+ ImagePrint RIP, Best Color, etc.

ImagePrint

Wide printer model support. Profiles for color and black-and-white prints using color, gray inks, and supporting image tints. Features an extensive library of downloadable profiles supporting a wide variety of papers and viewing conditions. Very neutral black-and-white prints are possible as well as image tints and split-toning.

Traditional RIP features like scaling, nesting, and crop marks with extensive print correction controls for color, tone, saturation, and resolution.

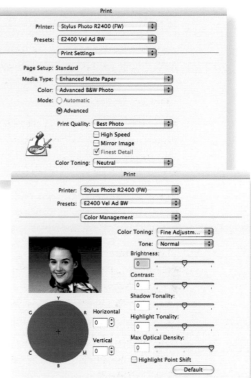

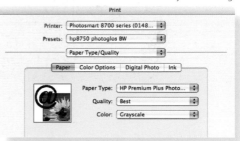

above: Epson R2400 Advanced Black and White Mode.
below: Hewlett Packard 8750 Grayscale setting.

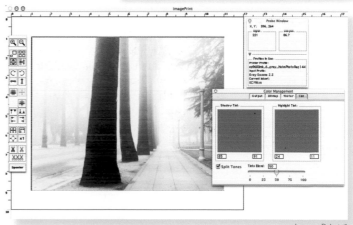

ImagePrint 6

Cone Piezography

This profile-driven printing is supplied by Cone for their PiezographyBW ink with various printer/paper combinations. Jon Cone has a long history as an Iris printmaker and in developing monochrome inkjet printing solutions which have included both inks, RIPs, and printer modifications.

PiezographyBW ICC profiles provided are designed to linearize a media and are to work with the manufacturer's own printer driver, thus bypassing the need for specialized software.

Other Solutions

A number of ink-makers and interested third-party developers have offered black-and-white printing solutions as well. Lyson's Daylight Darkroom and the Quadtone RIP are two that people have reacted quite positively to their functionality. Daylight Darkroom creates files for Photoshop (or other software) to print, and the Quadtone RIP uses GIMP drivers and just appears as another printer.

Quadtone Ink Control

This method uses the Duotone feature in Photoshop with measured inks, requires a spectrophotometer and straight-through printing without driver interference. It is rather involved, although it allows for good screen preview of the final result. A consistent workflow with very good record keeping is critical.

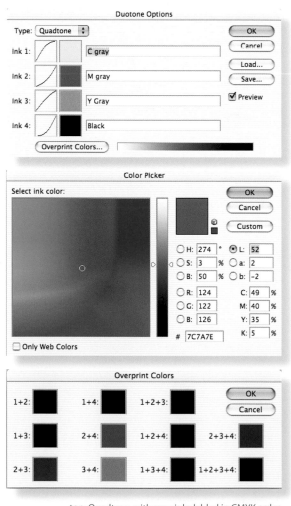

1. Print CMYK swatch to see which gray/black inks are printing in what color channel order (file available at www.ondigitalphotography.com).

2. Print solids and overprints of each ink (file available at www.ondigitalphotography.com) as test from a 4 black, no curve Quadtone, then change to multi-channel, then to CMYK and print.

3. Measure solids and overprint patches with spectrophotometer to derive Lab values.

4. Enter Lab values for each ink into the Duotone ink patches in your determined CMYK order.

5. Enter Lab values into Overprint Colors patches.

6. Use Duotone Tone curves to adjust ink distribution (use light inks for highlights and upper midtones). Screen preview should be close.

7. Change Duotone to Multi-Channel.

8. Change Multi-Channel to CMYK and print through RIP. The channels will map across in the correct order because you have previously determined which inks are printing as though as they were CMYK and have built the quadtone order accordingly.

top: Quadtone with gray inks labled in CMYK order.
middle: Color Picker window where Lab values are entered.
bottom: Overprint Colors window.

Custom Separations

A complex but effective approach is to actually build your own Quadtone CMYK inkset in Photoshop. CMYK ink definitions can be customized into specific grays for a Quadtone Separation setup right within Photoshop's CMYK selectable options.

CMYK Swatch printed with gray inks.

1. Print CMYK swatch to see which inks are printing in what color channel.

2. Print solids and overprints of each ink through RIP as previously described.

3. Measure both and enter Lab values into Color Settings/CMYK>Custom/Ink Colors>Custom.

4. Requires CMYK direct print path through a RIP that communicates the CMYK data to the printer, rather than a translation into RGB then to printer's CMYKlclm (cyan, magenta, yellow, black, light cyan, light magenta).

5. Convert your grayscale file directly into CMYK with this setup selected in Color Settings. Then print through RIP as described earlier.

The Quadtone RIP Shareware screen. It becomes its own printer driver using GIMP print.

Custom CMYK setup in Photoshop with custom gray set built.

Prepress Considerations

Preparing your digital photographs for mass reproduction via printing presses has its own set of criteria and areas in need of special attention. On the upside, there is a long history of digital imaging and printing that has helped to birth the desktop digital capability, and the workflows are often quite mature and function very well. There are also areas where a very large gap exists between the public's general understanding and the actual needs involved.

Gretag Testchart 2.9 for CMYK.

Resolution for Offset Reproduction

There is confusion about the actual input resolution (ppi) needed for offset reproduction. The standard rule of thumb and the standard request is for an almost arbitrary 300 ppi, or twice the halftone line screen. Neither of these truisms are true. The resolution needs for reproduction are determined by the halftone screen that will be used in the final publication. Digital photograph file size should be equal to 1.5 times the resolution of a given halftone screen (actually, only 1.4 is probably needed). This is governed by the actual data needed to form the halftone dot without imaging a pixel. Any information beyond that simply slows down computers and gives third parties access to more of your digital data than they require for the job.

CMYK Is Not Generic

Frequently, I am asked to provide magazines with CMYK. When I ask what kind of CMYK, more often than not, a silence insues, followed by, "What?" I am then generally handed off to someone who handles the details of reproduction, where I usually discover they have not developed a custom workflow but are simply relying on others to take care of color management.

CMYK color spaces and profiles are specific to a device (press), with specific ink, paper, and reproduction conditions. The closest thing to generic CMYK is average behavior for different kinds of presses and papers that have become something akin to "standard." These are only generalized capabilities, although they do help isolate and control some of the variables. Other variables specific to the press and personnel involved introduce differences that can change color and require custom press adjustment and supervision. Even prepress RIPs themselves can introduce "tweaks" to the process that may reflect the "expertise" of the software maker, but not the conditions you may face on press.

Typical Jobs & Halftone Screens
+ Newspaper: 85–100 lpi
+ Magazine: 133–150 lpi
+ Book: 150 lpi
+ Art magazine: 175 lpi
+ Art book or poster: 200 lpi
+ Very high-end reproduction: 300 lpi

Resolution Example
A 150-line screen needs 225 dpi (150x1.5=225).

Therefore, an 8x10 inch reproduction destined for a 150-line halftone screen needs 8x10 inches of data at 225 dpi, or 1800x2250 pixels, or a 3.8MB black-and-white single channel file and a 15.4MB 4-channel CMYK file.

Common CMYK Generic Profiles
For Web Press and Sheetfed Offset for coated and uncoated paper:

+ U.S. Sheetfed Coated v2
+ U.S. Sheetfed Uncoated v2
+ U.S. Web Coated (SWOP) v2
+ U.S. Web Uncoated v2
 (other countries have different inks and environmental regulations that govern their use)

Proofing and Soft-Proofing

The ability to preview how your job will appear on press is critical to preparing your job to print properly. Ironically, the move to an all digital workflow has made prepress proofing somewhat more difficult because direct-to-plate technology bypasses separation film from which traditional proofs have been made. Digital proof work-arounds have now been developed that actually mimic traditional prepress proofs, even duplicating some of their inaccurate quirks that the industry has become accustomed to.

In 1996 we put early soft-proofing to the test at Hatcher Press in San Carlos, California by arranging with monitor maker Radius to go to press on a poster project with no prepress proofs at all. We used only the soft-proof of their press profiles and CMYK soft-proofing on their PressView™ calibrated monitor system, viewed from within Photoshop. To my surprise, the test worked splendidly, and the confidence shown by the people at Radius was merited.

The Methodology Used in This Book

This work was reproduced with a tightly managed color reproduction workflow. Test targets were printed by the printer on the actual presses, with the actual link to be used and at a 200 line screen. I then measured these targets and created custom press profiles for this job. These profiles were then used to create the CMYK separation files for the book. These profiles were also used to proof the book on my inkjet printers set to imitate the printing press behavior.

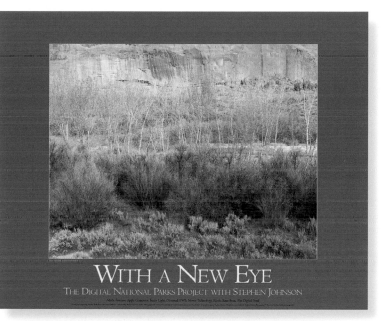

Radius Parks Project Poster printed with only PressView monitor CMYK soft-proof.

Hatcher Press Radius PressView Poster Run.
left to right, top to bottom:
Talking through the project; Michael McLaughlin examining press sheet next to monitor; pulling a press sheet, Steve and Karl Lang looking close at sheet, then examining in the sun; Steve, Michael, Karl and Bruce Fraser happy with the result.

Adobe Bridge: a sorting, reviewing and processing frontend to Photoshop.

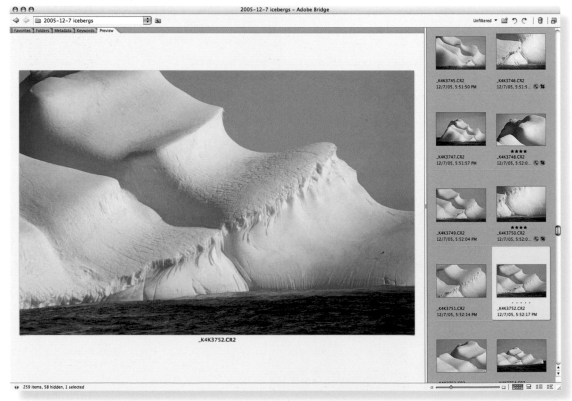

Chapter 15: What to Do with Your Images

Much as art schools rarely teach how to make a living as an artist, the practicalities of what to do with your photographs are often left out of the equation. Nuts and bolts such as print labels, web galleries, archival matting, and framing are in as much need of discussion as ever. Perhaps in the age of digital empowerment for the arts, it is even more important as so many people without formal training in the arts are more free than they have ever been to pursue their heart and vision. This chapter was written to help address that need.

In the darkroom days, our first task after developing the film was to make proof sheets so that we could see what we had done. Sometimes it was hard not to just start printing the negatives of obvious interest, but that sometimes led to work sitting unproofed for a time—sometimes for a long time.

The first step in any digital photography process is to look at your work and try to understand what you have photographed. I strongly recommend that you do as much of that inspection as you can in the field, where you can still make a difference in how you work, but most often the first best look is on the computer screen.

Adobe's Bridge has become the default first viewer for many photographers. It allows you to see the images, access the RAW processor, link directly to Photoshop, and do many mundane tasks like adding copyright metadata, making new folders, renaming, and resorting files.

Archiving, Storing, Cataloging, and Retrieving

Eventually, where you put your files is as important as any other step in the digital photography evolution. A non-archival shoebox can still work for storage, like it might have for your negatives, but the shoebox was never good enough. To even use the shoebox, your files must already be on a disk first, not the internal hard drive of your computer. Offline storage is far safer than your computer's disk which is in constant use, with a constant flow of data being written and disk file directories being constantly rewritten. The following sections look at some of the storage options.

Hard Drives

Hard drives are the most universal storage medium. They are, in many ways, re-engineered tape recorders that have been around for well more than half a century. They spin at very high speeds

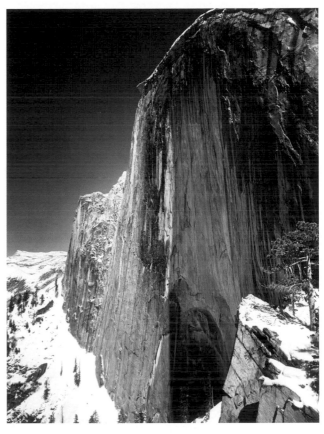

Monolith, The Face of Half Dome, Yosemite National Park 1927. Ansel Adams. © Ansel Adams Publishing Rights Trust/CORBIS. 6 1/2 x 8 1/2 Korona View camera. Glass plates: Wratten Panchromatic. Lens: Tesar formula lens of 8 1/2 focal length. Filter: red Wratten No. 29 filter. Exposure: 5 seconds at f/22.

Lessons from the Past

All of the above caption information can now easily be stored in digital metadata with the photograph. This is important to do, not only for historical purposes, but also to track things that go wrong, and right.

Many photographers have lost years of work to fire and water damage. Ansel Adams's well-known *Monolith and the Face of Half Dome* was almost lost to fire in 1937. The negative is printed cropped to avoid some of the damage.

It makes good solid sense to back up your files, duplicate the back up, and store it in two different places.

and write data at very high densities, but they remain devices that work by laying down a magnetic charge. The charge is being detected to read and re-charged with different signals to rewrite, making it an ongoing mass of binary numbers, written and rewritten constantly.

Though hard drive failure is an eventual certainty, hard drives are still among the most reliable storage mediums available. Nonetheless, the adage "It's not a question of if a hard drive will fail, it's a question of when" does hold weight. Still, I have friends who tell me they've had hard drives on for 12 years without failure, and that turning them on and off actually stresses the device more than just leaving it on.

With today's massive capacities and relative low expense, one can even make an argument that buying additional removable or external hard drives on which to store your data makes sense.

Its massive capacity also means that it is very tempting to keep adding data to your hard drive to the point that if it does fail without backup, you could lose an enormous amount of precious information.

DVD and CD

More practically, writing CDs and DVDs of your data is a pretty good bet for keeping your files intact for many years. For this type of media, lasers are used to change dye on the plastic disk's recording layer. They have become almost universally readable for everything from computer files to pictures to music.

If you use CDs or DVDs, label the disk cases with good information and keep them in whatever order you determine makes them accessible for you. Avoid adhesive labels on the disks themselves—they can bubble and start coming off during reading, damaging disk and drive.

The longevity of these disks is in question. You will have to protect them from fire, mold, and most environmental extremes. If the files are important enough to you, make duplicate sets and store them at different locations.

Take advantage of the digital age and its inherent ability to make perfect and identical back-up copies of your data. Keep backing it up to ever more contemporary and, hopefully, more stable media.

top: hard drive disk platter.
top middle: File Info window in Photoshop.
bottom middle: Disk Tracker name indexer.
bottom: hierarchical folders named for later finding.

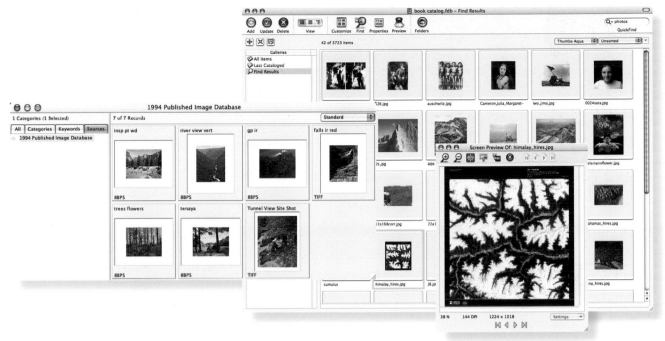

left: Canto's Cumulus image database software.
above: Extensis' Portfolio image database software, with floating window of screen preview open.

Image/Data Preservation (Metadata)

It is very important to preserve your camera data and any additional information that you have available about your photograph. Photoshop's File Info with its keywords and information fields can make a big difference in captioning the photograph for publication and identifying specific events, whether business-, artist-, or family-related. Camera data, if available, is also saved into the Origin fields. Use the File Info feature in Photoshop; it is extraordinarily useful.

Keep in mind that Photoshop will save previous entries you have made into any of File Info's fields, so re-entering already-used data is merely an arrow and drop-down menu away.

Keyword editing and image organizing tools like Camera Bits PhotoMechanic are also available. Such packages can be very useful for tagging multiple files with new dates, captions, and keywords.

Disk Indexing

Regardless of how you store your data, you need to know where you've put it. Good naming protocols and a simple disk indexing software can make a huge difference. Nesting your files inside folders with good identifying names can make your life much easier. With such information, at least you can search on what you do remember about the file, and often, find it on the first try.

Index the disk immediately upon writing it and mark it as indexed; then there is never a question of whether the disk is in the index. Make this a part of your normal workflow when you archive your data.

Image Database

Visual database programs create and allow access to thumbnails of your photographs. From simple applications like Apple's iPhoto, these software packages help to keep your photos accessible. More sophisticated software packages like Canto's Cumulus and Extensis Portfolio are also available.

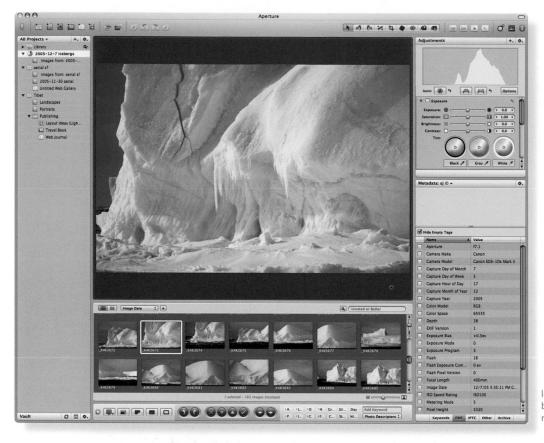

left: Apple's Aperture software
below: Adobe's public beta-
release of Lightroom.

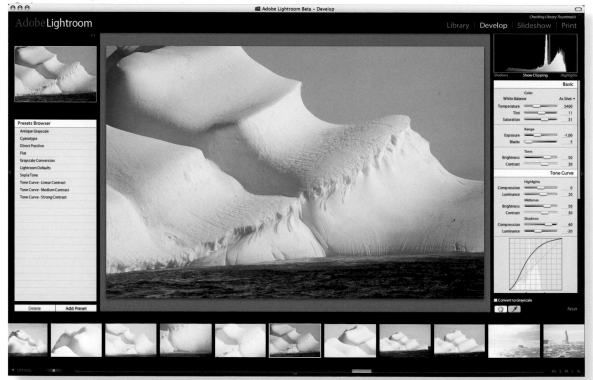

An image database can be the very basis for initial interaction with your digital photographs. Adobe's Bridge browser starts to give the user the feel of using visual information and keywording as a means of tracking, finding, sorting, and rediscovering your files. The effort needed to keyword your files remains, but is well worth the effort in order to aid image searching, both for your own use and a potential client's last-minute request.

Standalone Image Browsers and Editors

Both Apple and Adobe have made the decision to get into the photo editor/browser market with standalone applications that attempt to fulfill the needs of the photographer for organizing his work, preparing for printing and distribution, but staying out of the compositing business. Apple's Aperture was released in late 2005, with Adobe following shortly thereafter with a free beta release of their long-awaited Shadowland, which became Lightroom.

Both of these applications have real merit, and both need to be able to truly function as database programs as well, so that offline data can be referenced. Another misstep in the current versions is the creation of additional archive files which makes the possibility of yet more disk space used and confusion as to location of files and versions. However, they are both very promising programs.

I believe these kind of dedicated photo-editing packages will end up dominating the photographer's experience, eventually displacing Photoshop's huge toolbox capable of so many tasks. We might need both, but photographers will end up spending more time in the dedicated editors.

Register Your Copyright

Your photograph belongs to you and is copyrighted the instant you make the exposure. However, as is often the case in legal matters, if someone infringes on your copyright, you may have to litigate to recover damages. If you register your copyright with the federal Copyright Office, you can also sue for attorney's fees, which increases your ability to enforce your ownership.

Register

✦ U.S. Copyright Office
101 Independence Ave. S.E.
Washington, D.C. 20559-6000
(202) 707-3000
http://www.copyright.gov/
http://www.copyright.gov/register/visual.html

You Never Know...

My friend Dirck Halstead tells a great story about a news event and a face he remembered. After the news broke of Bill Clinton's involvement with Monica Lewinsky, Dirck knew he had seen her face before, and spent many weeks looking for a photo he believed he must have taken. Eventually he found the slide, it hit the services, and it was widely distributed. He then remembered two other photojournalists being at the scene with him when he made the photo and was perplexed why they weren't sending their photos of the girl with the bright red lipstick. It later turned out that Dirck had shot film, all of the slides came back from the processor; the other two had shot digital, and in the interest of saving space, had erased the files thinking there was nothing newsworthy there. Lesson: archive your files, keyword them, and never erase anything. (See Dirck's work at: http://digitaljournalist.org.)

US Copyright Visual Arts Form: a downloadable pdf.

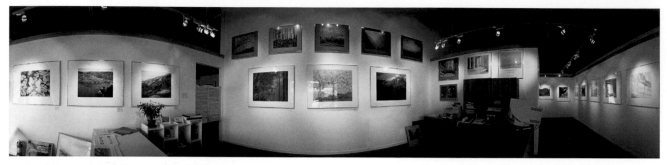

Stephen Johnson Photography Gallery, Pacifica, California.

Galleries: Real and Virtual

Displaying your photographs for others to see is the name of the game. Getting people to come and look is another challenge. The impulse to have your work appreciated has not changed with the digital age. Getting the attention has become harder and easier at the same time. We certainly have more tools to distribute our work, but everybody seems to have a gallery online, and standing out remains hard.

Vision and Style

Work from the heart almost has to be unique, but it may require a lot of thinking and trying to give visual vent to those unique feelings. It is one thing to feel things deeply, and another to express them with eloquence. Years of work, hard self-questioning, and showing the work to others all help.

Something Special

Uniqueness is both intangible and highly sought after. It cannot easily be described, but we think we know it when we see it. The work itself is what really counts. Try to understand artists whose work has inspired you, as you move toward an understanding of what you want to do. We all engage in art-making because of inspiration; one of the real tasks is to take that inspiration and work it into a new vision.

Oftentimes, people get caught up in the mechanics of putting the work together. While this is important, and can sometimes make a critical difference, it should come after accomplishing strong work. In today's digital world, rough hand-coated emulsion-look edges, photo-frames, drop shadows, and similar decoration rarely strengthen the work, and mostly look like the window dressing that they are. The presentation matters, and good work that is poorly presented often gets overlooked. The work is primary and the affectations transparent.

Lighting

It is now possible to carefully match your prints to the display lighting that they will be viewed under. This can be dangerous and powerful. Galleries are often lit terribly, with low intensity (to protect fragile materials) yellow light (from ordinary flood lamps that are also run at low voltage). Your prints can be balanced for these dismal conditions and look better in those particular circumstances, but then they might look downright awful on the mixed daylight/indoor lighting of a collector's wall.

I still am inclined to choose daylight (5000°K–6500°K) as my viewing light condition and print to that white point. In many situations, my prints have suffered from this decision, going very warm and losing most of the subtlety I try so hard to achieve. I do encourage artificial light that is closer to daylight, and as I said earlier in this book, the Solux 4700°K quartz halogen bulbs do help. That is exactly what I've put in the track lights of my gallery.

Selling Your Work

Price your photographs so that it is worth your time in making prints. It should go beyond the mere satisfaction of exchanging income for your art. Figure out if your time seems financially well spent as well. I know that most of us make our photographs for the pleasure of the experience, but selling the work is different. The emotional satisfaction needs fiscal encouragement as well, and making the same print over and over is a drag.

Most photographers seem to have a matrix of income, including print sales, commercial work, stock photography, and teaching. Ultimately, you need to calculate the physical cost of materials, your time, your generalized costs of doing business, and a profit margin. It is the formula for continuing to be able to make the work.

Image Permanence and Storage

If you are going to sell your work, the prints need to last. Pigment inks in inkjet printers and Fuji's development of their Crystal Archive Type C chromogenic color photo paper has now given us unprecedented longevity in our color photographic print work. Be up-front with your galleries and potential collectors' as to the type of printing technology used to make your prints and the accelerated aging tests of how long the prints should last without visible change (*see Wilhelm Imaging in the section "Software and Internet Resources" in the Appendix*).

Label your prints with all of the provenance information you can. Such information will be great value to future archivists as they seek to preserve the work from this interesting but improvisational period in photographic history. Avoid marketing terms like "giceé," which have no precise meaning.

Many protective sprays are now available to inhibit UV damage and provide some surface protection against scuffing. Bag the prints in polyethylene storage for long-term protection.

Steve at FotoFusion Florida showing one of his "contact prints."

PROVENANCE

TITLE:
CREATED:
PRINTER:
PAPER:
INK SET:

Print Provenance stamp.

PHOTOGRAPH BY STEPHEN JOHNSON

Trees and Fog. 1988.

Fitzgerald Marine Reserve, California

This is a digital inkjet print made with pigment on rag paper. Print is color-balanced for daylight illumination (5000°k). Display in a cool, dry area, away from direct sunlight to minimize exposure to visible and ultraviolet light. All reproduction rights and commercial display rights are reserved by the artist.

Stephen Johnson Photography • PO Box 1626 • Pacifica, California 94044
© Copyright 2006 by Stephen Johnson. All Rights Reserved Worldwide.

Print Label. We print them on our rag inkjet paper and use an archival glue to adhere them to the back of matts.

Outreach, Ownership, and Sharing

You own your photographs from the moment light strikes the recording media. A buyer has the right to display, enjoy, resell, but not to publish your work or use it for commercial purposes. Under most state laws, you also have the right to know who purchased your work and be supplied that information on request from anyone selling your photographs.

It doesn't hurt to explicitly spell out those basic rights on the print label itself. It makes for an informed process from the very beginning.

Image Sharing and Publishing

Internet picture sharing, TV picture sharing, and Print Package print sharing are all very viable methods of getting your images out to friends and family. If it were only for fulfilling family obligations, Print Package might be worth the cost of Photoshop. It saves so much time by making sets of prints from your files.

Gallery, Clients, and Magazine Submissions

Custom-built web sites can be amazingly quick ways of communicating photographic options to potential clients and art directors/magazine editors. More and more people are willing to take a quick look at a web site as an initial conversation starting point. This usually works best if they have contacted you first.

When you are making the overture, your best bet for drawing attention to your work is to discover their preferred method of submission and follow the procedure. It demonstrates respect for their process and empathy for the flood of work that might have caused the review process to be set up. That doesn't mean that you don't adopt other methods if the normal procedures don't result in a reaction.

Rejection is another issue entirely. It must be handled with a thick skin, attention to any comments that were made, and a re-evaluation if the rejecting entity was a good fit for your work. The book *Art & Fear* tackles many of these issues with humor and perspective. *(See Chapter 18 and the Appendix.)*

It is critical that your presentation is superb. Track and number any portfolio you send out. Make sure it is understood that it has value, that it is being given on loan, and that it is expected to be returned. It is often useful to include return shipping forms to make this clear and convenient. Anyone looking at lots of work will appreciate that their job has been made easier.

Photoshop's Print Package

Licensing work can put your photographs together with projects which you respect, like these Wallace Stegner book covers Penguin books licensed. Covers designed by Edward O'Dowd

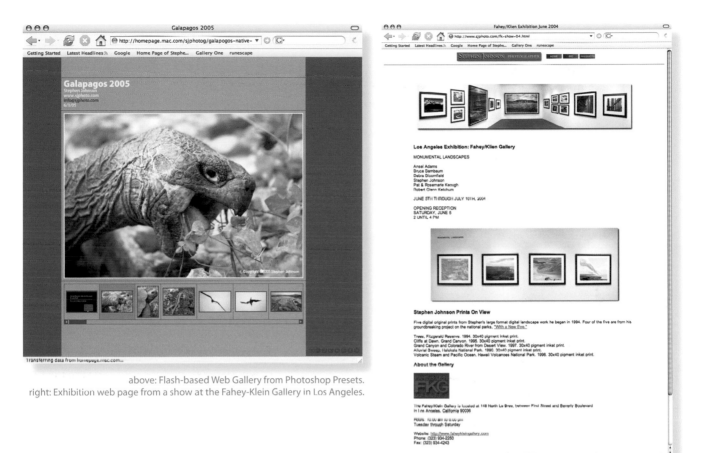

above: Flash-based Web Gallery from Photoshop Presets.
right: Exhibition web page from a show at the Fahey-Klein Gallery in Los Angeles.

Exhibitions That Live On

Don't let temporary installations of your work ever disappear. Make panoramic VR files of the installations and post them to your web site as an ongoing record of your exhibition history. It keeps a visual record of the exhibition, allows visitors to explore the space, and substantiates the validity of your exhibition record.

The PhotoMerge command within Photoshop's Automate menu is a built-in panoramic VR stitcher to make a panoramic file from individual frames (*see Chapter 7*).

Web Galleries

Photoshop's Web Gallery function allows easy creation of custom image web pages with very little trouble. The feature comes with a variety of styles and layouts. Simple HTML editing on the supplied styles (kept in Photoshop's Presets folder under Web Galleries) can further customize their appearance with your logos and navigation features. Many other packages are available, including WebPics, which also lays your copyright information on top on the photo. These packages give you a nearly instant photo-posting capability that can be handsome. Don't underestimate the power of having the ability to respond to photo requests with quick custom galleries. It's a way of showing your work with minimum effort.

Past exhibition web page with VR panoramic.

A Limited-Edition Fine-Arts Portfolio

17 original pigment inkjet prints on Hahnemühle paper. 17.5 x 14 inches. 21 pages. Edition starting price: $6000.

above: Mary Ford and Michelle Perazzo help with preliminary hand trimming on Portfolio production.

left and below: bound portfolio cover and close-up of foil die-stamped type, title page and image spreads.

Binding by Cardoza-James, San Francisco.

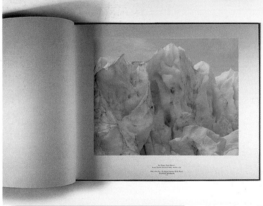

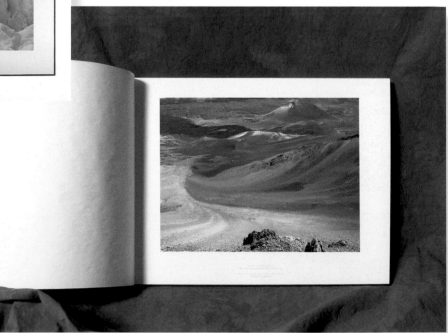

Portfolios As Books and on DVD

Providing galleries and potential buyers a Custom portfolios of your work are now a must. It is now too easy to produce prints and buy handsome display folios for you not to go to this effort on behalf of your work. Work can be printed in sheets with multiple images and custom-bound at a book bindery house, which can usually be found in any urban area. Allowance must be made on the left side of the sheets for the binding. Consult with the bindery regarding needed specifications before printing your sheets.

DVD portfolios are also growing in popularity now and proving extremely useful. Try the software that comes with your computer (like Apple's iDVD); it can do most of what is minimally required for video slide shows and more.

Take advantage of any technology you can that gets your work seen and the emotional content communicated. Pay particular attention to those technologies that don't put your work at great risk for theft. There are clearly good possibilities for getting your work out there now.

Again, make sure it is understood that you expect the material returned. Never let it seem as if it's disposable or unvalued by its creator.

iDVD project for gallery disk.

DVD cover of Apple's mini-documentary "A Photographer's Journey."

screens from "With a New Eye" DVD.

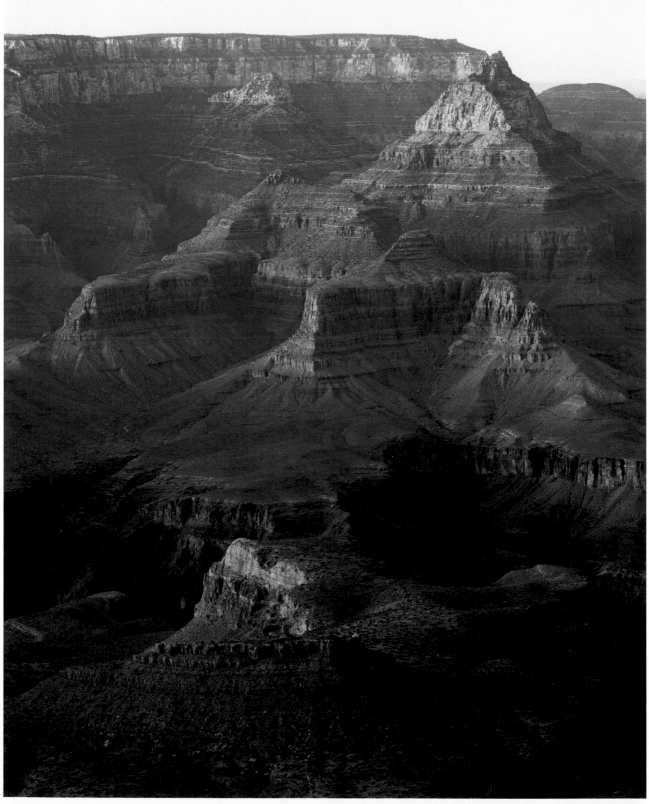

Solomon's Temple and Grand Canyon, Grand Canyon National Park, Arizona, 1996.
BetterLight Scanning Camera, 6000x7520 pixels.

Part 6:
A Photographer's Digital Journey

This benefit of seeing...
can come only if you pause a while,
extricate yourself from the maddening mob of quick impressions ceaselessly
battering our lives,
and look thoughtfully at a quiet image...
the viewer must be willing to pause, to look again, to meditate.

—Dorothea Lange

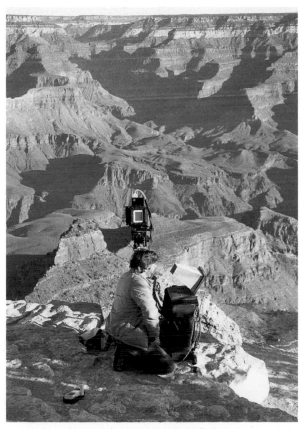

Stephen Johnson with prototype BetterLight Scanning camera rig.
Grand Canyon, Arizona, 1995. Photograph by Ed Stone.

Steve at the Badlands, South Dakota, 1997, Photo by Jeff Schewe.
On the bluff above Exit Glacier, Kenai Fjords, Alaska. 1995.
Man with Camera, Haleakala, Maui, Hawaii. 1996. Photo by Bill Schwegler.
Steve at Bryce, 1994. Photo by Darin Steinberg.

Chapter 16: With a New Eye

Passion is in all great searches and is necessary to all creative endeavors.

—W. Eugene Smith

The journey I've taken through the first all-digital landscape photography project has required passion and perseverance, gone through many ups and downs, with joy, frustration, and plain hard work. It was interesting being on the edge of technology (and several steep cliffs).

"Elusive Gigabyte of Light" by Stephen Johnson

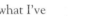

Revised and updated from: View Camera magazine September/October 1995

I've been a landscape photographer for 30 years. For the last 10 years, I have not even carried film. I would never have imagined the technology of digital photography could have evolved so quickly. I no longer think in terms of going out to photograph as a distinctly separate process from seeing the results, both ends of the process now occur together. I make the photograph and I see the result in real time, on the spot. That is a fundamental and welcome change.

The age of the digital landscape photograph has dawned, but it is still early. I'm seeing my current work as an exploration and confirmation of what is possible, but much of it does exist in the rarefied air of a subsidized art project, rather than the strains of the day-to-day life of a commercial studio or the budget of most landscape photographers. That is changing, and digital landscape photography of very high quality is now possible for many users.

After many years of using digital technology to scan, refine, and reproduce my silver-based photographs, I am going full circle and cutting the silver out of the process with direct digital photography. Harking back to the experience of mid-19th century photographers, I am seeing my photographs as I take them. I know what I've done. And I can make a new exposure if I'm not pleased with the photograph.

I've been using the BetterLight/Dicomed Digital Camera Insert, invented by Michael Collette. My use of the camera began when Michael and I went out in January of 1994 for a day of shooting in and around San Francisco. After shooting some comparisons with film that first day, and being amazed at the higher quality of the digital sensor, I soon considered embarking on what I envisioned to be an 18-month project exploring the National Parks, "With a New Eye." In June of 1994, I arranged a press conference with the Ansel Adams Gallery in Yosemite to demonstrate the technology and show the first digital view camera photographs of the park, which I hadn't made yet. It put me on the spot to go up to the park and see what I could do. After a day and a half of work, I was fairly happy with what I was seeing. Much to my surprise, even during the press conference the next weekend, I made an infrared photograph that I liked of Yosemite Falls caught mid-air blowing west.

I've always worked rather slowly when I photograph, trying to be as deliberate and careful as possible. The added options of digital technology seem to fit in very well with that general

draft cover: *With a New Eye* book.

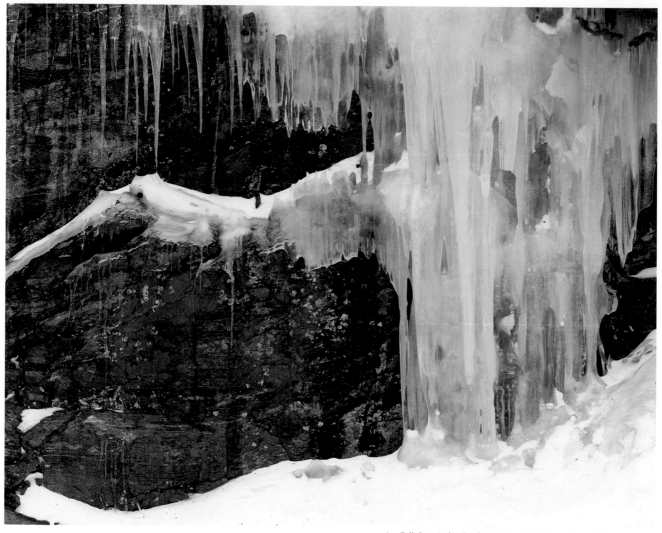

Ice Fall, Bear Lake, Rocky Mountain National Park, Colorado, 1995.
40 24 38nx105 38 11w.

approach. I can now not only compose carefully, I can also examine the photograph, seeing the design and shape relationships as a real image. When dealing with exposure and contrast control, digital imaging really begins to shine. The camera software has a built-in digital densitometer and more than nine-stop contrast range control. I can measure highlights and shadows, change the contrast, and measure again. All with only 4 seconds invested in a pre-scan (in daylight using f16 at 1/240 second per line). When satisfied, or tired of fooling with the process, I can make the full resolution 140MB photograph. I have not even carried a light meter for more than a decade.

Part of my enthusiasm for Mike's camera was that I could use existing view-camera equipment. The BetterLight scanning back I am using with my 4x5 camera is a scanning insert, essentially a battery powered scanner that fits into the camera. It originally came with a 1GB hard drive, which stored about 8 full-resolution photographs, many more if you choose a lower resolution. I added a second drive to double the exposure capacity. A typical exposure in bright sunlight was f16 at 3:45 with an image resolution of 6000x7520 pixels or about 300ppi at 20x25 inches. Now the camera takes 35 seconds for a full-res scan of 6000x8000 pixels in 14 bit and ships with a 40GB drive. The sensor is a 6000 element Kodak tri-linear array that scans red, green, and blue simultaneously,

Choice: Black and White Versus Color

I vividly remember an experience at Bear Lake. I parked the car and wandered around the snow-covered lakeshore for awhile. I spotted a flow of ice from across the frozen lake and couldn't resist the temptation to walk over for a closer look. I was about half way across when the ice gave way and my leg plunged through. At that point I was determined to have that look at the ice. I pressed on and made my way over to the formation. Deciding it was worth the effort, I went back after my camera, walking even more carefully, sloshing with every step. I carried my equipment back across the lake, somehow believing I was being more careful that second time.

Back at the ice, the composition came easily; deciding between a color image or black and white was harder. With the Dicomed Digital Camera, three black-and-white photographs are made (each seen through red, green, and blue filters) to produce a single color photograph. It was easy to delay the final decision until home in my studio. I printed the color image first, and showed it in talks for many months. Something kept bothering me about it, and I finally realized that the greenish ice just didn't set well with me. The black-and-white version seen through the red filter won out.

—from *With a New Eye: A Journey through America's National Parks*

above: Panorama, Sentinel Meadow, Yosemite, 1998.
BetterLight Scanning Camera. 6000x28,000 pixels.
below: frame from "Photographer's Journey" video showing image on-screen, and in the distance, on-site.

true color separations on the fly. The detail is astounding. I'm seeing things in my photographs I could never see before. Disappointingly, some weaknesses in my lenses also showed up, particularly some chromatic aberration I couldn't see with film, but which are clearly revealed by the digital sensor. That is a testimony to the sheer seeing power of the sensor.

The images once took minutes to make, and I was trying to take the system into the real world. Wind is probably the greatest challenge, just as it always has been, even for traditional silver-based photography. Now the wind can be a disaster for the image. Anything that moves transforms into some sort of digital tri-color stick image. At times that can be interesting, but mostly it is not. In one instance, the first image I chose to make in Yosemite was of the parking lot below Inspiration Point, a perfect place to start a digital photography project of the national parks in 1994. Digital tri-color stick people, buses, and cars decorate the asphalt with Yosemite's famous skyline behind. The distortion was purposeful, and I think, worked. But in the Grand Canyon two months later, the gusty wind made it almost impossible to photograph.

I spend much more time in the field on an individual photograph than I would have in the recent past, working to record just what I have in mind. In the past, with traditional methods, much of this time would have been spent in the darkroom. But now, most of the critical interpretive decisions can be made on site, when I am making the photograph and, in theory, when I care the most about the image. Losing the disconnect between when the image is made and when it is seen is one of the joys of this plunge into the digital recording of light. This process clearly lowers the number of photographs I make in the field, but dramatically raises my success rate.

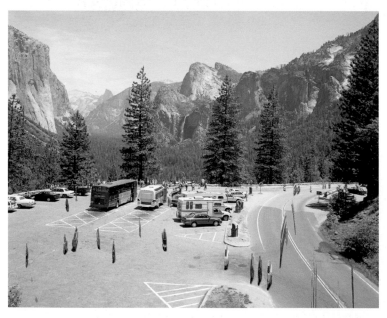

Tunnel View Parking Lot below Inspiration Point, Yosemite National Park, California, 1994.
Prototype BetterLight Scanning Camera. 6000x7520 pixels.

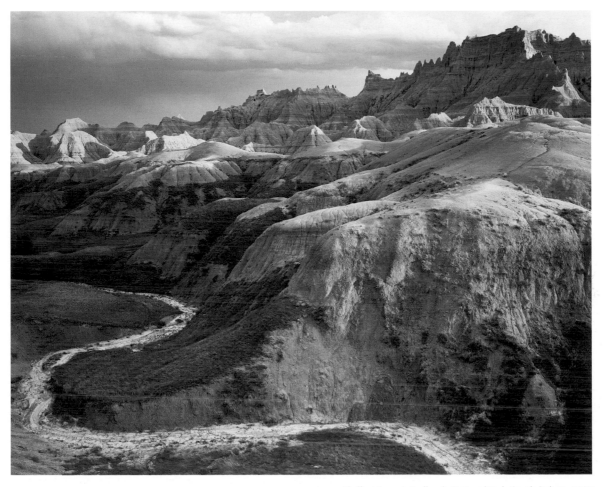

Bluffs at Sunset, Badlands National Park, South Dakota. 1997.
BetterLight Scanning Camera. 6000x7520 pixels.

I do worry that the technology will get in the way of inspiration. The more technology I take with me into the landscape, the greater the risk of distance I feel from the land. But I still find that I spend most of my time looking, walking, and imagining how the scene before my eyes will translate into a photograph. And although that process is essentially the same as it has always been, I am now sensing a greater freedom to try photographs where the contrast would have been unmanageable or the color unrenderable. My sense is that there is a net gain of tremendous value in my use of this digital camera.

The potential archival nature of these color images is also a long overdue step forward. Perfect, exact copies can be made of these photographic files. As long as we have technology and care to update the storage technology, these images can be preserved and seen a hundred, five hundred, or five thousand years from now. To enhance the potential archival and historical value of these images for the park project, I am carrying a Global Positioning Receiver and recording the longitude and latitude of every photograph I make.

With The Digital Pond, a fine arts printing house in San Francisco, we made our first 30x40 IRIS prints on rag paper. Wide-format Epson pigment printers are now my printers of choice. Seeing my photographs on rag paper has been one of the highlights of this entire experience for me. It is also ironic that this digital process is taking me back onto a material so basic and beautiful as rag paper. My digital prints were originally 11x17 dye sublima-

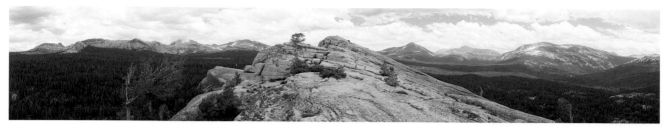

Lembert Dome, Tuolumne Meadows, 1997.
BetterLight Scanning Camera. 6000x34,000 pixels.

tion prints made with the Radius ProofPositive and 11x11 prints on the Kodak XL-7700 printer. Today, I use Epson and Hewlett-Packard desktop and floor-standing inkjet printers for printing.

When taken all together, results on the spot, digital density readings from the image, adjustable color balance, no film grain, color separation color purity, exact duplicates, extraordinary resolution, the argument for digital photography is quite convincing. At least it has been for me. That is why I am creating *With a New Eye: The Digital National Parks Project with Stephen Johnson.* So far, the project sponsors include Adobe, Apple Computer, Dicomed, NEC/Mitsubishi, Newer Technology, Radius, Ricoh, Sinar-Bron, and The Digital Pond of San Francisco.

Some Personal Observations

It isn't only the image quality; it's all sorts of qualities that come with it. For example, I can do a color balance to match the sensor's recording capabilities to the light source. This is different than tagging the photo with a white point that will later serve as processing guide. I'm actually rebalancing the way the sensor acquires the light, so that a gray is gray, to make it dead-on neutral to the scene. I put the gray card in front of the sensor, do a prescan, and ask it to balance the sensors on that gray, to make them gray. The red, green, and blue recording levels are changed to make that sensor dead-on neutral in that light source. Your camera is then balanced to the ambient light, not by editing it after the fact, but by changing the way it is recording light. This is phenomenal, and way beyond anything we've ever done with any other photographic technology.

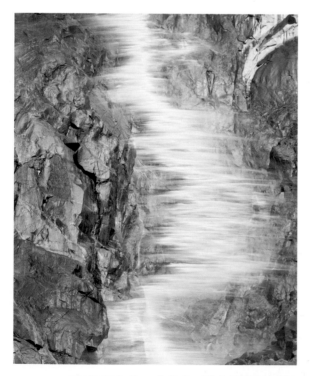

Bridalveil Falls, Yosemite National Park, California, 1994.
Prototype BetterLight Scanning Camera. 6000x7520 pixels.

Scanning backs are weird critters; it's a linear array, three stripes of red, green, and blue, that goes into large format cameras. It is using 6,000 pixels per linear array, so 6,000 under blue, 6,000 under green, and 6,000 under red, and then stopping, pausing, and sampling all the way across the back of the 4x5 imaging area. So the resolution is 6,000 pixels tall by 8,000 pixels long, or about 140MB of an RGB file if you stay in 8-bit. It is pure, already color-separated data. The scan times depend upon resolution, but they have also depended upon the evolution of the camera at the time. In 1994, it took 3 3/4 minutes to take a photograph. It now takes 34 seconds. But it is still hard for that to make sense for landscape images because it still takes half a minute to make the photograph. The earth moves (a lot moved in the almost 4 minutes of the early scan times), and if the world doesn't move, the wind moves the camera. A 4x5 is a bit like a sail in the wind. Even with film I didn't like wind with the 4x5, and using the scanning camera I sure don't like wind with the 4x5, so there are a lot of downsides. This camera is made primarily for the studio, to stay indoors where it is nice, safe, and steady. But inside is such a limited view and outside is so expansive and rich, waiting to be recorded with the kind of fidelity this camera can deliver. I couldn't resist.

STEPHEN JOHNSON
DIGITAL LANDSCAPES

My world as a photographer is changing. And it's looking much more like the world I see with my eyes.

For more than twenty years I've been making photographs. From an early age I was seduced by the beauty of the photographic print. I wanted to make such beauty. I worked very hard to translate the wonder I saw with my eyes onto paper. It never occurred to me that the craft of photography was anything other than learning to see using a silver-based medium.

As my projects became more complex, I needed to assert ever more control over the context and reproduction of my work. It was natural to use computer technology for the publishing and design tasks related to my photography.

I began to use digital photography programs to do image restoration, scan straightening, spotting, duotone creation and fine-tuning color separations. The control I could assert on a photograph in digital form was not lost on me. I didn't realize how quickly the technology would evolve. By 1994, I stopped using film to make serious photographs.

I find myself on the edge of a new technology, one that both frees our vision and assaults our sense of truth in photography. For me, the advent of digital photography is not about manipulation. Quite the contrary, it is about seeing more clearly, with less interference and delay from the inspiration.

I am showing, to the best of my ability, what was before the camera. Nothing has been moved, removed, cloned or otherwise digitally *enhanced*. The natural wonders of the world are already self-embellished, I've no need to do anything more than try to be an honest recorder of what I see, using my eyes, imagination and tools to select and capture those views with whatever skill I possess.

I'm recording colors in my photographs that escape film. Highlight detail is holding and shadow detail is opening up like never before. I am making the first archival color photographs of my career. Grain has vanished. I'm seeing the photograph, when I am photographing, on the spot, when I should. As it always should have been.

The fumes of the darkroom are being displaced by the flicker of a screen. Lung disease, supplanted perhaps, by CRT radiation. Art has always been about risk.

Photography has always seemed magic. The shutter clicks, and some unseeable change occurs on silver coated plastic. Nothing seems to have happened. The weight of the film does not increase with the burden of the light it carries. It is a secret, to be revealed by the spirits in the darkroom. Later.

Now the photograph appears as the image is being recorded. There is evidence that something has happened, visual evidence that a photograph has been made. And it can be studied, probed, rephotographed if necessary. And worked closer to perfection and beauty.

The way I think about making a photograph is changing. These photographs are less instantaneous in their witness, but visible on-site while the camera remains ready. Now they take minutes to photograph, and photographic time shifts once again—from an unreal slice of a moment, to an accumulation of time slices over time.

-Stephen Johnson

WITH A NEW EYE is a digital photographic survey of selected American National Parks during 1994 through 1999. This project will culminate in a photographic portfolio, a touring art exhibition, a poster, a CD (cataloging the work, demonstrating the technology and discussing the National Park ethic and system), and an interpretive photographic book.

The project employs the Dicomed and Better Light 4x5 digital cameras, and the Macintosh PowerBook G3 for completely portable digital photography of very high quality. The camera is capable of color, black and white, and infrared photographs of extremely high resolution and dynamic range (up to 6000 x 8000 pixels, 140mb files with more than 9 stops of exposure latitude). The panoramic images are created by mounting the camera on a rotating head and making a continuous scan up to 370°, (up to 6000 x 65,000 pixels, 1.12gig).

The photographs are previewed in the field, on screen, in order to determine appropriate contrast, exposure and color balance, and to check composition and focus. For documentary and archival purposes, a Global Positioning System Receiver (GPS) is being used to determine the longitude and latitude of the photographs.

Thanks to

Michael Collette (*inventor of the Dicomed & Better Light Digital Cameras*)
Peter J. Hogg *Digital Pond, San Francisco*, Mac Holbert *Nash Editions, Manhattan Beach*, Bill Atkinson

many prints in the exhibit are from my current project
With a New Eye: The Digital National Parks Project

sponsored by
*Adobe Systems, Apple Computer, BetterLight, Daystar,
Dicomed, Digital Pond, FWB, Iris Graphics, Newer Technology, Radius, Ricoh, Sinar Bron*

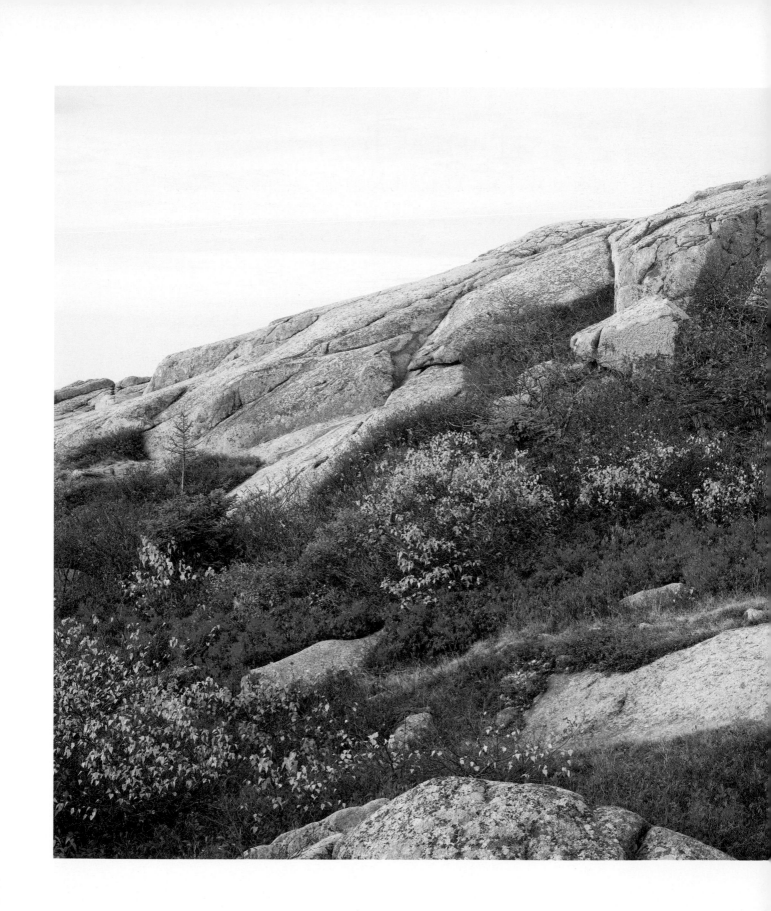

Chapter 17: Examples Portfolio

This portfolio features a selection of images that provide some illustrations of how I am working, some specific insights, as well as some problems and just plain peculiarities of the process. The text documents how a few representative photographs were made, chronicling the desires, challenges, methodology, success, and failures of some work from *With a New Eye: The Digital National Parks Project*.

Realistic, Restrained Color in Acadia National Park, Maine

Fall color on America's East Coast is among the most typically oversaturated, overdramatized subject matter of modern color photography. It's ironic that the stereotype of these photographic clichés may actually dampen some enthusiasm to explore this wonderful display by making them seem trite.

As the transition to digital photography progresses, it is also interesting to watch so many work hard to imitate the contrast and color limitations of film that helped build those clichés.

This particular photograph from Acadia National Park has been a good example of fall color rendered more accurately than I had ever managed it could be. The unique capabilities of the scanning camera allowed the inherent capabilities of silicon sensors to shine.

However, I have had to work hard to keep the reddish leaves from oversaturating when printed. They are just on the edge of being over-saturated in the file, but their tendency to float above the other colors have made me select the reds in many prints and bring their saturation down to print correctly.

This photograph is also an example of how things can come to you after you've given up and started to walk away. After a very pleasant but photographically unproductive sunrise, I packed up the gear to hike back to the car. Beside the walkway, this simple scene caught my eye.

Granite and Brush, Acadia National Park, Maine, 1994.
BetterLight Scanning Camera. 6000x7520 pixels. 12-bit. Tri linear Array.

Sensor Matched to Scene
at Arches National Park, Utah

Predetermined lighting expectations such as daylight color balance became an accepted fact of color balance in the silver-based film era.

This photograph from Arches National Park was made before the sun rose and hit these cliffs near Courthouse Wash. It was not typical daylight.

Our brain and eyes work together to adapt to different ambient light conditions. We don't see pre-dawn light as blue, as daylight film or a daylight color balance would. Our brain recalculates the color to normalize its appearance. Digital photography gives us the ability to do much the same, by matching the sensor to the real conditions.

The BetterLight Scanning camera's ability to custom balance the sensor to any lighting condition avoided imposing the bluish cast a daylight-balanced color technology would have rendered.

Although the BetterLight system is the first camera to have this unique ability to actually rebalance the sensor, it is an indication of capabilities to come. A less effective but still useful technique would be to photograph a spectrally neutral gray card at the scene and use it for custom RGB gray balance, to tag the file in-camera or in software processing after the fact.

Cliffs at Dawn, Arches National Park, Utah, 1995.
BetterLight Scanning Camera. 6000x7520 pixels. 12-bit. Tri-linear Array.

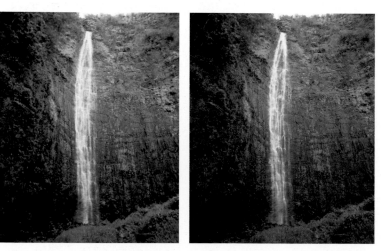

Waterfall, Haleakala National Park, Maui, Hawaii. 1996.
left: Daylight color balance in shade.
right: Sensor rebalanced for shade showing correct color.

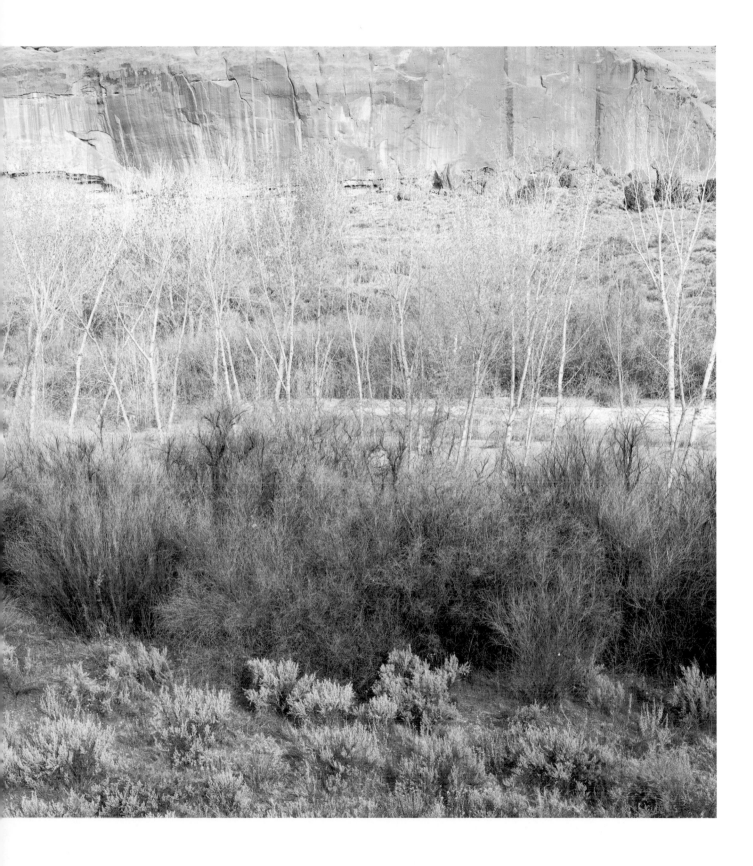

Silicon and Infrared
at Denali National Park, Alaska

Much like film's extra sensitivity to ultraviolet, silicon can not only image visible wavelengths of light, but it can reach deep into the infrared spectrum.

In fact, silicon IR sensitivity is so profound that human color rendering can normally only be achieved by placing an IR cutoff filter in the light path of the imaging system. These filters are usually laminated onto the CCD or CMOS sensor in most digital cameras. They can be left as add-on filters, thus freeing the camera to record color with the IR cutoff, or flood the sensor with IR and record an infrared photograph without the filter.

Many of the IR images I've made have been the black-and-white images formed under the red filter of a tri-color system, imitating the look and feel of black-and-white infrared film with a 29A filter. Except, of course, instead of the black-and-white infrared film's unpredictability, we can know the right exposure, the focus point, and what the image will look like.

Tokosha Mountains (infrared), Denali National Park, Alaska, 1995.
BetterLight Scanning Camera. 6000x7520 pixels. 12-bit. Tri-linear Array.

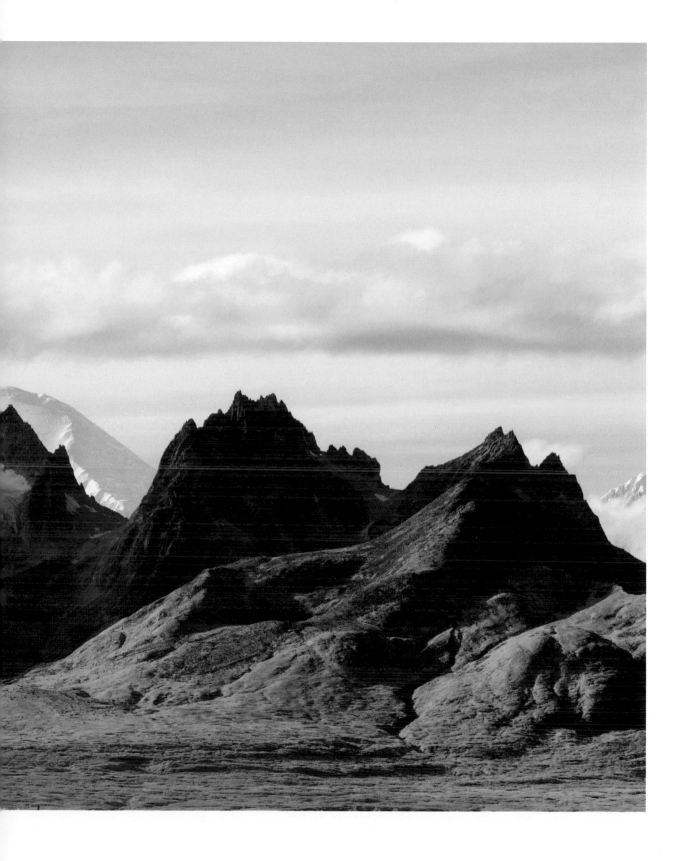

Motion and the Scanning Camera
at Hawaii Volcanoes National Park, Hawaii

A new rendering of photographic time is depicted in this photograph of Volcanic Steam at Hawaii Volcanoes National Park. In its first versions, the BetterLight scanning camera originally took 3:45 to move the sensor across the imaging plane. When this photograph of the steam was made, the fastest full-res exposure had dropped down to 2:30, but it was still a long time.

Magic and serendipity happen in photography. More often than not, the scanning camera's long recording time was a problem. In this particular instance, the clouds stretched out with a surreal beauty I found quite compelling.

The steam clouds were rising rapidly, and the wind was blowing off the ocean, making for a lot of movement, which I had to reconcile with my desire to keep the exposure short. I ended up doing a series of frames at every resolution, just to track the strange record of the full-res down to the preview size quick scan where the clouds were frozen in traditional photo time.

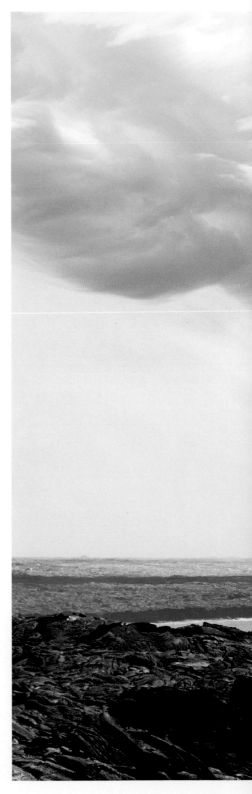

Volcanic Steam at Hawaii Volcanoes National Park. Hawaii, 1996. BetterLight Scanning Camera. 6000x7520 pixels. 12-bit. Tri-Linear Array.

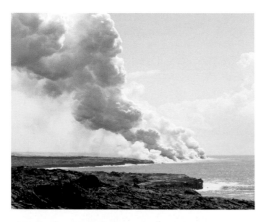

Wild Scanning Surf, Pt. Lobos, California, 1995. BetterLight/Dicomed Scanning Camera.

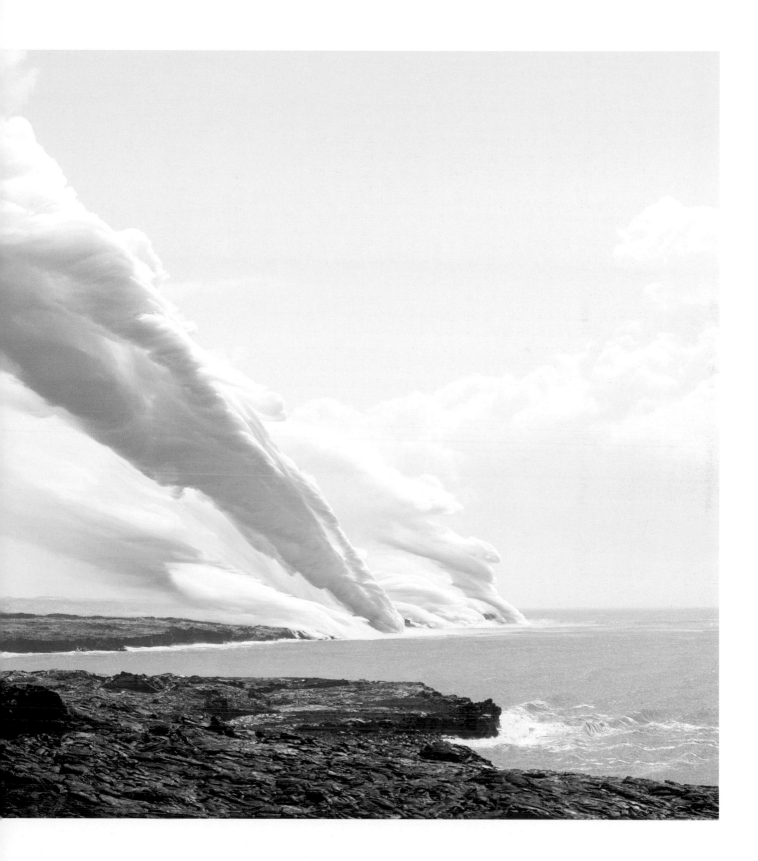

Worth the Climb:
Mt. St. Helens National Monument, Washington

We climbed 5,000 feet over five miles of trail, much of it on loose volcanic rubble, and the last few hundred feet up a steep slope of ash. It was my 40th birthday and I fortunately had lots of help getting equipment up the mountain. It took us most of the day, and we had only about an hour at the summit before we had to start down.

The view from the top of Mt. St. Helens was the reward for good planning and the day's hike up. The fact that the air was still and clear was a terrific bonus.

It was fairly high contrast, though, with the shadows off the lava dome in the crater looking essentially black without detail.

I scanned the scene very low in contrast to hold the extreme contrast range. This resulted in a gray, low saturation scan, but it held the detail. Consequently, it did require editing the file carefully on a calibrated monitor to force a darker black point and brighter white point, and then boosting the saturation some.

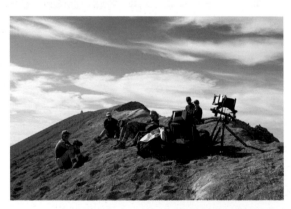

The Climbing Crew, Mt. St. Helens. Washington. 1995.

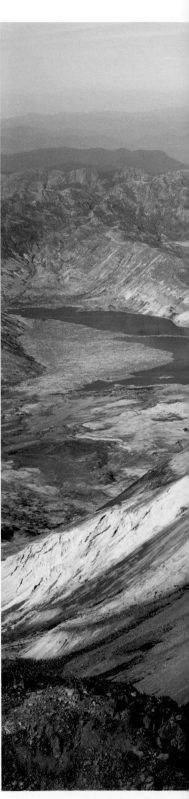

Crater, Spirit Lake and Mt. Rainier. Mt. St. Helens National Monument.
Washington. 1995.
40 11 29Nx122 11 15W 12° 3:50pm.
BetterLight Scanning Camera. 6000x7520 pixels. 12-bit. Tri-linear Array.

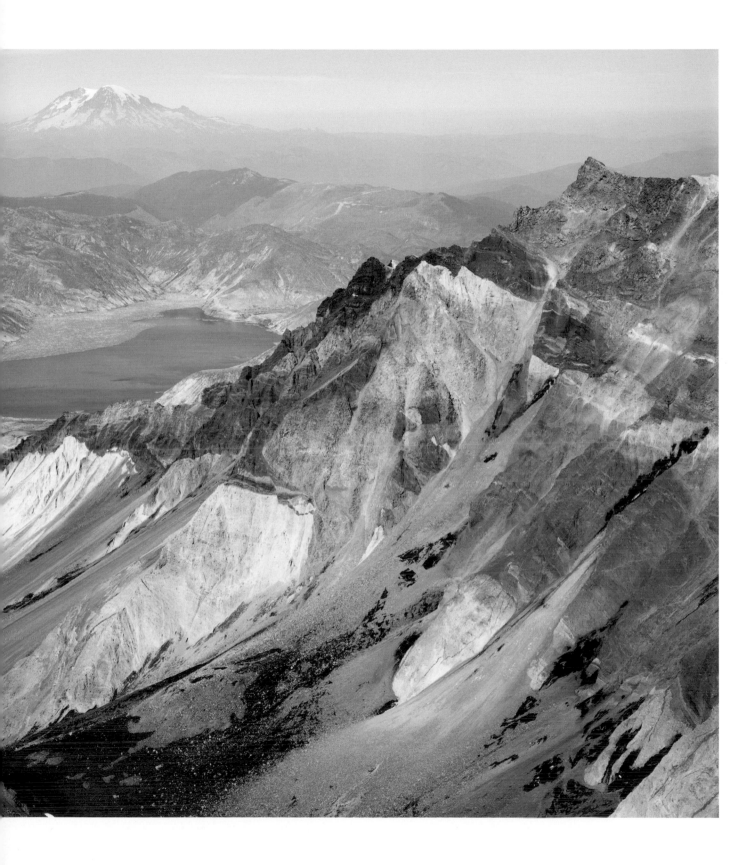

On the Digital Trail

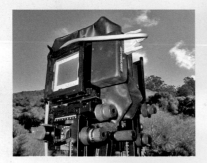

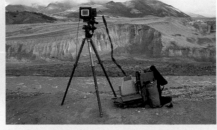

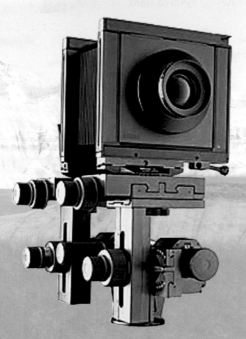

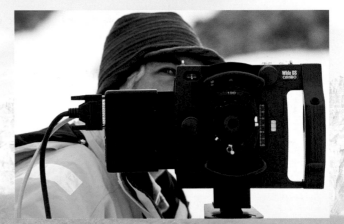

Steve in Antarctica photographs by Jeff Schewe.

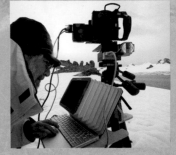

Digital Camera

- ✦ BetterLight Digital Insert, Super 6K2 (6000x8000 pixel, Tri-Linear sensor)
- ✦ Modified Dicomed Digital Insert (6000x7520 pixel, Tri-Linear array sensor)
- ✦ Prototype BetterLight Digital Insert (6000x7520 pixel, Tri-Linear array sensor)
- ✦ Sinar-X 4x5 Camera
- ✦ Sinaron 65mm, 150mm lens and 300mm lens
- ✦ Schneider 90mm and 210mm lens
- ✦ Goertz Red Dot 600mm lens
- ✦ Gitzo Carbon-Fiber Tripod
- ✦ Panoramic Adapter by Better Light and BayHouse
- ✦ Additional camera: Kodak DCS 460 on Nikon N90 body & Kodak DCS 14n
- ✦ Additional camera: Calumet Cambo Wide with 90mm Schneider Super Angulon

Field Computer

- ✦ 2003–2006: Apple PowerBook G4 17, 1GB RAM, 60GB internal hard drive, DVD writer plus WeibeTech MicroGB 40GB FireWire hard drive.
- ✦ 1998–2003: Apple PowerBook G3 series with 512MB RAM*, 40GB internal hard drive, 8GB and 12GB removable media bay drives
- ✦ 1996–1997: Apple PowerBook 3400c with 148MB RAM*, 2GB hard drive
- ✦ 1994–1997: Apple PowerBook 540c with 36MB RAM, 500MB hard drive

Software

- ✦ Adobe Photoshop CS2, CS, 7, 6, 5, and 4
- ✦ Apple System 7, 8, 9 and 10
- ✦ BetterLight Viewfinder Scanning Software for Dicomed Camera and BetterLight cameras
- ✦ ImagePrint printing software for inkjet printers
- ✦ Cumulus image database software (Canto)
- ✦ GPSy GPS software for Macintosh

Accessories

- ✦ Garmin GPS Receiver
- ✦ KISS Solar Panels
- ✦ Minolta Color Temperature Meter

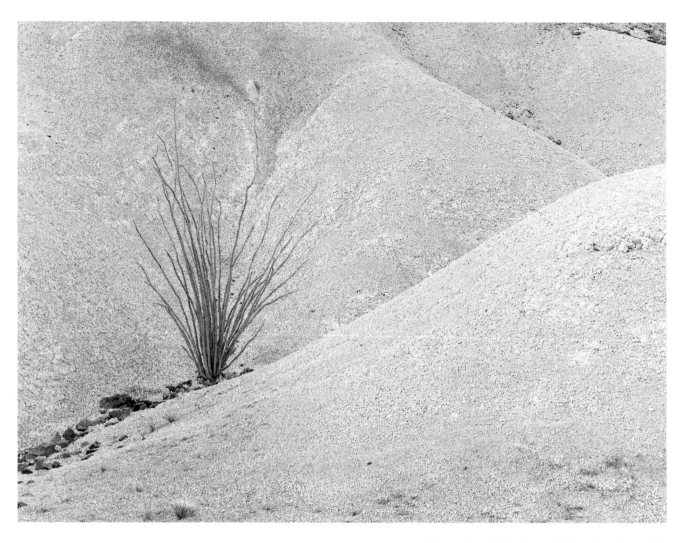

Ocotillo and Eroded Hills. Big Bend National Park, Texas, 1997.
BetterLight Scanning back in Sinar-X view camera. 150mm Sinaron. f16. 1/30 per line.
6000x7520 pixels. 12-bit. Tri-Linear Array.

I wandered Big Bend for a few days, not sure how to sort out a visual take on the place, a little overwhelmed at its complexity. Stopping at a single location and wandering more, finally let me start to take in smaller, simpler scenes. This view of mud hills and ocotillo gave me a visual entry I had been in search for. Many photographs came that day.

Chapter 18: Making Art

You don't memorize the dictionary and suddenly say profound things.

—Jerry Uelsmann, 2004

Talking about art is hard. Either there don't seem to be words to describe the motivations or reactions, or there are too many words that end up obfuscating meaning. Learning contemporary language and references of modern art criticism may help some understand art history, but "art-speak" is rarely a tongue I hear used by artists themselves. Plain talk, real dreams, and real passions are what drive us forward, sometimes irrationally, sometimes with a plan. Photography fits neatly into this long and confused history.

Art and Fear

A few thoughts about the making of art:

"In large measure becoming an artist consists of learning to accept yourself, which makes your work personal, and in following your own voice, which makes your work distinctive. Clearly these qualities can be nurtured by others. Even talent is rarely distinguishable, over the long run, from perseverance and lots of hard work.

Art is made by ordinary people...with the whole usual mixed bag of human traits that real human beings possess. This is a giant hint about art, because it suggests that our flaws and weaknesses, while often obstacles in our getting work done, are a source of strength as well.

Making art and viewing art are different at their core. The viewers' concerns are not your concerns (although it is dangerously easy to adopt their attitudes). Their job is whatever it is: to be moved by art, to be entertained by it, to make a killing off it, whatever. Your job is to learn to work on your work.

There's generally no good reason why others SHOULD care about most of any one artist's work. The function of the overwhelming majority of your artwork is simply to teach you how to make the small fraction of your artwork that soars. One of the basic and difficult lessons every artist must learn is that even the failed pieces are essential.

'Artist' has gradually become a form of identity which (as every artist knows) often carries with it as many drawbacks as benefits. Consider that if artist equals self, then when inevitably you make flawed art, you are a flawed person, and when (worse yet) you make no art, you are no person at all. It seems much healthier to sidestep that vicious spiral by accepting many paths to successful artmaking...from reclusive to flamboyant, intuitive to intellectual, folk art to fine art. One of those paths is yours."

—David Bayles and Ted Orland from *Art & Fear*

Passion and Commitment

In order to make art, the frustration of not working
has to be greater than working.

—Jerry Uelsmann

People make art, not machines, certainly not software. However, photography is such a technical medium, that we often lapse into tech talk, even when in our heart we're yearning for some comprehension of this drive, fear, and incessant desire to "get it out."

As a landscape photographer, I often wander the world in wonder at the scene before my eyes. It is a complex world, mixed with natural beauty, man-made kitsch, brutal laws of nature, and human chaos. The landscape is my refuge, my journey into something more fundamental and essential than the troubles of the current age. It's not that I can ignore human suffering, even on the edge of a long lonely horizon, but rather that I feel there is something more fundamentally human about being in natural surroundings than any other experience.

For me, art is an expression of those passions and ultimate humanness that takes me beyond the specific instance—being on top of a volcano, being in a lover's embrace—into an intuition about what it means to be human. Words don't express it well; that is why we make art.

It is also why we feel such a passion for the medium. I want an emotional response to my work because the work is in fact an emotional response to what I saw. True, there are many mechanics in between, but my work is an attempt to encapsulate what I saw into a photographic frame that both renders the scene before the camera and carries with it the power of what I felt. It requires a peculiar combination of attention to form and structure, while letting the grace and wonder remain dominant. Whether I judge a photograph of mine to "work" or not is tied up in that attempt and if I feel I've risen to that challenge.

William Henry Fox Talbot. Leaf, c. 1839.
RPS/NMPFT Science and Society Picture Library.

Other reactions flow from the experience. I have to find ways of giving back. My commitment to conservation and the environment runs back 30 years. I have always felt the need to work for my convictions and at least attempt to influence change.

Much of my professional work as a photographer has been tied up in large-scale projects that are about preserving wild places or trying to further an understanding of our relationship to the land. The projects are likely a manifestation of the instinct to "give back" and to not live my life just taking up space, but sincerely trying to make a difference while I'm here.

There is something running through these thoughts that if clearly felt and understood, seems capable of helping to calm the human heart and "make more compassionate the life of the world."

When power corrupts, art establishes the basic human truths
which must serve as the touchstone of our judgment.

—John F. Kennedy, 1963 Amherst College address

Photography and Magic

Photography is a wonderful tool that helps us see better and plunge deeper into the visual world. We notice more; we see more clearly. Photography is literally *light writing*.

Photography has been described as *The Pencil of Nature*, and it has extraordinary power. It can capture what we see, what we love, those we love. That is the magic that makes us reach for the camera.

We still want to believe in photography's ability to show us what was really there. There is still faith in the scene recorded by the lens. It is understood by the viewer to be a selection from a larger scene and a slice of time. Nonetheless, its sense of truth is undeniable.

The first photography book *The Pencil of Nature* by William Henry Fox Talbot, 1844. NMPFT/Science and Society Picture Library.

The Photoshop Paradox

As we are completely drawn into the power of digital photography software like Photoshop, it may dawn on many of us that we are sitting and staring at the computer screen for hours on end. Sometimes we may be trying to make the photograph something it is not. At the very least, sitting in front of a computer screen is not why most of us got involved with photography.

I love photography, not software. Photoshop is just a tool, albeit a critical tool, but so is your imaging system, and more fundamentally your heart. Even as I advocate using photography as a tool to record what we see, the instrument of real concern to me is the heart.

In this digital age, just because we can do something doesn't mean we should. Digital photography and Photoshop often seem to seduce us into using tools just because they are cool, not because they make the photograph stronger.

Recorded Light vs. Edited Pixels

I am far more interested in what was seen rather then what it can be changed into. Photography's magic is not the product of what we might do in Photoshop later. Those skills and inspirations are about other things.

I am interested in the captured scene, the magic of the real world, in real light. It is the same world we are seduced into photographing in the first place, an already embellished rich world of visual experience. The task for me is not to change that world, but to witness it, hold it, share it. Talent is in having the insight, skills, and dedication to capture those visual experiences, and the instinct to do it splendidly.

Vision and Structure (Inspiration and Composition)

Photographers often become explorers of their visual worlds. If photography does indeed help us to better appreciate the visual world more than we might have otherwise, it is not surprising that the more we work, the better we get.

Over time, we build a visual intuition as we learn to look for arrangement of line and space that gives a dynamic and sensual structure to the image. It becomes part of the vision behind making a photograph and we often intuit the image to be made in a situation where there is little time to do anything other than act on instinct.

A successful photograph seems to be an image that was both inspired and well composed. These are goals we are always likely to seek, but which we find much more rarely than we wish.

In teaching photography since the late 1970s, I've found that having students look at a lot of work, and try to understand what they like, and force them to think about how they are putting their own images together can lead to dramatic improvements in the work.

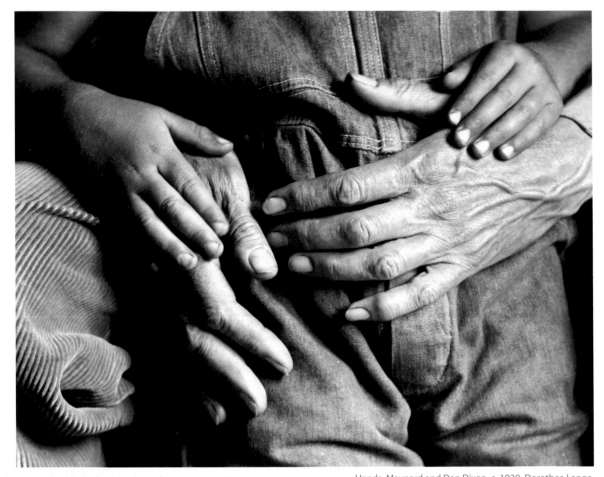

Hands, Maynard and Dan Dixon, c. 1930, Dorothea Lange.
Oakland Museum of California.

Seeing

We miss things all of the time. We stop because of a pat-
tern recognition out of a side glance, something out of
place, a small sense of order out of larger dissonance. It
draws us to look again and perhaps reach for a camera.
But we still miss far more than we see.

I was in Barcelona in the last few weeks of writing this
book, wandering the streets with the camera. A patch
of sky blue and yellow with a strange sign towering up
caught my eye. I walked across the street and made an
exposure. I was immediately confronted by agitated
Spanish Police insisting that I cannot photograph the
Police Station. I had never seen it. I was honed in on
something and didn't notice where I was. So soon after
the Madrid train bombings, their concern was under-
standable. I quickly called the file up, showed them I
meant only to photograph the sign, then erased it on the
spot. With film, and no ability to show what I was doing,
the evening might have taken a very different course.

Some Art Related Definitions

A few words have long had resonance for me in discussing
art, some meanings obvious, others more surprising, and
perhaps telling.

+ art: an activity creating beautiful things. an expression
 of beauty. a skill or craft. cunning. contrivance.

+ abstract: apart from reality, a model. to remove or
 take away from. summarize. without reference to a
 particular thing.

+ abstraction: preoccupation. distillation. a piece of
 the whole.

+ simple: not complicated. without embellishment.
 unassuming, unpretentious. not deceitful. humble.

White Fence, Port Kent, New York. Paul Strand. 1916.
©1971 Aperture Foundation, Inc. Paul Strand Archive.

About Art

Art is a lie which makes us see the truth.

—Pablo Picasso

The photographs about nothing very much tell us so much about human life.

—Dorothea Lange

Not to illustrate concepts already formed in the viewers mind—but rather a personal direct exposure—getting lost.

—Dorothea Lange

The camera is an instrument which teaches us to see without a camera.

—Dorothea Lange

Exaggerate the essential, leave the obvious vague.

—Vincent Van Gogh

Self-Portrait, Vincent Van Gogh.
Saint-Rémy: September, 1889.
Oil on canvas. Paris: Musée d'Orsay.

Henry Peach Robinson, Fading Away, 1858.
Combination Print - 5 Negatives. NMPFT/Science and Society Picture Library.

Oscar Rejlander.
The Two Ways of Life, 1857.
Combination Print - 30 Negatives NMPFT/Science and Society Picture Library.

Chapter 19: Photography and Truth—Imaging Ethics in the Digital Age

*Anyone who doesn't take truth seriously in small matters
cannot be trusted in large ones either.*

—Albert Einstein

No look at photography in the digital imaging era would be complete without an exploration of ethical issues: the consequences of frivolous personal and social behavior, the implications of digital tampering with history, the relative ease of image theft, and the creative freedom of expression. The subject of ethics touches upon art, notions of truth, creativity, and photography's meandering yet significant role through these concerns.

We are in an age where almost anything can be done to a photograph. Someone with good Photoshop skills can easily feel that if they open an image and do nothing, they have somehow not done their job. But just because we can do something doesn't mean we should.

Imaging Ethics in a Digital World

Revised and updated from:
Keynote Address by Stephen Johnson
Photoshop Conference (Thunder-Lizard), New York City. July 10, 1995

This is a very interesting and dynamic time for imaging. It is a exciting time to be involved in the arts. We are blessed with incredibly powerful new tools for controlling the appearance of our own work and the work of others that we need to reproduce. As a photographer, I now have unprecedented control over how I make and interact with my photographs. However, with that power comes responsibility.

It's not my intent here to propagate any notions of absolute truths or knowledge, or assert that my values should be your values. I do want to help shape the creation of an ethical climate where we can arrive at an understanding of what is appropriate to do and what is not. We are leaping into this new and exciting era without much consideration of the implications of what we are doing. It's time to step back and take a look at what we are doing.

Where Are We?

It seems to me that there are three major issues at hand. First, I think we need to examine how we are affecting the perception of photography, of photojournalism, of the photograph as evidence of events having taken place. We need to ask the important question—should people be suspicious of the truth in photography to begin with, and should they always have been?

We're also in a new era with new implications for image ownership or copyright and contracts. The ownership of your own artwork, the kinds of use fees you have to pay to use others' work, and what is legitimate to do and what is not legitimate to do with another person's work are all areas that need to be examined.

Additionally, I think we need to consider what we are saying about the world with these new digital creations. Most of what I see doesn't say anything very positive about the world, nor does it usually provide any deep thought as to what it means to be an artist in our time.

Abraham Lincoln. Stereograph, ca 1861–65. New York Historical Society.
Stereo photos are very hard to fake. Each image would have to be perfectly
done, including the 3D depth perception.
New York Historical Society collection.

Photography and History

There is nothing new about altering photographs. In fact, this is a very old practice. Oscar Rejlander and Henry Peach Robinson were making photo theater pieces in the 1850s. There was no assumption that they were true—they were faked, altered assemblies created by cutting, pasting, and re-photographing images. They were purposefully melodramatic; Henry Peach Robinson's work was a type of photographic theater. They were intended to push the art of photography forward. These photographs were very early examples of what we often assume to be a contemporary trend.

Photomanipulation is not just about the ability to manipulate the photograph after the fact. There are some who would say that a famous Gettysburg battlefield photograph by Matthew Brady's Civil War photographer Alexander Gardner had to be manipulated because a body would not fall into the position shown in the photograph. There is still controversy over whether Alexander Gardner actually went into the scene and moved the body around for a better photograph, but that is becoming

Alexander Gardner.
Dead Confederate Soldier in the Devil's Den, Gettysburg.
Library of Congress, Prints and Photographs Division: LC-B8171-7942.
The moved soldier controversy is explored at:
http://memory.loc.gov/ammem/cwphtml/cwpcam/cwcam1.html

Mao Tse-Tung from the
Little Red Book.

From *The Soviet Worker,*1939.

the accepted assumption. There is even another Gardner photograph that seems to show the same body in the open battlefield. This is an early example of image content manipulation and staging "journalistic" events.

Image Manipulation and Propaganda

Our perception of history has certainly been affected by image manipulation. There are the classic images that most of us have seen, the sort of Soviet-Maoist approach to portraiture with its heavy airbrushing of leaders to make them look even more ideal or the familiar kind of totalitarian deception glorifying the common citizen as hero worker art. There are multiple examples of this and they are based on photographs, but have very little to do with the way the original scenes looked. Stalin often had people removed from photographs after he had "removed" them from their lives. Mao's famous portrait that hung all over China and opened the *Little Red Book* is significantly altered, airbrushed into an ideal.

Historical Photographs

Photographs that are generally understood to be realistic representations are very problematic when it comes to manipulation. The widespread practice of heavy image restoration essentially attempts to airbrush your ancestors back into clarity. This practice has a terrific downside, in that you don't end up knowing what your ancestors actually looked like because the airbrush subsumes the content of the original. You can end up obscuring what your great-great-grandparents really looked like or where those eyes on your spouse came from. The scene setting, the clothing, whether or not that left foot that you cloned in and switched around is leaving the impression that both boots on this person were in fact identical, whether or not the lighting was what it appeared to be on a particular day—all of these add up to a synthetic history. Consequently, extensive retouching has the potential to affect our perception of history. As I mentioned earlier, our relatives can essentially become historical fictions.

In photographic history there is another icon that needs mention. I have the greatest respect for Dorothea Lange's work. The photograph of the *Migrant Mother* in Nipomo, California from about 1936 is one of the classic photographs in the history of photography. It's also been altered. It doesn't seem an important retouch, but

nonetheless in the bottom part of the photograph there is a thumb that has been touched back. It's holding back the fabric at the bottom right of the image. It's not an important aspect of the content of the photograph, but it does demonstrate that intervention—a willingness to alter reality to suit the needs of the curator, the project manager, that art director or editor—is something that has been going on for a long time. In this case, it didn't substantially affect the historical content and emotional power of the photograph itself, but it is a shame that someone decided to interfere with the photograph in that way. It makes you wonder what else might have been changed. Keep in mind, there was a political battle raging as to how to deal with and treat the dust bowl refugees, and this photograph became very influential in changing attitudes. As even minor alterations might be an excuse to undermine credibility, we don't want questions of authenticity arising about work of this significance.

Removing artifacts or damage from photographs is certainly an area of concern, but it clearly has a great deal of possibility as well. It just has to be done carefully and with respect for actual image content. However, the loss of information and confidence in the content that are the consequences of our manipulation of photographs is something that we don't often think about and need to consider. (*See Chapter 11.*)

left: Iwo Jima. 2/23/45 Patrol led by Lt. Harold Schreir raises a small flag on top of Mt. Suribachi at 10:20am after a fierce battle. Photograph by Marine Photographer, Sgt. Lou Lowery.
(some writing has been removed)
right: The larger flag is brought from a landing craft and raised later that day. Photograph by Joe Rosenthal/AP Images.

Photomanipulation and the News

Altering content or context of news images is a bit more profound and has been a longer term practice than some of these recent notorious issues you may have heard about. For example, *U.S. News and World Report* freely admits that it published a photograph of FDR in the 1940s where they moved microphones around in the picture because they didn't like the composition. Although this may seem trivial, it was published as a news photograph.

Consider as well the classic photograph of American soldiers raising the flag on Iwo Jima. It was a real photograph, but of the second event. There is, after all, a dramatic ability to influence the truth by how a photographer takes a photograph. Your angle of view, the moment you choose to make the photograph, the lens you put on, all of these can be heavy editorial choices that can influence whether or not the photograph is really telling the story of what was in front of the camera.

It can be easily argued that a photograph can never really tell the story. You are dependent upon the integrity of the photographer doing their best to use the materials available to record the scene with as much integrity as possible. The Iwo Jima photograph is not fake and it is certainly an icon in our photographic and cultural history, but it was a replay of an earlier event that was portrayed, at least by implication, as showing a single original event and used to commemorate a very costly victory in American and Japanese lives.

Dorothea Lange. Migrant Mother, Nipomo,
California. 1937.
Library of Congress.

Controversial photograph apparently of Lee Harvey Oswald holding a rifle and newspaper from March 1963. Warren Commission.

Truth Undermined

There are many examples of image manipulation that I think we need to consider very carefully in terms of what it does to our notions of the truth.

It's no wonder that the JFK assassination evidence has its critics and inquiries into authenticity. The photograph of Lee Harvey Oswald holding a rifle, or of Lee Harvey Oswald maybe not holding a rifle, or maybe not even of Lee Harvey Oswald is one example. The weather on the date that this sunlit photograph was supposed to be taken was overcast. Regarding the left photo, can you stand like that? It seems difficult; you would tend to fall over. You will also notice that despite the fact that the head is at two different angles in the two different photographs, the shadow underneath the nose is identical in both, as though the sun were directly over the head in both cases. There are also some questions about the size of the rifle relative to Oswald's known height and the shape of his chin. Our doubts of photographic veracity have been growing for years. Volume VI of the House Select Committee On Assassinations ultimately concluded that this photograph is likely genuine, but it's burdened by the weight of unusual qualities and the suspicions of an unlikely perpetrator to one of the 20th century's many tragedies.

The power to manipulate photographs in order to make you believe something has been in the hands of the rich and powerful for quite a long time. Photoshop and digital photography are democratizing that ability to manipulate images—making us more suspicious of things that we probably should have been suspicious about all along. There is good in that, and there is tragedy in that. It cuts both ways.

Historical Respect

I would also like to suggest that we need to be more respectful of other people's original work. I have a problem taking Leonardo's painting of Mona Lisa for my own use out of respect for Leonardo. You need to respect other people's work because they put their heart and soul into it, whether it is old work or new work, public domain or copyrighted. I think a respect for other people's artistic values is important. If you want to use someone's work, call them first and see if they'll give it to you or license it.

Without getting their permission, you may also be using their image in a way that violates some of the owner's core beliefs, and that's wrong. To consume the product of somebody else's heart and soul for your own motivations, in a way that may have an impact quite different than they ever intended, seems unethical. A few years ago a major aerial defense contractor licensed a famous American landscape photograph for magazine ads to be used to cast their corporate image in a positive light. The attempt to associate a war plane and the American wilderness with a particular view of patriotism was not well received by many in the arts nor those who knew the deceased photographer and felt that this usage would not have been in keeping with his beliefs.

Along that same line, with regards to changing people long dead, it seems that there's a temptation to take old photographs and treat the people in those photographs as though they were commodities that you can modify without having an effect. I think perhaps you do have an effect. I don't think it's proper to take someone's image from 20, 30, or 50 years ago and do weird things to it. That person has a right to their own visual integrity,

whether they're living or dead. Of course, we all open ourselves up to parody and criticism when we move into the public realm, but consuming other people's images seems to me to violate some deep magic about photography—perhaps even something akin to some Native American beliefs that part of your soul is taken when you are photographed.

These aren't legal judgments but ethical judgments. I can't say for certain what is right or wrong. No doubt the subjectivity of right and wrong is playing into your reaction in reading this chapter, but I do think that ethics needs to be a greater part of our consideration.

The Nature of the Photographic Process

There is a fundamental point of departure when a photograph is made. It is transforming a three-dimensional scene into a two-dimensional abstract representation of that scene. One could argue that the result, in a sense, is a lie. However, I believe it is really the best our technology can offer in terms of translating that scene into a light-based record of what was before the lens. Photographs have many limitations—the direction the camera is pointed, the lens chosen, the image recording medium used, and, as important as anything else, the moment the shutter is released. What is said, or not said, about that photograph, to provide context after the fact, is also critical. All of those things affect the perceived truth in the photograph. These are givens, the ease and seamlessness of digital manipulation have added new and justified suspicions about photographic veracity. But our first instinct remains to believe a photograph as evidence of what was there. This is still a precious quality of photography.

Editorial Distortion

A far-too-common practice that undermines that truth is the purposeful distortion of photographs in order to achieve a particular goal. These are often small agendas with no particular intent to lie. Several examples are relevant here, and although *National Geographic* has been long criticized for their February 1982 cover, this is a legitimate example. The pyramids were too far apart for the image cover composition to work the way they wanted, so what did *National Geographic* do? They moved the back pyramid closer to the front pyramid, digitally. They didn't do it on a Macintosh and they didn't do it with Photoshop; they probably did it on a Scitex retouching station because that's what was available at the time. It's the same sort of decision that other people have made on covers—synthesizing images or moving things around because somehow a magazine cover is seen as advertising rather than real content. I couldn't disagree more—a cover should be used because it is strong and revealing of the content. It should not be a contrived seduction in a news or documentary context. You have to make your own decision. *National Geographic* has sworn that they will never do this again, but I remain wary as I look through an issue. That is unfortunate because I've always loved the magazine and I don't want to see it in that light.

Ancient Pyramid moved to fit cover layout. February 1982.

Another example of this alteration of images by the press is the coverage of O.J. Simpson's murder arrest. The *Time* cover and the original photograph look very different. Did *Time* do anything wrong by using a dark, scary rendition? What if they had marked that photograph as an artist's rendition or interpretation? What if it had brush strokes imposed on it? Would that have changed things? The more you step away from the perception of this cover as a photograph, the easier it is to stumble in the interpretation. There is a fundamental line that was crossed when editorializing about a person's guilt by visual implication. It is a most ominous development where this sort of dark, dastardly look is imposed on something purporting to be news. It was done to kidnapped heiress Patty Hearst many years earlier. We need an aggressive press in search of the truth, not an editorializing machine pronouncing guilt and ruining reputations, while letting the big lies of war and greed go unchallenged.

left: Photo of Patty Hearst. right: *Time* cover. Time & Life Pictures. Getty Images.

Two Deceptions

Photography can be used for good, be a neutral record of a scene, be photographed to exclude and deceive, or through forgery be made to outright lie for greed, ambition, and worse. These two examples from 2004 exhibit some of the darker sides of image manipulation.

U.S. Constitution and Bill of Rights scan from
Library of Congress.

The Menacing Soldier That Wasn't

L.A. Times Photographer Fired Over Altered Photo From Iraq. The *Los Angeles Times* said Wednesday it fired a photographer for altering a front page photo of a British soldier and a group of Iraqi civilians.

In an editor's note in Wednesday editions, the *Times* said photographer Brian Walski acknowledged in a phone call from Iraq that he had used a computer to combine elements of two photos to improve the composition.

Journalism ethics forbid changing the content of news photographs, and it is specifically barred in the newspaper's policy.

The two photos, taken moments apart, showed a British soldier directing Iraqi civilians to protect themselves from possible Iraqi fire on the outskirts of Basra. Only after the altered photo appeared Monday did editors notice that some civilians in the background appeared twice, the *Times* said.

All three photos—the two originals and the altered photo—were published by the Times on Wednesday. Walski had been with the *Times* since 1998.

—*Associated Press: Posted April 2, 2003, 10:04 AM EST*

The Missing Pariah

In many ways, the United States was birthed on an ideal that public service could be a noble endeavor, one that works for human liberty and justice. Sadly, politics has become a vicious business, dominated by money, greed, and a depressing willingness to lie and distort. This was evidenced by one of many tirades against 2004 presidential candidate John Kerry, attempting to taint him for his work against the war in Vietnam with a fabricated "AP" news photo with anti-war activist/actress Jane Fonda.

According to photographer Ken Light: "Anybody with Internet access and an interest in John Kerry has probably seen my photograph by now—or the part of it that I made, anyway. The other part is a fake, a visual lie. There's an AP credit down in the right corner. That's a lie, too."

The faked photograph, where "an angry-looking Fonda appears to be in mid-speech, with Kerry at her shoulder, is a paste-up job that started with a photo I made in 1971, when I was a 20-year-old student with big ideas about the power of photography."

"What I've been trying to teach my students about how easy and professional-looking these distortions of truth have become in the age of Photoshop—and how harmful the results can be—had never hit me so personally as the day I found out somebody had pulled my Kerry picture off my agency's web site, stuck Fonda at his side, and then used the massive, unedited reach of the Internet to distribute it all over the world."

These digital photographic composites are not child's play, nor funny. When passed off as real, they are an evil attempt to deceive, cutting to the core of truthful human communication. They are nothing less than evil lies, meant to injure at one of our most vulnerable natures, our instinctive need to believe what we see.

It is not casual; it is not play.

Actress And Anti-War Activist Jane Fonda Speaks to a crowd of Vietnam Veterans as Activist and former Vietnam Vet John Kerry (LEFT) listens and prepares to speak next concerning the war in Vietnam (AP Photo)

Jane Fonda Protesting both the Vietnam War and President Nixon at a rally near the Republican National Convention in 1972. © Owen Franken/CORBIS.

John Kerry, Mineola, New York Anti-War Rally. 1971. Roll 68. Photo © Ken Light.

A Small Personal Experience

I have a direct set of experiences with regard to editorial impulse. In my book, *The Great Central Valley: California's Heartland*, the cover photograph had something in it that I would have preferred not to have been there. There's a paper cup that is sitting out on the landscape. I can tell you quite honestly I did not see that paper cup when I made the photograph. It was an overcast day, and I stopped for the clouds and the cattle and I was sort of caught up in the scene. The sun wouldn't come out, and it was not working as a photograph. I gave up and started putting the camera away, and then the sun suddenly broke out. I very quickly put a piece of film in and released the shutter. The sun disappeared before I could make a backup. I turned around and started putting things away, and I noticed the paper cup. The light was already gone. I can't tell you now for sure whether I would have hopped over the barbed wire fence and pulled the paper cup out of the photograph or not. I can tell you, if I would have seen it, I would have thought about removing it.

Central Valley book cover, paper cup inset.

Once it was in the photograph, it was going to stay. There are several reasons for this: the book is a portrait of the Great Central Valley in California, one of the richest agricultural regions in the world. No small part of the reason I was doing this work with my project partner Robert Dawson was that the Valley has been so affected by human change. When my publisher who was on press with me in Singapore noticed the cup as the cover was coming off the press, he said "Gee, Steve, it would have been so easy to have taken that out." I replied, "But look, the cows are not native in the photograph, the grasses aren't native in the photograph, the eucalyptus trees in the back aren't native in the photograph, the only thing that really is native, is the sky and the dirt and the hills. The cup kind of belongs there."

Leaving it in also allowed me to say with some impunity that no real objects were added or removed from any photographs in the book. I was proud to be able to say that because this was one of the first major documentary books where the photographs were all edited with Photoshop. I opened them, spotted them, straightened them (because they got put on the scanner cock-eyed often times), did the color correction to try to match the scans to the originals, and for the book to have the value that it needed to have, I had to be able to say that I didn't alter content. Even though it was based on the fine arts, this book had real documentary context. I can't remove objects from a photograph if I am trying to pass the photograph off as some sort of depiction of reality. Even with all of the qualifications I would have to put on top of "depiction of reality," I think that is an important consideration.

Julia Margaret Cameron, The Echo, 1868.
© The J. Paul Getty Museum. Reproduced with permission of the J. Paul Getty Museum, Los Angeles.

Portraiture

Commercial portraiture has some interesting implications with these issues as well. In a commercial photography studio the implied contract is to "please make me look good." I want that for my ego, and it's a normal expectation. I'm willing to pay you money, and I don't want to look bad as a result of your photography nor pass up an opportunity for your skill to make me look better. Most of us are sensitive about our weight, even if we're skinny, because that's part of what the advertising culture in the United States has taught us to desire. So we want to look thin. If it's a teenager with acne or someone with a skin problem of some sort, more than likely that commercial studio portrait is going to be retouched. But what can that do to our perception of our own family histories? If it goes beyond careful posing and lighting, you're not going to be able to look back and see what people really looked like. That is a loss that needs to be considered. Again, photo manipulation is not new. We've been trying to flatter people with studio portraits since the first Daguerreotypist's studios opened in the 1840s. Whether it is soft focus or highly stylized posing and printing, portraits are perhaps the most interpretive of all photography. I simply feel on more solid ground with the interpretation being in how I make the photograph rather than what I impose on it later.

President Shakes Hands with Alien

Throughout the Clinton presidency, the *Weekly World News* ran this photo of the Commander-in-Chief shaking hands with an alien, selling plenty of t-shirts and other memorabilia with the photograph as well. In 2003, photographer Douglas M. Bruce ended a four-year lawsuit against the *Weekly World News*, winning a judgement for $25,000 from the Florida tabloid for running his photo of Clinton without having paid for its use or acknowledging Bruce's ownership. Bruce's original photo depicted the President shaking hands with a Secret Service agent, and *Weekly World News* ran their particular version of it, featuring their "Space Alien," for several years during the Clinton presidency—even after Bruce's attorney asked them to stop. Although Bruce originally asked for $400,000 in royalties and damages, the First Circuit U.S. Court of Appeals ruled that Bruce's original photograph was "so routine and generic that it had very little market appeal," as opposed to the enhanced photo which had been digitally enhanced, rendering it noticeably more bizarre and interesting, thus more valuable.

Photography and Advertising

Modern advertising is clearly an area where there is quite a bit done to distort photographic truth. Dramatic retouching is commonplace in advertising and celebrity photography. The airbrushed model who wouldn't even recognize herself, is used to sell magazines, products of all kinds, and sex itself.

The loss of photographic truth with the advent of digital photography has some major potential consequences. In advertising, this loss of "truth" is being driven forward like a rocket in flight, creating an unreal world of desires. That unreal world is something we aspire to, and that on its own is a disturbing thought, because we're trying to aspire to something that doesn't exist, and we are promoting that aspiration, whether it's the perfect body or the perfect lie. There are some profoundly damaging aspects to that, and we far too casually accept it. Because advertising is so pervasive, it erodes confidence in all photographic veracity. It could be argued that is good, as all photos lie anyway. Of course, such photo-fantasy can be done with humor and satirical underpinnings, creating social value from within the industry itself.

Kitsch

On the lighter side, there's a whole body of images we see in grocery store lines and all night markets, "kitsch" photography of the *National Enquirer* variety, like *Spy* magazine, which seems to thrive on manipulated photographs. The cover of Bill Clinton with the alien is a good example. People don't take these things too seriously but at the same time these images do something to our perception, particularly as the tools have gotten better and better. They lessen the believability of photographs in general. It was one thing when we were talking about the *National Enquirer* or the *Weekly World News* with the shark eating the man. Those early images were so bad that nobody took them very seriously, but you will notice that even in these weekly rags, using Photoshop no doubt, the quality of the images has gotten better and better. I think that there is a gradual erosion, eventually becoming severe, of the believability of any photograph, as a consequence of even these kitschy things that come at us on a daily basis.

left: Le Violon d'Ingres, 1924. © 2006 Man Ray Trust ARS/NY-ADAGP/Paris.
Centre Georges Pompidou, Musée national d'art moderne, Paris.
right: Bush as Mullah. 2003. Courtesy Mister Hepburn, Radiant World.

Art and Satire

We see a lot of image alteration over the history of photography—some for propaganda and political purposes and some for purely artistic purposes. In *Le Violon d'Ingres* by Man Ray, he didn't do anything after the fact to the photograph; he merely pasted violin-like cutouts onto the back of his nude subject before the photograph was made to create an allusion to the form of the instrument. This is comparable to Henry Peach Robinson directing his characters in the photo theater art he was assembling, or a modern political humorist merging images of George Bush as president and mullah.

Traditional Practices

There are a number of things that we traditionally do to change a photographic print that have some analogies in the digital realm. We accept a certain level of personal interference with the photograph as being legitimate in order to try and make it look right. First of all, dust is the enemy of negatives and photographers, so we routinely spot-out dust on photographic prints and blow dust off negatives. If we had dust on the film when we first made the negative, dust was recorded on the film as part of the image. We attempt to etch that out of the print to remove the artifact. Any artifacts that are a part of the technical acquisition of the photograph are also candidates for correction, such as the artifacts of the film's sensitivity to light. We may put a yellow filter on a blue sky to make the blue sky appear more like our eye sees it because film is hypersensitive to blue. We focus the enlarger to try to make it as sharp as possible. We choose the kind of enlarger to depict different levels of sharpness in the way we like our photographic prints to appear. In a similar sense we use different levels of sharpening on the photograph when we go to a digital file.

However, interpretive changes involving major contrast changes in a photograph start to cross a line. This is a very thin line in a gray area between what I would call image finishing (those techniques I just described) and image manipulation, which I think is an entirely different matter.

If you take a photograph so far that it bears little resemblance to the original scene, then I think you cross over that line and are not merely finishing the photograph, but you are into a clearly more interpretive mode. When you change the photograph this dramatically, you have manipulated the image, which is perfectly legitimate to do *if the image doesn't pretend to be real.*

Of course, melodramatic black and white interpretations don't very much resemble the original scene. But their content can, and we have a history of understanding the monochrome interpretations, so we view the content through that understanding, and expect what we see to have really been there. Almost no one would expect that the scene was "magically" without color in reality.

Purposeful Manipulation

We clearly change images in the preparation for reproduction. We need to size the file. We may need to sharpen the file in a particular way because it was acquired with a CCD scanner that is not as apparently sharp as photographic film grain. We need to transform light-made images into ink-usable plates for printing. But this preparation for reproduction can also be an excuse for overdoing work. An example would be flipping an image over because it suits your graphic design. Is there anything wrong with that? This is a normal graphic design procedure, right? In my judgment, you shouldn't flip a photograph because it distorts the truth in the photograph. It's an unnecessary change that subsumes the importance of the photograph to the whims of the design. If you need the person to look into the page rather than out of the page, rearrange the page. It's more work, but where do you draw the line?

What if you just need a little more height in a photograph to fill your column space? Well it's very easy now to make the vertical size 110% and the horizontal size 100%. It's simple to reproportion a photograph. Should you do it? I would argue that you shouldn't. That is an interference with the photograph that is unnecessary, and I think it does damage to our notions of the value of the photograph.

When we cross into the area of purposeful manipulation, there are a lot of reasons why it is done. Some of the reasons are about making a more usable design, like the photo flipping, to make a more usable composition. For example, if a potential cover image doesn't have quite enough sky for the photograph to accommodate the title art, part of the sky could be extended up in order to make room. Is that appropriate to do? Many will feel like it's perfectly fine, even in a documentary book. Even if minor, I think it's a questionable thing to do, and particularly in documentary work.

Ownership, Copyright, and Theft of Intellectual Property

What about theft, where a photograph is stolen from someone else? Copyright law is only as good as your pocketbook is thick, because if you can't afford to litigate something, you can't afford to enforce your copyrights. If the violator of your copyright has enough resources, it's probably not even worth bothering to enforce your copyright beyond a courteous letter asking for a redress of the situation. Remember that filing your copyrights gives you the right to sue for attorneys fees as well as the violation, which increases your options considerably.

I believe that the ethics we practice and that we feel in our hearts have to go way beyond the law. I don't think the law can even work if that's not true. What I am suggesting is that our ethical behavior in general has to extend to that old adage of do unto others. If you don't want something done to your work, don't do it to someone else's.

In the 1990s, the photo stock agency F.P.G. had a dispute with *Newsday* magazine which took one of their represented photographs and turned it into their cover, synthesizing in yet another photograph that they didn't own or pay a license fee for and put them together without permission. I believe it was settled for $50,000, but there has been a lot of controversy about that sort of use.

There was no way anyone could assume they had the right to use work in that manner other than by a very circuitous argument such as, "Well I put a lot of work into it, and I changed it enough that it no longer looks like the originals." I think that is a very spurious argument. However, there are times when that poor argument might stand up in a court of law. If you changed something so drastically that the *reasonable person test* of whether or not this image looks substantially like the image it was taken from, the argument might possibly hold up. However, to take someone else's artwork just because you may get away with it doesn't make it right to do.

I've been urging scanner companies and software companies to put some sort of copyright warning whenever people turn on the de-screen function (half-tone dot blurring) in their scanning software. Many of us have used the de-screen function. I use it on my own work because it is sometimes easier to grab the book to scan than it is to go find the original photographs. Are you using it legitimately? If you are scanning someone else's work you are violating the law. If it's 50 years old, it may be out of copyright and in the public domain, and therefore it's probably not a problem from a legal standpoint.

The Real Cost of Theft

The real cost of theft is much more insidious than the monetary gains. Knowing our work can be exploited in ways beyond our control creates a climate of fear—if we put our work out there; somebody is going to take it. That gets to the heart of the most vulnerable aspect of trying to do work in the arts, that age old-choice of risking failure or remaining anonymous. Now we have to risk failure *and* theft, or be anonymous. For the benefit of reaching an audience, you have to get your work out there so it can be seen. Yet, at the same time, there is now

an added reason not to: fear that you are going to be ripped off. Creatively, there is a tremendous empowerment that takes place with this technology, and yet the alienation that can be caused by the fear of theft is a very sad impact on people working in the visual arts, music, and literary arts.

Fair Use and Theft

The topic of Fair Use is an important one. The Fair Use exception within copyright law is very important in our culture. It allows for parody, criticism, cultural commentary, and educational use of both text and images. It is a powerful tool for exposing misdeeds, and often requires courage to stand up and defend, particularly against big money.

Asserting copyright on manipulated photographs that deceive the public is yet another twist on the property rights issue. Does a corporation have the right to hide behind copyright law to prevent informed social criticism of their activities and judgement? I think not. But in this book, for instance, we were refused the right to reproduce doctored photojournalistic images by the very corporations that published the distortions or fabrications in the first place. Specifically, both AOL/Time/Warner and the *Los Angeles Times* refused to let us use images that had been manipulated by their employees and published as real or without accompanying disclaimers. This is an old ruse, seeking to keep public discourse at bay, while pretending compromised integrity never occurred. It did happen, and will continue to happen without the very discourse they are seeking to avoid. (*See http://www.camerairaq.com/ faked_photos/ to view what they did not want you to see.*)

But the Fair Use doctrine can be used as an excuse for theft as well. Part of what disturbs me about the casual stealing off the Internet, from magazines and books is that it consumes the product of other people's hearts and souls.

Copyright Law of the United States of America
and Related Laws Contained in Title 17 of the United States Code

§ 107. Limitations on exclusive rights: Fair use38

Notwithstanding the provisions of sections 106 and 106A, the fair use of a copyrighted work, including such use by reproduction in copies or phonorecords or by any other means specified by that section, for purposes such as criticism, comment, news reporting, teaching (including multiple copies for classroom use), scholarship, or research, is not an infringement of copyright. In determining whether the use made of a work in any particular case is a fair use the factors to be considered shall include —

(1) the purpose and character of the use, including whether such use is of a commercial nature or is for nonprofit educational purposes;

(2) the nature of the copyrighted work;

(3) the amount and substantiality of the portion used in relation to the copyrighted work as a whole; and

(4) the effect of the use upon the potential market for or value of the copyrighted work.

The fact that a work is unpublished shall not itself bar a finding of fair use if such finding is made upon consideration of all the above factors.

http://www.copyright.gov/title17/92chap1.html#107

If an image consumer makes a reasonable effort at securing rights and an image maker tries to charge reasonable fees when people ask, I think we will end up creating a much more cooperative and fundamentally more useful climate for all these exchanges to take place.

I've heard a number of people say that in this day and age we need to think about new notions of image ownership, and that we can't hold onto our old notions in terms of who owns what, who has to license what, and who needs to be able to get at what kind of information. The assertion is that we need to develop a new paradigm for image ownership. I would call it the new rip-off myself. The same old greed of trying to get something for nothing by greedy individuals or corporations is in conflict with our same old need of trying to derive some sort of income from our creations. We probably do need to rethink notions of ownership, but I can't see how free access promotes an income that allows the creator to continue to work.

In this electronic age of the Internet, images are going to be ever more available and we need to think about the kinds of risks involved in putting them out there, versus the kind of games involved in trying to be able to advertise your work in that particular way. It does seem to me that the loudest

advocates for loosening up this notion of image ownership are also the biggest consumers of images. Nonetheless, some of these areas do open up tremendous new opportunities for artists.

Computers and Art

Many of us use computers to make art. Many of us have used other people's images, myself included, as shown here in this example called "Resurrection." I used this photograph of the preacher Jimmy Swaggart from a videotape, and then added it to my Death Valley photograph and the cross of $20 bills. I'm confident I'm on fairly solid ground in using this image under the Fair Use doctrine, being able to use copyrighted material for parody and criticism. Any public figure, politician, artist, or preacher opens themselves to public reaction and parody. However, I would never publish nor attempt to make a profit on this image without first consulting a copyright attorney.

Resurrection, Stephen Johnson, 1991. Digital Composite.

Reproduction Rights and Some Small Protection Remedies

What are some remedies to all of this? You need determination to protect your rights if you're an image-maker. You should certainly speak up about how you want your images treated. You always have the right to say no. If you're trying to prevent theft, you should probably hold onto your images or be aware that there is risk. And that is a fundamental contradiction for any artist. Some practical steps can insure the integrity of your work and attempt to derive your rightful income:

- ✦ Register your copyrights because it's the only way to collect attorney's fees. Even though they can be removed, Photoshop can tag images with your copyrights.
- ✦ Try data encryption or watermarks on the images.
- ✦ Dramatically compress preview files you send out, either on the Web or for direct review, so that the files are virtually unusable for any final application.
- ✦ Write a good contract and have an attorney help you. License the use of your images conditional on the terms of the contract being honored. Make it for a specific use with a time limit. Specify the media and the context of the use. Define the penalties for losing your artwork.
- ✦ Do not allow derivative forms to be created from any photograph or illustration, and specify no manipulation (and you're going to have to spell that out because that is a very broad term).
- ✦ Be careful about granting electronic media rights other than those you are currently negotiating and being paid for.
- ✦ Your contract can specify no cropping, no reproportioning, no tinting, and no flipping.
- ✦ Allow no text over the image, unless you approve it in writing ahead of time.
- ✦ You deserve credit and copyright notice when your photograph is used. Credit should be with the image and not hidden away in the back of the magazine somewhere.

As I mentioned above, you should also be careful about your electronic rights in publishing—it is a very significant area. A magazine once asked me for a photograph from my national parks project to accompany a story on my work. I said fine and we proceeded with an interview. They said, by the way, we also require you to give us the electronic rights to put your photograph on our web site. I said, "No, I am not prepared to give you electronic rights to give away my photograph on the Internet. We need to at least specify a resolution." They said, "No thank you, we'll not run the story." There seems to be little concern for intellectual property rights on the Web, and that makes for something ominous floating in cyberspace.

Procession ii.
Elements in Stone,
Digital Composite,
John Paul Caponigro, 2000.

Trained as a painter, John
Paul is a thoughtful *photo-
sculptor* whose works are
emotional explorations of
a strange and mysterious
world. His evocative images
are understood to be
constructed imaginings.

Professional Respect and the Value of Your Work

With regards to expectations and respect, there is always someone else who will give their work away, but that doesn't mean that you should give your work away. Try to ask for reasonable fees so that the next person that comes along doesn't end up having to suffer renewed corporate expectations of cheap artwork or services. From a corporate perspective, don't prey on the hungry. Don't take advantage of people just because you can. Pay reasonable, normal, and customary fees for work. Don't find a college student who happens to have good work and pay them very little because they are hungry and don't have much power. There is quotation software out there (FotoQuote) that can help arrive at current market pricing. But every negotiation is unique.

Contemporary Art

There is important contemporary art that's based on assembling multiple images into photographs. A photographer like Jerry Uelsmann is a good example of how image montage can be used purely and precisely for the point of stimulating ideas and creating beauty. Jerry's photographs are generally not done with an intent to deceive about what was in front of the camera, but are a synthesis of elements. They're not digital in Jerry's case, nor electronic, but are accomplished by compositing photographs from many negatives with a number of enlargers along in a row in the darkroom. Jerry does get asked for the actual locations of some of his multi-image creations.

New Art Forms

A new rich area of artistic endeavor is blossoming where artists are using their images to synthesize something entirely new. There is great potential power of this synthesis of painting, photography, sculpture, and perhaps poetry and music, all coming together in these digital mediums to create something wonderful. There can be some very dynamic implications and hopefully a lot of content, thought, and emotion. I'm not seeing much of it yet, but there is some great work being produced.

This kind of photo-painting-compositing is sort of off the subject of what I'm warning against because the work is not being passed off as being real. Even our illustrations for this book by photo-realist illustrator Bert Monroy, who sometimes makes things look so real that they *seem* like photographs, are making it possible to see that which otherwise could not be seen. Although I think that some of this realistic work does something to our perception of the photograph as truth, that is a necessary condition for this new art to be able to function.

Integrity of Intent

A potential buyer of my work once asked me if I would alter the color of my photograph to match the color of his living room. I didn't really have to think about it, but I was trying to get a read on this guy. I said, "No, the photograph really needs to be what it is," and he said "Good, I'll buy it." He was testing me and at the same time he was testing my integrity. He was making a judgment as to the value of my work in terms of whether I was committed to my vision of the artwork or merely offering decoration. He bought a number of additional pieces over the years.

Cameras Never Lie. Digital montage, 1993.

Composited Photographs:
Two splendid examples of new visions that can be created in the darkroom and the computer.

left:
Untitled (toning experiment), 1968. Jerry Uelsmann. Jerry uses multiple negatives and enlargers, masked toning, and a wonderful sense of humor and irony to create his photographs. His imagination and intuition are as much his tools as his camera.

right:
Hands and Earth, 1998. Jeff Schewe. Jeff has been using Photoshop for his commercial work for years. His visual imagination and lust to explore Photoshop has created many strange and beautiful digital worlds that have delighted many of us and has pleased clients, and is now being shown in galleries.

Going Forward

Some ethical problems are improving. Even in these weekly magazines I am seeing some things that I think are good signs. A recent image on the cover of the magazine *Weekly World News* features a very interesting little note near the bottom reading "artist's conception."

In terms of the future, I think we need copyright reform where it is easier to get protection for your work. Reforms are needed such as not having to register the work to be able to get attorney's fees, easier registration for bodies of work, electronic registration, and the digital embedding of unalterable copyright. We need corporate cooperation, both in the tools that help us protect our work, and a modification of their expectations so that they don't want something for nothing themselves. It can work on the same principles as how a corporation wants its own products protected.

Art is unique in our culture, in our heritage, in our human soul and spirit. I don't like seeing it treated as a commodity. I think the digital age is increasing our tendency to do just that—to treat art like a commodity. Our photographic heritage is very valuable. I think we need to show a much greater respect for it and take responsibility for our actions. Think about both the immediate and the long-term consequences as well as the cumulative effects of the practical, legal, and ethical decisions we all make.

We are setting the standards for how work will be viewed and what is acceptable practice, for at least the near future. I think we users and creators need to rise to that responsibility and say we know that some of this behavior is wrong, we know that this is right, and we're going to work together.

Summer Corn, Tyler Island, 1984.
6x7cm Kodak Veri-color negative film.

During the Central Valley project, as we learned more about the valley—its complexities, its changed landscapes—it became more important to spend time looking intensely, trying to understand the human impact on our valley homeland. It may be one of the most changed non-urban landscapes on the planet.

Chapter 20: Empowerment in the Digital Age

*It is horrifying that we have to fight our own government
to save the environment.*

—Ansel Adams

Ideas are limited in power by their ability to reach people and to be discussed, inspired by, and enlarged upon. The opportunities to give vent to new ideas are expanding with digital technology.

With new technology come pitfalls: greater risks of intrusion into personal lives, living in front of computer screens, and further detachment from the natural world.

But this is the world we are living in, and there are issues to be discussed, injustices to be taken on, and art to be made. The new tools offered by desktop publishing (soon to be simply publishing) create a freedom to explore ideas, imagery, and design; discuss issues not generally covered by the media; and distribute those inspirations by conventional printed material (offset or laser printer) or electronically on the Internet. The possibilities are far reaching.

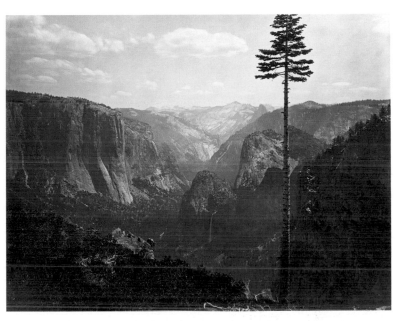

The Valley of the Yosemite, c. 1865.
Carleton Watkins.
Library of Congress, 09983u.

The very media of digital photography opens new opportunities for communication. Once digitized, a photograph is almost infinitely malleable, much like a clay sculpture in process. This new media is, in some ways, an integration of photography, painting, sculpture, and poetry. It creates a power to embellish and distort with images, but also a new ability to integrate ideas and visions. These are exciting times to be involved in the arts.

I am convinced that individuals with a desire to act on their concerns can be empowered by this technology. The process will take a lot of time and care, but if your ideas are powerful enough, the technology is ever more able to help you move them forward.

Today, there is less and less reason to leave the powerful technology of digital communication in the hands of the rich and powerful. It is increasingly available to any of us who have ideas to express and the will to get them out there.

Photography and Conservation

Photography's influence on the conservation movement has been profound. It has been used as a concrete tool for advocacy of land preservation.

From Carleton Watkins's early photographs of Yosemite that were used in the effort to pass the Yosemite Act of 1864, to William Henry Jackson's photographs of Yellowstone in 1872, landscape photography has almost become synonymous with conservation. Ansel Adams knew this in the 1930s when he photographed in Kings Canyon and Sequoia, and then lobbied FDR's Secretary of the Interior Harold Ickes for the creation of the parks. Adams later helped create the book *This Is the American Earth* which was a clear call for the preservation of natural landscapes. Influenced by these histories were Eliot Porter with his Glen Canyon work, and Philip Hyde when he worked for the creation of Pt. Reyes National Seashore. David Brower of the Sierra Club helped birth a new genre of photography/conservation books: large, heavily illustrated "exhibit-format" books that became famous for their effectiveness in lobbying for land preservation.

above: Stephen Johnson. Paoha Grasses, Mono Lake, 1979. 4x5 Kodak Plus-X negative.

right: *Island in Time*, Philip Hyde and Harold Gilliam's 1960 Sierra Club book on Pt. Reyes.

below: Carleton Watkins. Three Brothers, Yosemite. ca. 1865. Library of Congress, 09986u.

Documenting Our National Treasures

The national park concept was inspired by America's westward expansion into a vast wilderness of wonder. The magic of these places were portrayed with early landscape photographs by Carleton Watkins and William Henry Jackson. Those photographs were instrumental in the preservation of park lands. Today, our national parks are possibly the country's greatest attraction; travelers from around the world come to enjoy the parks' stunning landscapes.

With this history as background, I undertook my own landscape photography work for Mono Lake in 1979 with *At Mono Lake*, the Great Central Valley Project in 1982, and the national parks project I started in 1993.

> *With a New Eye is an innovative and dramatic new way of building appreciation and preserving those wonders. Johnson's digital capture of these landscapes and his prints made with pigmented inks will ensure that a visual documentation of the spectacular views will be available for viewing*

Marion Lake, King Canyon, 1925. Ansel Adams.
Ansel Adams Publishing Rights Trust/CORBIS.

Yellowstone, Mammoth Hot Springs, lower pulpit terraces.
circa 1870. William Henry Jackson.
William Henry Jackson Collection Colorado Historical Society. WHJ
4314. All rights reserved.

and study for generations to come. Historically, these images are truly unique, as new technology is allowing a pioneering photographer like Stephen Johnson to record these lands as they have never been recorded before. This project will aid the preservation of these parks and have a global impact on our notion of what digital photography and photography itself can be.

—from "With a New Eye: A Book and Exhibition Summary"

left: Ditched, Stalled and Stranded, 1934. Dorothea Lange.
Library of Congress.

Harlan County,
Kentucky, 1959.
Andrew Stern.

Photography and Social Concerns

Photography can effect change. It can be a tool of truth or distortion, but its fundamental reality usually wins out. During photography's 170 year history, many examples stand out in making a difference—sometimes large, sometimes small. Examples abound, from Lewis Hine's photographs of tenement housing and child labor, to Eugene Smith's work in Minamata, to the Japanese fishing village poisoned by mercury pollution, to the Farm Security Administration's photographs of rural America during the depression, to war photographs bringing the awful reality home, and photographic documentation of continuing human rights abuse across the globe. The list goes on and on, the wrongs to right seem endless, and the power of the photographic lens has emerged as pivotal.

But for that power to be sustained and enlarged through communication and access, the photograph needs to retain its fundamental power of being believed. That is tricky in this world where there is intent to deceive, and lies run parallel with a deep desire to document, expose, and make a more humane and just world.

upper right: Running from Napalm, Vietnam, 1970. AP Images.

upper left: Bill Owens, Suburbia, 1971.

left: Street Child, circa 1910. Lewis Hine. © The Estate of Lewis Hine.

above: Confronting tanks near Tiananmen Square during the student Democracy demonstrations, China. 1989. AP Images.

CLARENCE PAGE: WEAPONS OF MASS PHOTOGRAPHY
Saturday, May 22, 2004

If I had my way, every enlisted man and woman in the military would be issued a digital camera.

As we've seen in the scandal about abused Iraqi prisoners, the little gadgets help boost morale by providing snapshots that can be emailed back home. They also can come in handy when you need to gather evidence.

I like those little cameras because certain power elites don't.

Take, for example, the contempt that Defense Secretary Donald Rumsfeld showed for digital cameras during recent hearings on Capitol Hill.

His response to Sen. Susan Collins, R-Maine, turned into a bit of a rant of frustration: "We're functioning...with peacetime restraints, with legal requirements in a wartime situation, in the Information Age, where people are running around with digital cameras and taking these unbelievable photographs and then passing them off, against the law, to the media, to our surprise, when they had not even arrived in the Pentagon."

No, folks, it's apparently not the administration's gross lack of preparation for the management of post-Saddam Iraq that's the problem, in Rummy's view. It's those pesky soldiers and their Weapons of Mass Photography.

Yet, something rings a little hollow about Rumsfeld's complaint. While he gripes that the prisoner abuse photos arrived in the hands of the media before they reached the Pentagon, the Pentagon sat on the prisoner abuse report without telling Congress or President Bush for two months before the photos were released.

In late April, Rumsfeld told Congress how the war was going without mentioning Maj. Gen Antonio Taguba's damning report on abuse of Iraqi detainees at Abu Ghraib prison —even though the report had been sitting in the Pentagon since February.

But these matters apparently didn't register much with the top Pentagon brass until the night after Rumsfeld's April visit to Capitol Hill. That was the night CBS' "60 Minutes II" broadcast explosive photos of naked Iraqi detainees at Abu Ghraib being poked, prodded, wired, bagged, paraded around, stacked up, and otherwise humiliated by their male and female American guards.

When CBS informed the Pentagon of the photos, the reaction of Gen. Richard Myers, chairman of the Joint Chiefs of Staff, was quick and immediate: he asked them to withhold the pictures, claiming their release might put U.S. soldiers in harm's way.

Yet, one wonders, if the Big Brassos' only concern was for the safety of U.S. soldiers, why did neither Myers nor Rums-

During his testimony, [Secretary of Defense Donald] Rumsfeld made clear his exasperation with dealing with a "radioactive" scandal, when images shot by a digital camera can be beamed around the world almost instantaneously by e-mail or stored by the hundreds on a CD.

"We're functioning...in the Information Age, where people are running around with digital cameras and taking these unbelievable photographs and then passing them off, against the law, to the media, to our surprise, when they had not even arrived in the Pentagon," Rumsfeld said.

—*Newsday*: May 8, 2004

feld bother to tell Congress or the President about the photos? If the Commander in Chief is a national security risk, the rest of us would like to know.

We've come to expect phobic paranoia about pictures from this administration. At the beginning of the Iraq war it strengthened a ban on photos of coffins of war dead returning to Dover Air Force Base, Del., a policy that then-Defense Secretary Dick Cheney imposed in 1991 during the first Iraq war. The reason given is privacy, which strains believability, since photos do not reveal who's in the coffins.

Interestingly, the Bush-Cheney 2004 campaign showed none of that squeamishness about privacy when it included the 9-11 image of a New York City firefighter's coffin in a campaign ad.

Apparently the issue is not the photos but who has control of them. Fortunately, in this Internet age, it's not so easy to keep secrets from the American people, whether it's Bill Clinton's Oval Office peccadilloes or the far-more serious questions of our military's conduct overseas.

Those with long memories may recall writer Seymour Hersh's first big scoop, the 1968 massacre of unarmed Vietnamese villagers, including women and children, at My Lai. The incident didn't get much ink when he reported it in late 1969, until the Cleveland Plain Dealer printed photos taken by ex-Army photographer Ron Haeberle, a Cleveland resident. Pictures do have power.

Rummy's real problem isn't photos, it's democracy. If the public were less eager to know so much stuff, life would be a lot easier for our military leaders. Unfortunately, life soon would become a lot harder on the rest of us.

That's why I don't expect to get my wish. Instead of issuing cameras, the military, backed by the Bush administration, more likely will impose more restrictions on pictures. The first impulse of government is to put a lid on information about itself, even when the public has a right to know.

Sure, democracy can be messy and even confusing sometimes. But it's the best system we've got.

CLARENCE PAGE is a *Chicago Tribune* columnist.

Environmental Work

In keeping with my environmental concerns, I've often wondered whether my recent work has a lower earth-impact index with the shift of photography from a constant stream of chemical pollutants into a much cleaner, reusable digital workflow. Digital may well be more ecologically sound than traditional silver-based photography, being more environmentally friendly photography with little post-manufacture toxic results.

My interest in environmental protection goes back 30 years to activities in high school ecology groups, working to protect the California coast and running a recycling center. With *At Mono Lake,* I created a book and exhibition on the threatened ecosystem of California's Mono Lake, which travelled throughout California and now permanently resides at the Mono Lake Visitor Center. In 1988–93 *The Great Central Valley: California's Heartland* book and exhibit called attention to the dangers of agricultural chemicals. My own commitment continues with my involvement as a Board Member of the Pacifica Land Trust, working on additions to the national parks system. The current work on the national parks expands on these efforts, with the ethics of land and wilderness conservation being points of departure for the project.

The Great Central Valley Project

I embarked on the Central Valley project to better understand the place that made me a landscape photographer. The idea of going home and exploring where I came from was a powerful incentive to do the photography and research. It became much more than that, though. It grew into the discovery of a place I didn't know very well. It became an exploration of land use, water use, agricultural practices, racism, and poverty. The project later evolved into an exploration of digital design, photography, and graphics. Most fundamentally, it was about reaching out to people with the images that sparked my imagination and my passion for the land.

The book itself became something of a cause—it had to get done, it had to be beautiful, and it had to address substantive issues. The technology helped make it possible. I am convinced that individuals with a desire to act on their concerns can be empowered by this technology.

Saving Mori Point from Development

Environmentalists, citizens, and scientists had been trying to protect a magnificent coastal mountain for years. Located in Pacifica, California's Mori Point was about to be sold to developers likely to propose a hotel. Impacts on hikers, local wildlife and the pristine view would be considerable. I joined with the Pacifica Land Trust and together we crafted a public relations strategy, seeking the emotional and financial involvement of the citizens of Pacifica. With my wife Mary Ford, we designed and produced a direct mail campaign that included original photographs of the site and a dramatic call for community support. This successful outreach raised $100,000. With the aid of the Trust for Public Land and the California Coastal Conservancy, Mori Point was added to our national park system in May 2002. The photography I could provide for this cause was extremely high resolution, all-digital, and immediate.

far left: temporary Mori Point National Park Service sign.

near left: Promotional mailers used by the Pacifica Land Trust to raise local funds to buy Mori Point at auction.

opposite top: Mori Point poster.

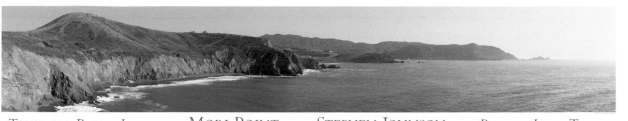

TRUST FOR PUBLIC LAND MORI POINT STEPHEN JOHNSON PACIFICA LAND TRUST

A Long-Term Instinct

I didn't know it at the time, but my 4th grade field trip to the construction site of Exchequer Dam on the Merced River, downstream from Yosemite, proved to be a hint of interest in landscape photography and perhaps a hint at compositional instincts. I used a borrowed Kodak Brownie 120mm film camera and black-and-white Verichrome Pan film. To me, these photographs give me a clue as to just how early my fascination with the reshaping of the land began.

Little did I know then, but twenty years later I would be flying over that very same site while working on the Central Valley project, and I'd photograph it once more. I had long forgotten about those early photographs, but I found them later at the request of a magazine editor.

We reshape land. It is how we seem to live on this planet. Some of these changes seem rational, many do not. In one way or another, my interest in landscape photography is bound up in the wild and the changed, and in trying to understand the values involved.

It is clear to me that digital technology expands those possibilities, just as it so easily let me go back in time to scan and bring these old photos to life.

Exchequer Dam, Merced River. 1965. Kodak Brownie 120mm camera and black-and-white Verichrome Pan film.

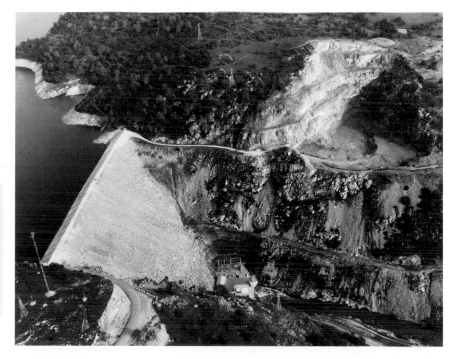

Exchequer Dam and Excavation Site. 1986.
5-inch Tri-X aerographic roll film.

Teaching Photography in the Digital Age

Teaching photography digitally empowers us with dramatic possibilities for conceptual and technical breakthroughs for students.

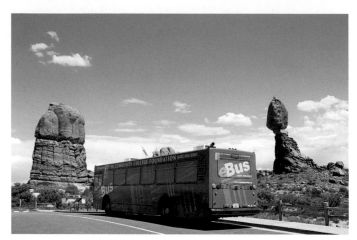

Digital photography strengthens field photography instruction, allowing for the review work on camera screens as the photographs are made and on portable computers soon after, to examine exposure, composition, and emotional impact. I also can conduct group reviews using digital projection for added feedback, mutual understanding, and growth. High-resolution printers are available to put some images to the ultimate test of image on paper.

The Magical Digital Bus at Arches National Park. 2003.

The assistance that can be provided in the field helps to prevent many of the problems students encounter in the darkroom, chemical or electronic. Whether it is looking through viewfinders and discussing composition, or talking through a difficult exposure problem, field workshops have proven to be very useful experiences. All of this interaction and individual problem-solving are facilitated by the use of digital feedback.

The process can go full circle every day: opening files, reviewing success, and printing some of the photographs made during that day, and constantly going back in the field, putting into practice lessons learned right away.

This real-time digital feedback can be used to discuss technical and aesthetic issues, tapping into emotional responses to landscape, working toward images that are uniquely your own. Here is an instructor's quick checklist:

- ✦ Instant image review:
 - —review work on camera screens as it is made
 - —remake the photograph until it is right
- ✦ Technical control:
 - —exposure check with histogram
 - —focus check
 - —depth of field check
 - —color balance check
- ✦ Aesthetic impact:
 - —assess composition and emotional impact
 - —assess real 2D scene comprehension
 - —consider design and interplay of form analysis
 - —distill down to the essential
 - —see silly inclusions
- ✦ Additional advantages:
 - —use digital projection for group evening reviews
 - —use high resolution printers to see photographs in their final form

Editing and printing workstation in my new hands-on digital classroom. Image being printed by Susan Beveridge. Photograph by John Csongradi.

Southwest Workshop and the Magical Digital Bus: Anecdotes from 2003

Our photography workshop to the American Southwest in the Magical Digital Bus was enlightening, intense, fun, exhausting, and incredibly rewarding. And it resulted in some fine photographs. The workshop itinerary was an overview of the Southwest's wonders and having the bus along turned the workshop into an innovative and deep photographic learning experience.

Balancing time between experiencing the parks and interacting with the photographs was a wonderful opportunity as well as a challenge. There was a constant range of options, sometimes too many, sometimes just right. Students were torn between direct experience of the beauty of the landscape and experiencing the photographs they just made. They were also enamored with being able to do both. There were never enough hours in the day. Many stayed up late working.

John and Eric Csongradi on Southwest workshop, 2003.

The ability to look at each other's work produced some great interactions, allowing us to react and be inspired by other's photographs.

Being able to check out our images as they were being made was dynamic and very worthwhile. "Did you get that lightning?" "Was that exposure right?" "Where did those highlights fall?" "What about this composition?"

The digital bus provided an unprecedented opportunity to complete work on site, not to mention an air-conditioned refuge from the heat. There were almost instant detailed feedback/critiques on some occasions, others were end-of-day looks back at the work. Lectures and demonstrations were also part of the mix.

Working on the Digital Bus. 2003.

An interesting tactic developed: people were swapping their compact flash cards around trying each other's cameras and or lenses. They were experimenting with the possibilities while still writing all of their photographs to their own storage card. Many discussions centered around the technology; many focused around art, emotion, and design.

We ran into a few interesting characters along the way. Two bikers from Belgium on their way to the Harley-Davidson centennial were photographed by Andrew Stern. He made gift prints on site, then bestowed them while the subjects were still with us.

There was unlimited beauty around us, and so many great things to do and see. The tours into Monument Valley and Canyon de Chelly brought us to places we could not have otherwise seen. People did not want to miss a dawn or a sunset, or an opportunity for a full moon. There seemed to always be lust for more and a desire to do everything possible, which just about everybody did.

As a teaching tool, combining the bus with the making of the photographs completed a critical circle of photographic realization. The bus prints were often looked at as reference prints, sometimes even as a finished interpretation. Being able to help with the seeing, the execution, the image processing, and the printing was a kind of educational nirvana.

The workshop ended way too soon, but at about the right time. We were all ready for more, but we were way tired. We liked the experience very much.

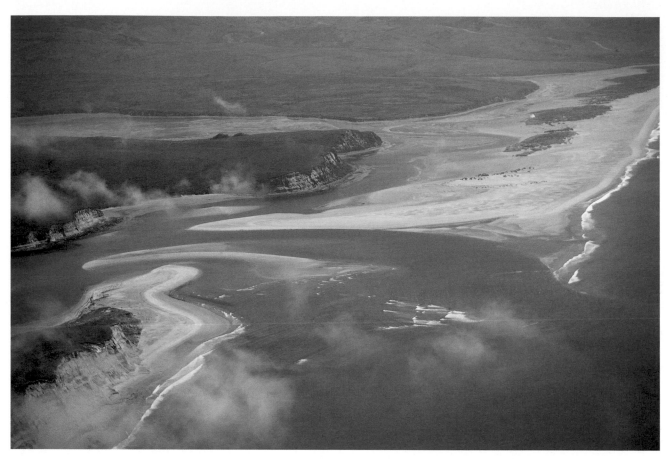

Aerial, Pt. Reyes National Seashore, 2003.
Kodak DCS 14n. 3000x4500 pixels, 12-bit, Bayer-pattern camera.

This photograph was made on one of the calmest flights I've ever experienced. My good friend Laird Foshay let me take the back door off his Bonanza airplane, giving me a luxurious picture window on the world as we flew.

On this day in the summer of 2003, we were out with no particular agenda, just flying for the joy of it over the beauty of the San Francisco bay area. It was a fairly foggy day coming up along the San Francisco coastline, but up near Pt. Reyes the fog broke up a bit and the scene was strikingly beautiful. We circled the seashore again and again, filling every data card I brought along.

Chapter 21: From the Digital Stone Age Onward

It has never been my object to record my dreams,
just the determination to realize them.

—Man Ray

As I said at the beginning of this book, we are in the Stone Age of electronic photography. We haven't even figured out yet the shape of the tools we need, much less developed sophisticated versions of such tools. We often fool ourselves into thinking that this new digital age represents some pinnacle of photographic ingenuity. We should remember that some of these tools and techniques have been around since the 1860s, and our modern imposition of computers and the binary numbers of digital itself primitive. Nonetheless, they are real advances, laced with both opportunities and many pitfalls.

This is only the beginning: the imaging capabilities to come are likely to be mind-numbing. Photography is moving toward an ever greater ability to replicate our real visual experience of being there and more. There is much greater wonder yet ahead.

STS-75 with the Space Shuttle Columbia on Launch Pad 39A, 1996. Kodak DCS460. 2000x3000, 12-bit, Bayer-pattern camera.

What We Still Need

Although we are in a remarkable digital age, there are some critical issues that need addressing, as well as basic old ones that will benefit from continued work and systematic integration. During the course of this book we discussed some of the ethical and technological issues. Here's a list of what we still need to see:

Fidelity

To the Scene: as sensors get higher in resolution, the glass optics become an obstacle. Other ways of focusing and recording light need to be pushed forward. As my friend Bill Atkinson pointed out, ideas such as Coded Aperture Imaging with multiplexing techniques might provide an alternative to focusing techniques, essentially building up multiple pinhole images without optics and then reprocessing them into recognizable photographs.

To the Image: there needs to be a recognition that there is value in representing accurately what the eye can see, and integrating beyond vision recording capabilities into future photographic results.

In the Print: color management is too complex and asks the user to do many things that the device makers should already have done. This needs to change; we need an integrated approach that measures and knows its own capability and delivers information to transform data accordingly. This, of course, still needs to preserve original image data for manual intervention.

On the Wall: we always need to consider how a print or image is viewed, almost as much as how we record it at the original scene. Daylight spectrum viewing conditions in museums, workplaces, and homes simply must become the standard for artificial lighting. This not only helps delicate color in artwork, but I believe it makes the brain function more rationally, as we are more at peace in daylight than elsewhere in the spectrum.

Accessibility

Usability: cameras must be usable. Burying ten sub-menus below a basic interface simply doesn't work. Cameras may be getting overburdened with features that may be better done later on the computer. Additionally, manual controls need to remain on camera, for all basic functions.

Transformations of color, contrast, and other appearance changes need to continue to be controllable, and those controls need to be deepened to preserve as much of the sensor's data in all formats that customers are likely to use. That is at odds with current JPEG implementations, but has moved toward with Kodak's Extended Range JPEG and some color spaces under consideration.

Archiving: this necessary step must become more automated and less improvisational. It should not be left to users to be the only ones capable of making sure their photographs don't get lost. Systematic archiving and backup need to be part of the digital photographic toolset.

Retrieval: easy visual sorting, cataloging, and access to all images in any file format is the goal. Adobe has tried to start down that path with their RAW file converter and some added features in the Browser. Adobe has moved conceptually forward somewhat with its Lightroom beta as has Apple with Aperture, but neither is there yet. Relying on third-party solutions to catalog and organize images remains an issue, as do the Mac and PC solutions for simple catalogs. This kind of organization needs to be cross-platform at the operating-system level, and customizable.

Security/Ownership

Copy Protection: the goal is to restrict the free exchange of our private property. This will likely require a secure image data format that can prevent copying, prevent screen captures (a really hard nut to crack), secure file opening, and prevent obvious conditions like re-saving to a new name and format without such protection. These are not simple technology issues to solve, and they require the cooperation of many companies and users.

Ownership: instant online copyright registration that takes place in an archiving scenario would be helpful. Building secure unalterable name and copyright embedding remains a challenge that must be addressed, and not by outside subscription, but by private concerns. This could be done through the Library of Congress with sufficient funding.

Storage Permanence: hard drives fail, and CDs and DVDs have a limited life. The archival storage of data is another big computer-industry—wide issue but has particular resonance with digital photography. We need stable data storage lasting hundreds of years with very clear keys to the understanding of the data.

E-Commerce Capabilities

Transactions: a built-in structure for e-commerce that would auto-charge fees for file viewing and use would be a dramatic step forward. This could be the most empowering technology of all, because it would allow artists a format for secure income from their creations. It could stimulate art and revenue at an unprecedented rate.

A New Realism

The ability to record light with ever more veracity is one of the most fundamental steps forward that digital photography technology enables. This will continue to be central to photography's evolution. Even with vast differences in style and intent, the technology that enables a realistic representation of the scene will likely be the starting point for all other derivations. This can engender a new realism, depicting the real world much more as it is, rather than through film's often melodramatic enhancements, stylistic derivations, and failings when compared to human vision.

In my own work, that attempted realism has been a crucial quality that has drawn me so deeply into this new world. The Photographer's Gallery invitation from a 1998 solo show in Palo Alto, California, gave me much encouragement:

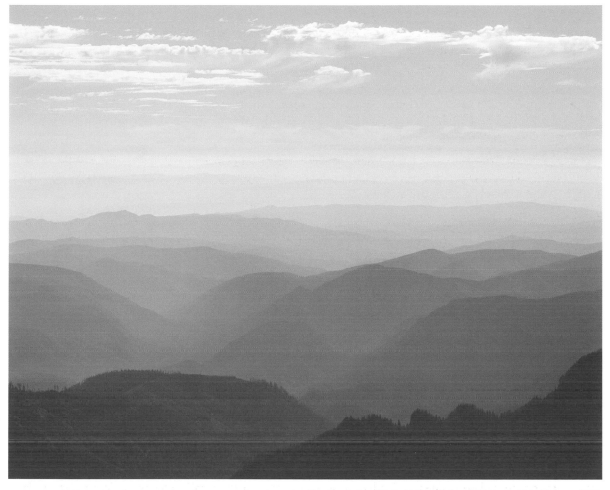

Looking South from Mt. St. Helens National Monument, Washington, 1995.
BetterLight Scanning camera. 6000x7520 pixels.

Johnson's work births a "new realism," a post-modern expression beyond the constraints of conventional photographic techniques and styles. Plunging into a rich pastel world rarely attempted in photography, yet uncannily familiar to human experience, he is doing battle with the color photographic convention of contrasty, saturated renditions, forcing us to see a world we know, but which photography has largely ignored. His sensitive design and color take us into a remarkable world of sensual visual experience.

Contending that the real world is already "self-embellished," he prefers a straightforward attempt at rendering of what he sees, working hard to portray what is before the camera optic. This significant break from film's inherent distortion and recent digital trends of embellishment and enhancement reveals his affection for seeing beauty, compelling form, and visual power in the world as he finds it.

"I want my experience in a place of visual power to be brought to the viewer. My ability to see the image as I make it gives me the on site power to test my vision as the two-dimensional interpretation of a photograph. Judging the light presence and design fully realized is critical."

The Idealized Albert Bierstadt, "Valley of the Yosemite," 1864.
Museum of Fine Arts, Boston

Aesthetics: A Personal Perspective

My own photographic style is such that I've tried hard for most of my photographic career to photograph subjects in a straightforward manner. I was never much interested in changing or embellishing, but I was very interested in trying to record what I saw. It's the reason that photography, backpacking, and liking to make things all blended together to make me want to do landscape photography. It was not because I wanted to go around changing what I saw but because I wanted to capture the wonder. In the same sense, I was never much interested in the idea of embellishment: simple most always seemed better, truer. My color work was always about trying to be as faithful to the original scene as possible.

I had trouble with transparency film because of the exaggeration of contrast. I mostly used color negative film because it was a better medium for recording the dynamic range of the original scene. It's probably the same reason I didn't photograph greens. Greens were recorded so unsatisfactorily to me that I avoided concentrating on them. For me, seeing color has always been about an attempt to make the sand look like sand and the trees look like trees. If there was a power to the vision, it was in what I saw to begin with, and how I photographed it, not what I did to it later.

Now we are in the age where it is not merely the film you choose or just the camera you use that influences the outcome of the image, but what you then decide to do to the image afterwards in Photoshop. Many of my friends in the digital industry think my conservatism is rather silly. I'm the brunt of a lot of their jokes. When they talk about a lot of the *gee-whiz* things they can do, they say things like, "...unless Steve's in the room, because then he would give us a bad time."

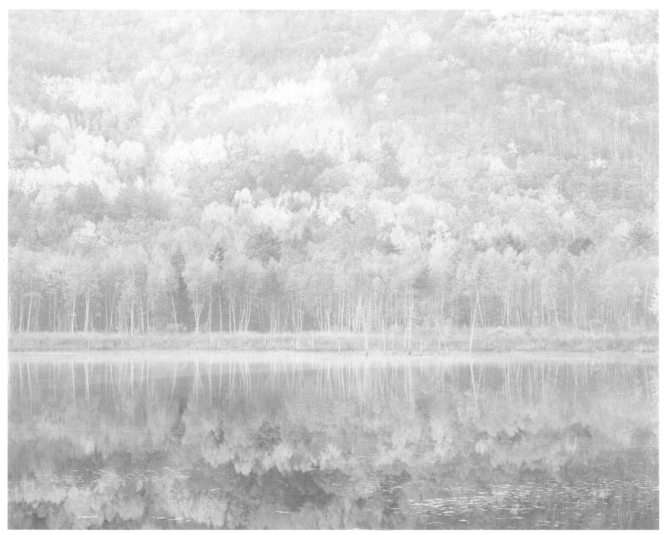

Misty Lake, Acadia National Park, Maine, 1995.
BetterLight Scanning Camera. 6000x7520 pixels. 12-bit. Tri-linear Array.

A Real Scene
A foggy morning at Acadia National Park; this is a pretty dead-on recording of the light as it was that morning. Bierstadt (to the left) is one of my favorite landscape painters, but his work was not necessarily about making a literal rendition. His style was more a kind of melodrama that let these places be something else. My photography is trying to be more literal but just as evocative. I think there is value in that effort.

Fundamentally, I do believe that photography contains a kind of truth, a powerful truth that is worth preserving even in the digital age. I think one of the fundamental powers photography has is that we still have a sort of faith that when we look at a photograph, we are looking at what was before the optic—what was there. It's true, we've selected a piece of it, we've chosen a moment in time. There is inherent distortion by that selection, in making those decisions. And we know photographs can be made to tell partial truths, that they can even be made to lie. But I fundamentally believe the real power of photography is that faith, that what we see in the image was there. It was real. That it was not constructed in Photoshop after the fact. We are in kind of wink-and-nod period with some films, where we know that the embellishment of Velvia, for example, is taking color over the top, yet we still want to believe. My approach to making photographs with film was to try and achieve a kind of direct, simple connection to the subject before my lens, without embellishment. It remains so in this digital age.

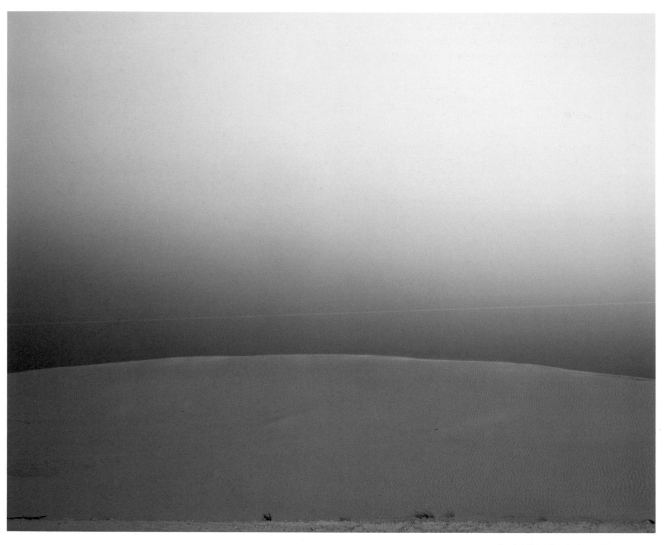

Dusk, White Sands, New Mexico, 1997.
BetterLight Scanning Camera. 6000x7520 pixels. 12-bit. Tri-linear Array.

Since Photography's earliest days, arguments have raged as to whether this tool was merely for documenting or a method for creating art. Early notions insisted that it could only be art if we transformed the record into something else—that we had to imbue the process with the human hand and heart. Others saw photography's raw power to record combined with sensitivity, talent, and care, as sufficient to raise it to a level of art. In many ways, those advocates of "straight" photography won out with the fame and acceptance garnered by photographers of the f64 Group including Ansel Adams, Edward Weston, Imogen Cunningham, and some of their predecessors such as Paul Strand and Timothy O'Sullivan.

With the advent of digital editing, we are now in a curious time in which many of the transformation advocate's arguments are being heard again. In this vein, they argue that digital photography enables modern imagemakers to make their photographs not only from what they saw, but from what they felt. I would agree there is great potential in such capabilities. My only real disagreement here is still calling it "photography," without the viewer's knowledge of the manipulations. I think an image's greatest strength is when the content is compelling because of what

it is, not in the pretense and subterfuge of being something else. That is a different transformation than the power of a successful photograph to raise from the specific truth of a real occurrence, to being an icon of the human experience. That is when a photograph moves into the realm of art. Digital assemblages can have tremendous power, but I advocate using that power wisely and exercising care not to devalue the believability of more straightforward optical photographs that use the photons and power of the moment as their subject.

The striking reality of the f64 work and the light-filled emotion of Impressionist painting do meld for me. I see the value in both, and ultimately do not see them as different, but as paths on a journey to appreciating the sheer wonder of the world before our eyes. I believe they join together at my best moments into completely straight, but highly sensitive, delicate, emotional renditions that are simultaneously literal and emotive. That is certainly my goal.

Some will argue that I am trying to advocate the camera be used only for soulless documentation, that no experimenting with expression beyond literal reality should be brought to bear. They might argue that the criticisms I bring to pixel manipulation are analogous to those formalists in the 19th century who criticized the Impressionists for their strange non-literal interpretations of nature. I disagree, photography has the unique quality of being understood to made from what was in front of the camera, painting does not, it has always been understood to be "through the painter's eyes." It's often the context that creates meaning, painting is understood in one way, photography another. A digital manipulation or creation can easily operate and inspire us in the same context as painting, as an imagined scene, seen through the creator's eyes.

It is also true that I've witnessed scenes very close to what the Impressionists painted. I love Impressionism; it rides the fragile ground between light, color, and emotion. I see a truth in their work that I believe a sufficiently sensitive eye can find literal manifestation of wandering around the planet. I think the wonder of being a photographer is that plunging into the real world, relishing its beauty, irregularity, natural form, aliveness, sometimes even its brutality, then finding a way of selecting moments and subjects that become iconic of those experiences. And all the while using only the photons seen and recorded, not the pixels pushed around in Photoshop.

What was so delightful and exciting to me about the BetterLight camera was that same quality. The ability to record the scene faithfully, admittedly with a huge caveat: unless it moves. But that faithful record continues to be its power for me. When I talk about seeing color, photographing color, and printing color, I'm thinking of the original scene. I want to do everything I can to try to preserve the incredible wonder of what I am seeing. Nature doesn't need the embellishment of super-saturated film. I think it's trite, perhaps even simple-minded. We don't need photography to create a souped-up video reality in order to appreciate the world. I don't believe photography has to be prey to that. But we come from a long visual history that has been doing just exactly that. How literal do you think the early paintings were that came out of Yosemite Valley? Albert Bierstadt got in there, looked around, and might have said, "My god, look at this place," but the paintings he made only looked somewhat like the place. When I look at an Albert Bierstadt painting of Yosemite Valley, I struggle to recognize the lakes and some of the cliffs depicted. One could say he painted the majesty he felt rather than the only cliffs he saw, and that is part of the magic of a painter's soul. I've heard modern Photoshop *enhancers* say much the same thing. Of course, Bierstadt's paintings were understood to be creations; a photograph remains an implied record unless you say otherwise.

However, it's true that the way a lot of the national parks got preserved was not only because of people sincerely believing they needed to be preserved on the merit of what was there, but also by people over-dramatizing what they were. (Of course, it didn't hurt that the railroad companies wanted to promote the national parks to take people there and make lots of money on the travel and the hotels they built.)

When I talk about seeing color for what it is, a few of my images come to mind, like pre-dawn in *Cliffs at Dawn* at Arches National Park. It was made before the sun came up, which would record blue on film. It is not blue, because I balanced the sensor for that pre-dawn condition. It is a pretty accurate rendition of the color. In the prints I make from that file, the sage really looks like sage, the cliffs really look like the sandstone cliffs. The very delicate

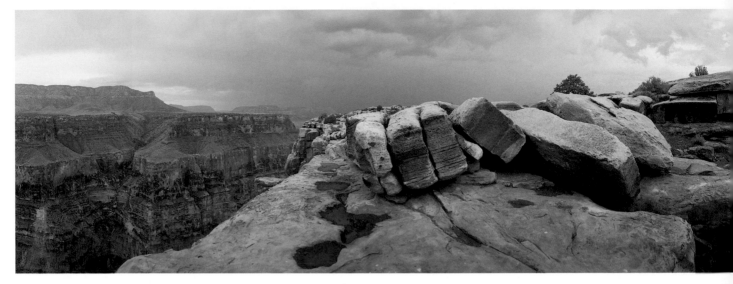

above: Grand Canyon at Toroweap, Grand Canyon National Park, Arizona, 1998.
top right: Stonehenge at Dawn, England, 1996.
middle right: New York City Skyline, 1998.
bottom right: Space Shuttle Columbia on Launch Pad 39A, Kennedy Space Center, Florida, 1996.

BetterLight Scanning Camera. Approximately 6000x35,000 pixels. 12-bit. Tri-linear Array.

rendition of color from my *Travertine Mammoth* at Yellowstone, where the dynamic range is so critical, works because of the highlight tonal response of the sensor. The fact that there is no shoulder to the tonal curve in this digital sensor is an asset, whereas film is always compressing the highlights because that's the way film responds to light. The fact that I can maintain a delicacy, an honesty, and a color balance that's fairly accurate in how the files are recorded has become critical to me. Where the greens really start to look like greens, where there is no need to dramatically saturate the subtle color of these cliffs because I can hold it, and where the subtlety is the beauty of the scene.

But that is not what we have lived with over the years. I think there is something to be said for trying to distinguish between the embellished and idealized and the real. I can't tell you that my photographs are any more real than anybody else's, but I can declare that as my intention. When I use the word "real" here, I use it with trepidation, reality being elusive at best and people in possession of "truth" are often as dangerous as they think they are inspired.

Moving Toward Our Perceptual Experience

Photography is moving forward, as it has always done. It will consume the technology, making useless additions to already overly complex devices, while at the same time enabling deeper recording of real experience.

Recording single-source 2-D photographic images is extremely reductive of our actual experience of being in a place. Photographic information has long been enhanced by the gathering of additional data, from stereo images to field notes that record weather, location, bearing, and distances. As technology grows, ever more information can be folded into the recording of light, including GPS data, spectral information, even radar-based topographic data, leading to an integration of depth information in the photograph. The future of photography is exciting.

Future photographs will come from a place and time that is known, with certain color of light falling on the scene, real distances and depth, sounds, and perhaps more. The virtual room from Ray Bradbury's *Martian Chronicles* or more contemporary holographic constructs in *Star Trek* may come in some form much sooner than we expect.

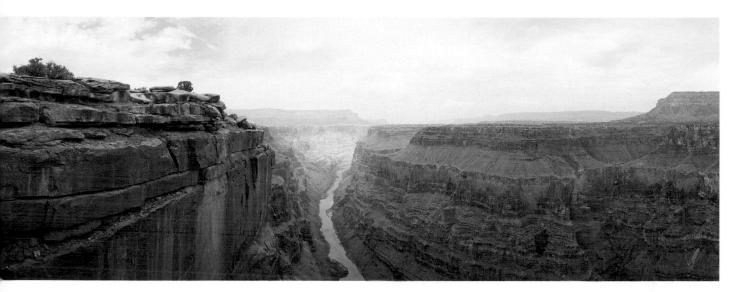

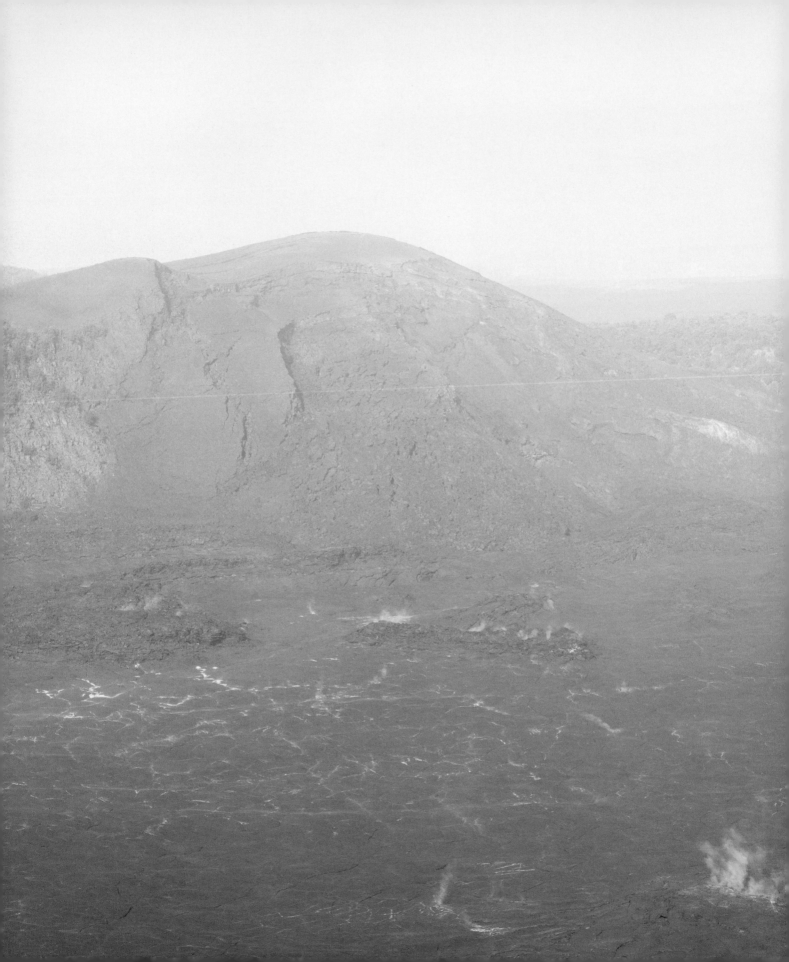

Appendix

A High-Resolution Digital Archive Project

Digital archiving has now become the de-facto practice of museums around the world. Although digitizing originals requires addressing storage media longevity issues, ultimately, the resolution, flexibility, and ultimate fidelity of digital photographic copies moves archiving into a new realm of quality and unprecedented possibilities for non-destructive forensic image analysis.

We understand history through the documents that are available to inform us. For example, The New Testament depiction of the life of Jesus has gone through multiple controversial versions, inclusions, and exclusions over the centuries. Naturally, each succeeding version has been commonly given the attribution of being a faithful link backward to an accurate record of Jesus' life and words. But, what we can actually presume is this: the earlier the source to the original Aramaic words, the more accurate those words are likely to be. This makes the ancient Aramaic New Testament, named The Khabouris Codex, of particular interest.

The Khaburis Codex

The Khaburis Codex is very possibly an authentic, hand-written duplicate of an original 2nd Century New Testament, written in approximately 165 AD. Carbon dating has found this copy of the New Testament to have been created at approximately 1092 AD, making it almost 1,000 years old. It was scribed on lamb parchment and hand-bound between olivewood covers.

The scribe is believed to have been from the area of ancient Nineveh (present-day Mosul, Iraq), according to the Colophon, which also bears the seal the Bishop of the Church at Nineveh. The Colophon, which has suffered much deterioration, still bears the Bishop's signature and seal, which certifies that the Khaburis was a faithful copy of the second century original. Of particular interest is the fact that the Khaburis is written entirely in Aramaic, the tongue of Y'Shua, otherwise popularly known as Jesus, the Nazarite.

The original second century manuscript, as well as the Khaburis, were scribed in the ancient Aramaic Estrangelo script. This is a version of Aramaic that included the vowel points so as not to have confusion in the sharing of the "Good News" of the Gospels. Modern translations of the New Testament originate from the Greek, then Latin, then Middle English, and then Modern English. Each translation increases the likelihood of progressively losing more and more of the original concepts and nuances of the original. Indeed, until this past century and the advent of modern day psychology, those early Western languages/cultures could not translate key concepts core to the Aramaic understandings of the mind. With the translation of this codex incorporating these re-discovered understandings, entire concepts that seemed baffling, have become crystal clear. The resulting message of Y'Shua's Teachings becomes even more logical, and ever more centered around the concepts of Love and Forgiveness.

The Codex was written as a whole New Testament of the twenty-two books of the Oriental Canon, which excludes Revelations and four short Epistles (II Peter, II and III John, and Jude). In the early 1960s two Americans, Drs. Norman Malik Yonan and Dan MacDougald, Jr., set out to find explanations for fundamental Christian words, like "blessed" and "forgiveness" from the most closely linked peoples to the ancient world of the first century church of the disciples of Y'Shua. Their quest led them into Mesopotamia, and eventually to a monastery on the River Khabur, a tributary of the River Euphrates, in the mountainous region of Northern Syria, and Southern Turkey: a region populated then with Aramaic-speaking Christians who could trace their genealogy to the first Church of Antioch referred to in the Book of Acts. After having spent time with the Abbot of the monastery, the Abbot offered to them an intact Aramaic New Testament as a gift to the Western World of a priceless original source of the New Testament. Mr. MacDougald purchased the codex for $25,000 to give the priests of the monastery the means to escape the persecution they immediately faced, and he brought the codex to the United States for study.

abridged from: http://www.whyagain.com/khaburishistory.htm

A Digital Archive of the Khabouris Codex for Conservation and Forensic Image Analysis.
The Khabouris Codex has been digitally copied by Eric Rivera using the BetterLight Scanning Camera Model S8K with the goal to preserve the original manuscript with a level of detail unprecedented for single scan captures in biblical archiving and research. Extraordinarily careful handling, fine focus, and depth-of-field adjustments, together with custom parchment leaf de-warping, made it possible to capture macro-level resolution full page scans. Each color 8,000x10,000 pixel 14-bit native file scan of a page was saved as a 500MB 16-bit file, enlarging the original size of approximately 5.5 x 7.5 inches for each page to a size of over 26 x 32 inches at 300 dpi. This non-interpolated pixel level detail in each color channel allows each character to be examined at a virtual microscopic level (where minute differences in color, line weight, bleed, and graphic intonation are revealed) without risking further handling of the physical manuscript.

PARADOXES OF ART, SCIENCE, AND PHOTOGRAPHY

Henry P. Robinson. *Wilson's Photographic Magazine*, Vol. 29, pp. 242–45. 1892.

"Stick to nature, my boy!" is an admonition often heard among artists, yet it is most true that, beyond a certain point, the closer the imitation is to nature the further it is from art.

Art is not so much a matter of fact as of impression; even realists adroit this. Their objections to what is called impressionism is that the impressionists seldom say anything worth saying, and sometimes nothing at all, leaving a shrewd suspicion that they have nothing to say, and glory in having no mission except to upset the experience and practice of centuries.

No possible amount of scientific truth will in itself make a picture. Something more is required. The truth that is wanted is artistic truth—quite a different thing. Artistic truth is a conventional representation that looks like truth when we have been educated up to accepting it as a substitute for truth. The North American Indian did not understand a portrait less than life size or a profile with one eye only; he was not educated up to the conventional.

Of late years there has been a great demand for truth in art, whatever that dark saying may mean. We have been impressed by literalists to be faithful to nature. To quote Mr. Oscar Wilde, "They call upon Shakespeare-they always do-and quote that hackneyed passage about Art holding the mirror up to Nature, forgetting that this unfortunate aphorism is deliberately said by Hamlet in order to convince the bystanders of his absolute insanity on all art matters…", reducing genius to the position of a looking-glass. On the other hand, it is sometimes said, perhaps jokingly—for we should not take Mr. Brett or Mr. Pennell too seriously—that photography cannot be art because it has no capacity for lying.

Although the saying is wrong as regards our art, this is putting the semblance of a great truth in a coarse way. In other and more polite words, no method can be adequate means to an artistic end that will not adapt itself to the will of the artist. The reason is this, if it can be reduced to reason: admit that all art must be based on nature; but nature is not art, and art, not being nature, cannot fail to be more or less conventional. This is one of those delightful contradictions that make the study of art an intellectual occupation. Men naturally turn to nature. We have evidence of this from prehistoric times. The ornament of all time, of all nations, with scarcely an exception, has been based on nature. The Greeks and Moors are the important exceptions—yet the ornament that approached nearest to exact imitation of nature has always been the most debased and worst. It is the lowest intellects that take the most delight in deceptive imitation. Mr. Lewis F. Day puts this very admirably in one of his recent publications: "Those who profess to follow Nature," he says, "seem sometimes to be rather dragging her in the dust. There is a wider view of nature, which includes human nature, and that selective and idealizing instinct which is natural to man. It is a long way from being yet proved that the naturalistic designer is more 'true to nature' than another. It is one thing to study nature, and another to pretend that studies are works of art. In no branch of design has it ever been held by the masters that nature was enough. It is only the very callow student who opens his mouth to swallow all nature, whole; the older bird knows better."

It is clear, then, that a method that will not admit of the modifications of the artist cannot be an art, and therefore is photography in perilous state if we cannot prove that it is endowed with possibilities a of untruth. But they who, looking perhaps only at their own limited experiments, say photography cannot lie, take a very narrow view and greatly underrate the capabilities of the art. All arts have their limits, and I admit that the limits of photography are rather narrow, but in good hands it can be made to lie like a Trojan. However much truth may be desirable in the abstract, to the artist there is no merit in a that cannot be made to say the thing that is not.

Here I am bound to admit a considerable weakness in my argument. We are told by a writer in a popular new magazine, edited by a member of our club, that it is "always the best policy to tell the truth—unless, of course, you are an exceptionally good liar!" This is, indeed, a misfortune, for there is not, I am ashamed to say, very great scope for sparkling unveracity in our art. That is to say, we cannot produce brilliant falsifications such as the painter may indulge in. One man may steal a horse, while another may not look over a hedge. A painter may unblushingly present us with an angel with wings that won't work, while a photographer is laughed at, very properly, if he gives us anything nearer an angelic form than that of a spook raised by a medium.

It must be confessed that it takes considerable skill to produce the best kind of lies. It is in the hands of first-class photographers only and perhaps the indifferent ones that photography can lie. With the first, possibly, graciously; with the latter, brutally. The photographers of only average attainments, and such as we should get turned out in quantities by an art-less Institute, seldom get beyond the plain, naked, uninteresting truth. Yet I think that many will agree with me that the very good and the very bad are much more interesting than the mediocre. That the best are interesting is clear; that the worst are often the cause of a good laugh is the experience of all; it is only the middling good that induce indifference.

There can be little doubt that, in this respect, and looking at it from this point of view, painting is a much greater art than photography; but what I am concerned to prove is that, although photography is only a humble liar, yet it is not the guileless innocent that some people suppose, and has a capacity for lying sufficient to enable it to worthily enroll its name among the noble arts. Nay, is it not the greater for its humility? Photography gives us the means of a nearer imitation of nature than any other art, yet has sufficient elasticity to show the directing mind, and therefore is the most perfect art of all. If we must have paradoxes, let us carry them to the bitter end.

"Let us have truth," says the conscientious writer who knows not what truth is. What should we get in art if we could capture it? We should have a representation of nature as we see it in a mirror, colors and all, and should tire of it as soon as the novelty wore off. The worst thing that could happen to photography as an art would be the discovery of a process giving the colors of nature-the one impossible thing in nature, I hope and believe. Its one great deviation from faultless virtue is, as I have endeavored to show, that it is more truthful than painting.

A writer, innocent of the resources of art, and wishing to depreciate it, makes a point of the photographer having no control over the action of he developer so as to produce the variation from nature he desires. I can only reply that among my own pictures there is scarcely one that does not owe a good deal of merit it may have to control the developer. The possibilities of control were greater, perhaps, in the collodion process than gelatine, but we are speaking of the capabilities of photography, not of any particular process.

The scientist may prove, beyond any possibility of doubt, that the relative values cannot be altered in development, but the photographer knows that variation in development varies the appearance of his results, and that should be quite enough for him. It is so difficult, and yet so tempting, to "find out what cannot be done, and then to go and do it!

I feel serious promptings here to have a fling at science that will surely bring down the wrath of our President on my unfortunate head. I will try to ameliorate him by saying that science demands our greatest respect. No one can have more reverence for science than I have myself—when it keeps its place. But we are suffering from science, and fancy is dying out of the land. It is doing serious harm to photography as a picture-producing art. When a student ought to be studying the construction of a picture, and developing in his soul the art of lying, he is led away by the flickering ignis fatuzis of science, and goes mad over developers. "Another new developer" has more effect on the tender feelings of the brethren of the camera than would the advent of a poet-photographer. This suggests a variation on Rejlander's "Two Ways of Life."

One youth travels along the pleasant and virtuous walks of art, not listening to the Sirens of Fact; but dozens of others are decoyed to the worser way, and are soon lost in the seductive vanities and subtleties of science.

They last long enough, perhaps, to modify a developer-with which science, however, tells them they can do little or nothing—and I heard of no more, except in the multitudinous platitudes used in the endless discussions of abstractions in society papers; and the scientific dream of the future is an Institute of Photography from which art is to be excluded. Art will be very glad to part company.

Let us be generous and admit that science has its good points, but it is doing a good deal of harm in the world. It is robbing us of our illusions. The science of history has defrauded Richard III of his hump, made Henry VIII a moral character, and gone audaciously nigh to proving that Jack the Giant Killer never existed. We are bored by the tedious papers of those who "have not the wit to exaggerate nor the genius to romance," and a synonym for dullness is a lecture at the, Royal Society. But scientists are not without their hilarious moments. In our own art I cannot help thinking that scientists are trifling with a serious subject when they tell us that we cannot do as we like with our developers or when they bring logarithms to bear on picture-making. But the humor is not all on one side, and we not unfrequently enjoy a smile at the prodigious engines they sometimes use to crack our poor little nuts.

What has science to do with art, except to provide materials for its use? It is only of late that art has, on the one hand, been made to depend on absolute truth: and, on the other, by the same writers, been proved, in the case of photography, not to be an art because it cannot deviate from truth. It is merely an incident, an accident, a detail—call it what you will—that science, sometimes of the highest and most distracting kind, is connected with picturemaking photography. The science that deals with the nature of the image or the calculation of the curve of a lens is a very distant cousin, indeed, to picture-making by the use of photographic materials. The use of materials invented by others for a definite purpose can scarcely be called science. No scientific theory should be allowed to have weight with an artist who has practised his art successfully for years and knows what he wants and how to get it. If, for instance, I was told that it was proved by science that the negative would not yield all the tones of nature, I should reply that many years' practice had convinced me of that well-known fact, but the mere fact of it being proved scientifically did not alter the facts or further limit the tones. When it was proved scientifically to Diogenes that he could not walk round his tub, that humorous philosopher settled the matter by walking round that desirable residence. I am afraid I have used this illustration somewhere before, but let it pass. In art the artist sees his results, and it is for him to judge, from his knowledge of art and nature, not science, whether his results are true, or, at any rate, if they lie properly and are what he wants. The artist has to do with appearances, the scientist with facts. It is not enough to say, This is not true. The question is, Is it true enough for artistic purposes?

I have alluded to development once or twice. Two very clever scientists, whom I much respect, Dr. Hurter and Mr. Driffeld, have proved to everybody's unsatisfaction that photographers have no control over the gradations; but this does not alter the fact that—to put the simplest case—he knows when a negative is over- or underexposed or developed too dense or too thin to properly represent his idea of nature as far as in him lies and his art will allow. Then there has been another great attempt made to show that the perspective of photography is not scientifically true. If the attempt was successful, which is very doubtful, who cares? It has been true enough not to be found out for fifty years, and that ii good enough for photography. Can it have been the want of truth that has unconsciously compelled artists since the beginning to admire the truth of photographic perspective and rely on its veracity? Here is another paradoxical nut to crack.

But my business is not to make a feature of the truth of any part of photography. On the contrary, I want to clear its character of the unartistic virtue of being nothing but a truthful, inevitable, stupid purveyor of prosaic fact.

Painters sometimes trust to us for truth; the law courts are becoming more wary, and appreciate our deviations. I was once found fault by an artist for "altering" a photograph, on the plea that it would mislead the painter if he wanted to copy it. I found he had copied it before he saw the scene and when he afterward compared his picture with it, he found a clump of trees that should have appeared on the left transferred to the right. I had made

When the Day's Work is Done. 1877.
Henry Peach Robinson
Albumen print from six negatives.
22 1/16 x 29 5/16 in.

the alteration by double printing, and improved the composition. I did not want a mere local view. I don't know that there is anything more exasperating than for a painter to take it for granted that it is a photographer's business to play jackal to his lion, and hunt up food for him; but it is a blessed truth that we can deceive him if we like. Painters ought to be more grateful to us than they are. Besides providing some of them with subjects, we taught them what to avoid—educated them on the Spartan and Helot principle—and art has vastly improved during the half-century of our existence. We have made the column and curtain background absurd. When our art was born painters thought nothing of violating perspective by placing the horizon as low as the feet of their portraits, and made no difficulties about hanging heavy curtains from the sky, and we are still fulfilling our useful mission of showing artists the ridiculous things they ought not to do, but it is asking too much to provide subjects for them-idea, composition, and detail. A painter should never use photography until he is capable of getting on without it, and then he should make his own photographs. To copy another man's work is not honest, and is a lazy and mischievous method of attempting to make a living.

I am afraid I have filled my space without giving as many specimens as I could wish of the possible delinquencies and untruthfulnesses that art requires and photography can accomplish, but I hope I have shown that if it cannot lie like paint, it has the merit of approaching it in mendacity.

I will conclude with another illustration of the capabilities of our art for useful falsification. I once knew a photographer (it sounds better to put it that way) who was employed, for the purposes of a parliamentary committee, to make a series of photographs showing that one place was much more picturesque than another. Some ugly gas works were to be erected, and it was desirable to place them on the least beautiful of two spots. It may be also mentioned that it was likewise necessary that they should be placed on the site that best suited the promoters. Both places were very picturesque, but in the photographs it was easy to see the one site was a little rustic paradise (with suitable figures and fine skies) and the other a dreary desert, all foreground of the plainest! Yet both were true to fact, and they had the intended effect.

In conclusion, let me express the pleasure I feel in being afforded the fascinating opportunity of saying a few humble words in praise of lying in a room which has been saturated with truth and fact for more than a hundred years-ever since, indeed, Barry "restored the antique spirit in art" by painting his anachronisms on the walls, and from which building emanates the prospectus of the Chicago Exhibition, which honors our art with the crowning paradox of classing photography with Instruments of Precision.

Camera Megapixels and Print Size

There is great discussion in this digital age as to how big quality prints can be made from various digital cameras and files. Camera and scanner manufacturers are not always the best source for such information, as part of their sales pitch has become tied up in just such numbers looking big.

A general working assumption is present in the digital photographpy industry that something in the neighborhood of 300ppi is about right as an input starting point for most work. Given that, it is very easy to calculate how big you can print without fabrication of data. Of course, most cameras have already interpolated their files because of their Bayer-pattern sensor structure, and enlargement beyond their already made up data does compromise things further. It is also true that this is a guide, and that individual taste and standards will vary and perhaps allow for much greater enlargment through various forms of interpolation.

Megapixel Rating	Camera Example	Pixel Dimensions		Native Print Size in Inches		
4mp	Canon PS A420	1704	2272	5.7	7.6	*(Bayer-pattern interpolated)*
6mp	Kodak 460, Nikon D70	2000	3008	6.7	10.0	*(Bayer-pattern interpolated)*
8.2mp	Canon 20D	2336	3504	7.8	11.7	*(Bayer-pattern interpolated)*
3.4mp x 3=10.2mp	Sigma SD10	1512	2268	5.0	7.6	*full color resolution X3*
10mp	Nikon D200	2592	3872	8.6	12.9	*(Bayer-pattern interpolated)*
12.2mp	Nikon D2X	2848	4288	9.5	14.3	*(Bayer-pattern interpolated)*
12.7mp	Canon 5D	2912	4368	9.7	14.6	*(Bayer-pattern interpolated)*
13.5mp	Kodak DCS14n	3000	4500	10.0	15.0	*(Bayer-pattern interpolated)*
16.6mp	Canon 1 Ds Mark II	3328	4992	11.1	16.6	*(Bayer-pattern interpolated)*
22mp	Phase-One P25	4080	5436	13.6	18.1	*(Bayer-pattern interpolated)*
39mp	Phase-One P45	5412	7216	18.0	24.1	*(Bayer-pattern interpolated)*
48mp x 3=144mp	Better Light Model 6000	6000	8000	20.0	26.7	*full color resolution*

The Megapixel Dilemma

Any full resolution camera tends to suffer from this kind of numeric comparison to cameras using the Bayer-pattern array. Whereas every Bayer-pattern pixel dimension is interpolated (synthesized) by a factor of three to reach their final resolution, the two full-resolution devices listed here—the Sigma Foveon SD10 and the BetterLight scanning camera—record the image at full-resolution using no interpolation and can therefore see much more detail and render color geospacially with much greater accuracy.

(calculations are based on sensor size divided by 300)

Film Size and Scanner Resolutions

There are many scanners on the market today, offering access to film scanning to a wide audience. Multi-purpose flatbed scanners are being built with transparency adaptors for film scanning. Dedicated film scanners remain pre-eminent in image quality, whether drum-based or designed for negative/film holder paths.

As film scanners are expensive, and film scanning is going to be with those of us with large archives from the silver-age, it seemed worthwhile to layout some basic scanner resolution, film size, and output size relationships.

35mm film						
	W - in	L - in	W - pixels	L - pixels	W - in @ 300	L - in @ 300
2000	1	1.5	2000	3000	6.7	10.0
4000	1	1.5	4000	6000	13.3	20.0
6000	1	1.5	6000	9000	20.0	30.0
8000	1	1.5	8000	12000	26.7	40.0
120 film						
	W - in	L - in	W - pixels	L - pixels	W - in @ 300	L - in @ 300
2000	2.25	2.75	2000	2444	6.7	8.1
4000	2.25	2.75	4000	4889	13.3	16.3
6000	2.25	2.75	6000	7333	20.0	24.4
8000	2.25	2.75	8000	9778	26.7	32.6
4x5 film						
	W - in	L - in	W - pixels	L - pixels	W - in @ 300	L - in @ 300
2000	4	5	2000	2500	6.7	8.3
4000	4	5	4000	5000	13.3	16.7
6000	4	5	6000	7500	20.0	25.0
8000	4	5	8000	10000	26.7	33.3

Selected Reading

The following list includes a few publications I've done, a few I've found useful, and a few I've found compelling—some digital, some photographic, some simply visual.

A Visual Artist in Today's Landscape.
Stephen Johnson. In *California History* (Winter 1989–1990). San Francisco, California: California Historical Society.

Art and Fear.
David Bayles and Ted Orland. Santa Barbara, California: Capra Press, 1993.

At Mono Lake.
Edited by Stephen Johnson. San Francisco, California: Friends of the Earth, 1983.

At Mono Lake: The Making of a Photographic Exhibit.
Stephen Johnson. In *Terra Magazine*, vol. 18, no. 4. Los Angeles, California: Los Angeles County Museum of Natural History, 1980.

Beauty in Photography. Essays in Defense of Traditional Values.
Robert Adams. New York: Aperture, 1981.

The Great Central Valley: California's Heartland.
Stephen Johnson, Gerald Haslam, and Robert Dawson. Berkeley, California: University of California Press, 1993.

Minamata.
W. Eugene Smith and Aileen M. Smith. New York: Holt, Rinehart, Winston, 1975.

Permanence in Photographic Materials.
Henry Wilhelm and Carol Brower. Grinnell Iowa. Preservation Publishing Company, 1993.

Picturesque America.
Edited by William Cullen Bryant. New York: D. Appleton & Company, 1874.

Real World Photoshop CS2.
David Blatner and Bruce Fraser. Berkeley, California: Peachpit Press, 2005.

Real World Camera Raw with Adobe Photoshop CS2.
Bruce Fraser. Berkeley, California: Peachpit Press, 2005.

The Nature of Light and Colour in the Open Air.
Marcel Gilles Jozef Minnaert. Dover Publications, 1948.

Software & Internet Resources

A variety of websites are available on the Internet with great information, products, and alternative software/shareware packages. Here are a few sites of photographers, teachers, image sources, and software of note:

Camera

- Better Light: www.betterlight.com
- Foveon: www.foveon.com
- Kodak: www.kodak.com
- Colleagues:
 - —Dan Burkholder: www.danburkholder.com/
 - —John Paul Caponigro: www.johnpaulcaponigro.com/
 - —Katrin Eismann: www.photoshopdiva.com/index.html
 - —Bruce Fraser: www.pixelboyz.com
 - —Ken Light: www.kenlight.com/
 - —Bert Monroy: www.bertmonroy.com/
 - —Ted Orland: members.cruzio.com/~tno/
 - —Jeff Schewe: www.schewe.com
 - —Andrew Stern: www.andresternphoto.com/gallery/appalachia
 - —Jerry Uelsmann: www.uelsmann.com/

Education

- Stephen Johnson Photography workshops: www.sjphoto.com/workshops
- Maine Photography Workshops: www.theworkshops.com/
- Santa Fe workshops: www.sfworkshop.com/
- Photoshop World: www.photoshopworld.com/
- Ben Willmore: www.digitalmastery.com/

Image Processing

- Adobe Photoshop: www.adobe.com
- Photoshop News: www.photoshopnews.com/
- SilverFast: www.lasersoft.com/
- Quantum Mechanic: www.camerabits.com
- PixelGenius: www.pixelgenius.com
- Fred Miranda Photoshop Actions: www.fredmirada.com
- Dalke Color: www.4gcolor.com/

Photographer-Centric Image Processing

- Apple Aperture: www.apple.com
- Adobe Lightroom beta: www.adobe.com

Printing

- Epson: www.epson.com
- Solux bulbs: www.soluxtli.com/
- ImagePrint RIP: www.colorbytesoftware.com
- Piezography: www.inkjetmall.com

Photo Organization

- Disk Tracker: www.disktracker.com/
- PhotoMechanic: www.camerabits.com
- Cumulus: www.canto.com
- Portfolio. Extensis: www.extensis.com
- Apple Aperture and iPhoto: www.apple.com
- WebPics: www.splons.com/m3/webpics/

Photographic Resources

- Robin Myers Imaging: http://www.rmimaging.com/

Print Longevity

- Wilhelm Imaging: www.wilhelm-research.com/
- Image Permanence Institute: www.rit.edu/~661www1/

Space and Earth from Space Photos

- National Aeronuatics and Space Administration: www.nasa.gov
- Jet Propulsion Laboratory: www.jpl.nasa.gov/
- United States Geological Survey: www.usgs.gov

Check for updates and revisions:

www.ondigitalphotography.com

A Glossary of Digital Terms

24-bit color: condition where 16.7 million possible colors are displayed on the screen at one time, each color channel consisting of an 8-bit (256 shades of gray) grayscale image.

48-bit: usually referring to a color file with three 16 bit grayscale channels, each defining 65,536 level of grayscale brightness.

8-bit color: 256 possible colors displayed on the screen at one time. Photoshop's Indexed Color Mode.

8-bit grayscale: 256 possible grays displayed on the screen at one time.

analog: continuously variable electrical signals.

archival: stable over time, should be coupled with life estimate.

A/D converter: (Analog/Digital converter) an electronic circuit that converts analog data (a continuous and variable flow of electricity) to absolute binary numbers/data.

Beseler: photographic enlarger manufacturer.

Bezier: a vector-based drawing interface using control points and curve handles for resolution-independent drawing programs and typeface outlines.

binary: a numbering system based on ones and zeros.

bit depth: levels of gray levels that can be seen or recorded by digital devices; 8 bit (256 levels of gray) is the native Macintosh bit depth.

BIT: the basic binary signal: 1 or 0, on or off, black or white.

bitmap: any computer image made up of pixels. Photoshop's term for line art mode (1-bit, black or white images).

byte: 8 bits (2x2x2x2x2x2x2x2) or 256 levels of gray.

CCD (charge-coupled device): a light-sensitive device that produces varying amounts of analog electrical current when struck by light.

CD (compact disc): a pre-recorded (metal stamped) laser-read disk for delivering digital data in music and for computers.

CD-R: a recordable CD.

CD-RW: a re-writable CD-R.

channel: a single plane of image information; three grayscale channels (red, green, blue) are needed to produce a color image.

chromatic aberration: the failure of the three primary colors of light to come into focus at the same point.

Clone: to make a duplicate.

CMYK: initials that stand for cyan, magenta, yellow, black—the opposites of the primary colors of light (red, green, blue) on the color wheel. Used as printing inks to subtract color from the white of paper (also known as subtractives). The file format used for printing in this manner.

color separation: scans or film that encode a full color photograph into three black-and-white images made through red, green, and blue filters.

compression: reduction of the size of a digital file through code repetition modeling or specific image compression technology like JPEG.

contrast: the relative intensity of blacks and whites.

CPU (central processing unit): the primary chip found within a computer.

Cromalin: a DuPont prepress proofing process imaged from color separation negatives, using ultraviolet light to expose sensitized material, making it receptive to toners of standard or custom colors.

Curves: an editing interface similar to film contrast curves.

DAT (digital audio tape): an extremely economical mass data storage medium.

density: the opacity of the image or ink.

dpi (dots per inch): referring to the number of ink dots on an inch of paper.

display: a high-resolution television-like screen for viewing computer images, now often assumed to be an LCD. Also often known as computer monitors.

drum scanner: a rotating drum imaging device, usually employing PMT tubes to pick up light.

digital: information represented as on or off conditions; absolute values for gray level in images.

DNG: Adobe's digital negative format, which is a documented standard for writing and reading raw digital image data.

duotone: printing a black-and-white image with two colors of ink. tritone: three. quadtone: four color.

DVD (digital video/versatile disc): a pre-recorded (metal stamped) laser-read disk for delivering digital data in movies and for computers.

DVD-R: a recordable DVD.

DD-RW: a re-writable DVD-R.

dye-sublimation (dye-sub): a heat dye-transfer process printer that creates prints that appear almost continuous-tone.

enlarger: photographic device for printing negatives or slides onto photographic paper.

EPS (Encapsulated Postscript): a postscript page description language file format.

extrapolation: a formula for decreasing the dpi (and file size) of an image, reducing the number of pixels.

fiber: paper-based photographic paper (as opposed to RC/resin-coated plastic paper).

filter: a semi-transparent colored material designed to transmit some wavelengths of light and block others.

flatbed: a scanner for imaging prints, much like a photocopy device.

floppy disk: a removable disk for digital data storage (standard Macintosh formats are 800K or 1.4MB).

floating point: a value stored in a scientific notation, like $3.5234*10^{-14}$, so that several digits of precision can be addressed across a wide range of magnitudes. The exponent allows the decimal point to "float", to accommodate large and small values.

font: an individual face in a family of typefaces.

four-color: refers to process color printing using cyan, magenta, yellow, and black inks to reproduce full color photographs.

gamma: the overall contrast of the image expressed numerically; a 45-degree line on a film curve represents a gamma of 1.0.

grayscale: a continuous tone black-and-white image (256 levels of gray) similar to a black-and-white photograph.

halftone: an image filtered through a screen of dots to imitate a continuous-tone photograph by rendering it with large and small dots of ink to form light and dark areas of an image.

hard disk: a magnetic storage device for digital data.

HDR (High Dynamic Range): an image that contains a wide range of original recorded brightness values, usually encoded into special and often still proprietary and conflicting formats. Floating point calculations and 96 bit encoding are often used to hold this data.

highlights: the lightest portions of an image.

histogram: a graphic representation of the distribution of grays in a digital image, essentially a pixel brightness counter.

imagesetter: a high-resolution device that writes digital files to high-contrast graphic arts film in preparation for printing.

interpolation: a formula for increasing the dpi (and file size) of an image, creating more pixels by sampling current pixel data and calculating the value for new pixels.

ISO (International Standards Organization): refers to film or an image sensor's sensitivity to light as defined by the International Standards Organization.

JPEG (Joint Photographic Experts Group): a compressed file format; developed by a committee to set a standard for image data compression.

kilobyte (KB): 1,000 bytes.

lpi (lines per inch): a measurement of halftone screen frequency.

matchprint: a 3M and Fuji prepress proofing process imaged from color separation negatives, using ultraviolet light to expose pre-colored sensitized material.

megabyte (MB): 1,000 kilobytes (1 million bytes).

memory: usually the volatile storage medium of a computer, devices used to hold information (RAM, hard disk, ROM). See also ROM and RAM.

midrange: the middle part of tonal range of image.

midtone: the midpoint in tonal range of image.

monitor: a computer display screen.

opacity: degree of transparency.

output: the final product from a computer, usually prints or paper.

photons: a particle of light described by a model of light's behavior that seems to indicate light is made of particles.

pixel: a picture element, individual block of data that makes up a digital image.

plate: a photosensitive metal sheet used by printers for individual printing inks.

platesetter: a device used to image directly onto printing plates.

PMS (Pantone Matching System): a system of precise ink color definitions and formulas.

PMT (photo multiplier tube): highly sensitive photoelectric device used in traditional high-end drum scanners.

posterization: separation of an image tone into distinct, discernible levels of gray (usually 2 to 16).

ppi (pixels per inch): referring to the measure of pixels in an image.

Postscript: a device-independent computer page description language (or file format) developed by Adobe Systems.

prepress: graphic arts operations that occur prior to going on press.

primary colors: basic colors of light; red, green, and blue.

proof: generally a positive paper print from film such as a Cromalin or Matchprint; any representation of a digital file on paper.

progressives: prints of the individual color plates from a printing job.

RAM (random access memory): memory held by the computer's CPU; fast electronic memory.

registration: multiple layers of an image overlaid (or superimposed) exactly.

RAW: an image file design to hold the raw image sensor data to be processed later in custom software.

RGB: multichannel image consisting of three grayscale images separated through red, green, and blue filters during scanning or picture-taking; channels are colored by the computer and superimposed to display a full color image.

rasterize: to convert a computer file (like postscript type or eps drawing) into bitmapped image (pixel based).

resolution: the amount of data present to represent images (pixels dimensions), generally expressed as dpi (in conjunction with size: 300 dpi 8x10 inches).

retouching: repairing damage or removing unwanted detail from an image.

ROM (read-only memory): the start-up code recorded onto computer chips; also information stored in a read-only format such as CD-ROM.

Rubber Stamp: Photoshop's Cloning Tool.

saturation: the relative intensity of color—increases as image darkens, reduces to pastel as image lightens.

scanner: an image-recording device used to produce a digital representation of film or prints.

Secondary Colors: cyan, magenta, and yellow, the opposites of the primaries.

Scitex: a manufacturer of drum scanners, imagesetters, and prepress software based in Israel.

separations: encoded color created by scanning or photographing a color image through red, green, and blue filters.

shadow: the darkest areas of image.

sharpen: to make an image appear more in focus, usually by edge-contrast enhancement.

signal to noise: the intended signal that is being recorded or transmitted as opposed to the often random, mostly low-level signals in any electronic circuit or accompanying a weak signal. Most often expressed as a ratio of signal strength to noise strength.

spotting: removing dust spots from image.

stripping: assembling loose film into composites of publication; the final step prior to making printing plates.

subtractive color: cyan, magenta, and yellow, the opposites of the primaries, used to subtract color from the white of paper.

TIFF (tagged image file format): a protocol for image data.

typeface: a character set of matched type including roman (normal), italics, bold, small caps, old-style figures.

vector: a line connecting two points in space.

video card: an electronic circuit board that creates video signal to display on computer monitors.

x-height: small character height in type.

yellowing: the aging of a photograph where whites turn yellow, lowering overall contrast.

Index

About the Author

On the trail with the digital view camera rig.
Steve Johnson, Pinnacles, 1999. Photograph by David Gardner.

Stephen Johnson is internationally recognized as a digital photography pioneer; his photographs are part of the permanent collections of many institutions including the Oakland Museum, the J. Paul Getty Museum, the City of New York, the U.S. State Department, and the National Park Service. *With a New Eye*, his digital national parks project, literally made photographic history.

His photography explores the concerns of a landscape artist working in an increasingly industrialized world. His work has also concentrated on refining the new tools of digital photography and empowering individual artists to use these tools to express their ideas. Since 1977, Johnson has also taught photography at the college level, in his own workshop program, and in varied forums from Stanford University to the Jet Propulsion Laboratory and FOGRA in Munich. In 1988, The U.S. House of Representatives awarded Johnson with a Congressional Special Recognition Award for his work on behalf of Mono Lake.

Johnson's publications and exhibits include *The Great Central Valley Project* (a photographic exhibit and book) that uses landscape photography to examine the dramatically human-altered heartland of California; and *The Great Central Valley: California's Heartland*, published by the University of California Press in 1993. He was also the curator, editor, and designer of *At Mono Lake*, a book and National Endowment for the Arts funded exhibition that toured the United States from 1980–1983. The exhibit reached an estimated audience of over two million people.

His work in digital photography is renown. His consulting has influenced products at the core of digital-imaging, for such clients as Adobe Systems, Apple Computer, Eastman Kodak, Epson, Foveon, and Hewlett-Packard. His work with Adobe includes consulting on the development of Photoshop since 1992 and the creation of its Duotone feature.

In 1999, *Folio Magazine* declared the publication of Johnson's digital photographs in *Life* magazine to be one of the *Top 15 Critical Events* in magazine publishing in the twentieth century. He was named as a 2003 inductee into the *Photoshop Hall of Fame*, recognized for his achievements in Art.

Stephen Johnson's photographs are in public and private collections across the country and have appeared in *American Photo, Communication Arts, Omni, Audubon, Sierra, California Magazine, California History, Outdoor Photographer, US News and World Report, MacUser, MacWeek, Photo District News, Photo Insider, Publish, Camera Arts, View Camera, Hemispheres, Fotografisk Tidskrift, Adobe Magazine, Hallå, Journal of the Royal Photographic Society*, the *Adobe Photoshop Deluxe Edition CD ROM, Nautilus CD ROM Magazine, The New York Times, ABC/Discovery News, The Computer Chronicles*, and PBS's *MacNeil/Lehrer Newshour*.

Original Prints, Books, Posters, and Videos by Stephen Johnson

To Order

Original Prints

Posters, Books, Notecards, and Videos

by Stephen Johnson

email: info@sjphoto.com

www.sjphoto.com